Index.

The Papers of Benjamin Henry Latrobe

EDWARD C. CARTER II, EDITOR IN CHIEF

SERIES III

THE SKETCHBOOKS AND MISCELLANEOUS DRAWINGS

Latrobe's View of America, 1795–1820

Latrobe's View of America, 1795–1820

Selections from the Watercolors and Sketches

Edward C. Carter II, John C. Van Horne, and Charles E. Brownell
Editors

Tina H. Sheller
Associate Editor

WITH THE ASSISTANCE OF
Stephen F. Lintner, J. Frederick Fausz, and
Geraldine S. Vickers

*Published for the Maryland Historical Society
by
Yale University Press, New Haven and London
1985*

EDITORIAL BOARD

The preparation of this volume was made possible (in part) by grants from the Program for Editions of the National Endowment for the Humanities, an independent federal agency, and the National Historical Publications and Records Commission. This volume is published with the financial assistance of the Program for Publications of the National Endowment for the Humanities, Lawrence A. Fleischman of the Kennedy Galleries, New York, and The J. Paul Getty Trust.

Designed by James J. Johnson
and set in Baskerville Roman.
Printed in the United States of America by
Murray Printing Company, Westford, Massachusetts.

Library of Congress Cataloging in Publication Data

Latrobe, Benjamin Henry, 1764–1820.
 Latrobe's view of America, 1795–1820.

 (The Papers of Benjamin Henry Latrobe. Series III, The Sketchbooks and miscellaneous drawings)
 Bibliography: p.
 Includes index.
 1. Latrobe, Benjamin Henry, 1764–1820. 2. United States in art. I. Carter, Edward Carlos, 1928– . II. Van Horne, John C. III. Brownell, Charles E. IV. Maryland Historical Society. V. Title. VI. Series: Latrobe, Benjamin Henry, 1764–1820. Papers of Benjamin Henry Latrobe. Series III, Sketchbooks and miscellaneous drawings.
 ND1839.L35A4 1985 759.13 84–7580
 ISBN 0–300–02949–7

The paper in this book meets the guidelines for permanence and durability of the Committee on Production Guidelines for Book Longevity of the Council on Library Resources.

10 9 8 7 6 5 4 3 2

Contents

Illustrations

(An asterisk indicates colorplate.)

PLATES

MAPS

Acknowledgments

The editors have enjoyed the assistance of numerous individuals and institutions who generously gave of their time and shared their knowledge and expertise of many of the subjects touched on in this book. We wish to record our gratitude to the following people, noting in each instance the subject on which we consulted them: Jeremy Adamson, National Collection of Fine Arts, Smithsonian Institution, on early views of Niagara Falls; Maxwell H. Bloomfield III, department of history, Catholic University of America, on matters of legal history; Bill Bolger, Burlington County Cultural and Heritage Commission, the Rev. Frank K. Jago, rector of St. Andrew's Church, Mount Holly, New Jersey, and Mrs. Morris K. Perinchief, Sr., and Mrs. Eleanor S. Rogus of Mount Holly, on Latrobe's drawings of Clover Hill and Mount Holly; Mary Bristow, of Harford County, Maryland, on the town of Bush; John S. Carter, Peabody Museum, Salem, Massachusetts, on the ship *Tabitha* of Salem; Margaret Marshall Coleman and her colleagues of the Boyds/Clarksburg Historical Society, and Francis Ugolini, Heritage Conservation and Recreation Service, on Sugar Loaf Mountain, Frederick County, Maryland; Jane L. S. Davidson, historian and preservationist of the Borough of Downingtown, Pennsylvania, on the bridge over the Brandywine at Downingtown; Linda Flint, National Register of Historic Places, Washington, D.C., on the

history of the falls of the Passaic River; George L. Gordon, Jr., of Stafford, Virginia, on William Robertson's house and quarry near Aquia; Carol Hallman, Eleutherian Mills Historical Library, Greenville-Wilmington, Delaware, on mills along Brandywine Creek; Owen Hawley, Washington County Historical Society, on Marietta, Ohio; the staff of the Lancaster County Historical Society, Lancaster, Pennsylvania; Nelson H. McCall, Historic Charlestown, Inc., on Charlestown, Maryland; George Meiser IX, of Limekiln, Pennsylvania, on Berks County forges; Mrs. Samuel W. Morris, French and Pickering Creeks Conservation Trust, on the Warwick Iron Furnace in Chester County, Pennsylvania; Margaret T. Peters, Virginia Landmarks Commission, Richmond, on the Chesterfield County estate Eppington; Arlene Peterson, Ohio Historical Society, on Marietta and Steubenville, Ohio; Charlotte M. Porter, Florida State Museum, Gainesville, on Latrobe's natural history drawings; Nancy Saxon, Washington County Historical Society, on Washington, Pennsylvania; C. Lavett Smith, department of ichthyology, American Museum of Natural History, New York, on Latrobe's drawings of fish; E. A. Smyk, Passaic County Historian, on the falls of the Passaic; Brent Tarter, Virginia Independence Bicentennial Commission, on the history of Norfolk; Mark Walston, Maryland-National Capital Park and Planning Commission, on Latrobe's Montgomery County scenes; Helmut Weickman, Cooperative Institute for Research in Environmental Sciences, Boulder, Colorado, on Latrobe's rendering of an unusual rainbow; and Joseph Williman, department of modern languages and literature, Catholic University of America, for translating a poem from the Italian. Special thanks are due to Dr. E. P. Richardson, dean of the history of American painting, who read the entire manuscript with great care and commented on Latrobe as a traveler and on his place in art history.

In addition the editors are indebted to several former members of the staff of the Latrobe Papers for important contributions to this

volume. Geraldine S. Vickers transcribed from Latrobe's writings and typed the contents of the volume several times over. Darwin H. Stapleton, assisted by Virginia Dawson, provided information on Latrobe's technical drawings, and Lee W. Formwalt drafted the commentary that accompanies the sequence of views along the Susquehanna River. Sally F. Griffith and Richard B. Wilkof conducted the initial research for several of the entries and searched Latrobe's correspondence for relevant material. Vivian C. Klein sifted numerous primary and secondary sources in Baltimore libraries.

Our photographers were Duane Suter of the Baltimore Museum of Art and Erik Kvalsvik of Baltimore.

Our cartographer was Wesley G. Le Faivre.

At Yale University Press we benefited enormously from the skills of editor Lawrence Kenney and designer James J. Johnson.

Work on this volume by Edward C. Carter II was aided by the Catholic University of America, which arranged a reduced teaching load, and by the American Academy in Rome, which appointed the editor in chief a visiting scholar in the fall of 1978.

And of course work on this volume could not have been completed without the sustained and unstinting support of the National Endowment for the Humanities, the National Historical Publications and Records Commission, the National Science Foundation, and the Andrew W. Mellon Foundation. Publication subsidies for this book were generously provided by NEH, Mr. Lawrence A. Fleischman of the Kennedy Galleries, New York, and The J. Paul Getty Trust.

Abbreviations

APS	American Philosophical Society, Philadelphia
BHL	Benjamin Henry Latrobe
DLC	Library of Congress, Washington, D.C.
DNA	National Archives, Washington, D.C.
MEL	Mary Elizabeth Latrobe
MGLC	Mrs. Gamble Latrobe Collection, Maryland Historical Society, Baltimore
PBHL	Papers of Benjamin Henry Latrobe, Maryland Historical Society, Baltimore

Latrobe's View of America, 1795–1820

Benjamin Henry Latrobe (1764–1820): Architect, Engineer, Traveler, and Naturalist

EDWARD C. CARTER II

1. LATROBE'S LIFE AND PROFESSIONAL CAREER

Benjamin Henry Latrobe, the great American architect and engineer whose watercolors and sketches comprise this book, practiced his art first and foremost for pure pleasure and diversion, then for a wide variety of reasons—to satisfy his "itch of Botany" and fascination with other fields of natural history, to inform his family and friends of his travels, to make drawings of potential sources of construction materials for later professional use and of the topography of project sites, and even once to maintain his grip on sanity in a moment of psychological storm and physical illness. As *Latrobe's View of America* dramatically shows, he was attracted to landscape painting and the illumination of nature. Indeed, the opening passage of his "Essay on Landscape," written in Virginia a few years after his emigration from England in 1795, confirms that Labrobe preferred landscape to historical painting: "For my part, I find nothing so instructive as the contemplation of the works of creation; and had I been appointed to settle the ceremonial of the arts, I believe I should have given the precedence to the representation of the Beauty of Nature, and not to that of the actions of man!"[1] In his early work, executed mostly in Virginia and Pennsylvania, he captured the special nature and qualities of the American landscape as perhaps no artist had previously (see, for example, Nos. 14, 78). In conjunction with the written record that Latrobe left in his journals, letters, and other papers, his drawings constitute a unique document in the history of American culture prior to 1820. His combination of artistic gift and written comment has no equal among the travel books written by early visitors to the United States. Latrobe's portrayal of the American scene is a remarkable achievement for one who viewed his efforts as an avocation and once judged himself to be "a very indifferent painter." But it was an avocation of notable value, for as he observed, "the habit of copying the beauties of nature, strengthens the talent and the pleasure of observing them, and, of course, renders this world, which is so full of them, a more delightful habitation while we stay in it."[2]

Latrobe was born in Fulneck, near Leeds in Yorkshire, on 1 May 1764. His mother, Anna Margaretta (Antes) Latrobe, was a native Pennsylvanian who had gone to England to complete her education and there met and married the Reverend Benjamin Latrobe, a leader of the Moravian church. Fulneck was at that time a newly established center of Moravian activity, and Latrobe's father served as both the minister of the community and headmaster of the well-known boys' school. Three years after his birth, Latrobe's parents moved to London, where his father undertook new responsibilities in the management of Moravian institutions in Great Britain and Ireland. Although his parents returned to Fulneck to visit their son regularly, Latrobe's education and moral development were in the hands of the church. This was an accepted practice among Moravians, who felt that well-regulated boarding school life would provide their children with a sound, useful education while fostering piety and self-control. A major and enlightened precept of Moravian philosophy was that each child should be educated to the limits of his or her natural capabilities and talents. Students progressed through

3

a series of communities, or "choirs," arranged by age and sex, all characterized by the sympathetic concern of both the clergy and teachers, who were devoted to the natural intellectual and spiritual growth of their charges. In 1776, at the age of twelve, Latrobe was sent to Germany, the world center of Moravian culture, to complete his advanced education. He attended first a pedagogium, or high school, at Niesky, and later the seminary at Barby, in Saxony. Normally the path that Latrobe had started upon would have led to the ministry or teaching, although occasionally the system was adjusted to accommodate those students who upon reflection desired to become lawyers or physicians. Latrobe found at Niesky perhaps the best education in Europe for boys between twelve and eighteen, and, as both contemporary evidence and the breadth of interests and richness of his mature mind show, he did extremely well in this stimulating intellectual environment. However, by 1781 Latrobe seemed to be entering troubled waters; there are hints that the traditional Moravian callings were not to his taste, and more important he apparently was assailed by doubt in matters of faith and doctrine.

In August 1782, the Unity Elders' Conference, the highest governing body of the Moravian church, took serious notice of Latrobe's difficulties. Evidently his questioning of certain doctrinal teachings of the church had been disruptive at Niesky, and this may have been the cause of his removal to Gnadenfrey, another Moravian community and school, where matters did not improve. It was reported that he could not "be helped in his studies" and that "he is confused and confesses his sins, but he still has no comfort and has not taken hold of the Savior."[3] Fortunately, while at Gnadenfrey he met Heinrich August Riedel, a Prussian government engineer, and spent an extended period in his company learning the rudiments of hydraulics, or river engineering. Under pressure from his father, the Moravian authorities allowed Latrobe to proceed to seminary training even though "he might be harmful to others in Barby." After an excellent academic beginning in the fall of 1782, Latrobe's "doubt and disbelief concerning the truth of evangelical teaching" surfaced again, and in June 1783, after a thoughtful agreement was reached by all parties concerned, the young man left the seminary and by August was reunited with his family in London. There he joined the Fetter Lane congregation presided over by his father, apparently remaining a Moravian until his marriage to the daughter of an Anglican cleric in 1790. Near the end of his life, Latrobe wrote that he was a professed member of the American Protestant Episcopal Church "chiefly on account of the liberality of its practice" of "Christian indifferentism" wherein all modes of Christian faith were viewed as beneficial to their adherents if sincerely believed.[4] Latrobe's critical but optimistic cast of mind, which unsettled his adolescent religious life, thus later allowed him to make a speedy transition into American religious life.

Although Latrobe failed to follow his father and elder brother, Christian Ignatius, into the ministry, he was exceedingly well served by the Moravian educational system, which provided him with a broad, modern academic base upon which to build his professional studies and career. As a boy in Fulneck, he studied arithmetic, writing, grammar, geography, Bible history, music, and "the rudiments of the Latin tongue." On his arrival at the pedagogium at Niesky, Latrobe was presented an extremely rich intellectual program—not only religious instruction but a curriculum that combined classical languages and history with a whole range of disciplines that today constitute much of the liberal arts: mathematics to calculus, music, modern languages (French), history, and drawing. Science too made its appearance in the seminary at Barby, where it was thought to reinforce that institution's basic purpose—the rational teaching of biblical and theological studies. Botany and physics were part of the formal curriculum, and the students could also make use of the seminary's cabinet of natural history, astronomical observatory, and experimental pneumatic apparatus. However, as a first-year student, Latrobe devoted most of his time to ancient history and languages, followed by philosophy, modern history, Bible history, and theology. This process was enriched by the outstanding teachers and fellow students he encountered along the way. Latrobe's arrival at Barby may have coincided with the final days of Friedrich Adam Scholler's directorship of the seminary (1772–82). Scholler had promoted scientific studies and activities there, leading the way by publishing *Flora Barbiensis* in 1775. In Latrobe's time Niesky was under the direction of Christian Theodor Zembsch, who had studied theology at Jena, published a work on Greek logic, and vigorously stressed the study of Latin, Greek, and Hebrew. Among Latrobe's Niesky classmates was Karl Gustav von Brinkmann, later a Swedish diplomat and man of letters. Perhaps Niesky's most famous student, Friedrich Schleiermacher, attended directly after Latrobe. His departure from the Moravian faith was more explosive than Latrobe's, and he became one of the leading theologians and a major philosopher of nineteenth-century Europe. Naturally, a

number of Latrobe's fellow students became leaders of international Moravianism.[5]

There also were positive intellectual, physical, and psychological benefits derived from the extracurricular side of Latrobe's Moravian educational experience. His lifelong engagement with music, which was to provide him with enjoyment, satisfaction, and relaxation during periods of stress, began in those years. While at Niesky, he was a frequent visitor in the home of Baron Karl von Schachmann, a deeply religious and culturally sophisticated Moravian collector of coins, medals, and paintings. Here Latrobe had his first taste of connoisseurship and the wider world of the fine arts. And he learned something of mineralogy by visiting the cabinets of neighboring amateur enthusiasts. The Moravians also stressed physical well-being, and they encouraged country walks to achieve this goal. These outings afforded Latrobe a chance to study natural history and helped develop his sensitivity to the topography of whatever landscape he later encountered professionally. Finally his German years introduced him to the rewards and rigors of foreign travel; he saw much of eastern Germany and central Europe, traveling perhaps as far east as Vienna.[6] The balance of his European travels in France and Italy most likely was undertaken after his return to England, and a few references to them are found scattered throughout his papers, generally in conjunction with observations on architecture or the fine arts.

A year after his return to London in the summer of 1783, Latrobe obtained a position in the Stamp Office, a branch of the government's tax service; he apparently worked there in some capacity until 1792, long after he had started both of his professional careers.[7] Such a convenient appointment may have been an act of patronage by one of his father's well-connected friends.

Latrobe had been born into an impressive world—one that was filled with music and books, devoted to learning, and although characterized by religious piety, it was nevertheless a world of privilege and opportunity. The Reverend Benjamin Latrobe was greatly admired for his intellect, natural kindness, good humor, charitable tolerance, and exemplary conduct by persons of all ranks and persuasions. He counted among his numerous friends those two eighteenth-century luminaries Dr. Samuel Johnson, the renowned lexicographer, and Dr. Charles Burney, the organist, music historian, and father of the famous novelist and diarist Fanny Burney. Latrobe and his elder brother Christian Ignatius both became intimates of the Burneys and their circle, which count-ed among its members such liberal aristocratic reformers as Arthur Young, the agriculturist. Sir Charles Middleton, a leading advocate of the amelioration of the condition of slaves and also First Lord of the Admiralty, befriended the Latrobes on several occasions.

About 1786 Latrobe began his professional training under John Smeaton, England's most renowned engineer. Little can be said of his experience in Smeaton's office except that Latrobe arrived in America extremely well versed in the technical and theoretical aspects of advanced English civil engineering, having worked at some time (probably 1788–89) as a resident engineer overseeing section work on the Basingstoke Canal. Perhaps it was in Smeaton's office that Latrobe learned to produce the magnificent architectual and engineering delineations that so distinguished his later American career. His most important English engineering commission was a survey of an alternate route for the Chelmer and Blackwater Navigation (1793–95) in Essex.

Latrobe's engineering training soon led him to develop his interest in architecture. Formerly it was not uncommon for one man to function as an architect-engineer, although this practice was dying out by 1790. Latrobe entered Samuel Pepys Cockerell's office about 1789–90, and there he gained invaluable experience and rapid advancement, for by his own account he "conducted," or managed, the office in 1791–92. By this association Latrobe was immediately drawn into the orbit of England's three most advanced architects: Cockerell himself, George Dance the younger, and Sir John Soane. Latrobe was greatly influenced by the latter two men's work. Years later in America, Latrobe, long out of touch with the English scene, independently produced brilliant solutions to sophisticated design problems that were strikingly similar to those Soane arrived at when faced with similar challenges.

During this period (most likely after 1786) Latrobe again visited Europe to improve his knowledge of architecture and engineering. In Paris he was impressed by the Halle au Blé and by the anatomical theater at the École de Chirurgie and was exposed to the other work of the most advanced practitioners of French Neoclassical architecture. He also traveled to Italy, where he visited Naples and Rome, studying such cardinal monuments as the Pantheon, a building whose architectural and acoustical qualities he greatly admired.

Near the end of his service with Cockerell, Latrobe received a minor official appointment as surveyor to the London police offices (c. 1792). And about this time he opened his own office. Latrobe's reputation

grew, and he received commissions for new residences, two of which still survive: Hammerwood Lodge (1792) and Ashdown House (1793), both in Sussex. The houses demonstrate an imaginative use of Greek orders that foreshadowed his later work.

It was a young man of good background, considerable achievements, and much promise who on 27 February 1790 married Lydia Sellon, the daughter of the Reverend William Sellon, a wealthy and well-known Anglican clergyman. Their marriage, though tragically short, was one of great happiness. They had two children: Lydia Sellon Boneval Latrobe and Henry Sellon Boneval Latrobe. In November 1793 Lydia died in childbirth along with their third. Shortly thereafter Latrobe's mother also died. Latrobe kept his small family together and for a while carried on professionally, although the renewed French war had economic consequences that limited his architectural and engineering prospects. His major undertaking, the Chelmer and Blackwater Navigation proposal, came to naught.

These dismal years had brought Benjamin Henry Latrobe one bit of good fortune—the land in Pennsylvania which his mother had left to him. He determined to start life anew in America, bade farewell to his two small children, who already were living with relatives, and journeyed to Gravesend from where, late in November 1795, he sailed for America.

Latrobe characterized the fifteen weeks spent reaching the United States as a "voyage, in which everything that deserves the name of anxiety had been experienced."[8] Indeed, the passage had been an arduous but not unusual one for the period. Yet almost daily under trying circumstances, Latrobe perceptively—and often humorously—described his Atlantic voyage in his journals and sketchbooks; the combined result is a fascinating account of eighteenth-century sea travel. Here in his earliest major graphic creations, we see two of his most salient qualities: a talent for precise observation and an unchecked engagement with life. Latrobe skillfully recorded the varieties of human character and behavior both satirically and sympathetically, and when he turned his attention to the world of nature the results were often even more remarkable. Latrobe saw beauty everywhere, not only in the sensuous forms of fishes (see No. 5) and whales but even in the uncomely Portuguese man-of-war. At the same time, he was curious to understand each organism's way of life; Latrobe was eager to appreciate each living thing for itself.

Landfall was made near Cape Henry on 3 March (No. 7), but first a calm and then a sudden, violent winter storm which drove the *Eliza* out to sea delayed Latrobe's landing in America by perhaps a week. A fortnight later, on 23 March 1796, having recovered from his Atlantic voyage and having studied Norfolk's town plan, architecture, wharves, and sanitary problems, Latrobe committed his observations to paper, thus commencing his American journals.

Quite naturally Latrobe immediately attempted to take the measure of American architecture and technology. A major theme of his American career was his determination to transfer advanced European architectural and engineering practices and standards to the United States. That twenty-five-year uphill struggle began in March 1796 when Latrobe designed a house for Captain William Pennock in Norfolk. Latrobe proposed a compact town house with an ingenious and elegant stair hall, but the local craftsmen spoiled the building in the execution. In 1797 he began building his only major Virginia commission, the state penitentiary at Richmond, a thoughtful but uninfluential essay in penal architecture which suffered severe modification after his departure for Philadelphia in 1798. Initially, however, it was Latrobe's engineering knowledge and skill that were in demand, for his arrival coincided with Virginia's first wave of internal improvements. His engineering work was largely devoted to canals and river improvement. Within three months of his appearance on the local scene, he was consulted by three companies. A visit to Mount Vernon (Nos. 22 and 23) afforded an opportunity to discuss the state's transportation needs with George Washington. Measured against his later professional activities and accomplishments, Latrobe was underemployed in Virginia, a circumstance that has proved to be posterity's good fortune. For with ample time at his disposal and the stimulus of a fresh environment, he was able to fill his journals and sketchbooks with astute observations and luminous impressions on a wide range of human activities and natural phenomena.

By 1798 Latrobe realized that the limited economic resources and provincial taste of Richmond would not support the public and domestic architecture he envisioned. When he visited Philadelphia in March, he found the professional chance he sought, the opportunity to design a revolutionary new type of building—the Bank of Pennsylvania (1798–1801)—which has traditionally been thought of as the first great American monument of the Greek Revival (Fig. 14, p. 33). Latrobe's accomplishments in Philadelphia were imposing. Within three years, he had

established himself as the most imaginative and professional architect and engineer in the country, settled happily into a new marriage with Mary Elizabeth Hazlehurst (with whom he had three children who survived to adulthood), was reunited with his first two children, and was elected to the American Philosophical Society.

The Bank of Pennsylvania was designed and built with seeming ease and an absence of friction between architect and client. American and foreign visitors alike admired and praised the completed building, which Latrobe considered his finest work. As his major biographer, Talbot Hamlin, has explained, "In the new country it was the first building to be erected in which the structural concept, the plan conceived as a functional agent, and the effect both inside and out were completely integrated, completely harmonious."[9] Latrobe conceived of the building as a domed banking hall forty-five feet in diameter, encased in an amphiprostyle temple which housed the subsidiary rooms at either end. He executed the whole in fireproof masonry construction, his great contribution to American structural engineering. For the porticoes he introduced the Greek Ionic order into American architecture. A major artistic achievement, the bank set a theme on which Latrobe played variations throughout his career.

Even as the bank rose, Latrobe directed the erection of the Philadelphia Waterworks (1799–1801), a technologically sophisticated project employing two steam engines and requiring heavy capital investment. Several years of yellow fever epidemics, which many thought were caused by impure water, had forced the Philadelphia city councils to finance a public water utility to replace the polluted backyard wells. Latrobe's system tapped the Schuylkill River on the west side of the city. First, water flowed into a settling basin and then into a canal and tunnel cut into the rocky bluff. At the end of the tunnel a perpendicular shaft led to the first engine house on the top of the bluff. A pump raised the water up the shaft, and it then flowed through an underground brick conduit to the Centre Square Engine House nearly a mile away. There a second steam engine pumped the water up to a reservoir from which it drained by gravity into a network of 30,000 feet of wooden pipes.

This was the first comprehensive American steam-powered waterworks. The settling basin itself was an impressive technological achievement, and the tunneling and extent of hydraulic masonry had no American precedent. By late January 1801 Philadelphians had fresh, clear water. The Philadelphia Waterworks demonstrated that innovative European technology and organization could provide a solution for one of the major health problems facing America.

In domestic architecture, Latrobe produced America's first Gothic Revival house, Sedgeley (1799), on the banks of the Schuylkill just above the city. When further commissions failed to materialize, he accepted an appointment as engineer for the survey and improvement of the Susquehanna River (1801–02), which facilitated river navigation from Columbia, Pennsylvania, to tidewater below the Maryland border and drew Latrobe into regional transportation planning (Nos. 69 and 70). His successful completion of this undertaking led to his appointment as surveyor and engineer of the Chesapeake and Delaware Canal (1803–06).

After 1802, Latrobe's career became more demanding. President Thomas Jefferson, confronted with the task of finishing the Capitol and planning and constructing additional federal buildings in Washington and elsewhere, appointed Latrobe surveyor of the public buildings of the United States in March 1803. The architect and the statesman entered into an artistic partnership that, although occasionally strained by the incompatibility of the two men's architectural ideas, produced a major result: the U.S. Capitol drew nearer to completion at the highest level of professional competence and taste (Fig. 7, p. 28).

The considerable technical problems that Latrobe faced in completing the Capitol were increased by the lack of cooperation and the hostile criticism of Dr. William Thornton, whose designs for the building had won the competition early in the 1790s. The president supported Latrobe in his attempts to effect certain necessary alterations of the original plans and also regularly defended the architect against congressional charges of excessive construction costs and delays. Latrobe's first term as architect of the Capitol was from 1803 to 1811, followed by a second term from 1815 to 1817. Starting his first building campaign, Latrobe faced formidable obstacles to success: an immense, imposed plan; the lack of a resident, trained labor force and of the material resources necessary to build monumental architecture; the lateness and uncertainty of congressional appropriations; and the aggressive hostility of Thornton. During this campaign Latrobe constructed an improved version of the South (or House) Wing including the chamber for that body. Latrobe also successfully rebuilt the North (or Senate) Wing's western side (including vaulted ceilings) in masonry and invented his corn order as a national alternative to the Greek orders. In his second

campaign following the 1814 fire, Latrobe worked with a freer hand to create an entirely new Hall of Representatives and reconstructed much of the North Wing as an enhanced version of the prefire design. His resignation in 1817 deprived the Capitol of his architectural abilities as they reached their height. Fortunately he was allowed to demonstrate fully his mature artistry in another great commission undertaken almost simultaneously with the Capitol—the Roman Catholic Cathedral of Baltimore.

The cathedral has long been recognized not only as Latrobe's masterpiece, but also as one of the chefs d'oeuvre of American architecture. At the outset Latrobe exposed the Baltimore congregation to the great tradition of Western ecclesiastical design, but even as he developed his conceptions for the building with the counsel of Archbishop John Carroll, his own understanding deepened. In the end, out of solid, uncompromised masonry he created a brilliant fusion of a rotunda and a Latin cross. The original masterful lighting of the cathedral demonstrated how he had profited from his years at the Capitol: mysterious illumination filtered into the rotunda through the crown of an outer, skylit dome.

Latrobe's other work included almost every kind of building. Some of these, such as houses and modest churches, were familiar to Americans. Others, such as government offices, arsenals, banks, exchanges, academic buildings, and public monuments, represented the newer needs of the emerging society. Buildings designed by him were constructed along much of the Atlantic seaboard and as far west as Kentucky, Ohio, and Louisiana. Latrobe consistently donated his services to nonprofit institutions, asking only to be reimbursed for his expenses.

Latrobe's engineering work has been less celebrated than his architectural achievements but was of great significance. His work was characterized by an adherence to current European practice and theory, energy and innovation, and a facility for transmitting professional knowledge and standards throughout the nation by example, training, and publication. Appointed engineer of the United States Navy in 1804, Latrobe supervised the construction of the Washington Navy Yard. His use of steam engines at the Philadelphia and New Orleans (1809–20) waterworks and at the Navy Yard, and his promotion of steam power for industrial use mark him as America's first great steam engineer.

He commissioned, designed, and on occasion actually built engines, thereby serving as an invaluable disseminator of technology. The lure of steam power's economic potential drew him to Pittsburgh in 1813 and set in motion a chain of events that nearly resulted in Latrobe's ruin. He became the agent and engineer of a company building Robert Fulton's steamboats for Ohio River commerce. After a promising start costs rose, funds became scarce, and Fulton turned against Latrobe, who foolishly attempted to continue the work on his own credit. In the end Latrobe incurred debts that eventually forced him into bankruptcy in 1817–18.

Earlier Latrobe had concluded that proprietorship, rather than professional practice, was the surest path to affluence for an American engineer. Accordingly, he obtained in 1811 a charter to construct and operate a waterworks in New Orleans. He placed his son, Henry, a talented architect and engineer of unusual promise, in charge. Then in 1817, as the project was regaining momentum lost by wartime delays, the younger Latrobe suddenly died of yellow fever. Grief-stricken and faced with the prospect of few commissions in Washington and Baltimore, Benjamin Henry Latrobe departed by sea for New Orleans in 1818 to finish the waterworks in hopes of insuring his family's security.

It was a new beginning. He was fascinated by the sights, sounds, and populace of this most cosmopolitan North American city (Nos. 148 and 149). More important, he was well received by men of station, influence, and wealth, the much needed waterworks progressed satisfactorily, and architectural commissions materialized and others were promised. Convinced that his future lay in New Orleans, Latrobe sailed to Baltimore, wound up his business in the East, and returned overland with his family in April 1820. He was swept up in his work on the waterworks and on the central tower of St. Louis Cathedral when the stifling summer heat descended upon the city and the fever returned. Then suddenly Benjamin Henry Latrobe died of yellow fever on 3 September 1820—the third anniversary of his son Henry's death.

In engineering, Latrobe's influence was profound during his lifetime. As the nation's first major steam engineer, he prepared the ground for Philadelphia to become the early center of that mode of industrial power. The capital expenditures of his engineering projects were not matched until the 1830s; the range and variety of his technological accomplishments were not approached until the advent of the large office engineering firm. His experience, grasp of technological and scientific theory, and high-level European education allowed him to solve a wide range of problems and see possibilities inherent in the nation's developmental requirements that escaped educated laymen

and even those who claimed the title of engineer. What Latrobe brought to the American scene were the latest English architectural and engineering principles and practices, an unusual organizational capacity, an ability to locate trained personnel at all levels of expertise, and a natural educator's inclination for nurturing the creative impulse of young technologists. Some of his assistants and students such as Robert Mills and William Strickland became leading engineers during the era of canal building, although they, like their preceptor, are generally thought of as architects. Thus Latrobe not only helped produce the first generation of native-born engineers but also eased the way for future generations of engineers by establishing professional engineering standards and continually informing entrepreneurs and politicians alike of the heavy costs, technical complexity, and economic and social benefits of sophisticated, large-scale public works.

Latrobe's contribution to American architecture was vast. His buildings set a wholly unprecedented standard for accomplishment because Latrobe comprehended the future of good architecture as the union of fitness to purpose, construction, and decoration. Latrobe, by personal example and through the agency of his students, hastened the acceptance by American professionals of standards such as precise architectural rendering and fireproof, vaulted masonry construction. Not only his pupils and associates, but at least three generations of architects of every persuasion studied Latrobe's works, making his influence felt down to the Civil War. In time, his favorite creation, the Bank of Pennsylvania, proved to be the greatest conduit of Latrobe's influence; the building was studied and imitated across the land.

2. LATROBE AS A TRAVELER AND NATURALIST

Reviewing his life's activities as he wrote to his maternal uncle Henry Antes in April 1798, Latrobe remarked that he had "traveled through a great part of Europe."[10] His American career also dictated that Latrobe travel from commission to commission, on surveys, searching for building materials, or seeking employment. Fortunately Latrobe, who stood six feet two inches tall, was endowed with strength and endurance, for, as he observed, those qualities were nearly as important to a practicing engineer's success as professional competence itself. It was during those frequent and often prolonged absences from home that he completed the greater portion of his journals and sketchbooks. Although not intended for publication, these products of Latrobe's eye, hand, and mind today constitute perhaps the most important contribution to that vast corpus of literary and visual commentary on America that appeared between 1740 and 1860—a period known as the golden age of foreign and native travelers' accounts.[11]

What is remarkable about the drawings that comprise this book is the breadth of interest that they represent. There is a great variety of subject matter depicted here: people and their social customs, institutions, habits, clothing, work, and play; homes and public buildings; rivers and harbors; roads and bridges; towns and cities; and fauna and flora. Yet for all this breadth of vision, Latrobe brought to his work the scientist's keen eye for detail. We do not have superficial views of a great many subjects made by a dilettante, but careful and precise renderings by a trained artist who had mastered many of the subjects required to draw all that he encountered—architecture, engineering, geology, botany, and zoology. Only in the drawing of the human figure did Latrobe falter. When combined with the written record Latrobe left in his journals, letters, and published papers, the drawings take on an added dimension. Together they document aspects of early America previously little known or understood.

These facts set this book apart from the works of such travelers as Chastellux, Rochefoucauld, the Duc d'Orleans, and later Klinkowström, Basil Hall, and Mrs. Trollope. The nearest parallel is Pavel Svin'in,[12] whose genre and street scenes illustrate the life of New York and Philadelphia, but he neither traveled so widely nor had Latrobe's gift as a landscapist.

Latrobe's first impressions of the New World are interesting, for he set down whatever struck him as distinctive, curious, and different from the Old World. He began by recording his voyage from the Cliffs of Dover (No. 1) to the Virginia Capes, where he found Norfolk still in ruins from the ravages of war (No. 10).

He saw a wooden America: bridges, mills, and rambling wooden plantation houses very different from the nineteenth-century plantation houses on which our notions of old Virginia are based. He recorded animals, plants, and wasp nests; an overseer on stilts watching Negroes at work in the fields; poor whites; Negroes fishing in the rivers; idlers playing billiards in a tavern; and the frowsiness of country courtrooms. He shows how rough and wild the country was still. He could on occasion do the usual set piece done by the illustrators of other books of travel,

but even these—like his views of the Capitol at Richmond (Nos. 28 and 37)—have an original note.

The zest and curiosity shown in the illustrations from his early years in America are striking. By the time of the Susquehanna survey he had become accustomed to the look of America; yet his habit of passing an idle hour by doing a drawing of something gives piquancy to his views of interior Pennsylvania—the town square of Lancaster, Pennsylvania (No. 82), German barns (No. 78), or a Conestoga wagon (No. 96).

In his travels he got out of the seaport cities and saw what the countryside between towns looked like (No. 122 ff), what it was like to cross the Allegheny Mountains (No. 156 ff), or approach New Orleans by sea (No. 142 ff). These are not the usual views of towns given us by engravers, but sharply observed and vivid scenes.

Although Latrobe, as a well-educated, middle-class man of affairs, resembled the majority of early nineteenth-century travelers, he nevertheless stands out for several reasons.[13] First, few, if any, travelers in this era visited, lived in, or commented upon as many locales over such a long span of years as did Latrobe. Second, this English-born and European-trained observer, like few others, saw America with both the perceptive vision of a foreigner and the understanding of a citizen long resident. Third, he was a man of many talents, and his personal interests and professional expertise enabled him to observe with the scientific scrutiny of an engineer, to explain with the literary skill of an enlightened European, and to draw with the artistic precision of an architect. Fourth and finally, Latrobe was a traveler who for twenty-five years assumed an important, active role in changing the character of the America he viewed. Significantly, he was a participant as much as an observer, and his engineering and architectural contributions made him well known to other travelers in his own lifetime.

It is unfortunate that Latrobe's literary and artistic impressions of the young United States have for so long remained unpublished and that his merit as a traveler has generally gone unrecognized by historians. Even the most shallow and inaccurate among contemporary travelers gained fame and attention because they quickly published their journals, diaries, and letters home. It has only been in the past two decades or so that Latrobe's unpublished journals, sketchbooks, and correspondence have been studied adequately and recognized as a national treasure.

Many of the early nineteenth-century travelers, especially the foreign-born ones, were like "a stream of witnesses moving through a crowded courtroom during the course of a major trial."[14] Some were of great importance, others worthy of only minor notice, but almost all spent only a brief time in attendance. In contrast, Latrobe spent a busy quarter-century in the United States and was thereby able to see changes taking place. He offers historians a view of the early national period that shows a society developing over time. Latrobe visited Virginia when the Old Dominion was still very colonial and much decayed; he journeyed to the northeastern cities of Philadelphia and New York when they were already turning into crowded industrial centers; and he later traveled to the west and south as the farms and towns of the Ohio and Mississippi valleys were being fashioned out of the wilderness. Through his writings and paintings one glimpses the faded glory of late eighteenth-century Williamsburg and the ageless sailboats of the Atlantic Coast, as well as the exciting vitality of New Orleans and the infant Mississippi River steamboats of twenty years later.

Endowed with curiosity, energy, and a talent for analysis, Latrobe was the consummate traveler; few persons of his day traveled as extensively or as intensively as he. In addition to his periods of residence in Virginia (1796–98), Philadelphia (1799–1806), Delaware (1803–05), Washington (1806–13, 1815–16), Pittsburgh (1813–15), Baltimore (1818), and New Orleans (1819–20), Latrobe followed the most popular routes of early nineteenth-century travelers. He visited most of the interesting parts of Virginia; he traveled extensively in the Susquehanna and Delaware river valleys and became quite familiar with Chesapeake Bay; he knew intimately the environs of the nation's capital, including the area's creeks and quarries; he followed land routes from Baltimore west to Pittsburgh and Wheeling; and he journeyed by steamboat down the Ohio past Cincinnati and other river towns, finally descending the mighty Mississippi to New Orleans.

Latrobe made use of the same modes of transportation as other contemporary travelers—horseback, stagecoach, wagon, sailing ship, and steamboat. In the Chesapeake area, his itineraries and topics of observation and commentary were almost identical to those of such foreign visitors as Rochefoucauld, Chastellux, and Isaac Weld, Jr. Interestingly, Latrobe and the Irishman Weld visited many of the same sites in April 1798; they may have been only days apart on some occasions. As a commentator, Latrobe had a great advantage over Weld, however, because his artistic renderings of the ruins of Norfolk, the

defaced statue of Lord Botetourt at Williamsburg (No. 24), the decaying "Greenspring" plantation house near Jamestown (No. 26), and the war-ravaged Nelson House at Yorktown (Nos. 58 and 59) put flesh on the bones of history as no mere words could.

As in the case of Virginia, Latrobe's travels to the eastern cities of Philadelphia, New York, and Baltimore, through western Pennsylvania, and down the Ohio and Mississippi valleys to New Orleans again produced itineraries and observations similar to those of others. One thing that separated Latrobe from a number of famous contemporary travelers to the East was that his own work was part of the interesting scenery for those visitors. The southerner Mrs. Ann Newport Royall, the Englishman Charles William Janson, the German nobleman Baron Axel Leonhard Klinkowström, and Karl Bernhard, the duke of Saxe-Weimar Eisenbach, all commented favorably on Latrobe's engineering and architectural achievements. Mrs. Royall became one of the architect's greatest admirers. She complimented his portrait in Charles Willson Peale's Philadelphia museum and marvelled at the "beauty, grandeur and durability" of Latrobe's Capitol—an "edifice . . . not surpassed . . . by any other in the world." When she got to Baltimore, Mrs. Royall proclaimed the Roman Catholic Cathedral the "most superb church in the United States. It certainly is superior to any thing I have seen, except the capitol of the United States and the President's house."[15]

Although sharing common experiences with other travelers, Latrobe differed from them in many ways. Between the American Revolution and the War of 1812, a host of British travelers published critical accounts of the United States, anticipating the malicious appraisal by Frances Trollope in the 1830s. Most of these individuals arrived and departed having never really appreciated this country; others became embittered by unrealized expectations or the failure of investment schemes. As an English book reviewer wrote in 1807:

> The Europeans who visit America are generally drawn thither by some commercial speculation, or by some plan of acquiring lands. They are seldom men of liberal education or possessed of those enlarged views which might enable them fairly to appreciate what they see; . . . If they remain in that country we hear no more of them; but if they are disappointed in their views, and return, they . . . generally revenge themselves by abusing the people among whom they did not find that agreeable reception which they had too sanguinely expected.[16]

Latrobe, too, criticized the malicious "travelling bookmakers" and believed that to properly analyze a society, "more is required than to have looked at it superficially, and through the medium of habits acquired elsewhere."[17]

Unlike his English countrymen, Latrobe usually did not exhibit Tory prejudice and insufferable Anglophilism, and he was anything but shocked by republican principles. He came to the United States intending to stay, and although he suffered serious business reverses and was mistreated occasionally by some Americans, he retained an enthusiasm for the United States and its citizens. Latrobe appreciated the "numerous civilities" he received, and he consciously tried "more to commend than to condemn the state of things and the characters of individuals here."[18]

Four general (often intertwined) categories of visual and literary subject matter seem to predominate in Latrobe's travel accounts: the landscape, man and man's work in the landscape, accounts of daily life or genre, and natural history (botany, zoology, and geology). The numerical distribution of these divisions of his observations will be commented upon in a succeeding section. Artistically, Latrobe's genre painting was the weakest area of his work but often it was vigorous and full of satirical insight. His portrayal of "Billiards in Hanover Town, Virginia" (No. 41) is strongly reminiscent of the drawings of his famous English contemporary Thomas Rowlandson, the caricaturist and illustrator. A number of his botanical and zoological paintings are exquisite examples of late eighteenth-century scientific illustration. But it was the American landscape and its variation from Europe's that most captured the attention and imagination of Benjamin Henry Latrobe, traveler and artist of the Picturesque. Writing in his journal in August 1806, he summarized what he had observed so far in America.

> The whole Landscape of America is most essentially different, considered in the view of Art, from that of Europe. Our country, at least from New York to Georgia, consists of *Systems* of Landscapes that may be Classed under a few heads, and from which many of the most picturesque kinds of Scenery, frequent across the Atlantic are absolutely excluded.

1. We have for instance no where bold and bare Mountains connected with large Masses of Water.

2. No Mountains the summits of which are craggy, or covered with snow while the Vallies are green.

3. No detached mountains of large size and intricate form, unless the Peaks of Otter in Virginia be of that kind. I have not seen them, but Mr. Jefferson tells me that they resemble Europaean mountains more than any others.[19]

4. I might add, no Artificial objects of interest, such as Castles, Abbeys, and Ruins of great beauty and extent.

On the other hand we have several species of landscape in infinite variety and of most grand and beautiful composition in which Europe does not abound.

1. Water scenery in immense expanse combined with wood. This species of scenery extends along our coast more than 1000 Miles, and is to be found in endless variety, from the flat promontories of Woods pushing into the ocean, or crawling along the Sandy margin of the sea, to the bluffs that are found nearer the falls of our rivers. In all these Landscapes however there is a great sameness, though often exquisite beauty. . . .

2. Rock Scenery combined with Water in agitation. In the variety, beauty and Grandeur of this sort of Landscape we can boast of possessing many scenes of the first Class. But the Banks of our rivers, even where they break through the high ridges below the blueridge, are not sufficiently high to rise into the *sublime*. But as beautiful scenes of the second Grade, there is not a country in the world that surpasses the groupes which the passages of our rivers through our Mountains afford.

3. The North [Hudson] river deserves a seperate mention. Its scenery forms a class of its own, and it reaches the sublimest style without that highth of Mountain which is often found in European Landscape. I do not indeed recollect to have seen or read of any scenery that equals the magnificence of the Rock *Walling* on the West side of the River above New York. . . .[20]

Even as these words were being written in Washington, Meriwether Lewis and William Clark were returning from their momentous expedition, bringing with them an enlarged, scientific view of the American landscape and its flora, fauna, and human inhabitants as yet unknown to Latrobe.

The Lewis and Clark Expedition represented the most organized collecting and exploring venture of Latrobe's scientific era—an era of American science in which the greatest rewards were in collecting, observing, and exploring—the kind of scientific activities that Latrobe excelled at as an individual. Once established in Philadelphia, Latrobe became an active member of the city's scientific community and of the nation's oldest learned society, the American Philosophical Society. The Society's committee reports and correspondence, as well as Latrobe's own correspondence, show that Latrobe associated with such important scientific figures as William Maclure, Benjamin Smith Barton, Charles Willson Peale, Robert Hare, Thomas Peters Smith, Robert Patterson, Adam Seybert, and, of course, his great patron Thomas Jefferson. Latrobe served on a number of the Society's committees and published three natural history papers in its *Transactions*. His reputation as a naturalist, which formerly rested upon those publications, is now being enhanced by the annotation and publication of several of his miscellaneous natural history drawings and by written commentary in the present volume and those of this edition's other series. When he finally moved his family to Washington in 1807, his personal scientific ties with Philadelphia, the center of national science, were severed; nevertheless, he continued to interest himself in scientific matters as best he could.

Latrobe considered himself an expert naturalist, and a careful study of his writings shows that his own evaluation was not presumptuous. At some point in his scientific education, he had the opportunity to carry on laboratory experiments in biology, for he later described in some detail those which he had performed to demonstrate the ability of the *Hydra* to regenerate lost parts. Evidently he had a good grasp of the history of natural history, being well informed of the recent work of Linnaeus and others. He recognized the importance of classification based upon accurate detailed descriptions and drawings, and he made some important contributions to scientific literature along these lines. Whenever practical, Latrobe made his own observations on the natural phenomena he encountered. As a mathematician he appreciated the importance of measurements, and he recorded both the weights and the dimensions of the organisms he described. Some of his recorded statistical data is still of value. He drew excellent illustrations of his biological subjects which included the entire organism, specific small anatomical details, and in certain cases a portion of the organism's life cycle.

Latrobe was at his best as a naturalist when describing animal behavior. One measure of his skill was his ability to execute surprisingly accurate sketches from memory. He spent several hours profitably observing the activities of some ants with which he shared a rather unattractive room in a Richmond tavern. Entomology held a special attraction for Latrobe, and he wrote at length not only about ants, but also about bees, hornets, moths, butterflies, and wasps, particularly mud daubers.[21]

The range of Latrobe's interest in nature can be gauged from the fact that he observed and recorded matters as broadly ecological as the conservation of wildlife and stages of plant succession on abandoned fields, and matters as detailed and specific as the presence of secondary parasites on the parasite of a fish. Very little seems to have escaped his keen eye in the world around him.

In 1802, he published a paper in the *Transactions* entitled "A Drawing and Description of the Clupea Tyrannus and Oniscus Praegustator," which reported his observations made in Virginia on a parasite found in the mouths of fishes called alewives, a type of herring. It was to be Latrobe's most enduring contribution to the literature of natural history. He made careful observations and drawings of both fish and parasite (No. 33), and later consulted the works of Linnaeus, Gmelin, Fabricius, and others in Philadelphia. He discovered descriptions of similar parasites but was sufficiently accurate in his observations to doubt that his was identical. To his surprise Latrobe learned that the fish had not been previously described, so he set to work preparing a well-organized scientific paper that is considered excellent even by modern standards. Believing both the fish and the parasite to be new species, he proposed names for them. Although the generic names he proposed have been changed, the crustacean parasite found in the fish's mouth is *Olencira praegustator* (Latrobe), and efforts are under way to restore Latrobe's name as the classifier of the alewife, now known, through an error, as *Alosa pseudoharengus* (Wilson). Thus in having his name designated as the first to describe these species, Latrobe achieved what Peter Collinson once called "a species of eternity."

For all his skill and achievements as a naturalist, it must be remembered that his scientific activities were the avocation of a well-informed, talented amateur. Much of the surviving evidence indicates that his approach to natural history at times was haphazard and often reflected his professional, philosophical, and even literary attitudes and interests.[22] Like many amateurs, he was not overly concerned with the systematic or taxonomic aspects of the field; often it was the unusual that caught his eye. Thus he recorded the rather ordinary flower Ellisia growing abundantly in Louisiana outside its normal range (No. 161), found a quantity of garfish (typically freshwater) in a marine estuary (No. 34), and made the only recorded painting of an elephant (certainly outside her normal range) that was touring the Eastern seaboard's cities and towns (No. 117). Latrobe's travel notes were not final statements and they should not be read as such. He was not interested in discovering new species (although he did so on one occasion). Latrobe was attracted to biocommunities, especially those with parasitic elements. His natural history drawings and discussions reflect an architect's sense of spatial relations and an engineer's concern with function. His detailing of the mud constructions of wasps and their use of picture frames, of the internal anatomy of the garpike's snout, and of the placement of a louse in the roof of the alewife's mouth are examples of this orientation. An expert might not be able to identify his wasps out of context, but when viewed with their cells, identification is easy.

Latrobe's conceptual view of science was fundamentally Baconian, that is, experimental, empirical, descriptive, and lacking hypotheses. Baconianism was the framework which dominated British science in the latter eighteenth century, and it was unquestioned orthodoxy in American science during the early nineteenth century. It also accorded well with Latrobe's vocation, since both architecture and engineering were still guided by precedent rather than by theory.

Latrobe's scientific publications consisted largely of his careful observations of things and processes. Even in geology, where he acknowledged the validity of a general theory (Neptunism), he emphasized that careful observation of current processes led one to a different conclusion about the origin of certain rock formations than that theory would have suggested.[23]

Latrobe's Baconianism was connected to the broader stream of ideas known as the Enlightenment, which flourished in America as well as in Europe. Like his friends Thomas Jefferson and Joel Barlow, Latrobe generally believed that man was essentially a rational being whom God expected to use his intellect for the extension of knowledge and refinement of human society.

He did modify one concept of Enlightenment science, the Great Chain of Being, which suggested that careful study of the world's flora and fauna would discover a continuous range of God's creation from the

insensitive and unthinking (rocks and minerals) to the most rational and sensitive (man). Some philosophers took this concept to the extreme of stating that only man was capable of reasoning and of expressing the higher emotions of love and affection.[24] Latrobe accepted the existence of the Great Chain and took some interest in the problem of which creatures joined the animal and vegetable kingdoms. He studied two candidates for the position: the freshwater polyp, or *Hydra,* and the barnacle.

However, in assuming the existence of the Great Chain, Latrobe did not agree that man's exalted position was in itself proof of a monopoly on reason, love, or affection. He saw such qualities in other creatures. In his paper on the blue wasps, or mud daubers, of Virginia he described how they apportioned captured but living spiders among the cells which they made for their eggs. Latrobe weighed and counted the accumulated spiders in several cells and concluded that the parent wasps placed the same weight in each cell, even if the number of spiders varied. (He also commented on the wasps' cruelty in sealing the living spiders in the cells so that the larval wasps could eat them.) Latrobe went on to relate how he damaged a group of cells under construction and how the wasp first rebuilt the damaged cells before continuing with its project.[25] He concluded: "If it should become necessary to break through the barrier anciently traced between reason and instinct, the oeconomy of the whole class of *hymenoptera,* and particularly of the wasps, may contribute to it."[26]

Thus there were aspects of Latrobe's natural history that reflected a questioning of the supreme social value of intelligence commonly associated with the thought and action of the Enlightenment. He leaned toward something more complex while not denying the rational basis for law in nature. At times he argued for a reevaluation of the importance of instinct and a diminution of man's inflated position in nature. By doing so, his thought revealed the seeds of Romanticism.

It was in the study of geology that Latrobe the scientist and Latrobe the artist merged most creatively. His early travels in America and his river engineering work contributed to his intense interest in and preoccupation with the geology of the Coastal Plain and the Piedmont Plateau. As his *Virginia Journals* and published writings show, within a few years of his arrival, he had established a map in his mind of the geology of the East coast and of those natural forces at work there. For example, he spoke of the Fall Line as "the great granite ridge" and took particular care to determine both the courses and geological structures of that area's rivers. Latrobe later used his mental map when planning his canals and consulting on river improvement projects. Such an overview assisted him in executing accurate surveys and determining the most economic routes by causing him to think systematically about the problems of river flow and flooding, silting, location of potential construction materials, and availability of water sources for lockage.

Latrobe's 1809 American Philosophical Society paper on freestone quarries (to which his "Sand-hills of Cape Henry" paper served as a natural introduction) was a brilliant piece of analysis and strengthened his conceptual overview.

Benjamin Silliman commented on the state of American geology in 1806: "[The] science did not exist among us, except with minds of a very few individuals, and instruction was not attainable in any public institution." Latrobe was one of those individuals, and in the opinion of some historians of science his 1809 effort has no peer, not even William Maclure's highly acclaimed "Observations of the United States, Explanatory of a Geological Map," published in the same volume of the *Transactions.*[27]

Analogous to his geological conceptualization and supportive of it was Latrobe's landscape painting. A late eighteenth-century topographical artist who occasionally employed the Picturesque style, Latrobe's work sometimes expressed his peculiar desire to visualize vast extents of landscape, far beyond that visible from one vantage point. He lyrically expressed this imaginative desire in his "Essay on Landscape" (a guide to watercolor painting).[28]

This passion to see beyond the horizon—to conjure up the details of civilization—was to Latrobe not merely an artistic convention of the time; rather it was a force that ran throughout his life and career. He was unique among all those who recorded the American scene in that he alone contributed to its physical alteration. Latrobe built canals and turnpikes, created beautiful and healthful public and private buildings, fostered modern modes of transportation such as the steamboat, promoted the use of steam power and thus furthered the industrial revolution, and planned cities that accommodated both human and environmental needs. Optimistic yet at the same time rational, he was concerned that his fellow countrymen might despoil the land and its resources in their quest for material progress. He noted how the intensive farming in coastal river plains and valleys contributed to the siltation of their estu-

aries, thus eventually damaging those regions' economies and promoting unhealthy environments. In a moment of hiatus between his great Philadelphia achievements and his appearance on the national scene as architect of the U.S. Capitol, Latrobe executed a brilliant survey of the Susquehanna River from Columbia, Pennsylvania to tidewater, the purpose of which was to improve navigation and facilitate the movement of the state's agricultural products to Europe (No. 69 ff). Even the briefest glance at the beautiful seventeen-foot-long survey map and the sketches and watercolors he created during his work (1801–02) reveal Latrobe the modern, technological man enraptured by the Arcadian yet settled landscape of this majestic river valley. His vision encompassed what had been and what was yet to be. Thus this book should be thought of not only as Latrobe's view of America but also, in part, as Latrobe's vision of his adopted land.

NOTES

1 BHL, "Essay on Landscape," *Journals*, 2:467–94.

2 Ibid., pp. 477, 493–94.

3 Minutes of the Unity Elders' Conference, 11 August 1782, Archives of the United Brethren, Herrnhut, DDR.

4 BHL, *Journals*, 3:227 (28 February 1819).

5 Heinrich Casmir Gottlieb Graf zu Lynar, *Nachricht von dem Ursprung und Fortgange, und hauptsächlich von der gegenwärtigen Befassung der Brüder-Unität* (Halle, 1781), p. 151; Martin Redeker, *Schleiermacher: Life and Thought*, trans. John Wallhauser (Philadelphia, 1973), pp. 12–14; Minutes of the General Synod at Marienborn, 1 July–17 September 1769, Moravian Church House, London; Hermann Plitt, *Das Theologische Seminarium de Evangelischen Brüder-Unität in seinem Anfang und Fortgang* (Leipzig, 1854), pp. 54, 56; D. Paul Kölbing, ed., *Die Feier des 150 jährigen Bestehens des theologischen Seminariums der Brüdergemeine in Gnadenfeld am 24. Mai 1904* (Leipzig, 1904), pp. 65, 75; E. R. Meyer, *Schleiermachers und C. G. von Brinkmanns gang durch die Brüdergemeine* (Leipzig, 1905), pp. 94–95; BHL to Law and Jones, 11 December 1810, Latrobe Letterbooks, PBHL.

6 Minutes of Unity Elders' Conference, 26 June 1783. Years later, when describing the crowded and raucous accommodations at a Virginia tavern during the horse race season, Latrobe wrote that an earlier four-day stay in a "Polish Alehouse" had prepared him amply for the endless noise, nonstop drinking, and the multiplicity of self-created titles he encountered. BHL, *Journals*, 1:102 (23 April 1796).

7 For a full discussion of the balance of Latrobe's life and career, see Edward C. Carter II, Introduction, BHL, *Journals*, 1:xix–xxix, vii–xvii. The rest of the first section of this biographical sketch is drawn from these pages.

8 BHL, *Journals*, 1:70 (7 March 1796).

9 Hamlin, *Latrobe*, p. 157.

10 BHL, *Journals*, 2:368 (8 April 1798).

11 The following evaluation of Latrobe's visual and literary assessment of America was generously provided by Dr. E. P. Richardson, Philadelphia, Pennsylvania.

12 A relatively obscure foreign commentator and a friend of Latrobe, Pavel Svin´in (1787–1839) was secretary to the Russian consul general in Philadelphia (1811–13). During his twenty months in America, he traveled from Virginia to Maine executing some impressive genre and landscape paintings and recording his observations on the similarities and differences between the two countries. On returning to St. Petersburg, the diplomat published his observations in 1815 under the title *Opyt zhivopisnago pŏteshestŭiia po severnoi Amerike* (A Picturesque Voyage Through North America). A number of Svin´in's watercolors, hauntingly similar to BHL's work, were published in Avraham Yarmolinsky, *Picturesque United States of America, 1811, 1812, 1813; Being a Memoir on Paul Svinin, Russian Diplomatic Officer, Artist and Author* (New York, 1930). See also Abbott Gleason, "Pavel Svin´in 1787–1839," in Marc Pachter and Frances Wein, eds., *Abroad in America: Visitors to the New Nation, 1776–1914* (Reading, Mass., 1976), pp. 12–21.

13 The ensuing judgments on Latrobe as a traveler are based on text and research materials produced by J. Frederick Fausz, department of history, St. Mary's College of Maryland, formerly a member of the Latrobe Papers staff.

14 Thomas D. Clark, ed., Editor's Preface, *Travels in The Old South: A Bibliography*, 3 vols. (Norman, Okla., 1956–59), 2:xiv.

15 Ann Newport Royall, *Sketches of History, Life, and Manners, in the United States* (New Haven, 1826), pp. 137–38, 189–90.

16 Charles William Janson, *The Stranger in America, 1793–1806*, ed. Charles S. Driver (New York, 1935), pp. vii–viii.

17 BHL, *Journals*, 3:183–84 (22 January 1819).

18 Ibid., 3:207 (24 February 1819).

19 Latrobe referred only to the coastal plain, fall line, and eastern edge of the piedmont geological province. Even in the eastern United States there are "detached mountains" such as the Adirondacks and those of New England. The Peaks of Otter are in Bedford County, Virginia, about thirty miles west of Lynchburg.

20 BHL, *Journals*, 3:65–67 (10 August 1806).

21 Ibid., 1:239–42, 2:502–03. See also illustration No. 20.

22 The balance of this discussion of Latrobe as a naturalist is drawn from Darwin H. Stapleton and Edward C. Carter II, "'I have the itch of Botany, of Chemistry, of Mathematics . . . strong upon me': The Science of Benjamin Henry Latrobe," American Philosophical Society, *Proceedings* 128 (1984): 173–92, which utilized in part materials provided by Charlotte M. Porter, Florida State Museum, Gainesville.

23 BHL, "Memoir on the Sand-hills of Cape Henry in Virginia," American Philosophical Society, *Transactions* 4 (1799): 437–43, plate, and BHL, "An Account of the Freestone Quarries on the Potomac and Rappahannoc rivers," ibid. 6 (1809): 283–93, in BHL, *Correspondence,* 1,2.

24 Arthur O. Lovejoy, *The Great Chain of Being: A Study of the History of an Idea* (Cambridge, Mass., 1936).

25 BHL, "On Two Species of Sphex Inhabiting Virginia and Pennsylvania and Probably Extending through the United States," American Philosophical Society, *Transactions* 6 (1809): 73–78, plate, in BHL, *Correspondence,* 1.

26 Ibid., p. 77.

27 George P. Fisher, *Life of Benjamin Silliman, M.D., LL.D., Late Professor of Chemistry, Mineralogy, and Geology in Yale College,* 2 vols. (New York, 1866), 1:195.

28 BHL, *Journals,* 2:473 (1 September 1798); quoted on p. 18, below.

An Introduction to the Art of Latrobe's Drawings

CHARLES E. BROWNELL

History remembers Latrobe above all as a professional architect and engineer who spent most of his career in the United States. Art historians remember him foremost as a great Neoclassical architect, whose three most important productions are the Bank of Pennsylvania in Philadelphia; his work at the Capitol in Washington; and his masterpiece, the Roman Catholic Cathedral in Baltimore. But Latrobe left another artistic legacy, a wealth of nonprofessional drawings: fourteen sketchbooks that cover his American years from the time of his voyage from England (1795–1820); the illustrations in his two-volume "Essay on Landscape" (1798–99), nominally a book of instruction in landscape drawing; and miscellaneous other drawings. A distinguished amateur rather than a great artist made these works. They hold two kinds of special interest. They offer essential insights into the extraordinary mind of a major historical figure, and, if studied with other Latrobe documents and outside material, they provide a unique look at the United States during a twenty-five-year period.[1]

Latrobe was a universal man. It seems scarcely possible even to count all the significant currents that run through his amateur drawings. His diversity shows itself, though by no means to the full, in his subject matter. Landscapes; botanical, zoological, geological, and meteorological studies; genre scenes (scenes from ordinary life); satirical subjects; portraits; literary illustrations; still lifes; records of curiosities—so runs a list that is not exhaustive (nor composed of mutually exclusive categories). But it is the landscape—that word here includes the seascape and the city view—that predominates and that therefore dominates this essay.

1. HOW LATROBE DREW

Using landscapes, we can look at the basics of Latrobe's *normal* method of making drawings.[2] The normal drawing began as pencil lines, without pencil modeling. In representing a landscape for the first time, Latrobe drew in his sketchbook on the spot, and he often penciled notes on the drawing to guide him in finishing it later. (Thus, on No. 124 the notations include "loose locusts" over a group of trees at the left and "smooth green" on the ground near the center.) The present essay can only raise and set aside the question of Latrobe's relationship to mechanical aids in drawing, such as the camera obscura for which he thanked President Thomas Jefferson on 21 March 1807. Latrobe colored a landscape indoors, a much more convenient place to set out his watercolor materials. He used a medium in which the British excelled, translucent watercolor. Unlike the case with opaque watercolor (called *body color* or *gouache*), light shines through the films of translucent watercolor, strikes off the paper underneath, and reflects outward, suffusing the picture with delicate luminosity. Latrobe's basic principle in coloring dictated that *modeling,* or shading, precede the application of *local color,* the color belonging to a given object or area, such as green, the local color of much vegetation. Latrobe painted in the modeling with gradations of *neutral tint,* a *monochrome underpainting.* No. 83 shows the beginning of this process. No. 82, a drawing interrupted at an advanced state, permits one to compare buildings (far right) that have only their neutral tint with, say, the central courthouse, which has a local color, a red for brick, over neutral tint on its shadowed front and over plain paper on its sunlit side.

In typical fashion, the neutral tint mutes the red layer over it. An area that was to be white took its color from the paper. The area had to remain blank throughout the coloring, as in the case of clouds, or else had to have paint removed, say by scraping waves with a sharp instrument to produce the effect of foam.

The procedures resulted in *tonal compositions,* works whose compositional structure depends on the gradations from dark to light created by the underpainting in neutral tint. One thus sees an overall gray cast to the pictures, and squinting at them reveals how Latrobe composed them in grades of grayness. The subordination of brushwork to line drawing and of local color to monochrome underpainting makes these works *tinted drawings* or *watercolor drawings.* Latrobe's practices were standard in late eighteenth-century British topographical drawing, a major artistic phenomenon. But, in the late eighteenth century, creative spirits such as John Robert Cozens, Thomas Girtin, and J. M. W. Turner had begun to explore the routes toward the nineteenth-century *watercolor painting,* which, in liberating color and the brush, endowed watercolor with a new power and sensitivity.

Latrobe's procedure encourages some confusion about dating. In the case of original versions of subjects, he might color a pencil drawing at any time after making it, but he seems to have made a habit of giving a finished watercolor the date of his original pencil work. This book follows his policy in these cases, for ordinarily one has no way to determine the date when Latrobe completed such drawings. Repeatedly, as with Nos. 135–37, he copied his drawings on unknown occasions and gave the copies, too, the date of his original pencil sketches. The present book assigns a corrected date to these repetitions.

2. THE PICTURESQUE, THE NEOCLASSICAL, AND THE SUBLIME

Of the many strands that run through Latrobe's drawings, we can examine three (which also, in a different pattern, run through his architectural work): the Picturesque, the Neoclassical, and the Sublime. Examining these strands permits us to tie in other important subjects along the way.[3]

The Picturesque

Let us begin by taking a second look at the Latrobe passage mentioned at the close of the preceding essay. These words of 1798, from the "Essay on Landscape," can introduce the Picturesque:

> When you stand upon the summit of a hill, and see an extensive country of woods and fields without interruption spread before you, you look at it with pleasure. On the Virginia rivers there are a thousand such positions. But this pleasure is perhaps very much derived from a sort of consciousness of superiority of position to all the monotony below you. But turn yourself so as to include in your view a wide expanse of Water, contrasting by its cool blue surface, the waving, and many colored carpet of the Earth, your pleasure is immediately doubled, or rather a new and much greater pleasure arises. An historical effect is produced. The trade and the cultivation of the country croud into the mind, the imagination runs up the invisible creeks, and visits the half seen habitations. A thousand circumstances are fancied which are not beheld, and the indications of what probably exists, give the pleasure which its view would afford. Having satiated your eye with this prospect, retire within the Grove, so that the foreground shall consist of trees, and shadowy earth. The landscape is immediately lightened up with a thousand new beauties, arising from the novelty of the Contrast. This particular effect, of seeing a distant view glittering among near objects is familiar to every observer. The Landscape is now become a perfect composition.

The passage states that a spectator who moves through the countryside can find views there that compose the way a good painting composes. These views are *Picturesque.* That is, they are "like pictures" composed by good painters, and most particularly like good landscape paintings. (No. 22 has much in common with Latrobe's "perfect composition.")

The Picturesque movement is an eighteenth-century British creation. Its adherents believed that they could apply criteria for judging the composition of paintings, especially landscape paintings, to other arts and to the works of nature. Numerous areas of activity felt the transforming power of the Picturesque point of view. For example, the movement played a cardinal part in the creation of the "English garden," the informal gardening that the British developed in opposition to

the European tradition of formal, overtly artificial gardening. The devotees of the Picturesque learned to recognize—and seek out and draw—the kind of natural beauty that Latrobe's "Essay" passage describes. And architects and connoisseurs discovered how to apply Picturesque criteria to architecture. Late in the century, the movement reached sweeping dimensions. Important figures from this phase include some men whose names remain widely familiar, such as Reynolds, Gainsborough, and Adam, and others who today concern the specialist, such as the Reverend William Gilpin (1724–1804), the "Apostle of the Picturesque," a prolific author of books that popularized the hunt for the Picturesque in natural scenery.[4] The Picturesque, having begun to affect North America in the later eighteenth century, grew stronger here in Latrobe's time and after, assuming the proportions of an inundation at the middle of the nineteenth century.

Latrobe's description of the hilltop view provides a good starting point for enumerating some important and standard Picturesque pleasures of his time. In essence, his spectator *moves through* the countryside in search of a succession of gratifying views and, one can understand, enjoys each such "prospect" standing still. Latrobe does not isolate three fundamental Picturesque pleasures of the moving viewer, curiosity, anticipation, and surprise. Surprise (an effect at least allied to the novelty achieved by stepping back into the grove) he brings up later in the "Essay." Curiosity and anticipation come into the passage insofar as Latrobe mentions, apropos of a stationary viewer, the power of the unseen and the partly seen to excite the imagination. (The motionless observer can preserve curiosity and anticipation, whereas his surprise fades.) If we revise Latrobe's somewhat muddled treatment, we can make two points. The indications of what probably exists, or does exist, stimulate the imagination to a pleasure that a full view would *not* afford. (Thus, screening parts of the scene with the trees of the grove revitalizes the prospect.) And motion through scenes or stationary contemplation of a scene can prompt the imagination to pursue chains of association. To return to Latrobe's handling, the passage stresses contrast, an effect of variety and a quality required by the moving and the stationary Picturesque viewer. The last sentences of the excerpt emphasize the importance of a rich play of light and shade, one species of contrast. Latrobe does not treat by name the Picturesque love for two manifestations of variety, roughness of texture and irregularity of outline, but one recognizes this taste in the waving vegetation, in the trees that half-conceal the houses or form the grove, and in the broken surfaces glittering in the distance. This scene of a thousand beauties carries variety to the point of complexity. At the same time, Latrobe's remarks indicate the requirement of unity, for, with the addition of the dark grove, an ordering, or, specifically, a framing device, the whole scene becomes a perfect composition. Further on in the "Essay" he names a crucial unifying effect in nature (observed during mornings and evenings with scattered clouds) and art: the concentration of areas of light "into one mass." (He means nothing so exaggerated as a spotlight effect.) In his words of 29 October 1806 to Thomas Jefferson, this is the principle of the *"Unity of light."* All the variety in a Picturesque view must lie under the dominion of unity, for the Picturesque viewer seeks a composition, a unified "picture" that gives (to the stationary eye) a strong, intelligible impression.

Latrobe did not open his essay with the passage just discussed. Because of the loss of two pages from the manuscript, his comments begin:

> . . . is only pleasing. For my part, I find nothing so instructive as the contemplation of the works of creation; and had I been appointed to settle the ceremonial of the arts, I believe I should have given the precedence to the representation of the Beauty of Nature, and not to that of the actions of Man.

Latrobe here countered an argument from the aging humanistic or classical theory of painting, a subject that requires a look backward. The artists of the Italian Renaissance sought to bring about the rebirth of the arts of classical antiquity and, to an epoch-making extent, they succeeded. Their achievement founded a tradition that, in metamorphosis after metamorphosis, lasted in the visual arts of the West down into the nineteenth century. (In architecture, Latrobe's Neoclassicism belongs to the last pervasive renewal of the tradition.) Within this tradition, one finds a central tenet: great painting is the ideal imitation of what is greatest in nature, the most noble human actions. Pretty surely, Latrobe's fragmentary first sentence stated a humanistic argument that such art, commonly called *history painting*, gave instruction as well as pleasure, but that landscape, an inferior kind of painting, could offer pleasure alone. Latrobe turned the tables by declaring that he found nothing so instructive as contemplating nature and therefore would rank landscape over history painting.

Latrobe here nearly admits that he drew for instruction and delight.

His remarks on the "historical effect" in his hilltop view fit under the former heading. Those remarks seem to argue that the Virginia countryside can compete with the subject matter of history painting; and they call to mind William Gilpin's and Turner's goals of elevating the art of landscape to the level of history painting. But, in reality, it appears that Latrobe found the contemplation and depiction of nature enormously instructive much more in his role of amateur scientist than in his role of landscape artist. Although an inquiring mind cannot keep learning and delight separate, Latrobe's drawing, the activity of a man who contracted the itch to draw in boyhood, hinged on pleasure. The "Essay" tells of the role of drawing not only in giving pleasure generally but also in providing solace and relaxation, in communicating pleasure to others, and—here instruction blends in—in increasing the perception of natural beauty. The "Essay" further points to the fact that Latrobe's drawing could serve uniquely specialized purposes: he drew the illustrations in order to offer instruction in landscape drawing, and he apparently started the whole project as a gesture in a courtship.

Having brushed aside a portion of the humanistic theory, Latrobe proceeded to identify his greatest artistic hero, a painter whom he ranked with the Raphaels and Michelangelos of history painting:

It is Claude Lorraine. Words cannot describe his pictures [Fig. 1].

Fig. 1. *Claude Lorrain*. Landscape with the Marriage of Isaac and Rebecca. *1648*. (*National Gallery, London*)

They live. The spectator can travel in them. They contain the Geography of Kingdoms. . . . You almost feel the Warmth of his Sun; or the coolness of his breeze, which appears to wave the vegetating foliage.

Claude Lorrain (1600–82), a French-born landscape painter who worked in Italy and who ranks as one of the great masters in Western art, had served as one of the principal inspirations for the Picturesque movement. Latrobe paid tribute to him in two other important passages, a word-painting à la Claude of 1797 (see BHL, *Journals*, 1:285–87) and a commentary of 1800 (see No. 61). Latrobe's artistic debts to Claude will come in for attention later on.

Here we should acknowledge that Latrobe, like many other creative individuals of the eighteenth and the early nineteenth centuries, had to perform a balancing act. Perhaps it is not too bold to say that the Picturesque was born inside the classical tradition and broke free. Certainly, it owed that tradition essential debts. Certainly, in eighteenth-century Britain, the development of the Picturesque and the development of the classical tradition in architecture wound together; the rupture would come in the nineteenth century. In other spheres, incompatibility between the new movement and the old tradition had become explicit earlier, as with Gainsborough, whose pursuit of Picturesque qualities has nothing to do with the ideal representation of humanity in the performance of man's most noble actions.

Latrobe left ample evidence of the tension between the new movement and the classical tradition. As a brilliant professional architect, he held the two in creative equilibrium. But he did not reach anything like this level of achievement as an amateur who drew and who wrote about drawing. Thus, in the "Essay," he kept portions of art theory from the classical tradition and threw portions out. The principle of the unity of light, like that of instruction and delight, comes from the humanistic theory. Much more important, Latrobe agreed with the old theory that art imitates nature, but he disagreed as to what an artist imitates, and how. The humanistic theory argued that an artist should elevate his likeness by referring to an ideal standard that subordinated the portrayal of nonhuman elements to the portrayal of the human form. An artist should not take the route of *naturalism,* the "mere" attempt to recreate faithfully the appearance of the visible world. Latrobe embraced the principle of naturalism, at least for landscape art. Accordingly, he

praised Claude for naturalism. One would scarcely guess from the "Essay" that Claude poetically "translated" classical and Judaeo-Christian themes, together with his experience of the actual world, into idealized imagery. In the mix of Latrobe's ideas on art one sees the declining strength of the classical tradition and the mounting strength of the Picturesque movement.

The "Essay" clearly expresses Latrobe's own commitment to naturalism. Thus, he wrote that "painting . . . is only perfect as its imitation of nature is exact." If such a statement survived in isolation, its author would seem to promise that he made faithful pictorial reports on what he saw. But, as we shall see, Latrobe believed that nature defies the power of even the greatest artist to capture her, and he also acknowledged that nature and art abide by different rules. He wrote that his principles in landscape drawing had foundations in nature (he did not treat these foundations in a consistent fashion), but that the principles directed the use of *knacks* or *manners,* "a sort of stage-trick." Relying on these techniques, an artist took legitimate liberties, or *licenses,* with nature's face, if he did not carry a technique to excess and produce unnatural-looking effects or an unrecognizable representation of a particular place.

By interpreting an inconsistent passage of the "Essay," one can briefly illustrate the relation between knacks, or manners, and nature's superiority to art. In the passage, as in his drawings (for instance, No. 13), Latrobe espoused a certain stylization of foliage for trees—a stylization based on natural appearances—because real foliage confronts the artist with overwhelming intricacy.

Having described how the addition of the shadowy grove to the foreground of the hilltop view converted the whole into a "perfect composition," Latrobe stated that

> From experience like this [in nature] have arisen the Laws [or principles] that govern the arrangement [or manners] of the Landscapes of good Painters, and the licences which they are so justly accused of taking with . . . Nature.

Then, after stating two compositional principles, he wrote:

> A painter of taste immediately rejects a prospect which he cannot so arrange, or if he must paint it, rocks, trees, figures, and clouds casting broad shadows are called to his assistance in a moment. These licences become with many painters such a habit, that it is

impossible to recognize the *character* of the countries they represent in their pictures, although you may here and there discover a single object.

Latrobe deemed a dark foreground beneficial to compositions and a dark foreground with trees more beneficial. This is one of the "Laws" that had arisen from nature, as in the shady grove, and that regulated a good manner in composition. The "Essay" had already stated in more detail than the second excerpt that, if nature did not provide a dark foreground, the artist could take a license. He could supply a shadow in the foreground (or anywhere else) by supposing that an object outside the picture, such as a cloud or trees, cast the shadow. (See, among many, Nos. 26, 37, 67.) We have just seen Latrobe include some unspecified use of trees among licenses. Certainly he had in mind the addition or rearrangement of trees in one kind of foreground. As in No. 13, an artist could reduce the foreground to a shallow area that gave little or no topographical information and amounted chiefly to a compositional device, setting off the depths of the scene. Here, without doing violence to his reliability, the artist could dispose trees (or other elements) to suit his ends. In particular, he could place a tree or trees at one or both sides to serve as *repoussoirs*, elements literally intended to *push back*—give depth to—the further distances of the scene.[5] Thus, by taking licenses, Latrobe could, on certain occasions, add a dark foreground and (conveniently explaining the shadow) a *repoussoir* tree or two. Thus he could improve unfortunate subjects and, although he did not say so in the "Essay" passage, thus he could make good subjects better. In rereading his statement that experiences in nature like that on his hilltop had inspired the principles governing "the Landscapes of good Painters," we can, in the present case, supply an identification. The painters are Claude and his followers, in whose works dark foregrounds with *repoussoir* trees typically appear. As in No. 22, a dark foreground can perform an essential service for an artist who wishes to gather his principal bodies of light. And it becomes clear now that this manner of lighting, too, takes liberties. As we have seen, Latrobe derived it from *specific* conditions in nature, a morning or evening sky with scattered clouds, and recommended it for most if not all circumstances. The last passage just quoted closes with a warning about licenses. Licenses could run to excess, so that the character of a piece of terrain became unrecognizable. (In this case, the twentieth-century reader needs no explanation of the word *character*, only the warning that it is an important but treach-

erous term from the period's art theory.) With all the foregoing said, we shall still find surprises in Latrobe's deviations from fidelity to the visible world.

Two Latrobe drawings of Mount Vernon will clarify Latrobe's variety of Picturesqueness. In July 1796 Latrobe visited President Washington at his estate (see BHL, *Journals*, 1:161–72). The visit prompted the architect to make eleven known drawings (counting rough sketches), a group exceptional in its number and variety. The principal reason for this large output is that Latrobe recognized his extraordinary opportunity to meet a hero and wished to record the experience in detail, but in addition the Mount Vernon scenery and Eleanor Custis, Mrs. Washington's granddaughter, also had their impact on him. Four drawings form a body within the Mount Vernon group, and we must isolate that body now for future reference:

a view of Mount Vernon looking toward the southwest (No. 22), drawn (but of course not colored) on the spot;
a later version of the same view, elaborated with figures of the Washingtons and intimates of theirs (Fig. 2);
a figural study (Fig. 3), made, surely from memory, in preparation for Fig. 2;
and a second figural study (Fig. 4), related to the first and again surely made from memory, but this time in preparation for an unknown drawing.

We shall use the two views to illuminate the Picturesque. One might well have preferred to study the lessons of the second version, evidently an ambitious performance, but the drawing has suffered such damage that one must concentrate instead on the first rendition, a well-preserved drawing of high quality.

Latrobe stationed himself so that a living landscape would create a good picture, in accord with a compositional pattern that took its authority from Claude, as in Fig. 1. Latrobe's scene divides into a foreground, a middle ground, and a background. The terrain does not recede into the depths of the picture smoothly but as a matter of *coulisses*, elements like wings in stage scenery, with edges past which the eye jumps into deeper distance. (In both No. 22 and Fig. 1, one easily recognizes the effect in the jump that the eye takes inward and downward from the foreground to the river.) The foreground is darkened and has *repoussoir* trees at the right, while another grouping of trees to the left helps frame the prin-

cipal vista. The light, concentrating in the middle ground, comes from a sun low in the luminous sky at one side. The time is sunset (sunrise would make no difference to the formula), and, therefore, the sky and lesser areas receive a special bloom of color. Latrobe hid the sun behind the foreground, some of which is set off against the light. Water, pale-colored, occupies much of the middle ground. The elements just named are not the ingredients of an unvarying recipe, in either Claude or Latrobe. They represent one set of possibilities within a classic general pattern. If one could distill the essence of the pattern, it would differ from No. 22. For instance, the distilled composition would certainly give

an important role to a bridge, an element beloved by Claude (compare Fig. 1). One must seek the treatment instead in other Latrobe variations on the pattern, such as Nos. 83–84. Latrobe's subject matter prompted more important deviations from the typical. Making his picture to show Washington's house, he gave the foreground unusual prominence in relation to the middle and the background, and he carried the house more than halfway across the picture. While the portico does set off the depths of the picture, as primary subject matter it differs from the typical foreground building in Claude, which serves as a *repoussoir*, not as a focus of interest, and so takes up no very large space.

Fig. 2. *B. H. Latrobe. "View of Mount Vernon looking towards the South West." Second version. Pencil, pen and ink, and watercolor. [After 16 July 1796.] (Private Collection)*

Fig. 3. *B. H. Latrobe. "Sketch of a groupe for a drawing of Mount Vernon." Pencil, pen and ink. [After 16 July 1796.] Sketchbook II. (PBHL)*

Latrobe did not have Claude's mastery at conveying the immensity of space, but such landscapes as this do invite "the spectator [to] travel in them," as Latrobe recognized that Claude's do. To this end Latrobe, like Claude, treated the eye to screening elements—the left-hand grouping of trees (a similar screen occurs at the left of Fig. 1) and the portico piers. These screens afford incomplete glimpses into the depths of the picture, thereby tempting the imagination to journey beyond the reach of the eye. In his second version, Latrobe added sailing vessels. Such details in any case lure the eye into distances, but here Latrobe intensified the effect in places by uniting the vessels with his screens in one of his most delightful devices, the picture-within-a-picture. The trees at left become a frame for a little view of a ship; the same treatment occurs at the portico but does not show up in a small reproduction. This teasing device of a screen framing an interesting picture—used also by Claude, as in the series at the left of Fig. 1—recurs in Latrobe, as in Nos. 108, 145, and 149, and variations show up (Fig. 5). One must admit that Latrobe did suffer from a weakness for placing an element a little too obviously at about the center of a minute framed view. As for the Mount Vernon drawings, Latrobe obviously put the vessels into Fig. 2 at will. It comes as no surprise that his important journal entry of 10 August 1806 on the American landscape (BHL, *Journals*, 3:65–67) adds vessels to the class of licenses.

The southwest view of Mount Vernon afforded Latrobe little

Fig. 4. *B. H. Latrobe. "Outlines of a group for another drawing of Mount Vernon." Pencil, pen and ink. [After 16 July 1796.] Sketchbook II. (PBHL)*

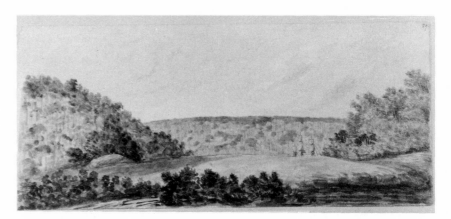

Fig. 5. *B. H. Latrobe. "View of the Road to Kingsbridge, in the Island of New York (Manhattan)." Pencil, pen and ink, and watercolor. 4 June 1800. Sketchbook V. (PBHL)*

enough of roughness and irregularity. One must seek his attraction to these qualities elsewhere, as in Nos. 62–65. But No. 22 does illustrate the unity of light, a principle compatible with Claude's influence. Latrobe concentrated the brightness—one can describe the configuration only approximately—above and below the horizon around the center of the picture.

Other drawings bring Latrobe's Picturesqueness into sharper relief. The variable relations between naturalism and the Picturesque in these drawings will point up a major issue, that it is a mistake to take Latrobe's drawings too literally as representations of what he saw. Other themes will conveniently weave their way into our discussion.

Around dawn on 3 August 1806, Latrobe drew two scenes on the Delaware River, *View looking towards Philadelphia* (No. 97) and *Sketch of Redbank and Fort Mifflin* (No. 98). At first glance, the two drawings look much alike. But their creator wrote of them in his journal on the same day—it sounds as if he had just finished coloring the *Philadelphia* during a stopover on his trip—that the *Philadelphia* "is picturesque tho' no object of prominence distinguishes it, the city with Christ church steeple seen over the meadows . . . , and the long range of blue distance with the *dots* of Houses . . . closing the river." But *Redbank and Fort Mifflin* was "a mere topographical view" of the site of important action during the Revolution. Latrobe's vantage point for the *Philadelphia* did indeed afford him a Picturesque landscape. Thus, on the left-hand, an accumulation of elements exhibits roughness of texture, irregularity of form, ample contrast, and complexity, and these elements create a *repoussoir* in front of a screen at the second wharf. Across the picture, clumps of foliage break open to reveal and be set off by glimpses of the "blue distance," with its accents, the pale flecks for houses near the middle of the picture and, a little to the left, the paler spire, centered over the meadows between framing groups of trees. This treatment, particularly in the case of the spire, belongs to the class of picture-within-a-picture, like the framed vessels in Fig. 2. The lessons of the Mount Vernon views also suggest the likelihood of a license in the *Philadelphia*, the vessels, which Latrobe probably placed freely in the latter drawing, while the gathering of the lights (into something roughly like a wedge, its hypotenuse running from the upper right corner to a subordinate focus of illumination at the wharves) shows the hand of the pictorial composer who did not fill in modeling and color on the spot. In other words, one would err in supposing that, even in this picture, the claims of natu-

ralism and Picturesqueness coincided perfectly, so that Latrobe represented just what he saw. Sad to say, hasty execution produced a drawing of such disappointing quality that one has to excavate the original, vivacious ideas from their burial under the picture. (Latrobe's decision to give the landscape the light of a chilly northern sky barely touched with the warmth of dawn contributes materially to the poor effect of the picture.) One should keep in mind that Latrobe's pleasure in a scene must normally have sprung up for him as a moving viewer, who saw the changing elements coalesce by degrees into a good composition. Presumably this remembered Picturesque pleasure heightened his enjoyment of his finished Picturesque drawings. Unfortunately we can rarely come close to reexperiencing this pleasure that he experienced.

Redbank and Fort Mifflin displays the finer and no doubt later, more leisurely execution of what Latrobe regarded as a pictorially inferior but historically important subject. (The historical significance mattered enough to him that he wrote a précis on the facing page of his sketchbook.) From the left, past the center, to the tip of Red Bank, he had fairly dull raw material. Fort Mifflin at far right (Fig. 6) presents the opposite of Picturesqueness: repetitive angular masses backed by what looks like a stiff, rectangular poplar plantation. Latrobe tried to redeem his composition. His measures probably included his treatment of the vegetation—certainly the contours of the verdure as colored differ to some extent from the outlines underneath the paint. He surely deployed the vessels for contrast and animation. And he made much of the light. He located the chief concentration around the horizon at the right (and, in so doing, formed an artificial pattern of light on the water); among other ambitious lighting effects, in an elegant Claudian touch, he illumined the tiny forms of Fort Mifflin and its trees with a dawn glow muted by distance. The flush of sunrise falling here converted a negative element into a delightful one.[6]

The central point about the two views is that Latrobe drew one as a Picturesque composition and the other as a record of a site that had only nonpictorial interest. It appears that, in the view that he saw of Philadelphia, the claims of naturalism and the claims of Picturesque artistry did not significantly conflict. But they did conflict in the second view that he saw, and Picturesqueness could enter in only as a cosmetic aid.

We can now profitably look back at the "Essay" passage on licenses: "A painter of taste immediately rejects a prospect which he cannot [present artistically], or if he must paint it, rocks, trees, figures, and

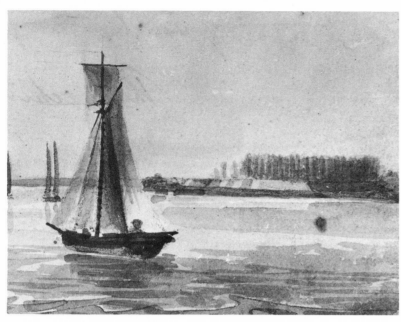

Fig. 6. *B. H. Latrobe. "Sketch of Redbank and Fort Mifflin" (No. 98). Detail. Pencil and watercolor. 3 August 1806. Sketchbook IX. (PBHL)*

clouds casting broad shadows are called to his assistance in a moment." In essence, the comment divides landscape drawings into the good composition and the likeness of an ill-favored subject, the same two classes as in the 1806 journal passage. Latrobe, in fact, must have mentally made this distinction throughout his American career.

We can pursue the two kinds of composition. Of his depiction of Yorktown, *View at Little York in Virginia* (1798; No. 59), a copy of an original drawn from nature in the summer of 1798 (No. 58), Latrobe wrote in the "Essay":

> As a composition this View . . . is wholly destitute of merit. All that can be said for it is, that it is an accurate representation of a scene of great political importance. . . . I have attempted to make the most of the subject, by collecting the Light in a Mass upon the Ravelin [the acute-angled fortification on the right-hand side] and the opposite river; but . . . the piece . . . has nothing of what the painters call, pittoresque.

Latrobe moved on to historical remarks related to the *Little York*, much as he accompanied the *Redbank* with historical notes in his sketchbook. In the opposite class of subject matter, we have already seen him doing approximately this when he discussed "historical effect" in connection with the Picturesque hilltop view. In fact, in the "Essay," he supplied his landscape drawings, Picturesque or topographical, with all sorts of commentaries of, broadly speaking, an instructive nature independent of pictorial values. Clearly, he devoted his topographical landscapes to this sort of significance. The reverse, though, can hardly hold true: it seems highly improbable that he devoted any of his Picturesque landscapes exclusively to pictorial values and pictorial pleasure. No doubt he could have analyzed any of his Picturesque subjects along the lines of the "historical effect" observations.

It is not easy to reconstruct Latrobe's connoisseurship, to assess all his landscapes by his standards, on a scale that runs from highly Picturesque to the opposite. But one can distinguish representatives of the two contrasting classes without an attendant commentary by him. A good case occurs with two drawings showing Thomas Jefferson's temple-form Virginia Capitol of 1786 ff. *The View of Richmond from Washington's Island* (1796; No. 13) fits readily under the Picturesque heading. Conspicuously, it reduces the Claudian pattern to a cut-and-dried formula of dark foreground with *repoussoir* tree, watery middle ground, and background (compare Fig. 1). The 1797 *View of the Capitol . . . from Dr. James Macclurg's Dining room* (No. 37) is a harsh report on the most important portion of the same city, without the license of a single leafy branch. In truth, the ludicrous proximity of the "temple" and the glorified shanty on stilts makes one wonder whether Latrobe did not have a satiric intent. One also wonders about something else. Latrobe drew some buildings as curiosities (Nos. 138, 156A). In No. 37, did he intend chiefly to report on this strange state of civic architecture as an architect, or to make a more general document to say "life in this part of the new nation has a great deal of crudeness to outgrow"? (On the other side of the coin, views of his own works as executed [Nos. 128 and 141] are rare among his extant drawings.)

We have come nowhere near the end of the issue of Latrobe's fidelity. Whenever one has a drawing from nature and a later copy, the two differ. The two versions of the *Little York*, drawn within about a month of each other in 1798, can stand for Latrobe's early American years and the topographic drawing (Nos. 58 and 59). The original *View*

of Bloody run village, begun 11 April 1815, and its undated copy can stand for the later years and the Picturesque subject (Nos. 135 and 136).

One can probably explain a high proportion of the discrepancies between versions of a scene by the fact that Latrobe drew freehand and for his own pleasure, without feeling obliged to transcribe each detail with absolute fidelity. This accounts, no doubt, for much of the difference that patient comparison reveals between the two Yorktown drawings.

As to the Bloody Run views, clearly Latrobe made the first drawing out of pleasure with the scenery (which he praised in a letter of 12 April 1815 to his wife). The second drawing diverges in almost every detail. In its foreground, we see compositional choices in the different *repoussoir* trees, in the altered group of soldiers, and in a highly Picturesque addition, the partly hidden team and Conestoga wagon, which lead the eye out of the foreground. We know enough about license in foregrounds to feel no surprise at this freedom. On the score of fidelity, what matters is the changes in the further distances. For instance, Latrobe pervasively altered the mountain contours and, right of center, even narrowed the gap. On the ridge at right in the middle ground, he wholly changed the vegetation, to create a new silhouette that contrasts vivaciously with the valley floor and the most distant slopes. Comparable changes occur at the right all the way back. We can see the modification of the scene as the outcome of rather casual draftsmanship combined with the wish for a Picturesqueness heightened over that of the original. Actually, the pursuit of the Picturesque gave both drawings a contrived quality. Even so, the artist certainly did not carry his licenses so far that one can legitimately call the effect unnatural, or "that it is impossible to recognize the *character*" of the location. Indeed, some of the deliberate deviations from fact in the landscapes, including exaggerated heights, may possibly represent a wish to convey more of the character of a place than Latrobe could show by an accurately reproduced view of the specific part of the locale that he framed within his drawing.

The Bloody Run drawings—a pencil sketch made on the site and washed in later, as usual, and a finished watercolor no doubt prepared later still—underscore the fact that memory played a most considerable role in Latrobe's drawings. Let us look at an example of the treachery of Latrobe's memory (No. 105), which also permits us to touch on the connections between his amateur drawings and his professional career.

The links seem almost countless. The most important reason is that Latrobe's wide-ranging mind, rather than segregating interests, promoted their cross-pollination. We have space only to look at the ties between Latrobe's landscapes and his highly finished architectural perspectives and to glance at the pertinence of the Picturesque to his Neoclassical architecture.

Other species of architectural drawing were indispensable technical diagrams that confused laymen. The finished architectural perspective, unnecessary for designing or constructing a building, could convey information about a design to virtually anyone because it provided a reasonably naturalistic picture. In the realm of architectural drawing, such perspectives stand just over the border from landscape drawing, as witness No. 105.

In 1806, probably in August, Latrobe began No. 105 as a landscape to show the Capitol under construction. The drawing erroneously makes the depth of the near wing sufficient to hold only five windows per floor, not the actual seven. This circumstance, along with less striking discrepancies, means that Latrobe drew from memory. His discovery early on that he had drawn incorrectly doomed the picture to remain unfinished. But at some point he marked in lines to crop the image. (The most visible of these is the vertical at the bottom of the sheet, about a quarter of the way in from the left.) These added margins focused the picture on the building and thereby converted a landscape drawing into the model for an architectural drawing. Latrobe most likely trimmed his view simply in order to produce a compositional guide for preparing his earliest known architectural rendering of the Capitol in perspective (Fig. 7). That drawing, which Latrobe gave Jefferson in November 1806, and his subsequent known architectural perspectives of the building take the basic format established on the sketchbook page as cropped. (No. 119 similarly started as a landscape and later received cropping, but if Latrobe made an architectural drawing on this basis it has not come to light.)

This brings us to five observations. First, it is the matter of focus that forms the recognizable distinction between a Latrobe landscape showing one of his buildings (Nos. 119, 128, and 141) and a Latrobe architectural perspective of one of his buildings. Second, because no known Latrobe architectural perspective shows the actual state of a building as constructed, and because these drawings incorporate imaginary embellishments, they have no place in the body of a book basically devoted to Latrobe's pictorial records of the American scene. Third, by now the

reader can recognize the Picturesque touches in Fig. 7. Fourth, Fig. 7 and Latrobe's letter to Jefferson of 29 October 1806 have an important place in the story of Latrobe's Picturesque Neoclassical architecture. With them, he unsuccessfully presented two Picturesque arguments for using cupolas at the Capitol: cupolas would improve the composition of the exterior, and a cupola over the Hall of Representatives would give that chamber the *"Unity of light."* One cannot in fact isolate Latrobe's Picturesque connoisseurship of nature and drawing from the Picturesque connoisseurship that he applied to the creation of architecture. Fifth, No. 105 had an extraordinary progeny, not merely Latrobe's finished perspectives of the Capitol, but also British, European, and American prints that derived from these drawings, such as Fig. 8.[7]

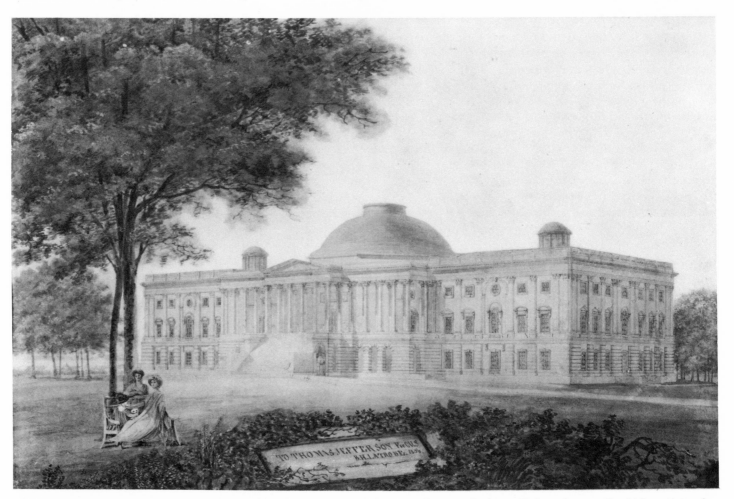

Fig. 7. *B. H. Latrobe. East and North Fronts of the United States Capitol, Perspective. Pencil, pen and ink, and watercolor. [After 1 September and by 17 November 1806.] (Reproduced from the Collections of the Library of Congress)*

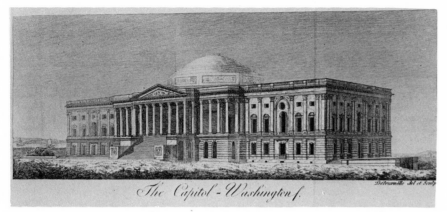

Fig. 8. *B. H. Latrobe, draftsman, and Détournelle, engraver. "The Capitol—Washington." From David Bailie Warden*, A Chorographical and Statistical Description of the District of Columbia *(Paris, 1816), facing p. 34. (American Philosophical Society)*

Fig. 9. *John Flaxman, draftsman, and Tommaso Piroli, engraver. "Venus Presenting Helen to Paris." From Flaxman*, The Iliad of Homer . . . from the Compositions of John Flaxman *(London, 1795), pl. 5. (The British Library)*

Fig. 10. *John Flaxman, draftsman, and Tommaso Piroli, engraver. "Venus Disguised Inviting Helen to the Chamber of Paris." From Flaxman*, The Iliad *(London, 1795), pl. 4. (The British Library)*

The Neoclassical

Yet another kind of departure from naturalism brings us back to the Mount Vernon drawings, but it takes us out of the realm of the Picturesque into that of Neoclassicism. For many of the figures in these drawings, above all Latrobe's figures of Nelly Custis (Figs. 3, 4), imitate compositions (Figs. 9, 10) by the British Neoclassical sculptor John Flaxman (1755–1826).

Neoclassicism began to crystallize around 1760 as a renewal of that classical tradition that the Renaissance had established at the center of Western art. The Neoclassical movement is the final renewal of that tradition before the tradition, in the nineteenth century, fell from its central position in the arts of the West. Neoclassicism consisted of successive phases that varied by location, it operated internationally, and it embraced all the visual arts. It is by far the broadest, deepest current in Latrobe's work as an architect; indeed, he ranks as the most important Neoclassical designer to carry the movement to the United States. The influences that he bore with him included that of Flaxman.

Art historians, especially from the 1960s onward, have exposed the

error of an old notion that the Neoclassical arts are typically "cold," enslaved by Greek and Roman example. (The remarks already made here on Latrobe's architecture and the Picturesque indicate the justice of the newer point of view.) The Neoclassical creations of a Latrobe or a Flaxman drew vitally from highly diverse sources outside classical antiquity, sources that lay within later phases of the classical tradition and sources that lay without. The two men exhibit no trait more striking than their ability to respond to fresh stimuli, in an age when an artist essentially of the classical tradition could find an inspiring freshness in nature, supposedly "primitive" phases of art, ancient art, medieval art, art from the Renaissance down to the moment, and non-Western art, all at the same time.

In the early 1790s, Flaxman drew a series of Neoclassical compositions on the basis of Dante, Homer, and Aeschylus, for publication as engravings in pure outline. At the time, he stated that "my intention is to shew how any story may be represented in a series of compositions on principles of the Antients." In Flaxman's interpretations of the principles of the ancients, art revolves around the human form, idealized, simplified, and used to tell a story. Line reigns supreme in creating the image, without modeling in light and shadow, without naturalistic atmospheric effects, and without color, except that of the ink and that of the paper. And traditional perspective effects are sharply curtailed. The compositions are distinguished late representatives of the humanistic tradition, but the style is radically innovative in its degree of simplification and abstraction. Although the nature of the style, formed on the basis of multiple sources, remains troublesome to understand, Flaxman's outline style seems to have pivoted on the purification and elevation of natural appearances via the study of imagery from antiquity and the later phases of the classical tradition. Flaxman's inspirations included one of the freshest sources for the Neoclassical movement, Greek vase painting (Fig. 11).

Flaxman's recourse to these paintings belongs to primitivism, a phenomenon that operated inside and outside of Neoclassicism. It entailed the search, among cultures that really or theoretically lay outside the great phases of high civilization, for the supposed natural origins of the arts, as well as for pure sources of inspiration in early stages of art related closely to the origins. (The word *primitivism* has a great disadvantage in that the word *primitive* has become hopelessly discredited in connection with the arts and has little if any serious meaning left.) In Figs. 9 and 10,

Fig. 11. *Meidias Painter. "Hercules in the Garden of the Hesperides." Detail of an Attic red-figure hydria. c. 410 B.C. From Pierre François Hugues, called d'Hancarville, Collection of . . . Antiquities . . . of the Honble. Wm. Hamilton (Naples, 1766–67), vol. 1, pl. 127. (Winterthur Museum Library)*

we see a style and content shaped by primitivism. The style owes to the early traditions of the Greek vases and, one suspects, to a theory that painting originated as pure outlines in a state of culture close to nature. The use of Homeric subject matter owes to the fact that eighteenth-century literary primitivism had "discovered" Homer, the earliest of Western poets and supposedly a profound disciple of nature, and had exalted him. But Figs. 9 and 10, as is usual for primitivist works in this

period, are saturated with the sophistication of their age and give us little temptation to apply the word *primitive* in any of its common or dictionary senses.

Flaxman's outlines came as a revelation to artists, critics, and connoisseurs. The issuing of the engravings counts not merely as one of the most important events in the Neoclassical movement but as a key event for the development of nineteenth-century art, for they exercised their influence from the 1790s, past the decay of the classical tradition itself, for an entire century. In Flaxman's own time alone, the artists who responded to his outlines included men as various as the French painters David, Gros, Girodet, Ingres, and Géricault; the French sculptor Rude; the Danish sculptor Thorvaldsen; the Spanish painter Goya; the German painters Runge and the Nazarenes; the British painter Blake; probably the Anglo-American painter West; the British reformer of the decorative arts, Hope; the American painter Allston; and, of course, Latrobe.

Latrobe's response to Flaxman goes with his general pursuit, as an architect, of the most advanced Neoclassical ideas known to him, a pattern most readily detected during his first decade and a half in the United States. Presumably he owned the first British editions of Flaxman's *Iliad* (London, 1795), *Aeschylus* (London, 1795), and *Odyssey* (London, 1805), or one of the early *Odyssey* reprints. The respective outlines affected his work soon after each of the dates in question. It seems probable that he brought the *Iliad* and *Aeschylus* with him from London in 1795 and thus conveyed these avant-garde compositions to America almost immediately after their first British printing.

Latrobe recorded some of the qualities he admired in the compositions in a journal entry of 7 August 1806 (BHL, *Journals,* 3:51–52) about the reaction of one Miss Clinton, a model of physical and spiritual beauty, to joyous news. He wrote of "a grace, a lightness, and an expression in her action and face which neither the inimitable figures of the antients, nor the magic sketches of Flaxman or [the great Italian Neoclassical sculptor] Canova dare to approach. . . ." For Latrobe, then, the outlines, along with the work of the ancients and Canova, had set a standard for beauty and expression of emotion in figural art, but nature could far surpass that standard. As in the "Essay," nature surpasses every artist's attempt to represent her. One remembers that the "Essay" set the portrayal of beautiful scenery above the portrayal of man's actions, and one cannot forget that there, as elsewhere, Latrobe rapturously extolled

Claude's fidelity to nature, without mentioning the limits on art. It appears, in fact, that, as much as he admired Flaxman (or Canova, or what ancient figural art he knew), his feeling for Claude and the depiction of landscape went much further. This is one manifestation of the tension that existed in his brain between Neoclassicism and the Picturesque. Although they pulled in conflicting directions, a creative mind could employ them in harmony. In Latrobe's architecture, as in that of other great architects of his age, Neoclassicism dominated, enlivened by the Picturesque. But Neoclassical elements entered only infrequently into the nonprofessional drawings, which belong to the Picturesque more than to any other category.

To date, eleven cases of direct and unmistakable borrowing from Flaxman have surfaced in Latrobe drawings. Of these eleven drawings only three of Mount Vernon certifiably represent scenes that Latrobe saw in the United States. But a discussion of Flaxman and Latrobe belongs here because the mingling of the Neoclassical with the Picturesque was central to Latrobe's entire artistic production, because the influence of the outlines on this output was important, and because it would be wrong to omit from an anthology of Latrobe's American drawings all those that, although they permit special glimpses into his mind, do not give views in America.

As to the three Mount Vernon drawings, Nelly Custis prompted Latrobe to borrow from Flaxman. The lonely widower characterized her in his 1796 journal entry on Mount Vernon much as he would later characterize Miss Clinton:

> Miss Eleanor Custis . . . has more perfection of form, of expression, of color, of softness, and of firmness of mind than I have ever seen before, or conceived consistent with mortality. She is every thing that the chissel of [the fifth-century B.C. Greek sculptor] Phidias aimed at, but could not reach; and the soul beaming through her countenance, and glowing in her smile, is as superior to her face, as mind is to matter.

Miss Custis, too, surpassed the powers of the greatest art, much less Latrobe's own powers. At no time did he have more than slender abilities at drawing the human form. He could not have made the sophisticated pencil portrait of Jefferson (Fig. 12) that earlier scholars have attributed to him. Under no illusions about his limitations, he can have wanted only to make the best possible picture of the group at Mount Vernon. To

Fig. 12. *Artist unknown. Thomas Jefferson. Pencil. N.d. (PBHL)*

level, does the Bank of Pennsylvania [Fig. 14], a building designed in the spirit of a classical temple.) When a weak artist specifically "quoted" from another artist, that amounted to slavishness. But a gifted artist could remain within the bounds of good imitation in "quoting," and he could quote for various reasons: to incorporate another master's excellences into his own work, pay homage to that master, surpass that master's treatment, or make a witty allusion. Flaxman, too, made quotations. The two figures of Helen illustrated here may or may not quote whole figures from earlier art, but, in any event, Flaxman did not originate their graceful gestures. The gestures belong to a family of poses that enjoyed wide currency during Flaxman's lifetime and extended back through the Renaissance to antiquity itself, in works that Flaxman knew well (Fig. 11).

make the best possible picture of Miss Custis, particularly when he had to work from memory, he needed help. In his study (Fig. 3) for the revised Mount Vernon view (Fig. 2), he—paying tribute to both the lady and Flaxman—chose to copy a portrayal of one of the greatest beauties of antiquity by one of the masters of his own time (Fig. 9). In another study (Fig. 4), he extended his Flaxman borrowings to other figures (Fig. 13). (The second likeness of his heroine testifies to his prudence in relying as little as possible on himself.) And, in his ultimate watercolor of Mount Vernon (Fig. 2), he continued to adapt Flaxman figures.

One should not suppose that Latrobe acted furtively nor that he acted merely as an amateur when he copied Flaxman. In every instance, he probably would have felt delighted to encounter a connoisseur up-to-date enough to recognize his sources as the outlines. In the classical tradition, the judicious imitation by artists of other artists' works held a place of honor. By a distinction that became prominent in the later eighteenth century, Latrobe and his age commonly condemned uninspired imitation as "servile" or "slavish" and took good imitation of a work to mean, above all, mastering its principles. (Latrobe's imitation of Claude modestly represents the second kind of imitation, as, at a higher

Fig. 13. *John Flaxman, draftsman, and Tommaso Piroli, engraver. "Hector Chiding Paris." From Flaxman,* The Iliad *(London, 1795), pl. 10. (The British Library)*

Latrobe, then, did not "borrow" merely as an amateur. But his borrowings are "slavish" because he could not make the lessons of the outlines his own in his amateur drawings (compare No. 42). In much of his creative output, as with any other practitioner of the visual arts, one can detect his sources. Only with Flaxman figures did he make a practice of copying. Up to 1800, he copied them because of his own limitations. After 1800, copying Flaxman became exceptional in his private drawings, where Latrobe's study of the outlines seems to have produced a modest improvement in his representations of the human form, some

increase in self-confidence regarding this subject, and some compositional notions. On this last head see, for instance, *Nondescripts* (1796; No. 16) and *Conestoga Wagons and Draft Horse* (1808; No. 96), which may owe something to Flaxman's compositional principles. Where Flaxman's influence fell on really fertile soil, however, was Latrobe's professional work decorating buildings.[8]

Latrobe significantly changed his Flaxman figures, for he transported them to the alien realm of the watercolor drawing. In Fig. 3, as elsewhere, he chose a Flaxman figure to inhabit a Picturesque setting

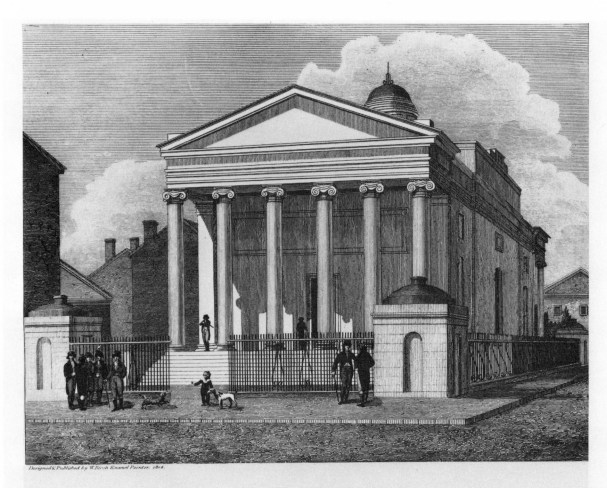

Designed & Published by W.Birch Enamel Painter. 1804.

BANK OF PENNSYLVANIA, South Second Street PHILADELPHIA.

Fig. 14. *B. H. Latrobe. The Bank of Pennsylvania, Philadelphia. 1799–1801. From William Russell Birch,* The City of Philadelphia, *2d ed. (Springland Cot, Pa., 1804), pl. 21. (Winterthur Museum Library)*

Fig. 15. *John Flaxman, draftsman, and Tommaso Piroli, engraver. "Iris Advises Priam to Obtain the Body of Hector." From Flaxman,* The Iliad *(London, 1795), pl. 33. (The British Library)*

(Fig. 2), and one can scarcely ask for a more sweeping contrast than that between a Flaxman composition and a Picturesque landscape by Latrobe. We can look at some of the differences.

In a Latrobe landscape, the human figure may appear but it equally well may not, as in No. 22. Flaxman, working in the humanistic tradition, represented human action. Because landscape would distract from his subject, he assigned a minimal role not merely to it but even to rocks and vegetation. In the world of the Flaxman plates, paper plus line achieves a high degree of abstraction. Here beautiful patterns of roughly parallel strokes perform a puzzling variety of purposes, including serving as an alternative, of sorts, to shadows, but were meant to excite little interest in their own right. Here atmospheric phenomena, such as the rainbow in Fig. 15, take stylized and often highly geometrical form. And here, as a rule, our eyes have little or no reason to travel beyond the action in the foregrounds. In Latrobe's landscapes, paper plus line plus modeling plus local color creates a world of convincing light and shadow, a chiaroscuro meant to receive pleasurable attention in its own right and enriched with such delectable details as the streaks of sunlight in the shadowy foregrounds of both Mount Vernon views. Here atmospheric effects, such as the sunset in No. 22, repeatedly called up Latrobe's

deftest powers of illusionism. And here the scenery invites us to wander into deep space and out of sight. So we come back to the fact that Latrobe's landscape drawings make the most out of what Flaxman's humanistic outlines minimize. The outlines show a world humanistically purified and ennobled over what we see around us by the idealization of the figures and the simplifying reduction of distracting nonhuman minutiae. If one defines *nature* as the appearance of the universe, Flaxman's art surpasses nature. Latrobe's Picturesque landscapes stand on the premise that nature surpasses art: an artist should wish to capture the boundlessly intricate profusion of natural appearances, cannot succeed, and therefore approximates appearances via tricks of stylization, such as the leaves on the *repoussoir* groupings in the two Mount Vernon views. In sum, the incorporation of Flaxman figures into Fig. 2 represents one of countless marriages of the Neoclassical and the Picturesque in Latrobe's output as a practitioner of the arts.

The Sublime

An important Flaxman borrowing occurs in the small class of Latrobe's literary illustrations, in an illustration to Ossian, or Oisin, a legendary Gaelic bard of about the third century A.D. (Fig. 16). The fortunes of Ossian, "the Homer of the North," form a major chapter in the history of primitivism. In 1760 a Scot, James Macpherson (1736–96), began publishing prose poems that he claimed to have translated from Ossian. His books met with a spectacular international reception comparable with what greeted Flaxman's outlines a generation later. Ossian's admirers included Jefferson, Goethe, Mme de Staël, Chateaubriand, Napoleon, and Victor Hugo. The poetry influenced a variety of artists, and the Ossian and Flaxman influences mingled. But, after charges of falseness from the first, an investigation of 1805 marks the turning point in the recognition that Macpherson had worked up authentic materials into falsified form.

In 1797, Latrobe made two illustrations to a passage of Ossian, or Macpherson, in which a chieftain, Armin, the last of his line, laments the death of his son and his daughter to another chieftain, Carmor. Of the two drawings, only Fig. 16, here called *Oft by the setting moon* à la a Latrobe inscription, concerns us. The passage that Latrobe wrote in his sketchbook to accompany the drawings appears in various forms in Macpherson's books, but "The Songs of Selma" in the 1762 London edition of

Fingal, an Ancient Epic Poem, gives nearly Latrobe's wording. In the 1762 *Fingal*, the lines pertinent to Fig. 16—Armin's account of watching the rock islet where his children died—read:

> When the storms of the mountain come; when the north lifts the waves on high; I sit by the sounding shore, and look on the fatal rock. Often by the setting moon I see the ghosts of my children. Half-viewless, they walk in mournful conference together. Will none of you speak in pity? They do not regard their father. I am sad, O Carmor, nor small my cause of woe!

Latrobe copied Armin from an *Iliad* plate (Fig. 15) that shows Iris, the messenger of Zeus, appearing to Priam, King of Troy, as Priam grieves for his slain son Hector. Latrobe made a logical choice for his model. He matched an illustration to Homer, the poet who had sung of an early phase of culture in the Mediterranean, with the supposed text

Fig. 16. *B. H. Latrobe. "Oft by the setting moon." Pencil, pen and ink, and watercolor. 20 July 1797. Sketchbook III. (PBHL)*

The Art of Latrobe's Drawings 35

of Homer's counterpart, the poet who had sung of an early phase of culture in the North. More specifically, in the Flaxman plate, as in the Macpherson text, an aged leader who grieves for his offspring beholds an apparition from another world. (Like Armin, Latrobe, a widower, had temporarily "lost" his son and daughter, the small children whom he left behind in England in 1795. It is wiser, however, not to guess at what the parallelism meant to him.)

Fig. 16 makes a bridge from Neoclassicism to the Sublime. The devotees of the Sublime sought in nature and the arts for experiences that would fill them with an elevating awe. Greek ruins, a Gothic cathedral, or a Neoclassical public building; a passage in the Bible, Homer, Ossian, Dante, Milton, or Shakespeare; wild cataracts, mountains, and forests, or a storm on the ocean—all these and much else might produce the desired response and be labeled *Sublime*.

Alas for neatness, the history of the taste for the Sublime exhibits anything but clarity. The devotee had his choice of published theoretical statements, such as the opinion of the British statesman-to-be Edmund Burke that the Sublime hinged on terror, and the opinion of a writer much influenced by Burke, the Reverend Hugh Blair, a Scots academic who championed Macpherson's Ossian, that the Sublime hinged on mighty force or power, with or without the accompaniment of terror. The vocabulary of the period also presents problems. For such reasons, it is hard to track the Sublime in Latrobe's writings. The first part of a discussion of Picturesque effects, the remarks of 1800 quoted under No. 61, appears to mean that the area of the falls of the Passaic contains almost all the ingredients on a small scale that on an awesome scale would constitute Sublime scenery. Just this distinction according to scale figures prominently in an 1806 attempt to categorize American kinds of Picturesque scenery, in comparison with European varieties (BHL, *Journals*, 3:65–67); according to Latrobe, American scenery largely lacked the magnitude "to rise into the *sublime*," although he excepted the Hudson, particularly the Palisades, and Niagara Falls. But elsewhere he used *sublime* to mean *of exalted quality*, a traditional sense irrelevant to our concerns, and he repeatedly employed the aesthetics of Sublimity without using the word *sublime* at all. Despite the confusion, though, one can say that multitudes in Latrobe's time sought to experience elevating awe as the supreme aesthetic response, that this emotion pertains importantly to the arts that Latrobe practiced, and that the dominant label that the period gave to the awe-inspiring was *sublime*.

Latrobe left no analysis of Fig. 16. But Dr. Blair's remarks from his *Critical Dissertation on the Poems of Ossian* (here quoted from a 1773 printing) permit us, after a fashion, to see the drawing through eyes of the period. Blair extolled the Sublimity of Ossian as one of the bard's two great characteristics. (The second trait was tenderness, in which class Blair stressed melancholy, the object of yet another cult of the age. Fig. 16 in fact weights melancholy more heavily than awe.) According to Blair, "Homer's sublimity is accompanied with more impetuosity and fire; Ossian's with more of a solemn and awful grandeur. . . . Ossian elevates, and fixes you in astonishment." One can easily relate these words to Fig. 16. Blair tells us that "amidst the rude scenes of nature, amidst rocks and torrents and whirlwinds . . . dwells the sublime. It is the thunder and the lightning of genius . . . and is heightened by all the images of Trouble, and Terror, and Darkness." Again the words fit, with minor qualifications. Latrobe and the Armin passage merely give us different kinds of wild water and wild sky from what Blair picked as specific examples. And Fig. 16 deals not in terror, or extreme fear, but in awe, a blend of emotions including fear. Some of the awesome, mysterious quality came about unintentionally: Armin's eeriness owes much to Latrobe's simple lack of skill in throwing moonlight onto Flaxman's unmodeled figure, and, insofar as the weirdness of effect overall depends on stylization, it depends on the limitations of an artist who strove for naturalism. But we have Blair to encourage us in viewing the natural and supernatural imagery in Fig. 16 as awesome. Of the latter, he tells us that the ghosts and spirits in Ossian "heighten the subject by an awful grandeur." And mysterious celestial effects, such as those of the setting moon in Fig. 16, are obviously part and parcel of what Blair found awesomely elevating in Ossian.[9]

As may have become apparent, the history of the cult of the Sublime intertwines with the histories of Neoclassicism and the cult of the Picturesque. At the same time, the Sublime could work against the Picturesque and the Neoclassical.

The tastes for the Sublime and the Picturesque shared a love of wild scenery. In Fig. 16 we see elements suited to Picturesque taste, such as the rocks. But we see mighty rocks of virtually unadorned, rugged strength, not mighty rocks contrasted with delightfully Picturesque embellishments of vegetation. We see something astonishing, not merely an agreeable Picturesque surprise. We see a scene that excites a sense of mystery, not just a pleasurable, Picturesque curiosity. We see Sublime

characteristics pushing related but humbler Picturesque characteristics out.

The Sublime and Neoclassicism meet in Fig. 16. A figure from a non-Sublime Neoclassical plate illustrates a Sublime text that has points of contact with the classical tradition without belonging inside it. Though certain of Flaxman's outline compositions attain the Sublime, and though contemporaries of his recognized the strain of the un-classical in his compositions, his outlines do not pursue the mood of Fig. 16. Wild landscapes, eerie celestial effects by night, half-visible specters—such elements typify Ossian's realm instead. In Fig. 16, the Ossianic Sublime all but submerges Flaxmanesque Neoclassicism. For the brilliant fusion of the Neoclassical with the Sublime—and the Picturesque—one must look elsewhere, to Latrobe's architecture.[10]

Oft by the setting moon makes for a helpful introduction to Latrobe and the Sublime, but we must also consider the Sublime in landscape drawing. We can look at four works, two of which are not Sublime and two of which are.

We saw that Latrobe found Niagara Falls and the Hudson River Palisades Sublime; we cannot ignore a drawing that he made of each place. Niagara Falls figured as one of the great examples of the Sublime. Latrobe's friend Dr. Giambattista Scandella wrote a sonnet about Niagara (quoted under No. 45) that deals with the literally terrific effect of the falls. But in 1798, when Latrobe, who would never see Niagara, drew No. 45 on the basis of a Scandella sketch, description, and advice, the Sublime eluded him. He did see the Palisades. But Fig. 5 deals Picturesquely in a curiosity, the effect of a ship on an invisible river, not in the Sublimity of the Palisades, which have become simply a backdrop. (Despite Latrobe's several visits to Manhattan, New York State scenery, Sublime or Picturesque, basically lay outside his territory.)

The storm at sea is a fundamental Sublime theme. (Fig. 16 has already provided one version of this subject.) On 21 December 1795, en route to America, Latrobe experienced a memorable storm and attempted to draw the scene as it would have appeared from a nearby ship. On 12 February 1796, he made a finished watercolor of the same subject (No. 2). His December account (BHL, *Journals*, 1:20) provides the commentary:

A more sublime scene it is almost impossible to imagine, than the united effect of the dark Ocean agitated into mountainous waves, the broad shadows of which were contrasted by their white foaming summits; the horizon covered with heavy clouds from which perpetually flashes of red lightning issued; and the Moon breaking through the gloom and beaming a silver light upon the whole scene from a sky of the clearest blue.

We read of vast, threatening natural forces in an astonishing combination, replete with darkness and uncanny lighting effects. But we see a flimsy picture, afflicted with naive stylization, naive composition, and smallness of scale. Thus, the little ship, seen approximately in profile, looks as insubstantial as a toy. Almost *tidily* positioned at the center of the picture, it encounters a melodramatic portrayal of the terrors of the deep. The drawing lacks the naturalism to make the phenomena real to us and the strength to make them awesome.

On 23–24 December 1818, on his way to New Orleans, Latrobe again found himself aboard ship in a fierce gale (No. 143). Although his subject this time lacks marvels in the heavens, it does reach the Sublime. The event gave Latrobe a deeply pleasurable astonishment despite seasickness and loss of sleep. His picture revolves around the meeting of a natural marvel, the fearsome might of the waves, and a human one, the wondrous facility with which the ship rode the wild waters. In his journal, Latrobe wrote, "the motion of the brig through the most awful sea I ever beheld or imagined . . . appeared the most wonderful effect of human art, and indeed of human Courage that can be imagined." In the drawing, this time we see a convincing image of dreadful forces: beneath a wet, believable sky, mighty, believable waves sweep and break. As part of this dynamism, the ship, which Latrobe likened to a living creature, rolls right to the edge of the picture. The effective naturalism owes much to heightened painterliness, that is, to an increased reliance on the capacities of the brush to produce effects. It also owes much to scale and dynamic composition. Thus, the actual image is more than one-fourth larger than that in No. 2. And the ship is no thin profile miniature rocking away but a stout, seaworthy, three-dimensional vessel that rides the huge waves. The composition may or may not have a connection with engravings of Claude seastorms. One must fault the birds right of center, for they become muddled with the water, and they confuse and diminish the scale. Despite this, the drawing remains potent, well calculated to induce an uplifting awe in the face of fearsome elemental power contrasted with man's successful defiance.

3 · LATROBE'S EVOLUTION AS AN ARTIST

The comparison of the last two drawings brings up a question independent of the Sublime: how did Latrobe's art evolve? The shortage of documentation on this issue for his pre-American years makes that phase of his development highly problematic. (The richest source of information is the "Essay," particularly volume 2, though one must always handle Latrobe's reminiscences cautiously.)

Even in the American years, when the documentation becomes abundant, it is difficult to sort out Latrobe's development, not least of all because the surviving drawings fall into an irregular chronological pattern of bunches and gaps. Latrobe indulged in the activity when he had the time. His unique degree of leisure in 1795–98, during his Atlantic voyage and his Virginia stay, produced a uniquely copious body of drawings, four out of fourteen sketchbooks, and the two-volume "Essay," which are further exceptional for the proportion of highly finished pictures. With his move to Philadelphia in 1798, there began the crowding of his time that lasted until his death in 1820. In these years, he tended to find the impetus for amateur drawing in travel—naturally enough, for travel and drawing had the most intimate connections.

Here let us rest content with saying that the comparison of the two seascapes does not lie: the best of Latrobe's latest finished drawings reveal an impressive increase in the breadth and deftness of his naturalism, a phenomenon marked by a heightened responsiveness to the capacities of the brush. The comparison of drawings from the 1795–96 Atlantic voyage with drawings from the 1818–19 trip to New Orleans and the remainder of Latrobe's life makes the point again and again. The skies and waters in the views of Dover (1795; No. 1) and Pico in the Azores (1796; Nos. 3–4) clearly do not belong in the same league as those in the *Appearance of the Sky, after Sunset . . . previously to the Gale of Decr. 23d–24th* (1818; No. 142) and *The hole in the Wall . . . Island of Abaco* (1818; No. 145). The latter, a delicate study of a natural wonder and twilight effects, with the embellishment of the picture-within-a-picture technique, is captivating, but even it takes second place in interest to the *Appearance of the Sky*, which, although by no means Latrobe's most facile drawing, displays a remarkable boldness and simplicity. The title suggests that Latrobe made the picture at least partly out of scientific interest, and obviously the *Sky* is not Picturesque, although, in this interesting variant treatment of the unity of light, the viewpoint that looks straight toward the sun comes from Claude. But reading the artist's contemporary meditations on an ocean sunrise (BHL, *Journals*, 3:150–51) suggests that, at the least, we are not far from the Sublime and the religious contemplation of nature (and thus not far from another kind of instructive role for art).

4 · LATROBE AND AMERICAN GRAPHICS

Latrobe's American work as a draftsman began at a fairly early point in the rise of drawing activity in this country and at an early point in the rise of the practice of representing the American scene. The years 1796–1820 witnessed considerable and varied activity by both professionals and amateurs, some of whom drew only a little and some of whom drew much. The professionals who drew American scenery and life run the gamut from the famous on downward—for example, Charles Willson Peale, John Trumbull, John Lewis Krimmel, William Dunlap, Titian Ramsay Peale, William Russell Birch (Fig. 14) and his son Thomas, Archibald and Alexander Robertson, John Rubens Smith, Joshua Shaw, William Guy Wall, George Isham Parkyns, and John Joseph Holland. In Latrobe's general orbit, the amateurs include Dr. William Thornton, the nominal author of the U.S. Capitol design that Latrobe inherited, and a man whose entertaining included drawing parties of some sort; the Russian diplomat Pavel Petrovich Svin′in, with whom Latrobe shared some of his own landscape drawings; Latrobe's friend the Baltimore architect and drawing teacher Maximilian Godefroy; Latrobe's pupil Robert Mills, architect and engineer; a Mills patron, the Baltimore connoisseur Robert Gilmor, Jr.; and Latrobe's pupil William Strickland, an amateur who turned professional artist in the lean years before his career as an architect and engineer got off the ground. One could easily extend the lists of names much further. Even so, the proportion of people who drew native subjects to those who did not—a man so responsive to scenery as Jefferson did not draw landscapes—seems to have been small. Had Latrobe lived another ten or, even better, twenty years, he would have felt pleased to see the activity in those decades. (Actually, the careers of some of the artists just listed belong more to those years.) In particular, Latrobe would have seen the national landscape enter upon a triumphal course as subject matter for painting and drawing.

One of Latrobe's own sons (an amateur who, incidentally, had not

learned landscape drawing from his father) played a part in popularizing landscape art. John H. B. Latrobe (1803–91) put together *Lucas' Progressive Drawing Book, . . . Consisting Chiefly of Original Views of American Scenery* [1827–28], an important book of instruction in Picturesque landscape drawing. The young man helped himself liberally to the contents of his father's drawings as the bases for illustrations, such as Figs. 17 (see No. 84) and 18 (see No. 121). In this way, his father had an indirect hand in popularizing Picturesque landscape drawing.

The persistence of imagery has emerged as an important theme in the present essay, and further instances appear in the catalogue. Imagery as diverse as that in Nos. 84 and 121, Fig. 7 (or, rather, its derivatives), and Nos. 20, 33, and 52 passed out into the world via publication; that this variety of his subjects was deemed worthy of publishing is a tribute to Latrobe's universality. The present introduction has offered only a glimpse into his intricate mind. To see more of that memorable mind and the world that it contemplated, the reader can turn to the body of *Latrobe's View*, where Latrobe's drawings offer their abundance of instruction and delight.

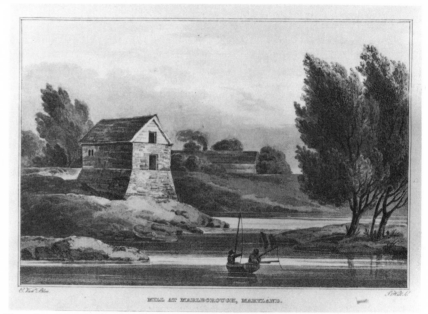

Fig. 17. *John H. B. Latrobe, draftsman, and Joseph Cone, engraver. "Bridge on the Brandywine Near Downings Town." From Latrobe,* Lucas' Progressive Drawing Book *(Baltimore, 1827–28), pt. 1, pl. 10. (Maryland Historical Society)*

Fig. 18. *John H. B. Latrobe, draftsman, and John Hill, engraver. "Mill at Marlborough, Maryland." From Latrobe,* Lucas' Progressive Drawing Book *(Baltimore, 1827--28), pt. 2, pl. 7. (Maryland Historical Society)*

NOTES

The author is indebted to Dr. Frank H. Sommer III, Head of Library, Winterthur Museum, Winterthur, Delaware, for his careful reading of and helpful comments on this essay.

1 To expand that look, the body of the present book adds selections from Latrobe's professional and semiprofessional drawings, such as details from drawings that he undertook as a surveyor, when these selections record something not designed by Latrobe.

2 Some valuable information on Latrobe's techniques occurs in his "Essay on Landscape"; see BHL, *Journals*, 2:455–531, with a headnote that covers some territory not reinvestigated here.

3 The three subject headings will immediately raise, in many readers' minds, the question of what relation Latrobe has to Romanticism, actually an applied form of the question "What is Romanticism?" This essay does not tackle this notorious question. Instead it concentrates on three issues that must be digested in their own right before anyone can proceed to the ambitious consideration of Latrobe and Romanticism.

4 One suspects that Gilpin influenced Latrobe's thinking on scenery during the latter's London years, although Latrobe did not become a thoroughgoing Gilpinian, and although his earliest explicit reference to Gilpin occurs as late as 14 May 1804, in a letter to the Philadelphia merchant Joshua Gilpin, a disciple of the Picturesque, and a friend from whom the architect borrowed one or more volumes by the British cleric.

5 One finds this thinking about license in the foreground expressed in the period. William Gilpin argued along these lines in the second edition of his *Three Essays* (1794).

6 Stephen F. Lintner, in work for the present book, has concluded that Latrobe sometimes exaggerated the heights of distant elements because, drawn at true scale, the features would have become invisible or insufficiently intelligible. Thus, in *Redbank*, to show Fort Mifflin in detail and to distinguish Red Bank from the New Jersey shore in the far distance, he exaggerated the elevations of these two elements. (One wonders, though, whether this issue of exaggeration stands wholly by itself—wholly distinct, say, from a Picturesque love of contrast.)

7 *The Architectural Drawings of Benjamin Henry Latrobe* (forthcoming) will discuss both the Picturesque constituent in Latrobe's architecture and Fig. 7 in detail.

8 For more detail on these schemes, see *The Architectural Drawings of Benjamin Henry Latrobe*.

9 Elsewhere, in his lectures on rhetoric and literature, Blair—indebted to Burke, as in the foregoing material—assigned Sublimity to solitude and to distance in time, qualities seen in Fig. 16, as well as to vastness, a quality associable with Latrobe's stormy sky and waters, and loudness, a quality more closely connected with the Ossian passage than with Latrobe's illustration of it.

10 *The Architectural Drawings* also deals with this central issue.

Editorial Considerations

JOHN C. VAN HORNE

From the inception of this project the editors have intended to publish a folio volume of selected Latrobe watercolors and sketches. Indeed, one of the most important considerations in the decision to undertake this edition was the great value of the pictorial record of early America that Latrobe left. The illustrations in this volume have been gleaned primarily from Latrobe's fourteen extant sketchbooks, now in the collections of the Maryland Historical Society, which contain more than 350 pencil, pen and ink, and watercolor drawings. This volume reproduces over a third of these drawings, as well as several of Latrobe's works from other sources, such as individual sketches or watercolors in private collections or museums (about a dozen of which have survived) and published plates after original Latrobe drawings.

Initially the volume was to have been a chronological presentation of the drawings with simple catalogue-type entries giving the titles and dates, and it was to have been one of the earliest of our publications. But over the more than ten years that our project has existed, the concept of this volume has evolved and grown more complex, resulting in the present book. As we worked through all the Latrobe Papers we discovered the close correlation between the sketchbooks and the journals and other of Latrobe's writings, making it possible for us to annotate the drawings to a great extent with Latrobe's own words. And we discovered that the sketchbooks did not fall into a neat chronological pattern. Latrobe filled the pages of some of them in strict chronological order, but others he picked up and put down intermittently, selecting blank pages to fill seemingly at random. This fact made it difficult to date

many undated sketches and ultimately precluded our presenting the drawings in strict chronological sequence. Rather, we have gathered the sketches into sections based roughly on geography, enabling us to follow Latrobe in his travels through various parts of the country.

Perhaps the most important change in the nature of this book was our decision to attempt to identify topographical views as accurately as possible in order to provide information that those interested in historical geography could use to replicate Latrobe's views. At first we presumed that this could be done by using Latrobe's titles and descriptions of his drawings in conjunction with the quadrangle maps published by the U.S. Geological Survey. But as we began to research each drawing, we were struck not only by the number of times that Latrobe's renderings turned out to be the earliest (and in many instances the sole) known view of a particular subject, but also by the fact that a great many of the sites depicted are no longer extant. (Indeed, what is exceptional about this collection of drawings is the mere handful of views and structures that have remained much as Latrobe drew them.) This fact of course made identification of topographical scenes very difficult and necessitated numerous site inspections.

Stephen F. Lintner, a physical geographer now with the Department of State who had initially undertaken to provide us with map references for each topographical view, enthusiastically took on the added responsibility of visiting many of the sites in order to obtain accurate data. Lintner conducted site work in Virginia, Washington, D.C., Maryland, Pennsylvania, New Jersey, and West Virginia. On some

of these excursions he was assisted by M. Edward Shull, Jr., parks planner for Howard County, Maryland. Lintner's primary purpose was to replicate Latrobe's view of a particular scene in order to ascertain two crucial pieces of information: the exact spot Latrobe stood when making the view, and the direction in which he was looking. Seemingly a simple matter, it was only when Lintner had difficulty in identifying many of the locations that we realized the magnitude of the changes that have been wrought in the landscape by man and nature. The construction of dams has submerged many areas in Latrobe's river views, and the filling of river channels has modified the shorelines in other cases. The construction of highways has altered the well-worn paths of Latrobe's drawings. In one case the site of a town had changed. And most of the buildings, mills, forges, and bridges depicted by Latrobe no longer exist or are markedly changed. Thus many of these views cannot be precisely reconstructed today. They depict, in part, an America that once was but is no longer. With a few exceptions, such as monumental buildings like Mount Vernon (No. 22), the Nelson House in Yorktown, Virginia (No. 58), St. John's Church in Washington, D.C. (No. 141), and the public buildings of New Orleans (No. 154), Latrobe's America has proven to be both malleable and ephemeral.

In this volume are drawings and sketches that Latrobe executed from the time of his departure from England in November 1795 to just a few months before his death from yellow fever in New Orleans in 1820. His America was to a degree circumscribed by the professional projects he undertook and the routes he used to reach them, and the contents of this book must necessarily reflect this fact. Thus there are no drawings of the New England states, for Latrobe never traveled further north than New York. Nor did he venture further south along the Atlantic seaboard than the Dismal Swamp in southeastern Virginia. And since Latrobe filled his sketchbooks almost exclusively while he traveled, there are few drawings from his periods of residency in Philadelphia, Washington, or Pittsburgh. Most of the drawings are of scenes in Virginia, Maryland, Pennsylvania, Delaware, New Jersey, New York, and the states and territories along the Ohio and Mississippi rivers, to the Gulf of Mexico.

Besides these geographical limitations, the reader will not find here a conventional biography in pictures of Latrobe or a pictorial documentation of his works. Rather the volume constitutes a generally geographically arranged record of his graphic reportage of those things that engaged his interest as he traveled throughout America. It is our hope that the general public, as well as art historians, social and economic historians, historians of science and technology, historical geographers, and industrial archaeologists, will gain from this volume new insights into the early years of the Republic.

We employed several criteria in selecting from the large body of Latrobe's works those drawings to be published in this book. An initial survey of all the drawings immediately eliminated from consideration many pencil sketches that are too faint to be reproduced. As we continued to work through the collection, certain drawings commanded our attention and seemed impossible to leave out. These are primarily drawings that are visually striking or particularly beautiful, as well as those that are particularly well annotated by Latrobe in his sketchbooks. Also selected were drawings of prime significance to the history of architecture and technology—views of buildings, mills, forges, and bridges that are no longer extant. And we aimed to include important drawings that, in the event Latrobe left no annotation, we could thoroughly document through our own research.

This selection process yielded over 160 drawings comprising seven studies of historical subjects, such as views of the ruins of Norfolk (No. 10) and of the New Orleans battleground (Nos. 150 and 151); twenty views of towns as diverse as Bladensburg, Maryland (No. 104), Steubenville, Ohio (No. 129), and New Orleans (No. 149); twenty-two views of such architectural subjects as Virginia mansions (Nos. 19, 22, 26, 30, 36, and 39), a ferry house on the Susquehanna (No. 77), a college (No. 128), taverns (Nos. 116, 122, 133, and 134), and a church (No. 141); seventeen drawings featuring such technological subjects as mills (Nos. 18, 125, and 126), bridges (Nos. 43, 83, 84, 91, 93, and 132), a quarry (No. 107), and a factory (No. 130); seventeen genre scenes or views of folk life, such as courtroom dress (No. 38) and billiard players (No. 41) in Virginia, an evangelical preacher outside Washington, D.C. (No. 109), and a collier and his family on a Maryland mountain (No. 140); twelve drawings of natural history subjects, from fish (Nos. 33, 34, and 153) to insects (Nos. 20, 33, 50, and 110) to plants (Nos. 35, 46, 47, and 161); six satirical views of American life, from incidents that occurred on Latrobe's honeymoon trip (No. 66) to a droning preacher (No. 44); nine technical views, such as river and town surveys (Nos. 61, 69, 70, and 99); and finally the largest group, fifty-one landscapes and seascapes. In fact, a great many of the drawings classified here as historical scenes, town views, architectural

and technological views, and social commentary fall under the rubric *landscape*, for Latrobe rarely drew a subject in isolation from its natural surroundings.[1]

The fourteen extant sketchbooks, the source of most of the illustrations in this volume, vary widely in size, most covers measuring from 7-3/16 × 10-7/16 in. (18.3 × 26.6 cm.) to 9-3/16 × 11-5/8 in. (23.4 × 29.6 cm.), with 8-1/4 × 12-3/4 in. (21.0 × 32.4 cm.) being the most common size. (Sketchbooks V and XII are much larger than the other twelve, measuring about 8-1/2 × 19-1/4 in. [21.6 × 48.9 cm.].) Page size is slightly smaller. The sketchbooks also vary a great deal in length, the shortest being seven pages and the longest seventy, with an average of about forty pages. This disparity in length is no doubt attributable to the sketchbooks having been selectively pruned, by Latrobe or later owners, over the years.

Among Latrobe's correspondence is an undated letter to a Mr. Pumfrey ordering what is apparently a sketchbook. Latrobe requested Pumfrey "to bind me up *lengthways* 5 sheets of . . . paper into an octavo book as soon as convenient. The book will then contain 80 pages. Leather back and corners."[2] All the surviving sketchbooks have paper boards covered with marbled paper and are bound in three-quarter leather.

Each illustration in this volume is accompanied by a catalogue-type data section, providing title, date, medium, size, inscription (when applicable), and repository. The titles of the drawings are in Latrobe's words whenever possible. They are taken from several sources: from the drawings themselves; from the verso of the preceding sketchbook page, where Latrobe frequently wrote titles and/or descriptions of the scenes; or from Latrobe's indexes to his sketchbooks. All titles derived from such sources are given within quotation marks. If Latrobe left no such title, the editors have provided one, without quotation marks.

The dating of the drawings is sometimes problematical. Generally the date given is that which Latrobe inscribed on the drawing. On occasion, however, we have concluded that the date Latrobe inscribed is erroneous, based on conflicting evidence from his journals or letters. In such instances what we believe to be the correct date is given within brackets, and the discrepancy is explained in the commentary accompanying the drawing. For those drawings that are undated, we have supplied dates, within brackets, based on our knowledge of when Latrobe was at a particular site. It should be noted that Latrobe frequently executed drawings over time. He may have made a pencil or pen and ink sketch of the subject from life and added a watercolor wash later the same day, or perhaps days or even weeks later. And some sketches with notes for coloring were never finished.

The media generally used by Latrobe are pencil, pen and ink, wash, and watercolor, or some combination of these. By *wash* we mean monochrome coloration done in brown or gray, watered ink, or watered watercolor. We apply the term *watercolor* to all water-soluble media applied with a brush, including body color or gouache, and various inks. A drawing with monochrome washes plus watercolor is considered a watercolor; a high percentage of Latrobe's colored renderings do have monochrome underlayers. Inks applied with a pen are designated *pen and ink;* this term is used both by itself to describe a drawing with no color and in conjunction with the terms *wash* and *watercolor* where appropriate.

The measurements given are those of each sheet as reproduced, not those of the drawing proper. In instances where a drawing occupies only a portion of a sheet and the entire sheet is not reproduced, the dimensions of both the detail and the entire sheet are given.

Following the measurements is the text of any inscription (other than title) to be found on the drawing. The inscription might include signature, date, city where executed, and perhaps a notation such as "*del.,*" the Latin abbreviation for *delineavit,* "he drew."

The last item of information is the repository. Since most of the drawings are from Latrobe's sketchbooks, in the possession of the Maryland Historical Society, we have not repeated that information in each instance; only the sketchbook number is given. For illustrations from sources other than the sketchbooks, complete information is provided.

For topographical views, an additional data section provides information on the site. The map reference identifies the U.S. Geological Survey quadrangle map or maps on which the scene occurs. Unless otherwise stated, all maps referred to are from the 7.5 Minute Series (Topographic).

Next the Universal Transverse Mercator (UTM) coordinates are

given. The UTM Grid System provides a simple and accurate method for recording the geographical location of any site. In the UTM system, the earth is divided into sixty "zones," running north and south, each six degrees wide. Each zone is numbered beginning at the 180-degree meridian near the international date line. On a map, each zone is flattened, and a square grid is superimposed upon it. The grid is marked off in meters, and any point in the zone may be identified by citing its zone number, its distance in kilometers and meters from a reference line (easting), and its distance in kilometers and meters from the equator (northing). These three figures—the zone number, easting, and northing—make up a complete "UTM grid reference" for any point and distinguish it from any other point on earth. The UTM coordinates are accurate to within 100 meters (approximately 300 feet).

The orientation indicates in what direction Latrobe was looking when he took the view, measuring clockwise from 0° at true north.

As we have tried to use Latrobe's own words as titles for the drawings, so also have we attempted to use his words as commentary to accompany the drawings. As noted above, Latrobe frequently wrote his own commentary to a sketch on the verso of the preceding sketchbook page. The length varied from a phrase or two to detailed analyses of the drawings, depending on the complexity of the subject and the amount of time Latrobe wanted to (or was able to) devote to it. In some cases, especially in natural history subjects, his drawings have numbered figures within them, and his commentary is keyed to each figure. For other views, Latrobe inscribed letters at the top or bottom margins and commented on what was to be seen in the drawing directly above or below those letters.

In addition to reproducing the sketchbook texts, we have culled all extant Latrobe documents—journals, letters, pamphlets and reports, and scientific papers—for passages that shed light on the drawings. For those times when he was keeping a journal and a sketchbook simultaneously, journal descriptions of scenes or events are a wonderful complement to the drawings. Since Latrobe made many of the sketches while traveling, he less frequently was composing letters concurrent with keeping his sketchbooks. Thus passages from letters are rarer in this volume than those from the journals. On more than one occasion a sketch became the basis of a plate accompanying a scientific paper, and we have been able to extract passages from the published papers to accompany the drawings.[3]

A second type of commentary used in this volume is extracts from such contemporary sources as travelers' accounts, gazeteers, and emigrants' guides. Latrobe often visited places and drew subjects that attracted the notice of others, and especially in those cases where the site has changed greatly or where Latrobe has left no description, these contemporary accounts are most valuable.

Third, almost every drawing is accompanied by some editorial commentary, usually in conjunction with one or both of the two other types mentioned. Our goal has been to thoroughly annotate each drawing in the same way we would a written record; that is, we have tried to place each drawing in its proper context by detailing the history of structures and towns, the lives of the people involved, and the geography of topographic views. We have also noted changes that have occurred to the scenes over the almost two hundred years since Latrobe executed his drawings, such as whether structures or towns are no longer extant or have been drastically altered, and whether changes in building patterns and land use have eradicated a site as Latrobe viewed it. It is our hope that the combination of these three types of commentary will make the drawings more comprehensible and more valuable as historical documents.

NOTES

1 The American landscape has recently become an important subject of scholarly inquiry. See, e.g., John R. Stilgoe, *Common Landscape of America, 1580–1845* (New Haven, 1982).
2 Ellis-Allan Papers, Library of Congress, Washington, D.C.
3 A word about our presentation of Latrobe's writings is in order here. In transcribing from manuscripts, we have in this volume followed the editorial procedures that we developed and utilized in publishing Latrobe's *Journals* and *Correspondence*. In brief, we have attempted to follow a middle course in presenting a printed text that stands between a type facsimile of the manuscript itself and a completely modernized version. Thus while our general practice has been to adhere as closely as possible to the original manuscript in matters of orthography, capitalization, and punctuation, we have made certain textual alterations in the interest of clarity and comprehensibility. For a detailed explanation of these editorial changes, the interested reader should consult the front matter of our previously published volumes.

I. Atlantic Voyage, 1795–1796

1. "Dover, as seen from the Eliza . . ."

28 November 1795
Pencil, pen and ink, watercolor
17.7 cm. × 26.2 cm. (6-15/16 in. × 10-5/16 in.)
B. H. Latrobe del.
SKETCHBOOK I

Map reference: Not applicable
Geographical coordinates: 51° 07′ 00″ N, 01° 21′ 00″ E
Orientation: Approximately 315°

The Coast between the north and south Foreland has a character of beauty peculiar to England. A deep Bay skirted by lowland which rises into a mild amphitheatre of cultivation and is bounded at each end by bold and abrupt chalk cliffs. The hills were this morning covered with snow. Deal has not even the merit of most dirty towns, to afford a good prospect from a distance. It lies upon the edge of the Sea like a black heap of rubbish. Sanddown Castle is a bold object. . . . The coast of England, which cannot have varied much since the days of Caesar in its appearance, has sufficient beauty to have tempted a less ambitious conqueror, than he was. It is not probable that the bleak Chalk Downs were ever covered with wood. They are now, I should suppose, no more, nor less the smooth undulation of hills variegated only by the mixture of clear turf and purple heath, and the occasional breaks of light and shade, which they presented to his eye. If, as some antiquarians suppose, he landed in Pevensey bay, the beautiful woody country breaking into the cold extent of Chalk Cliffs between Folkestone and Romney and again between Fairlight and Bexhill to Beacheyhead must have formed a landscape of the most romantic contrast. We sailed along the charming coast with a fair brisk wind till the evening haze hid the yellow cliffs of Hastings from us. Every spot of the coast was so well known to me, that I had a superior pleasure in seeing and recognized the different towns and eminences. (BHL, *Journals*, 1:6)

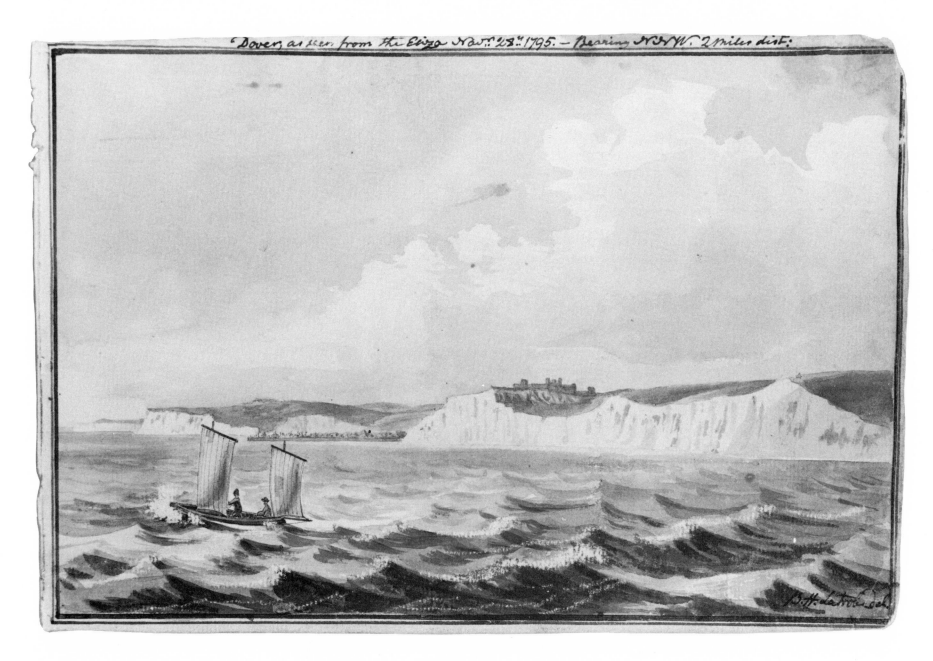

"Dover, as seen from the Eliza Nov.r 28.h 1795. — Bearing N.N.W. 2 miles dist.

B.H. Latrobe del.

NO. 1

47

2. "Situation of the Eliza Decr. 21st 1795"

12 February 1796
Pencil, pen and ink, watercolor
17.7 cm. × 26.2 cm. (6-15/16 in. × 10-5/16 in.)
B H Latrobe del.
SKETCHBOOK I

While on the *Eliza* on 12 February 1796, Latrobe executed this water-color, which he copied from a rough sketch that he had made at the time of the gale. Just after the storm he described the scene in his journal:

> In the afternoon with a very clear sky, the gale blew with astonishing violence. About 6 a very heavy cloud collected towards the West, from which issued frequent flashes of lightning but without thunder. By degrees the whole horizon was encircled with low heavy clouds, the lightning was frequent, and notwithstanding, the moon shone most brilliantly. Its effect was strong and awful. The wind blew with the greatest force about 9 o'clock and the jar was tremendous. Our situation, as scudding before the Wind under our foresail, I have attempted to represent in the Drawing. A more sublime scene it is almost impossible to imagine, than the united effect of the dark Ocean agitated into mountainous waves, the broad shadows of which were contrasted by their white foaming summits; the horizon covered with heavy clouds from which perpetually flashes of red lightning issued; and the Moon breaking through the gloom and beaming a silver light upon the whole scene from a sky of the clearest blue. There was no thunder. At ten the ship was laid to under her forecourses. We were well prepared for the storm and received no injury. (BHL, *Journals*, 1:20)

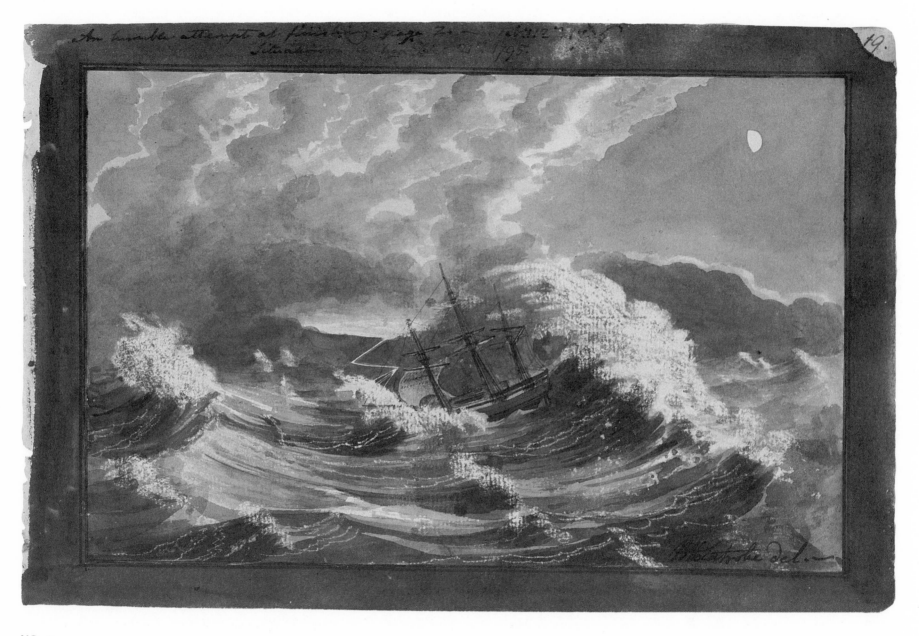

NO. 2

3. ". . . View of the Azores . . ." and "View of the Summit of Pico di Azores . . ."

6 January 1796
Pencil, watercolor
17.7 cm. × 26.2 cm. (6-15/16 in. × 10-5/16 in.)
B H Latrobe del.
SKETCHBOOK I

Map reference: Not applicable
Geographical coordinates (top): Viewing position: approximately 38° 10′ 00″ N,
 28° 09′ 00″ W; Pico: 38° 27′ 00″ N, 28° 17′ 00″ W
Orientation: Approximately 335°

Soon after six we were all called upon deck by the cry of land to the NNW of us. Surprise and vexation took possession of all our seafolks from the Captain to the cabin boy. For my own part, I confess that the beauty of the morning, and the grandeur of the scene exhibiting three or four Islands covered with clouds that were gilded by the rising Sun, gave me much more pleasure, than I felt disappointment from the certainty of our being most considerably behind our hopes and our reckoning. By degrees the Sun dispelling the clouds, showed the majesty of Pico di Azores, half covered with snow, the brilliant whiteness of which, was equal to polished silver. It was a view that cannot be described. With the encreased elevation of the Sun it became a more distinct, and splendid object. The wind was light, and we seemed during the whole day scarcely to change our distance or our position respecting it. Fayal and Tercera appeared one on each side of Pico, more distant but clear. . . . The mountains on the East end of the Island appear of very considerable height; I could not discover any snow upon them. The snowy region of the Pic seemed level with their tops excepting where two or three arms of snow extended lower down. Those seemed to fill some valleys or ravines as seen through a small acromatic glass belonging to my sextant. The snow upon the tops of the Mountain was broken through in every few places by the appearance of black rock. The Depressed parts of its surface were very visible by the shadows upon the snow, and they appeared to consist of ravines radiating towards the point. The Crater seemed to be elevated upon two bases or offsets near the top of the mountain, perhaps the vestiges of very old eruptions. The Crater itself is a beautiful conic mountain, appearing at the extreme eastern end of the Pic, and sparkling in the Sun like a Diamond, especially when backed by a cloud. Below the Crater is a black spot, some of the Portugese sailors who have been at Fayal said that a pond of water is on that place. Perhaps some remaining volcanic heat may keep snow melted in a reservoir which happens to have no vent. The surface of the snow below it seemed not to be interrupted by any stream which might issue from this supposed piece of water. I do not recollect ever to have heard or read of an irruption of this volcano. Not the smallest appearance of vapor was about its head. The day was so perfectly clear that it could not escape observation had their been any such thing. Might not this mountain be the Atlas of the Ancients as well as Teneriffe, as Gibbon suggests? Was it not equally accessible to them? Though the other is nearer Africa, it is more distant from Greece.

About noon a girdle of heavy clouds collected just above the commencement of the snowy region. By degrees they fell below it, and detached the snowy top from the blue tint of the Island below. Before sunset the whole mountain was enveloped in clouds, the wind changed to the SW and blew hard with a short unpleasant sea. (BHL, *Journals*, 1:27–29) *(continued)*

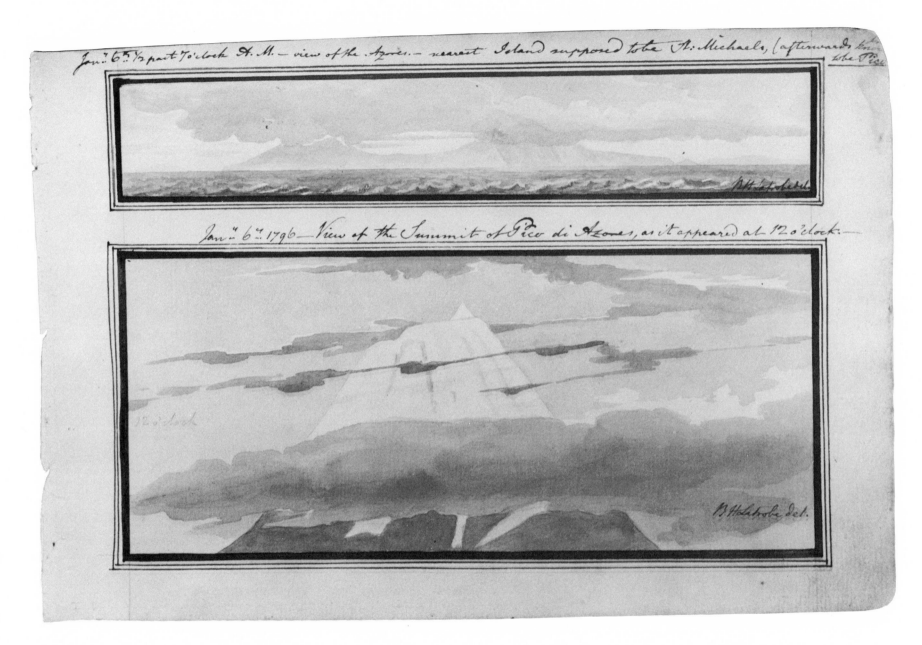

Jan.ʸ 6th ½ past 7 o'clock A. M. — view of the Azores. — nearest Island supposed to be St. Michaels, (afterwards known to be Pico.)

Jan.ʸ 6th 1796 — View of the Summit of Pico di Azores, as it appeared at 12 o'clock. —

NO. 3

The upper portion of No. 3 depicts several islands in the Azores viewed from the southeast at 7:30 A.M. The large island in the center is Pico, although before the clouds lifted to reveal its summit, the passengers on the *Eliza* thought it was São Miguel, the largest island in the archipelago. The island on the left (west) is probably Faial, and that on the right (east) is probably the eastern end of São Jorge.

The upper portion of No. 4 shows the same scene half an hour later. The summit of Pico was then visible, and Latrobe attempted to identify the other islands. Faial is correctly identified on the left, but the island on the right is probably São Jorge rather than Terceira, which is further to the east.

The lower portions of both drawings show the summit of Pico at different times. The summit is a volcanic cone with an elevation of 7,673 feet.

4. "Pico, one of the Azores . . ."

6 January 1796
Pencil, pen and ink, watercolor
17.7 cm. × 26.2 cm. (6-15/16 in. × 10-5/16 in.)
SKETCHBOOK I

Map reference: Not applicable
Geographical coordinates (top): Viewing position: approximately 38° 10′ 00″ N,
 28° 24′ 00″ W; Pico: 38° 27′ 00″ N, 28° 17′ 00″ W
Orientation: Approximately 335°

(See commentary for No. 3)

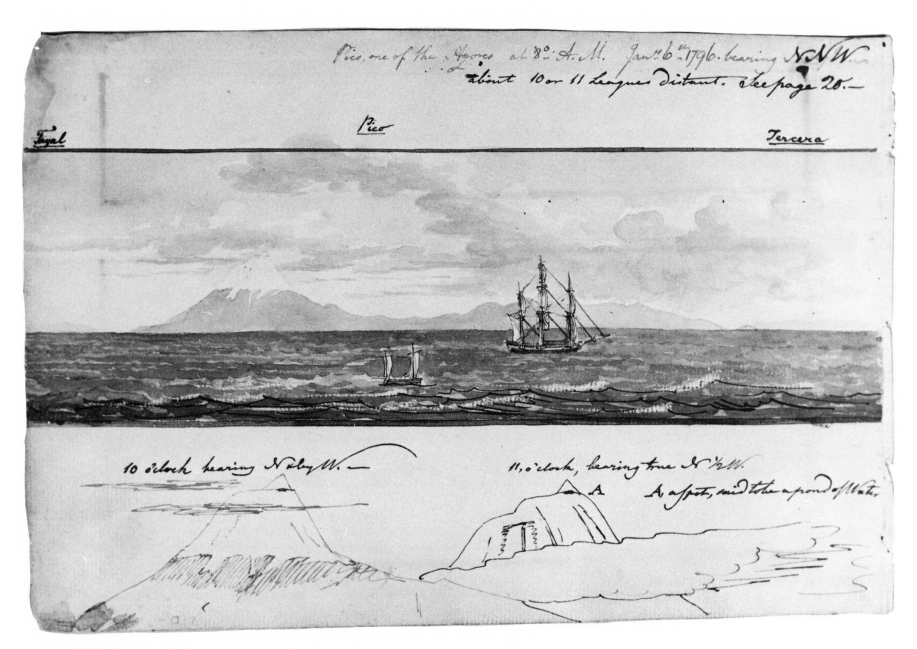

Pico, one of the Azores at 8º A.M. Janᵈ 6ᵗʰ 1796. bearing NNW about 10 or 11 Leagues distant. See page 20.—

Fayal Pico Tercera

10 o'clock bearing N ¼ by W.—

11, o'clock, bearing true N ½ W.

A A, a spot, said to be a pond of Water.

5 · "Dolphins"

Undated [c. 17–18 January 1796]
Pencil, pen and ink, watercolor
17.7 cm. × 26.2 cm. (6-15/16 in. × 10-5/16 in.)
SKETCHBOOK I

Remarks on *Dolphins.* (French, *Dorade*)

The first Dolphin we saw was on the 12th of Jany. in Lat. 31°30′. . . . He seemed to be solitary, though some of us *thought* they saw another. He would not bite, perhaps the extreme roughness of the sea prevented him, as the bait was suspended from the Spritsail yard, and the ship pitched much. He kept close to the Ship all the evening, but was not to be seen in the morning. Though they are certainly a gregarious fish, they are sometimes seen alone. . . . The chief food of the Dolphins is I believe the flying fish, that fish being most frequently found in their maw when opened, but they must have other inducement to hover about a vessel in flocks as they do, than to prey upon fish, or indeed than the hope of food at all. They do not bite eagerly in general, and as to the Barnacles or other Shell fish which may adhere to the Bottom of the Ship, their Mouth seems not in the least adapted to the business of breaking, or drawing them from their strong holds; so that I doubt whether they attempt it. Besides as inhabitants of *deep* water, nature would scarcely give them an appetite for a Species of food, not generally to be procured by them. How far *curiosity* may be attributable to Dolphins, Metaphysicians may determine, but if they possess it, it is in a most insuperable degree. One of the Dolphins who took a strong hook on the 16th of Jany. broke the line, and though his jaws were extremely lacerated, he continued with the flock dragging a fathom or two of line after him the whole day. He contrived to disengage himself however from the line, but still was one of the five that remained with the Ship, till they all left us on the 18th meeting perhaps with some food to divert their attention, for with us they would have starved. . . .

Colour. Nothing can exceed the beauty and gaiety of the colours of the dolphins. When at a very great depth, so that their form cannot be distinctly seen, the curled surface of the waters above them, sparkles with the beauty of a labrador stone, and indeed their is nothing, to which the effect can be more properly compared, unless (if the comparison be not too humble) to the beautifull colors that are often seen swimming on the surface of stagnate water. When they rise nearer to the surface, they appear of a light blue, as lively and transparent, as that of the neck of a peacock. Their side fins appear of a pale gold and green color, and their tails of the most brilliant gold. When drawn up out of the water, their whole bodies play with blue purple pale green and gold colors, which by degrees approach to a warm brown, but almost vanish as the fish dies, which is in about a quarter of an hour. They are however not wholly lost even when he is dead. The Gold predominates on the belly part, and the purple and blue on the back and back fin. Besides these general colors, the whole body and head is covered with small spots, each of which is equal in beauty and color to the eye of a peacock's feather, changing in the same manner with every inclination of light.

The color of the water however evidently adds to the beauty of the dolphin while he remains in it, notwithstanding that imagination cannot exceed his appearance, even without its assistance. The Dolphin may properly be called the *Peacock* of the Ocean. (BHL, SKETCHBOOK I)

Truly the "*Peacock* of the Ocean," these fish (*Coryphaena hippurus*) should not be confused with cetacean dolphins. These dolphins, or dorados as they are called in Spanish-speaking countries, inhabit deep tropical and warm temperate waters, where they swim among floating patches of kelp, logs, or flotsam. They feed upon surface-living fish like juvenile jacks (see No. 153). As Latrobe noted, small schools of dorados are frequently attracted to slowly drifting ships. "Dolphin" is a prized food fish, and the unusual endurance Latrobe observed makes them a fine game fish. Dorados follow flying fish, and Latrobe, like many other fishermen, believed that flying fish were the main food of the dorado, although this claim has not been substantiated by modern science. It is now believed that squid are the main diet of dorados.

The male grows much larger than the female and can achieve a length of five feet. Latrobe's drawing shows the distinctive high vertical forehead of the male, which increases in size with age.

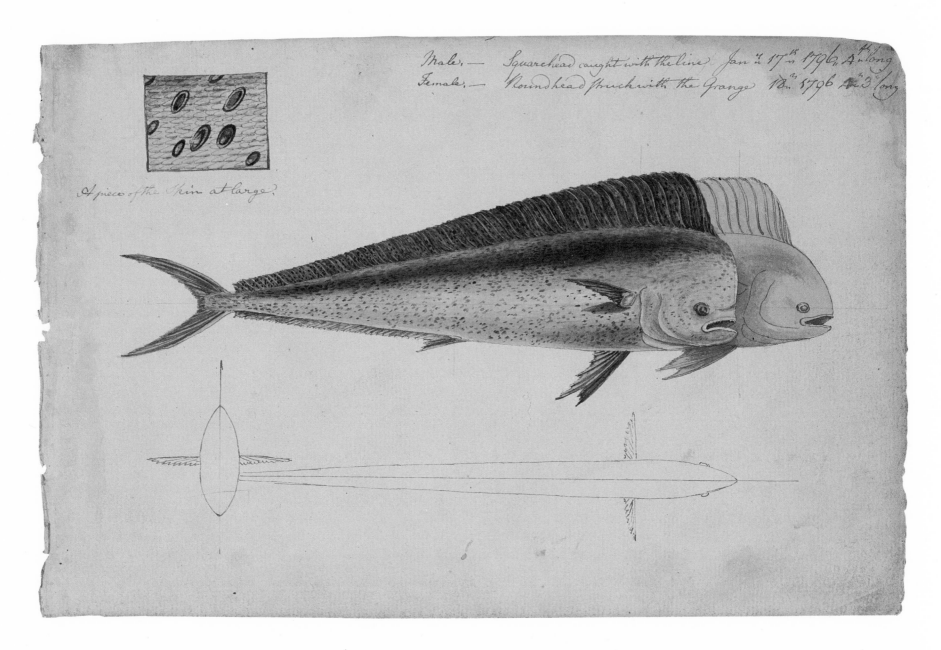

Male. — Squarehead caught with the line, Jan.ʸ 17ᵗʰ 1796, 4" long
Female. — Roundhead struck with the Grange 18ᵗʰ 1796 ft. 3 long

A piece of the Skin at large.

6. "Breakfast Equipage . . . of the Eliza . . ."

4 March 1796
Pencil, pen and ink, watercolor
17.7 cm. × 26.2 cm. (6-15/16 in. × 10-5/16 in.)
B. H. Latrobe delr.
SKETCHBOOK I

This drawing converts Latrobe's miserable voyage on the *Eliza* into an exercise in wit. In trompe l'oeil fashion, it shows an accumulation of cards and papers. The principal object within the drawing is a sheet of paper bearing the drawing of "Breakfast Equipage." Latrobe's inscription on the preceding sketchbook page identifies the contents of this drawing-within-a-drawing. The drawing and inscription re-create some of the elegancies of the captain's table.

> *Breakfast Equipage set out for the Passengers of the Eliza, the Captain and Mate in all 9 Persons, March 4th, 1796, being the compleat set.*

1. The table is furnished with Bars and Cross bars, to prevent the Things from rolling down.

2. In the first partition on the left hand are knives and forks for those who love saltbeef for Breakfast: A Plate intended to serve Mr. Shaw for a Saucer, the Vinegar bottle used at Supper the evening before, and a biscuit which has been toasted to kill the Maggots.

3. In the next to the right, is a Cup, for Mrs. Taylor *with a Saucer,* and a Pewter spoon, which the loss of part of its Handle has converted into a Teaspoon. A basket of Biscuit, *all alive-o!* The Slop bason, formerly part of a Gallon keg, and the Salt jar, which once contained candied Ginger. NB. The Slop bason also feeds the Goat, and serves to wash Mrs. Taylor's baby.

4. The right hand partition holds, the tea and sugar Cannister, a saucer with butter, a cup and saucer, a teaspoon as above, a biscuit, and two knives. The Mustard pot serves the Captain in the double capacity of a Coffee cup and tea cup. In the hole of the cross bar is the pepper box.

5. The small partition on the left hand, belongs to Mr. Shaw the Mate who drinks his Coffee out of a Horn Beker (if it does not happen to be employed as a slop bowl). The two others are provided for Passengers, who breakfast as the utensils become vacant.

6. In more prosperous times the cross bars were cut to receive Wineglasses and Tumblers, but these things are now with the dead, with the Wine and Porter that made them usefull.

7. At night the whole table is illumined by a tall brass Candlestick which formerly lighted a Pew in St. John's Church, Wapping. (BHL, SKETCHBOOK I)

Most of the other sheets of paper and cards also pertain to the voyage. Playing cards refer to an activity used to while away the hours on shipboard. To the right of the cards, a small portrait of a sailor peeps through. Across this likeness lies a card that sarcastically expresses Latrobe's exasperation with the seemingly endless voyage. Dated "March 3d Norfolk, Virginia," it is an imaginary invitation from an actual hotel proprietor named Lindsay, who "hopes Captain Noble [and] his Passengers will do him the [honor] to use his Hotel upon their arrival"—expected ten months later—"at Christmas next."

Across the edge of Mr. Lindsay's card lies another, its meaning unclear. Underneath, Latrobe drew an advertisement that parodied the medicinal advertisements of the period, and, at the same time, provided a wishful cure for certain of his own ills. It reads: "BY [HIS M]AJESTYS [APPOINTM]ENT A specific remedy for Headaches, [V]omitings, Corns, Warts, and long sea-Voyages, also cures Pulmonary di[se]ases, Bankruptcies, and [s]udden Death. Sold in [b]oxes at 2s 6d and 5sh: [ea]ch, with good Allowance [for] Masters of Vessels. NB: [A] red Lamp over the door. and a private door for the Ladies who wish to consult the Doct[or in] Secresy . . ."

What may represent an open volume of Latrobe's journal shows under the bottom fold of the drawing of the equipage. Latrobe allowed space for little more than random words. That little more, in a final, sly touch of wit, reads "random writing."

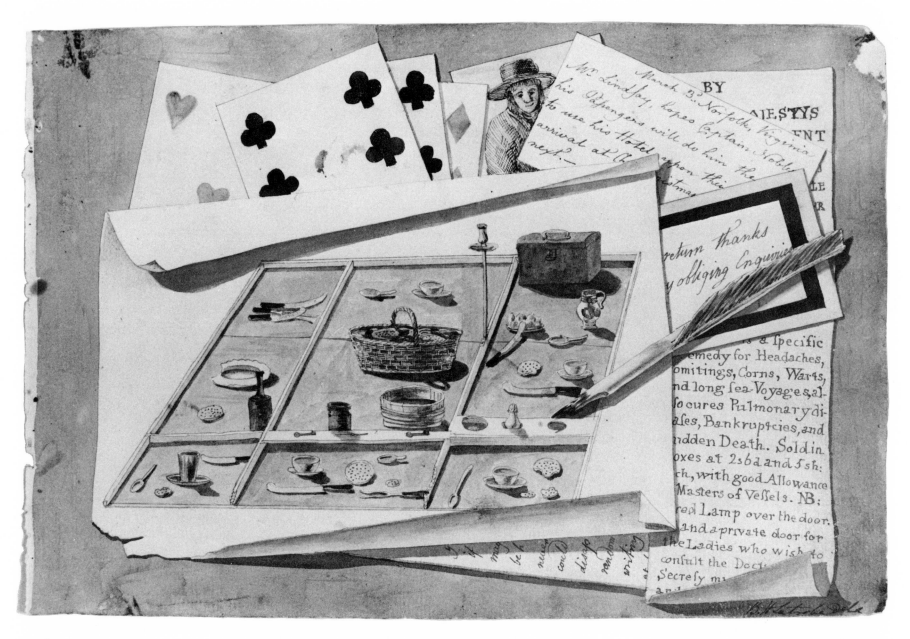

NO. 6

7. "First View of the Coast of Virginia"

3 March 1796
Pencil, pen and ink, watercolor
17.7 cm. × 26.2 cm. (6-15/16 in. × 10-5/16 in.)
B H Latrobe del.

SKETCHBOOK I

Map references: Cape Henry Quadrangle, Virginia; Virginia Beach Quadrangle, Virginia
UTM coordinates: Viewing position: approximately 18.041671.048621; Lighthouse:
 18.041009.408688
Orientation: Approximately 250°

The morning was extremely cold and hazy. Indeed for this week past, it has been most miserably cold and damp with frequent sleet. As soon as the mist rose, we saw the tops of trees ahead, and soon after a long range of very low land ending in a low point at Cape Henry. In the Southward was the peninsula of Currituck somewhat more elevated, upon a range of sand hills. Our joy was damped by the impossibility of weathering the Cape with the wind we had, and at noon we found ourselves by observation in Latitude 36°38′, 20 miles to the south of it. The coast was entirely woody. The wind died away and it became perfectly calm. (BHL, *Journals*, 1:66)

With the *Eliza* off Cape Henry and present-day Virginia Beach, Latrobe looked to the west-southwest toward the Currituck Peninsula and the site of Virginia Beach. The lighthouse at Cape Henry is visible at the right of the view.

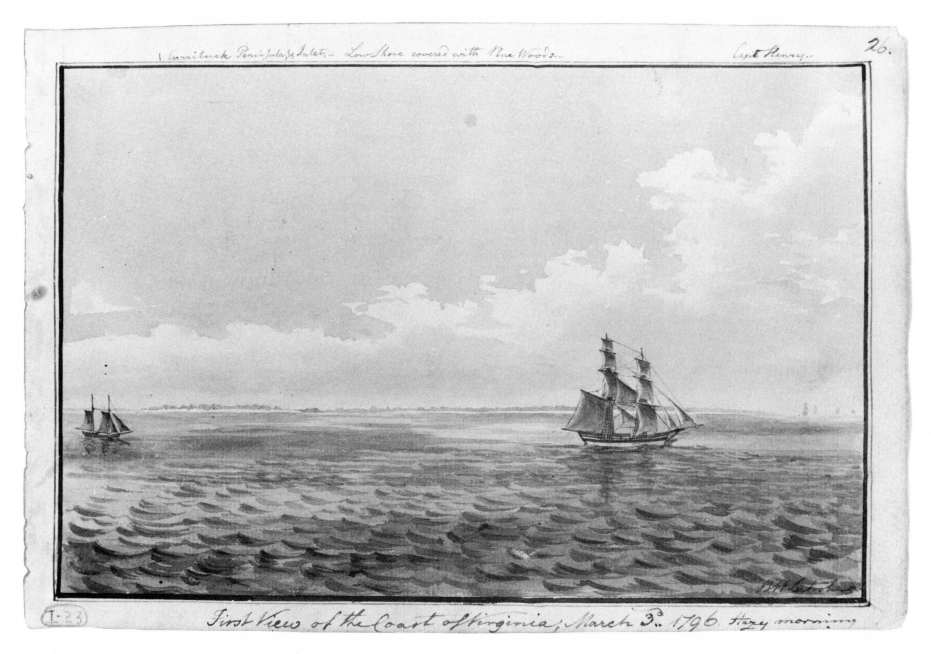

Currituck Peninsula, & Inlet, — Low Shore covered with Pine Woods. — Capt Henry. —

T.23 First View of the Coast of Virginia, March 3ᵈ 1796. Hazy morning

NO. 7

8. "Virginia Pilot Boats"

7 March 1796
Pencil, pen and ink, watercolor
17.7 cm. × 26.2 cm. (6-15/16 in. × 10-5/16 in.)
B H Latrobe delr. March 7th 1796
SKETCHBOOK I

About 4 a Pilot boat came alongside of us, but she had no Norfolk pilots on Board, and the Patowmack and Baltimore pilots, have no right in the navigation of James River. The boat was a beautiful thing. Its form is not easily described but by a drawing; and I had no time to make a perfect one. It was scooner rigged, its masts very strong and beautifully tapering, and its deck without waist, the gunnel being raised only about four inches. The masts were perfectly free from stays and shrouds, secured only in the step and wedged on the deck. A single halliard raised the gaff (throat and peak) at once. The foresail sheet was without a boom, the sheet blocks being fixed to the clue and leading on to the deck. The mainsail had a long boom. The gaffs were very short in proportion. The Master of her said that he would take any bet to sail her at the rate of 12 knots close hauled upon the wind. They are excellent sea boats and peculiar to Virginia, very few of them being used even in other parts of America. The deck is so perfectly free from any thing to support the seaman when the vessel is in motion; that it appears a dangerous surface to tread, and yet no man was ever known to be lost from it. Security in more cases begets incaution and consequently danger. The sun set with uncommon beauty, the wind fell, it was perfectly calm and we prepared to cast anchor about 4 leagues from the light house upon Cape Henry which could plainly be descerned with the naked eye. About 7, another pilot boat of the same construction came along side, but she had no Norfolk pilot. It is astonishing with how little wind these boats steer along. At a time when our vessel had not sufficient motion to obey her helm, both these boats approached and left us at pleasure, steering within 3-1/2 points of the wind. (BHL, *Journals*, 1:69–70)

Latrobe's drawing illustrates a vessel similar to the Virginia pilot schooner *Swift*, which had been built at Norfolk before 1794 and crossed the Atlantic to become a model for a class of Royal Navy dispatch boats. Length on deck: 49 feet; beam: 15 feet, 7 inches; draft: 6 feet, 3 inches.

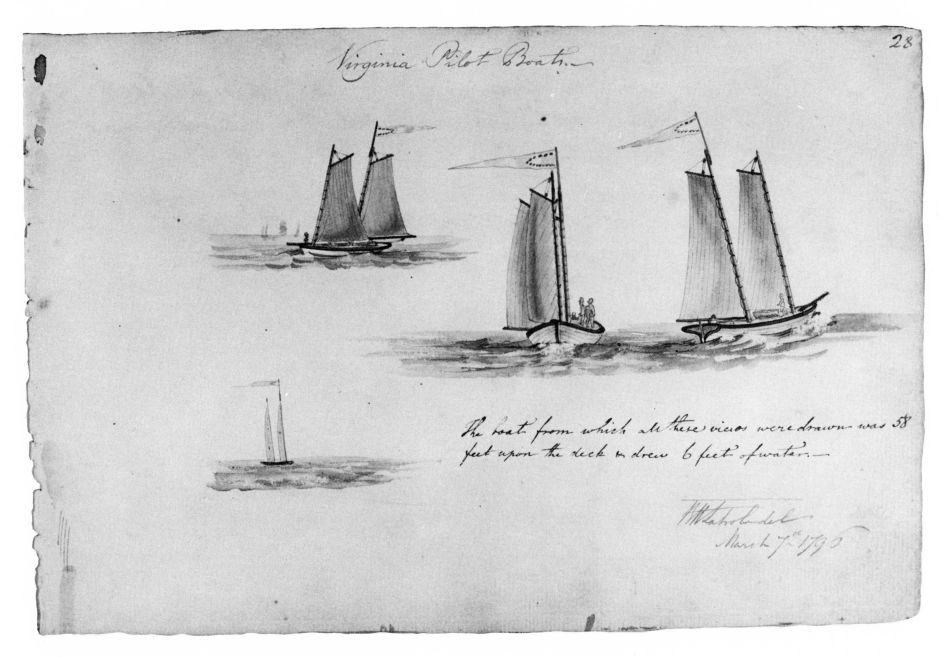

Virginia Pilot Boat.

The boat from which all these views were drawn was 58 feet upon the deck & drew 6 feet of water.—

BHLatrobe del
March 7th 1796

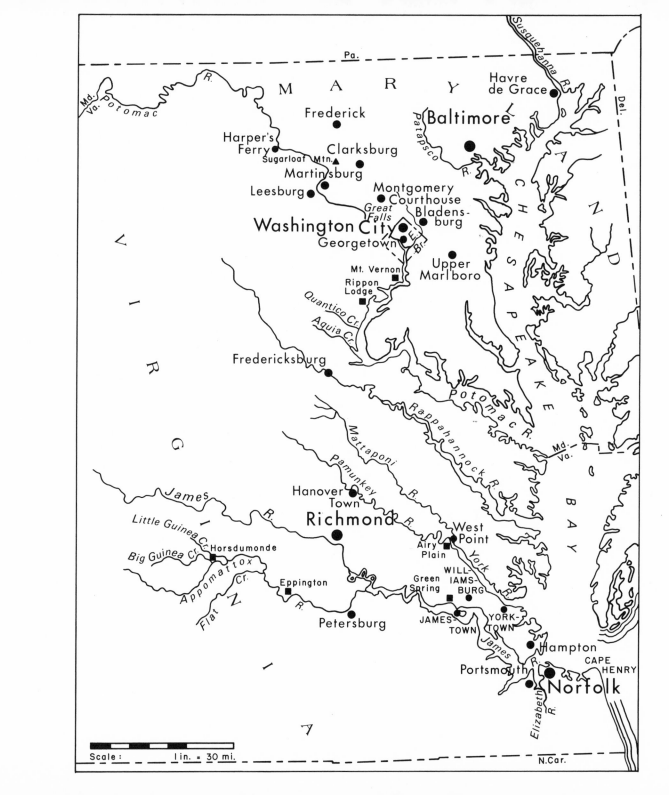

Pa.

M A R Y L A N D

Potomac R.

Md.
Va.

Susquehanna R.

Del.

Havre
de Grace

Frederick

Baltimore

Patapsco R.

Harper's
Ferry

Clarksburg

Sugarloaf Mtn.

Martinsburg

Montgomery
Courthouse

Leesburg

Bladens-
burg

Great
Falls

Washington City

E.
Br.

Georgetown

Upper
Marlboro

C H E S A P E A K E

Mt. Vernon

Rippon
Lodge

Quantico Cr.

Aquia Cr.

V I R G I N I A

Fredericksburg

Potomac R.

Rappahannock R.

Md.
Va.

Mattaponi R.

Pamunkey R.

Hanover
Town

James R.

Richmond

West
Point

B A Y

Little Guinea Cr.

Horsdumonde

Airy
Plain

York R.

Big Guinea Cr.

Appomattox R.

Eppington

Flat Cr.

Green
Spring

WILL-
IAMS-
BURG

Petersburg

JAMES-
TOWN

YORK-
TOWN

James R.

Hampton

CAPE
HENRY

Portsmouth

Norfolk

Elizabeth R.

N.Car.

Scale : 1 in. = 30 mi.

II. Virginia Years, 1796–1798

9. "View on the Elizabeth river, Norfolk Virginia"

21 March 1796
Pencil, pen and ink, watercolor
17.7 cm. × 26.2 cm. (6-15/16 in. × 10-5/16 in.)
B H Latrobe del.

SKETCHBOOK I

Map reference: Norfolk South Quadrangle, Virginia
UTM coordinates: Approximately 18.038423.407908
Orientation: Approximately 225°

Latrobe initially titled this drawing "View taken opposite to Crany Island in the Elisabeth river" and identified the island as "the Woody patch behind the Schooner rigged boat to the left." But he then wrote that he "was misinformed. The *woody patch* is merely a peninsula between two Creeks. Crany Island is lower down the river." Of this drawing he also wrote: "The river has not an appearance of sufficient width in the drawing. The trees on the right hand are those behind which the brig appears in the next Landscape [No. 10]." (BHL, SKETCHBOOK I)

Latrobe was most likely standing near the foot of York Street looking southwest across the Elizabeth River toward Portsmouth. The creek whose mouth is visible in the center of the view is probably Scotts Creek. The Western Branch of the Elizabeth River flows into the Elizabeth River behind the ship that is not under sail.

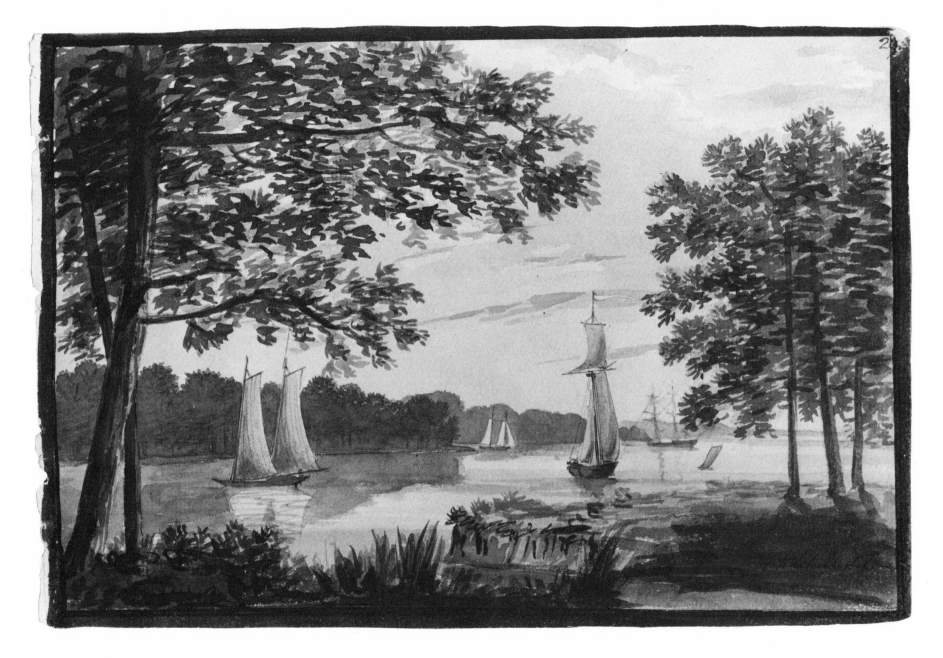

NO. 9

10. "View of part of the ruins of Norfolk"

Undated [late March 1796]
Pencil, pen and ink, watercolor
17.7 cm. × 26.2 cm. (6-15/16 in. × 10-5/16 in.)
SKETCHBOOK I

Map reference: Norfolk South Quadrangle, Virginia
UTM coordinates: Viewing position: 18.038498.407910; Fort Norfolk:
 18.038356.407952
Orientation: 260°

John Murray, fourth earl of Dunmore, the last royal governor of Virginia, attacked Norfolk on 1 January 1776 from several British warships in the Elizabeth River. As a result of the British shelling and the subsequent burning of the town by American forces, the city was almost totally destroyed.

Latrobe noted: "This View was taken near Mr. Whittels house, between Catharine Street and the river. All that side which is at present much deserted is covered with ruined Walls and Chimneys, and the town seems to have formerly been much larger on that side of the Creek than on the other, if the number of ruins prove any thing." (BHL, SKETCHBOOK I)

Latrobe was probably standing near the home of Conway Whittle (d. 1817), a native of Ireland who lived on Back Creek at the foot of Granby Street, and looking west. The creek has since been filled in, and the location would today be near the intersection of Granby and City Hall Avenue. As Latrobe looked west, he saw Portsmouth on the left across the Elizabeth River, and Fort Norfolk on the right on the near shore of the Elizabeth River. The copse of trees in the right middle ground was near the point from which Latrobe made the next drawing.

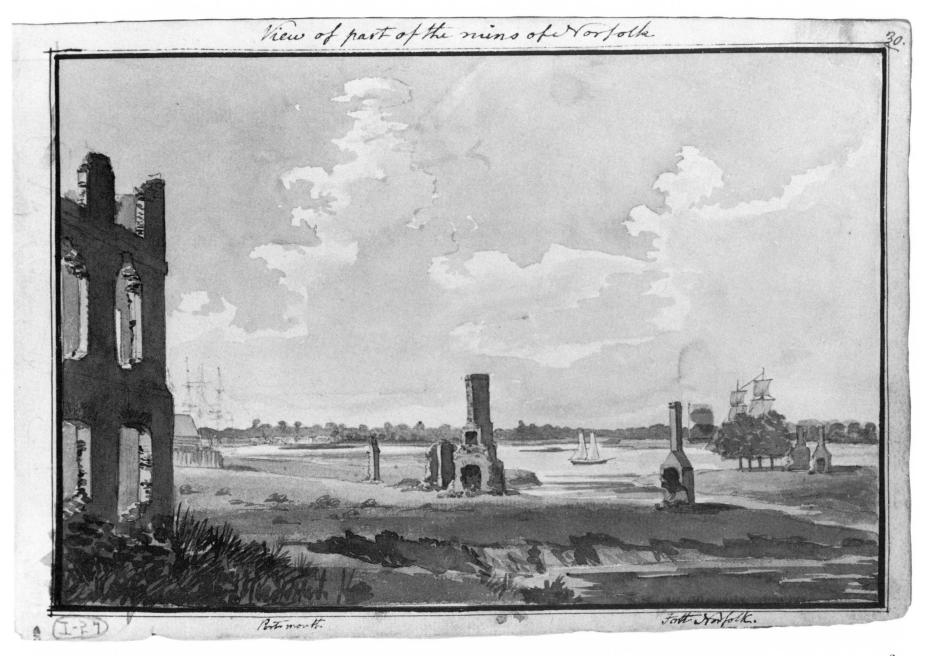

View of part of the ruins of Norfolk

Portsmouth. Fort Norfolk.

I·P·7

NO. 10

67

11. "View of Norfolk from [Smith's] point"

Undated [late March 1796]
Pencil, pen and ink, watercolor
17.7 cm. × 26.2 cm. (6-15/16 in. × 10-5/16 in.)
SKETCHBOOK I

Map reference: Norfolk South Quadrangle, Virginia
UTM coordinates: Viewing position: 18.038423.407908; Town Point: 18.038548.407834
Orientation: 160°

In making this drawing, Latrobe probably stood on Smith's Point, at the foot of Botetourt Street, and looked south across Back Creek (now City Hall Avenue) toward Town Point and the warehouses of Water Street (now Waterfront Drive) and ships in the Elizabeth River. This view, drawn twenty years after the fire of 1 January 1776 destroyed most of the city, reveals the progress Norfolk residents had made in rebuilding their port city. It is the earliest known illustration of Norfolk.

> This View is taken from the point near the 4 Trees behind which the Brig appears in the foregoing Sketch [No. 10].
>
> The turret between AA is upon the Court house.
>
> The turret between BB is upon the old Courthouse in the Marketplace now converted into Stores.
>
> The house on the point CC is the Custom house, a mean timber building. The Main street runs up between that and the next house to the right.
>
> The brigs DD lie close to the Wharfs in Elizabeth river, along which the other vessels extend. The single Brig to the right lies in main Channel of the river, the deepest water being on the Portsmouth side.
>
> Behind this brig is *The Point,* upon which an hospital is built. It is unfinished and tumbling rapidly to decay.
>
> Between *the point* and FF, is the opening of *Deep creek* which extends to the Dismal swamp Navigation. Upon FF is a small town called Gosport. *Gosport* is divided from Portsmouth by a creek navigable by the tide. Portsmouth lies on the right hand. Under B is a creek navigable for boats at high water into the heart of the town. The ruins of a Wharf destroyed by fire appear at the point. (BHL, SKETCHBOOK I)

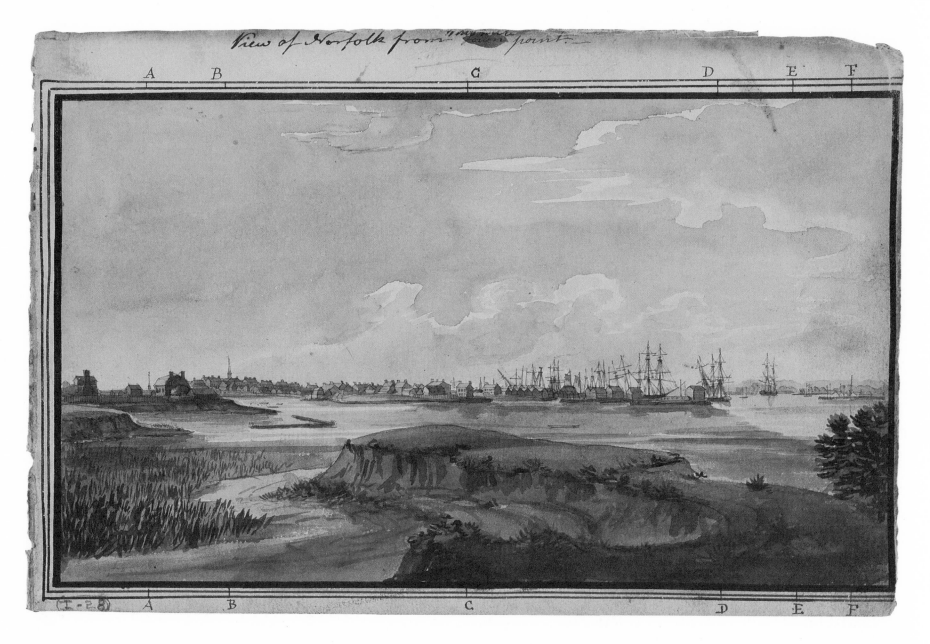

View of Norfolk from Town point.

A B C D E F

(I. 28) A B C D E F

NO. 11

12. "Sketch of the lower end of the Falls of James River, Virginia"

[8] April 1796
Pencil, pen and ink, watercolor
17.7 cm. × 26.2 cm. (6-15/16 in. × 10-5/16 in.)
SKETCHBOOK I

Map reference: Richmond Quadrangle, Virginia
UTM coordinates: Viewing position: 18.028474.415672; Ross's Mill: 18.028460.415686;
 Tip of Belle Isle: 18.028358.415662
Orientation: 270°

The Falls of James River at this place [Richmond] add much to the beauty of its situation. They extend from about 6 miles above, to the middle of the length of the town. . . . The descent is over an extremely irregular stratum of Granite. In some places the stream is uninterrupted for half a mile together, and in others the rocks are very thickly scattered across the whole river. At the upper and lower ends the water meets with the most frequent interruption. (BHL, *Journals,* 1:90–91)

This View of the lower end of the Falls is taken from a Rock opposite to the Mills at Richmond. It exhibits only the Northern half of the River, there being a large Island at this place upon which the trees on the left hand grow. The distant hill is another Island higher up.

The bridge from the shore to the rock is made of a single pine tree squared kept down at its thickest end by a large trunk of another pine fixed to it thus

a a, are iron straps or hoops: As the pine does not reach quite over, a board is laid upon its end to the rock. This bridge is merely for the use of the fishermen who take the Fish (*Chad principally* at this season) among the rocks in their attempt to mount the river. They catch them with very large spoon nets (skim nets) groping about for them at a hazard. Every *fourth* Chad is paid as a toll to the erector of the bridge. The bridge is about 150 feet long. (BHL, SKETCHBOOK I)

At the fishery at Rosses Mill, a bridge of a single tree is constructed to carry the fishermen to the Rocks. The highest toll ever taken in the beginning of May, by the tollman of whom I enquired, was 250 fish. On the day I made the enquiry Aprl. 8th he had taken 70. In the first instance the fish caught was, of course, 1,000, in the latter 280, *average,* 640. (BHL, *Journals,* 1:95)

The Ross's mill depicted by Latrobe was probably the mill at the foot of Twelfth Street that was part of what were later known as the Columbia Mills. Owned by David Ross (c. 1739–1817), a leading Richmond merchant, this was one of the earliest gristmills in Richmond. Latrobe would have been on a rock just off the northern bank of the James, opposite Thirteenth or Fourteenth streets, looking due west upstream. The wooded hill in the left distance is Belle Isle.

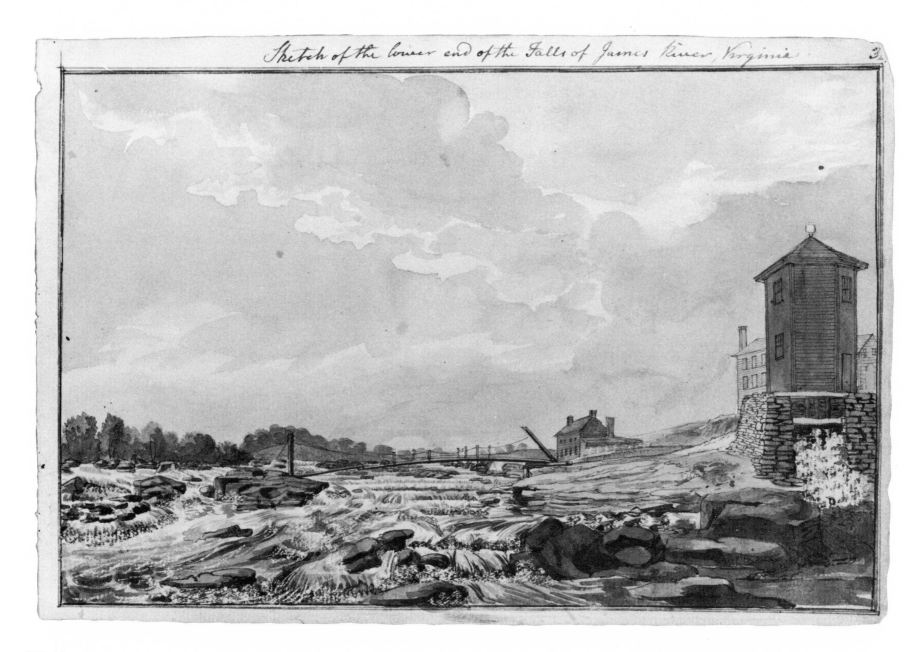

NO. 12

13. "View of Richmond from Washington's Island"

Undated [April 1796]
Pencil, pen and ink, watercolor
17.7 cm. × 26.2 cm. (6-15/16 in. × 10-5/16 in.)
SKETCHBOOK I

Map reference: Richmond Quadrangle, Virginia
UTM coordinates: Viewing position (tip of modern Belle Isle): 18.028358.415662;
 Capitol: 18.028484.415740; Washington (Belle) Island: 18.028312.415633
Orientation: 63°

Latrobe entered Richmond for the first time in April 1796. Immediately, he was struck by the similarity of the general outline of the city with its namesake in England.

The general landscapes from the two Richmond-hills are so similar in their great features, that at first sight the likeness is most striking. The detail of course must be extremely different. But the windings of James river have so much the same *cast* with those of the Thames, the amphitheatre of hills covered partly with wood partly with buildings, and the opposite shore with the town of Manchester in front, and fields and woods in the rear, are so like the range of hills on the south bank of the Thames, and the situation of Twickenham on the north backed by the neighbouring woody parks, that if a man could be imperceptibly and in an instant conveyed from the one side of the Atlantic to the other he might hesitate for some minutes before he could discover the difference.

The want of finish and neatness in the American landscape would first strike his eye, while his ear would be arrested by the roar of the falls of James river below him. He would miss the elegance of Richmond bridge, and find in its place the impatient torrent tumbling over huge masses of granite. To his right he would see the small neat willow Island in the Thames towering into a woody Hill, which seperates the curled stream of James river. Instead of the velvet lawns of Mr. Cambridge's park and the precise arrangement of Twickenham, the wild trees growing among the irregular Islands and the rambling edifices of Manchester would bewilder his attention. The neat walks and iron railings surrounding him there, would here be changed into rough roads and wooden inelegant fences. The perfection of cultivation in the first instance, in the second, the grandeur of Nature, would fill his mind. Other circumstances of important Geographical difference, would pass much longer unnoticed. . . . When however the whole country was in wood, I am convinced that it was the *general* similarity of the characters of the two situations that impressed upon this spot the name of Richmond. (BHL, *Journals*, 1:90)

Latrobe recorded this view from the island belonging to his soon-to-be friend, Richmond lawyer Bushrod Washington (1762–1829). Situated in the James River to the southwest of the city, Washington's island was then called Broad Rock Island, due to the presence of "an immense flat rock on the Northern shore extending near 100 feet each way without a fissure." The island is today known as Belle Isle. On 24 January 1798, Latrobe wrote to his friend Dr. Giambattista Scandella that he "purchased of Mr. Washington an island in the midst of the Falls of James river," probably Broad Rock Island. "It is a beautiful, fertile and romantic spot. It contains about 80 acres of good land, and its scenery would not disgrace the magic rivers of Italy. I mean to live there." (BHL, *Journals*, 1:91, 2:340–41) Latrobe was not able to carry out his intention, for he had moved to Philadelphia by the end of the year.

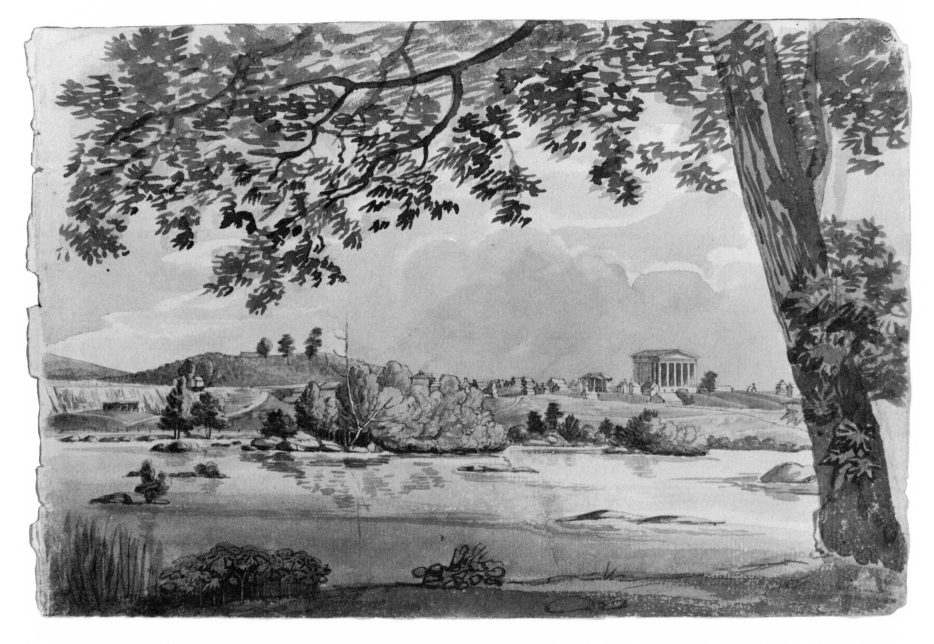

NO. 13

14. "View down James river from Mr. Nicolson's house above Ricketts"

16 May 1796
Pencil, pen and ink, watercolor
17.7 cm. × 26.2 cm. (6-15/16 in. × 10-5/16 in.)
B H Latrobe May 16th 1796
SKETCHBOOK I

Map references: Drewerys Bluff Quadrangle, Virginia; Richmond Quadrangle, Virginia
UTM coordinates: Viewing position: approximately 18.028620.415562; Rocketts
 Landing: 18.028625.415532; Powhatan: 18.028647.415478
Orientation: Approximately 175°

View to the Eastern [that is, south] from the Portico of Mr. Nicholson's house. May 16th, 1796.

The houses in the foreground are part of the Village of Rocketts. So far the river is navigable for Vessels not drawing more than [*blank in ms*] feet of Water. The tide rises from 4 f. 6 i. to 6 feet at Rocketts, according to the Wind an easterly Wind making the largest tide. About a mile above Rocketts is the lower end of the Falls represented [No. 12]. There are several ledges of Rock below the surface of the Water between the Falls and Rocketts. The last ledge is in the situation of a small two masted Vessel in the middle of the River. There is however a good Channel close to the left hand Shore. The house close to the Water's edge is Mr. Nicolson's lumber Warehouse. Behind it to the left is his Rope Walk. The low Grounds on each side of the River are extremely fertile. The hills consist of clay mixed with pebbly Gravel upon a Basis of Granite Rock.

The distant house over the Sloop under Sail is called Powatan. It is said to be built upon the site of a hunting seat of King Powatan of the Powatan Nation. See Jefferson p. 100 and Stith's History.

The Sloop is going into the Mouth of a Creek which serves as a Dock. (BHL, SKETCHBOOK I)

Rocketts, or Rocketts Landing, was located just upriver from where Gillies Creek enters the James River, at the southeast end of Richmond. Named for Robert Rocketts, who had a ferry in that area as early as 1730, Rocketts served as the port of Richmond. Nicholson's Rope Walk was located just downriver from Gillies Creek and was in existence as early as the time of the Revolution. Latrobe's view of Rocketts was taken from the home of George Nicholson, once mayor of the city, who, according to Samuel Mordecai, "resided on one of the . . . most commanding heights overlooking the city," on Church Hill. (Mordecai, *Richmond in By-Gone Days*, p. 103)

Downriver from Rocketts, and also on the north bank of the James River, was Powhatan, the estate of the Mayo family. Purchased by Joseph Mayo in 1727, Powhatan was originally the site of an Indian town which was, according to Stith, "the chief Seat and Metropolis" of the Indian nation of the same name. Powhatan remained in the Mayo family for several generations, but it is no longer extant. (William Stith, *The History of the First Discovery and Settlement of Virginia: Being an Essay towards a General History of the Colony* [Williamsburg, 1747], p. 53. Thomas Jefferson also identified this site in *Notes on the State of Virginia*.)

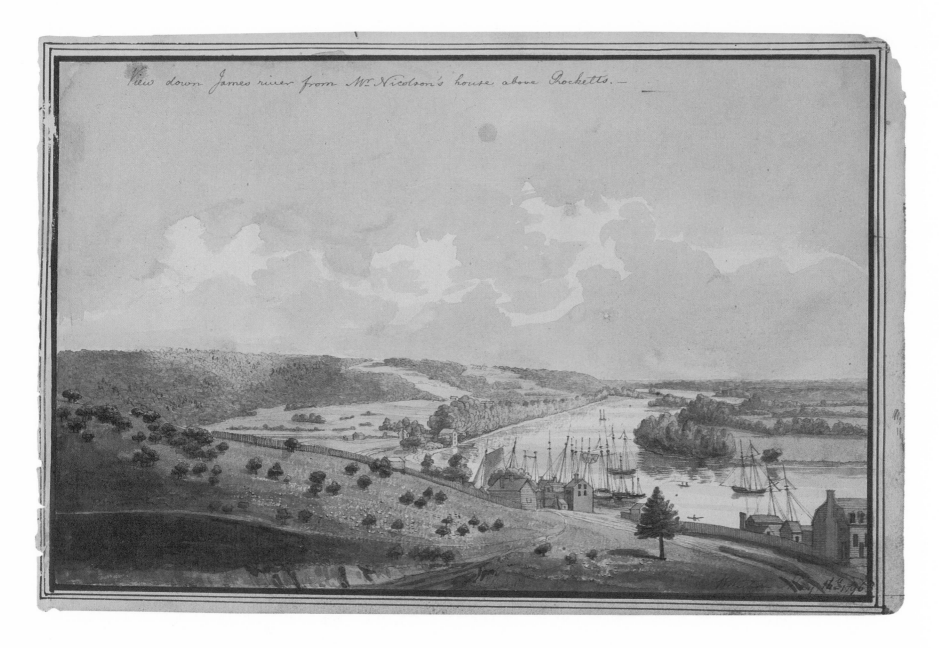

View down James river from Mr. Nicolson's house above Rocketts. —

NO. 14

15. "The Ground Squirrel"

31 May 1796
Pencil, pen and ink, watercolor
17.7 cm. × 26.2 cm. (6-15/16 in. × 10-5/16 in.)
B H L.
SKETCHBOOK I

The ground squirrel, or chipmunk, *Tamias striatus striatus,* is found only in the eastern United States and southeastern Canada and was thus unfamiliar to Latrobe when he arrived in Virginia. He was in Richmond at the time he made this drawing. The chipmunk derives its common name from an Ojibway term meaning "headfirst," referring to its method of descending trees. Abundant in woodlands, chipmunks dig long, shallow burrows with nesting chambers. They feed upon fruits, nuts, seeds, berries, and tender vegetation but sometimes they will eat insects or small mammals. The eastern chipmunk attains a length of nine or ten inches. The notation "*phlebotomy gratis*" seems to be Latrobe's humorous "scientific name" for the chipmunk, which performed for free the bleeding that physicians of Latrobe's day frequently used as a treatment for many diseases.

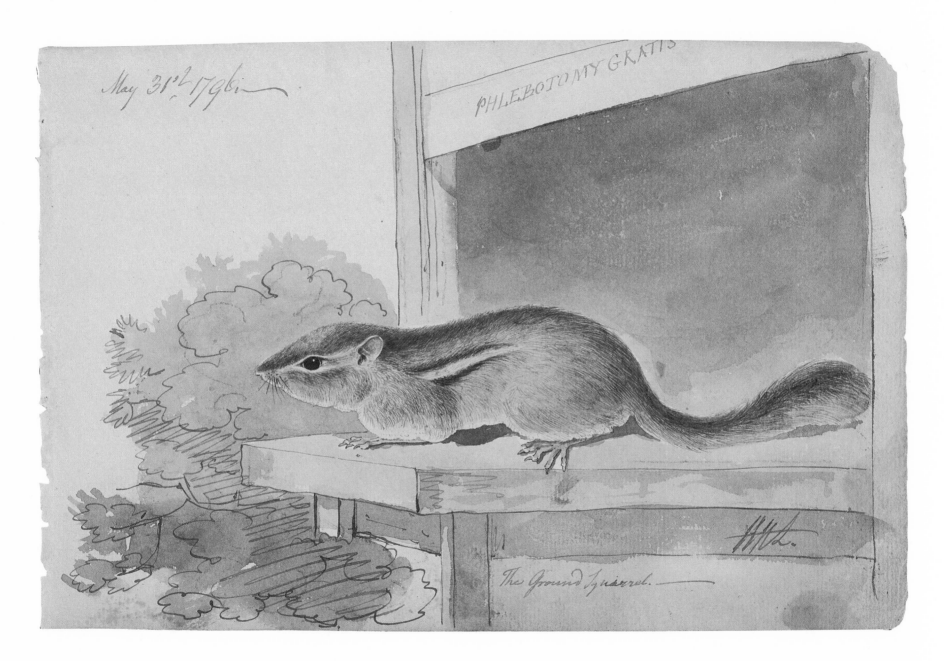

May 31st 1796

PHLEBOTOMY GRATIS

The Ground Squirrel.

NO. 15

16. "Nondescripts . . . near the Oaks, Virginia"

Undated
Pencil, pen and ink, wash
17.7 cm. × 27.8 cm. (6-15/16 in. × 10-15/16 in.)
SKETCHBOOK II

"A family of poor White children observed from the Stage carrying peaches to a neighboring Barbecue for Sale." (BHL, SKETCHBOOK II)

> The common people in the lower parts of Virginia have very sallow complexions, owing to the burning rays of the sun in summer, and the bilious complaints to which they are subject in the fall of the year. The women are far from being comely, and the dresses, which they wear out of doors to guard them from the sun, make them appear still more ugly than nature has formed them. There is a kind of bonnet very commonly worn, which, in particular, disfigures them amazingly; it is made with a caul, fitting close on the back part of the head, and a front stiffened with small pieces of cane, which projects nearly two feet from the head in a horizontal direction. To look at a person at one side, it is necessary for a woman wearing a bonnet of this kind to turn her whole body round. (Weld, *Travels*, pp. 89–90)

The Oaks was the Amelia County home of Edmund Harrison (1764–1828). Harrison's second wife, Martha Wayles Skipwith (1786–1837), was the daughter of Henry Skipwith, whose home, Horsdumonde, Latrobe visited in 1796 (see No. 17). Latrobe traveled to Amelia County on several occasions. In June 1796 he was employed as an engineering consultant by the trustees of the Upper Appomattox Navigation Company, which had been chartered in 1795 to improve and extend the river's navigation. While on the survey trip down the river he drew the following sketches of Horsdumonde and Walk's Mill.

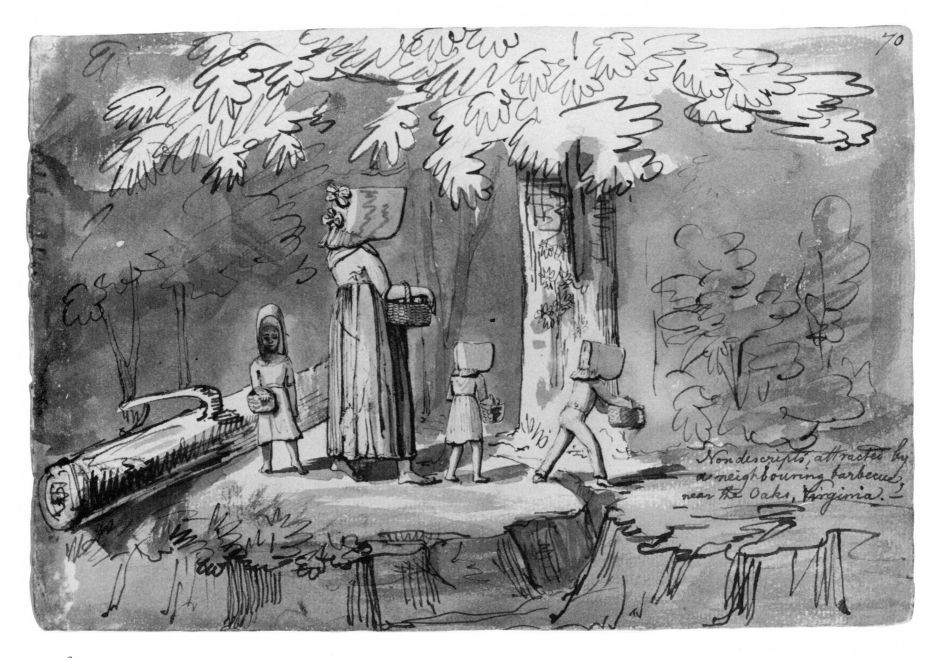

Nondescripts, attracted by a neighbouring barbecue, near the Oaks, Virginia.

NO. 16

17. "Horsdumonde, the house of Colonel Skipwith, Cumberland County, Virginia"

14 June 1796
Pencil, pen and ink, watercolor
17.7 cm. × 27.8 cm. (6-15/16 in. × 10-15/16 in.)
B H Latrobe June 14th 1796.
SKETCHBOOK II

Map reference: Cumberland Quadrangle, Virginia
UTM coordinates: Mouth of Big Guinea Creek: 17.074876.414744; Mouth of Little
 Guinea Creek: 17.075114.414880
Orientation: Approximately 135°

This place has a name very appropriate: *Horsdumonde* [out of the world]. No possibility of communication by letter or visit, but by riding half a dozen miles *into* the world. In other respects there is a great deal of worldly beauty and convenience about it. The house is a strange building, but whoever contrived it, and from whatever planet he came he was not a *Lunatic,* for there is much comfort and room in it, though put together very oddly. Before the South front is a range of hills wooded very much in the Stile of an English park. To the East runs the Apomatox to which a lawn extends. Beyond the hills to the South West the river also winds, and to the Vapours tending Eastward from thence the unhealthiness of the place is ascribed. (BHL, *Journals,* 1:142)

Colonel Skipwith's house, lies near the North bank of the Appomattox, which flows on the left hand between the most distant wood and the hill. The place is extremely unhealthy, the trees having been cut down to the Water's edge, an operation which admitting the autumnal fogs to creep up the Valleys, has been found to render situations subject to fever and ague which were formerly considered as healthy. (BHL, SKETCHBOOK II)

Horsdumonde, no longer extant, stood on the northwest bank of the Appomattox River between Little Guinea Creek and Big Guinea Creek. Its owner, Henry Skipwith (1751–1815), son of Sir William and Elizabeth (Smith) Skipwith of Middlesex County, Virginia, was one of the wealthiest planters in Virginia. A prominent political figure in Cumberland County, Skipwith was also a trustee of the Upper Appomattox Navigation Company. The occasion of Latrobe's visit to Horsdumonde was a meeting with several company trustees prior to the commencement of his survey of the river for the improvement of its navigation. Latrobe composed this drawing from a point northwest of the house, looking to the southeast across the Appomattox River into the hills of Amelia County.

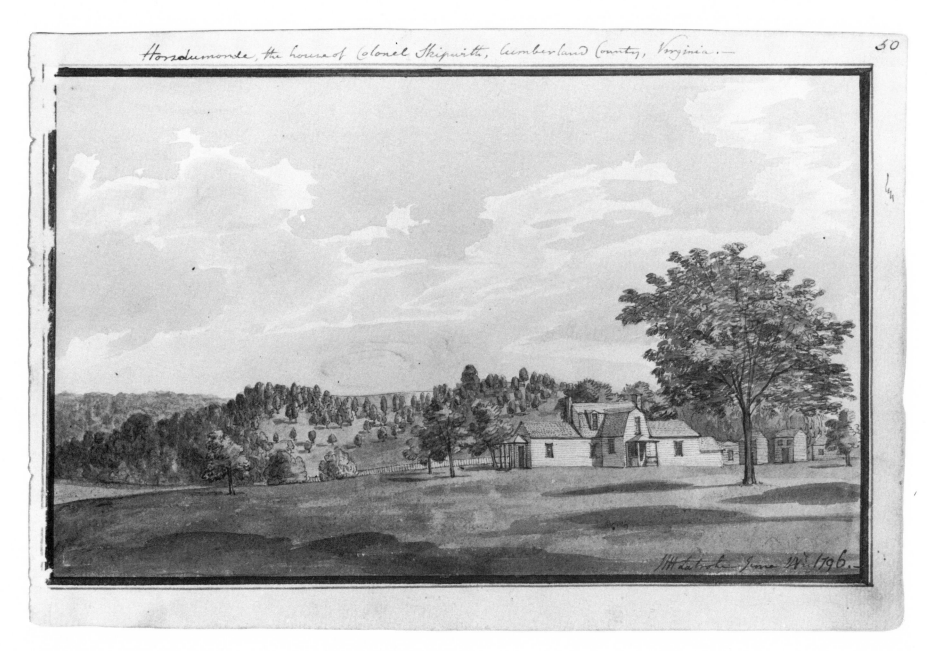

Horsdumonde, the house of Colonel Skipwith, Cumberland County, Virginia.—

BHLatrobe June 14th 1796.—

NO. 17

18. "Sketch of Mr. Walk's Mill on Flat Creek,
 near its junction with Appomattox river"
 Undated [15 June 1796]
 Pencil, pen and ink, watercolor
 17.7 cm. × 27.8 cm. (6-15/16 in. × 10-15/16 in.)
 SKETCHBOOK II

 Map reference: Clayville Quadrangle, Virginia
 UTM coordinates: 18.024555.414200
 Orientation: Approximately 340°

In traveling down the Appomattox River toward Petersburg, Latrobe
and his companions arrived at the mouth of Flat Creek in Amelia
County at 7 o'clock on the evening of 14 June 1796. Latrobe described
Flat Creek as

> a very considerable stream, which with little trouble might be made
> navigable 40 miles up the Country. . . . We found the Stream in Flat
> creek so rapid and so full of logs that having attempted to get up to
> the Mill we were obliged to return and land on the shore of the
> Appomattox. From thence we walked up the hill to Mr. Walk's
> house, where we were determined to stay all night; no introduction
> or previous notice being necessary in this hospitable country.

Walk, who was "a sensible, good humored man, made his house" com-
fortable and pleasant to Latrobe and his party.

"The morning of June the 15th was chiefly employed in strolling
about. I took a view of Mr. Walks mill on Flat creek, a wretched tub mill
in a most advantageous situation." (BHL, *Journals*, 1:150–51) The view
was taken looking upstream from the south side of Flat Creek. The
confluence of the creek and the Appomattox would be further to the
right, or downstream, than the area depicted in this drawing.

Sketch of M.r Walk's Mill on Flat Creek, near its junction with Appomattox river.

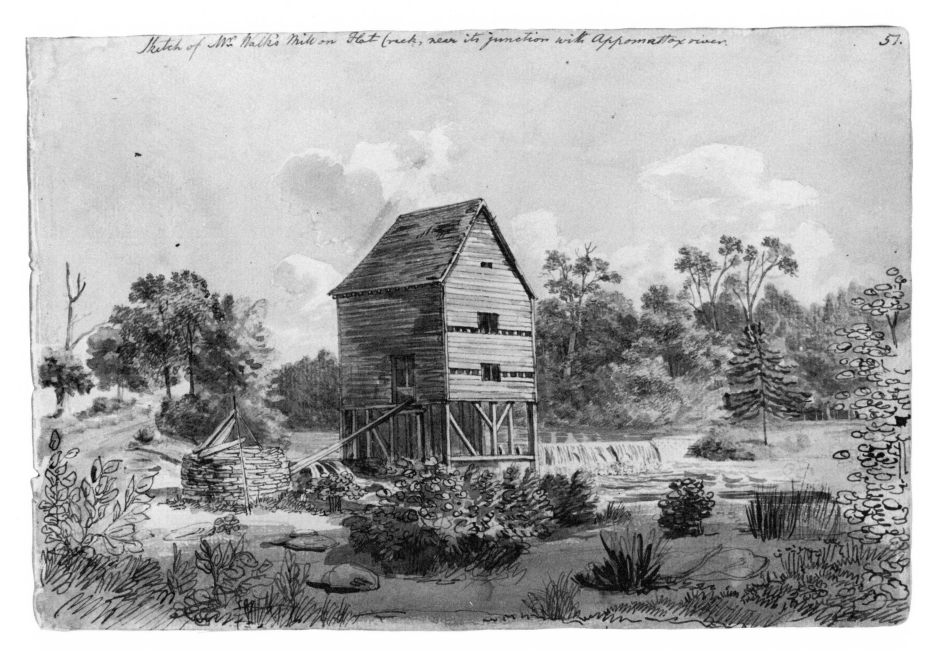

NO. 18

19. "Sketch of the House of Mr. Francis Eps on the Appomattox"

Undated [16 June 1796]
Pen and ink
17.7 cm. × 27.8 cm. (6-15/16 in. × 10-15/16 in.)
SKETCHBOOK II

Map reference: Winterpock Quadrangle, Virginia
UTM coordinates: Viewing position: 18.025817.413116; Building: 18.025810.413104
Orientation: 205°

On 17 June 1796, while on his Appomattox River survey, Latrobe recorded in his journal: "Mr. Eps has a charming estate about 4 miles below Watkins mill on the North bank. Here we met with a reception different from that of last night, a hearty welcome, an excellent breakfast, and provisions for the day." (BHL, *Journals,* 1:153)

Eppington was the Chesterfield County estate of Francis Eppes (1747–1808), prominent planter and brother-in-law of Thomas Jefferson. Built around 1770 and still standing today, it is situated about three-quarters of a mile north of the Appomattox River in the Winterpock Creek region. It was here that Francis and Elizabeth Eppes cared for two of Thomas Jefferson's daughters following the death of their mother in 1782. In 1784, young Lucy Jefferson died and most likely was buried at Eppington. Her older sister, Mary Jefferson, spent much of her life at Eppington and married her cousin, John Wayles Eppes, in 1797. Their son Francis recorded his memories of the estate:

> The mansion-house itself, an old fashioned, two story building, with a hipped roof in the center, and wings on the sides, with a long hall or passage in front and rear, was placed at the extreme side of a large level or lawn, covered with greensward, extending to a considerable distance in front, and declining on the left side as you entered, and in the rear of the house to the low grounds of the Appomattox, a mile off. In front and over the neighborhood road which skirted the lawn, was situated the garden, long famous in the vicinity for its fine vegetables and fruit; and to the right of the lawn, as you entered, was an extensive orchard of the finest fruit, with the stables between, at the corner and on the road. The mansion, painted of a snowy white, with green blinds to the windows, and its rows of offices at the ends, was almost imbedded in a beautiful double row of the tall Lombardy poplar—the most admired of all trees in the palmy days of old Virginia—and this row reached to another double row or avenue which skirted one side of the lawn, dividing it from the orchard and stables. The lawn in front was closed in by a fence with a small gate in the middle and a large one on either extremity, one opposite the avenue of poplars, and the other at the end of the carriage-way which swept around it. (Weaver, "Mary Jefferson and Eppington," p. 31)

Aside from front porch alterations and a two-story addition to the rear, the exterior appearance of the two-and-a-half-story frame house has changed little from the time when Latrobe executed this sketch. However, at the time of Latrobe's visit, just west of the house stood a one-story wooden schoolhouse, part of which Latrobe depicted in the sketch, and a one-story wooden kitchen building, not shown. These outbuildings, described in an 1806 insurance policy, do not appear in recent historical surveys of Eppington.

Sketch of the House of Mr Francis Epes on the Appomattox

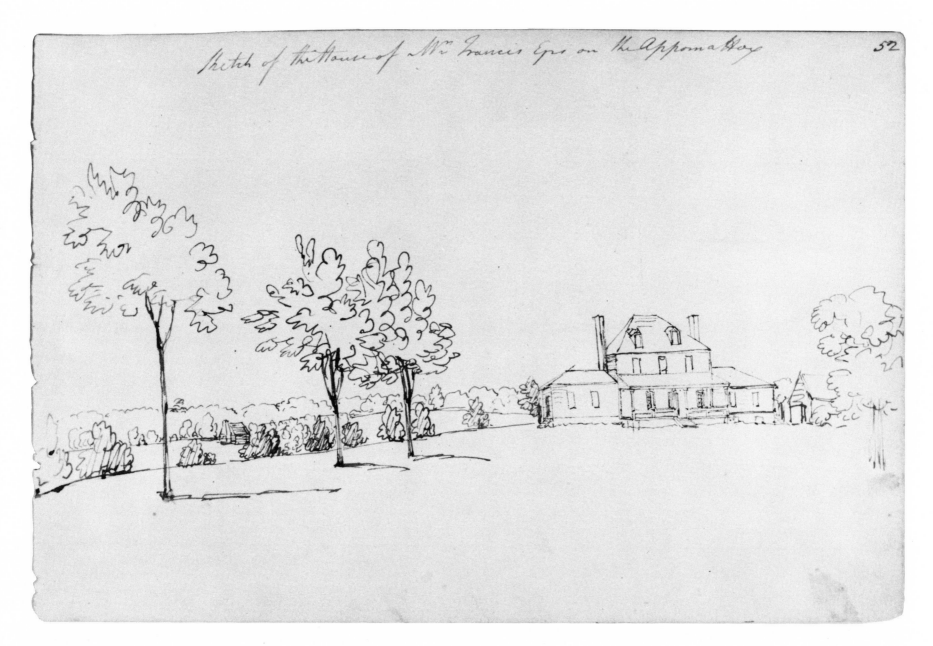

NO. 19

20. "Masons, or Dirtdaubers"

15 July 1796 and 28 June 1797
Pencil, pen and ink, watercolor
17.7 cm. × 27.8 cm. (6-15/16 in. × 10-15/16 in.)
SKETCHBOOK II

Latrobe began this drawing on 15 July 1796, while he was visiting Col. Thomas Blackburn (1740–1807) at Rippon Lodge, Prince William County, Virginia. He completed it on 28 June 1797 while visiting Col. John Mayo (1760–1818) at the Hermitage, near Richmond (see No. 39). The drawing later served as the basis for the engraving that accompanied Latrobe's article, "On two species of Sphex, inhabiting Virginia and Pennsylvania . . . ," published in the American Philosophical Society *Transactions* 6 (1809): 73–78; printed in BHL, *Correspondence*, 1. When he first began his study of this insect, he recorded the following observations in his journal and sketchbook:

> Among the many ingenious insects that I have met with in Virginia, the *dirt-daubers,* more decently called Masons, are particularly worth notice. They are a species of Wasp, of a dark blue color. Their cells are built of clay and are in appearance somewhat similar to the nests of the English house martins. These are the nests of the Sphex pensylvanica [the yellow mud dauber, now *Sceliphron cementarium*]. I have not had an opportunity of examining them, but am told that each cell contains an egg, and a spider. They are now at work, later in the Year I shall break into one of their fortresses, at present I think it a pity to put them out of their way. . . .
>
> A whole forenoon has been employed by me in examining the operations of these ingenious Wasps [the blue mud dauber, now

Chalybion californicum] without being yet able to understand completely their domestic Oeconomy. Behind a number of framed prints which hang in the Drawing room here a large colony had established themselves; all of which I destroyed and searched.

Their Cells are of two kinds; but whether two species of the same insects construct them, or whether eggs of different Sexes of the same are deposited in them I have not yet discovered. The first kind consists of a tube which is continued without internal divisions at first for some length, perhaps 4 or 5 inches. The second consists of separate cells joined to one another in a parrallel arrangement, each of which is begun and finished before the next is constructed. The former seem to be executed with more neatness. The latter with more strength, the Dirt being daubed over them in a great number of layers. I have not seen any of the Masons in the act of bringing Dirt to the Cells, but from the Quantity which every Cell requires their Labor must be very great. Internally each species of Cell is finished and filled alike. I think the horizontal Cells however are somewhat less in general.

The inside of the Cells is made perfectly even and smooth. The Mason had fixed his Work to the back of the print frame and made use of the Wood as part of his internal finishing without being at the trouble of carrying his coat of Dirt all round, and I have seen one

instance of a pipe being constructed in a hollow moulding of a pannel so as to save nearly half of the Labor which a flat surface would have demanded. The Dirt has the appearance of being platted, the Mason while at work keeping the lowest edge always in an angular form the point of which is upwards, and working first on one and then on the other leg of the angle. The tube being carried to a satisfactory length the Mason collects as many Spiders as will fill about 3/4 of an inch (for the Cells are not exactly equal in length). The poor Devils are crammed in with unrelenting cruelty, as tight as possible. I have counted 27 in two Cells, 12 in *one* frequently, often only 6 or 7 if they happened to be large ones, and once as many as 16 small yellow spiders in one cell. Upon opening many of the Cells these miserable creatures were still alive though so languid that they could but barely move, and soon died when exposed to the Sun. (I have been often shocked and distressed at the Scenes of cruelty and misery that seem to form part of the System of nature; but I scarce ever saw so dreadful a contrivance of torment as appears to be employed by the Masons against the poor Spiders; if we may reason upon their feelings from our own.) The variety of Spiders collected by these industrious Robbers is much greater than my own curiosity ever exhibited to me in my searches after subjects of natural history. They remain in the cells in very good preservation

87

even when dead; not being in the least mutilated till devoured by the grub for whose food they are provided.

Having filled the cell with spiders, the Mason then lays an egg into the lower part of it and closes it up with dirt. Another stop is then put to the head of the next Cell close to the stop of the last and the same provision laid in. The horizontal Cells are managed in the same way. The egg produces as usual a grub. The different appearances of the grub at its different stages are pretty accurately represented in the drawing. The upper most cell produces the first compleat insect.

It is astonishing with what strength and dexterity the Mason attacks conquers and bears off a large Spider much heavier than himself.

In the woods they fix their pipes to the South sides of overhanging rocks.

The young Mason makes a hole in the side of his cell to extricate himself. (BHL, *Journals*, 1:157–58, 159–60)

Fig. 1. External appearance of the Cells of *one* species of Masons.
 2. External appearance of the Cells of *another* species of Masons }
 3. Internal appearance of the Cells of the Masons Fig. 2 } next to the Wall
 4. Internal appearance of the Cells of the Masons Fig. 1 where attached to the Wall.
 A. Pipe first made without partitions.
 B. A Magazine of spiders containing also an egg or perhaps an infant worm.
 C. A Worm nearer maturity feeding on the Spiders collected for him.
 D. Another Magazine of Spiders: but drawn erroneously, for in this Cell which is the highest and first finished, ought to be a Worm advanced nearly to a Chrysallis, spinning a Web, with only one Spider left.
Fig. 5. The Worm in its last Stage in which it spins its Web, which thinly covers the Cell and Wall.
 6. The Chrysallis, broken across, showing the grub almost transparent and of a bright yellow color.
 7. The Mason newly fledged, building the Cells fig. 1.
 8. The Mason who builds the Cells of Fig. 2.

York River, March 19th 1797. . . . In reading [William] Derham's *Physico-Theology, [or a Demonstration of the Being and Attributes of God, from His Works of Creation; Being the Substance of 17 Sermons Preached at the Hon. Mr. Boyle's Lectures* (London, 1713)] I found the following passage.

p. 204 of the Edinburg Edition [1773] note *c*. After relating that he had seen a small *Vespa Ichneumon*, lay 2 Eggs into a cell formed in a small hole in his window, and then fetch a Maggot bigger than herself which she disposited with the Eggs, and then close up the cell, Dr. Derham proceeds:

"Of this artifice of these Ichneumons, Aristotle himself takes notice, but I believe he was scarce aware of the Eggs sealed up with the Spiders. *As to the vespae called ichneumones less than others, they kill spiders and carry them to their holes, and having sealed them up with dirt they therein hatch and produce those of the same kind. Hist: Animalium.* L.v.c.20." So that if the Virginian Dirtdauber did not [*torn*] in Greece, his peculiar oeconomy seems to be common to other species of this architectonic Insect. (BHL, SKETCHBOOK II)

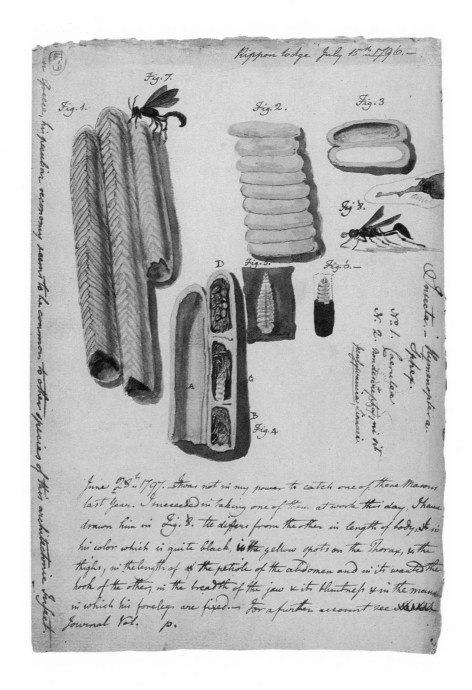

Rippon lodge July 15th 1796.—

Fig. 7. Fig. 1. Fig. 2. Fig. 3. Fig. 8. Fig. 5. Fig. 6.— D A C B Fig. 4.

Connecta.— Hymenoptera.
Apes.
No 1. Caerulea.
No 2.

June 28th 1797. It was not in my power to catch one of these Masons
last year. I succeeded in taking one of them at work this day, I have
drawn him in Fig. 8. He differs from the other in length of body, in
his color which is quite black, in the yellow spots on the Thorax, in the
thighs, in the length of the petiole of the abdomen and in its wanting the
hook of the others, in the breadth of the jaw & its bluntness & in the manner
in which his forelegs are fixed.— For a further account see
Journal Vol. p.

21. "Colonel Blackburn's Specific against Muskitoe bites . . ."

July 179[6]
Pencil, pen and ink
17.7 cm. × 27.8 cm. (6-15/16 in. × 10-15/16 in.)
SKETCHBOOK II

Latrobe visited Col. Thomas Blackburn (1740–1807) at Rippon Lodge in July 1796 on his way to and from Mount Vernon; he apparently misdated this drawing. Blackburn, one of Latrobe's earliest Virginia acquaintances, represented Prince William County in the House of Burgesses from 1774 to 1776. He served as a lieutenant colonel in the Second Virginia Regiment and as an aide to George Washington during the Revolution. In this drawing Latrobe took Blackburn's unsightly but practical "Specific" for preventing mosquito bites and turned it into a pseudoscientific expedient, complete with a receipt including quasi-medical instructions, grossly exaggerated amounts, and the dictum *"Probatum est"* (It has been proved).

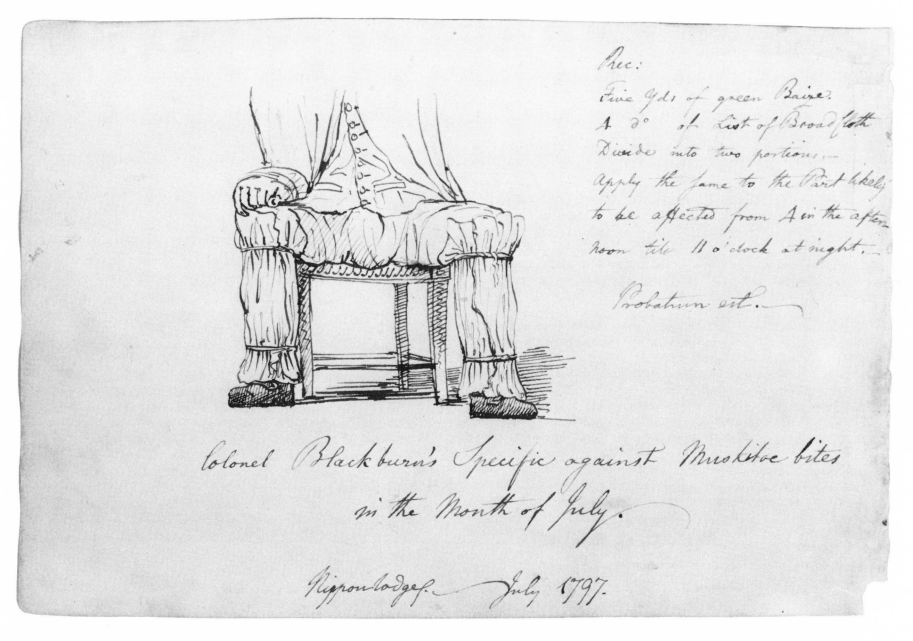

Rec:

Five Yds of green Baize.
A do of List of Broad Cloth
Divide into two portions,—
Apply the same to the Part likely
to be affected from 4 in the after-
noon till 11 o'clock at night,—

Probatum est,—

Colonel Blackburn's Specific against Muskitoe bites

in the Month of July.

Ripponlodge.——— July 1797.

22. "View of Mount Vernon looking towards the South West"

Undated [16 July 1796]
Pencil, pen and ink, watercolor
17.7 cm. × 27.8 cm. (6-15/16 in. × 10-15/16 in.)
B H Latrobe [Original signature reinforced by a later hand]
SKETCHBOOK II

Map reference: Mount Vernon Quadrangle, Maryland–Virginia
UTM coordinates: 18.031873.428632
Orientation: 213°

On 16 July 1796, Latrobe took advantage of his friendship with Bushrod Washington to meet the latter's uncle at Mount Vernon. Aware of the significance of his visit to the home of President George Washington, Latrobe meticulously recorded the details and impressions of his day and a half visit in both his journal and sketchbook. At the beginning of his extensive journal entry, he described his first impressions on approaching the house from the southwest:

The house becomes visible between two Groves of trees at about a miles distance. It has no very striking appearance, though superior to every other house I have seen here. . . . It is a wooden building, painted to represent champhered rustic and sanded. The center is an old house to which a good dining room has been added at the North end, and a study &c. &c., at the South. The house is connected with the Kitchen offices by arcades. The whole of this part of the building is in a very indifferent taste. Along the other [east] front is a portico supported by 8 square pillars, of good proportions and effect. There is a handsome statuary marble chimney piece in the dining room (of the taste of Sir Wm. Chambers), with insulated columns on each side. This is the only piece of expensive decoration I have seen about the house, and is indeed *remarkable* in that respect. Every thing else is extremely good and neat, but by no means above what would be expected in a plain English Country Gentleman's house of £500 or £600 a Year. It is however a little above what I have hitherto seen in Virginia. (BHL, *Journals,* 1:163–65)

Latrobe drew this view of the east front of the mansion from the lawn looking across the Potomac River estuary toward present-day Fort Belvoir, Virginia (center horizon) and the Maryland shore (left horizon). The locust trees at the right, which are not present today, obscured from Latrobe's view the cupola and a large window on the side of the mansion. In his journal, he described the scene:

Towards the East Nature has lavished magnificence, nor has Art interfered but to exhibit her to advantage. Before the portico a lawn extends on each hand from the front of the house and of a Grove of Locust trees on each side, to the edge of the bank. Down the steep slope trees and shrubs are thickly planted. They are kept so low as not to interrupt the view but merely to furnish an agreeable border to the extensive prospect beyond. The mighty *Potowmac* runs close under this bank the elevation of which must be perhaps 250 feet. The river is here about 1-1/2 miles across and runs parallel with the front of the house for about 3 miles to the left and 4 to the right. . . .

After running about 4 Miles to the right, the river turns suddenly to the Eastward but is seen over a range of lowland for a considerable distance. A woody peninsula running to a point backs the silver line of the water, and the blue hills of Maryland just appear above the edge of the trees, beyond the next bend. (BHL, *Journals,* 1:165, 166)

View of Mount Vernon. Looking towards the South West.—

59

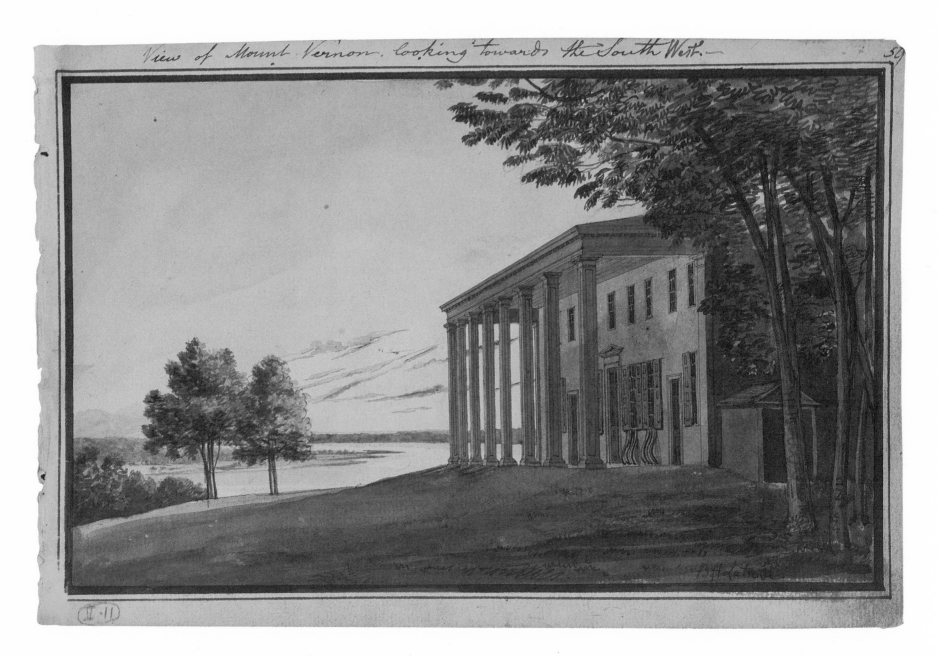

NO. 22

23. "Sketch of General Washington"

Undated [16 July 1796]
Printed facsimile (original lost)
14.0 cm. × 18.1 cm. (5-1/2 in. × 7-1/8 in.)
Maryland Historical Society

When my youngest Brother [John Frederick Latrobe] was about six years old he went with the family to see the king of England go through St. James's park in State to the House of Lords. Upon being told that he rode in such and such a carriage, he would scarcely believe that the person he saw could be the king; and being assured that he really was so, he cried out: *"Good lord, papa, how like a man he looks."* The Sentiment *expressed* by the boy, is, I believe, *felt* by every man who sees for the first time a man raised by merit or reputation above the common level of his fellow creatures. It was impressed upon me, upon seeing one of the greatest men that Nature ever produced, but in a less degree than even when I saw that least-like-a-man-looking-king Frederic the Second of Prussia. Washington has something uncommonly majestic and commanding in his walk, his address, his figure and his countenance. His face is characterized however more by intense and powerful thought, than by quick and fiery conception. There is a mildness about its expression; and an air of reserve in his manner lowers its tone still more. He is 64, but appears some years younger, and has sufficient apparent vigor to last many years yet. He was frequently entirely silent for many minutes during which time an awkwardness seemed to prevail in every one present. His answers were often short and sometimes approached to moroseness. He did not at any time speak with very remarkable fluency:—perhaps the extreme correctness of his language which almost seemed studied prevented that effect. He seemed to enjoy a humourous observation, and made several himself. He laughed heartily several times and in a very good humoured manner. On the morning of my departure he treated me as if I had lived for years in his house; with ease and attention, but in general I thought there was a slight air of moroseness about him, as if something had vexed him. (BHL, *Journals,* 1:171–72)

This likeness has a rather elaborate history. In 1879, Virginia historian Robert A. Brock placed an inquiry in the *Richmond Standard* (4 January) concerning the whereabouts of a pen and ink profile of Washington done by Latrobe which Brock claimed to have seen in 1870 in the temporary possession of his friend and colleague, Thomas H. Wynne. Latrobe's son John H. B. responded to Brock's query with the following statement, which was printed in the *Standard,* 25 January 1879:

My father had an extraordinary facility in catching a likeness with a few strokes of his pen, and on the fly-leaf of one of his sketch-books there used to be a pen and ink profile with the note underneath: "Stolen at Mount Vernon while General Washington was looking down the Potomac for a vessel in which he expected some friends from Alexandria," or to that effect. This fly-leaf, with which I was familiar from infancy, is not now in the volume, but my sister fortunately made a tracing which is in my possession. I think it likely that the drawing you speak of was a copy made on his return to Richmond for some friend to whom he showed the original.

At the time Brock saw the sketch, he learned that Davies and Son of Lee Gallery, Richmond, had photographed the likeness and reduced it in size by one-third, making it *carte de visite* size. This may help account for the existence of several known facsimiles, such as the one shown here.

Sketch of General Washington,
Stolen at Mount Vernon while
he was looking to discover
a distant Vessel on the Po-
towmac; in which he expec-
ted some of his friends from
Alexandria.

24. "View of Lord Botetourt's mutilated Statue Wmsburg."

Undated [July 1796]
Pencil, pen and ink, watercolor
17.7 cm. × 27.8 cm. (6-15/16 in. × 10-15/16 in.)
SKETCHBOOK II

Norborne Berkeley (1718–70), Baron de Botetourt, was governor of Virginia from 1768 until his death. On 20 July 1771, the House of Burgesses agreed unanimously that a statue of Botetourt "be erected in Marble at the Public Expence, with proper Inscriptions, expressing the grateful Sense this House entertains of his Lordship's prudent and wise Administration, and their great Solicitude to perpetuate, as far as they are able, the Remembrance of those many public and social Virtues which adorned his illustrious Character." (*Journals of the House of Burgesses, 1770–1772*, p. 138) The Council concurred unanimously on the same day.

The statue, carved by Richard Hayward, arrived from London in May 1773 and was placed in the Capitol. It was apparently defaced just a few years before Latrobe saw it. With this example in mind, Latrobe explained in 1800 why a statue of George Washington might not be the best means of commemorating the first president: "A very striking proof of this folly of expecting that any statue will be always respected exists in Williamsburg, where Lord Botetourts statue which had remained untouched during the whole [American Revolutionary] war, was mutilated, and decapitated by the young collegians, in the first frenzy of French revolutionary maxims, *because it was the statue of a **Lord**.*" (BHL to Robert Goodloe Harper, [post 24 April 1800], in BHL, *Correspondence,* 1)

The statue, now restored, stands in the library of the College of William and Mary.

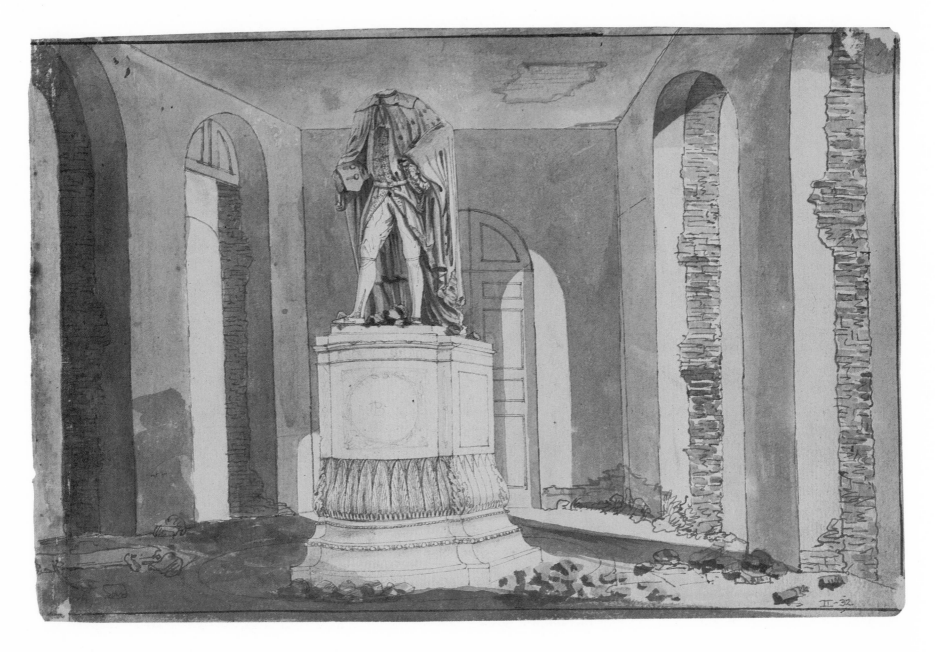

NO. 24

97

25. Pedestal of the Statue of Lord Botetourt, Williamsburg

Undated [July 1796]
Pencil, pen and ink
17.7 cm. × 27.8 cm. (6-15/16 in. × 10-15/16 in.)
SKETCHBOOK II

In his letter to Robert Goodloe Harper cited in the preceding entry, Latrobe stated that the inscriptions on the pedestal of the statue of Botetourt "remained the libel of the country and age." Then in his sketchbook he carefully copied out the inscriptions:

On the South side of the Pedestal is this inscription:

"*America!* behold your friend, who leaving his native Country, declined the additional honors which were there in store for him, that he might heal your wounds, and restore tranquillity and happiness to this extensive Continent: with what zeal and anxiety he pursued these glorious objects, Virginia, thus bears her grateful Testimony."

On the West side is inscribed:

"The Right Honourable Norborne Berkeley, Baron de Botetourt His Majesties late Lieutenant and Governor General of the Colony and Dominion of Virginia."

On the North side

"Deeply impressed with the warmest sense of Gratitude for his Excellency the Rt. Honble. Lord Botetourt's prudent and wise Administration and that the Remembrance of those many public and social Virtues which so eminently adorned his illustrious Character might be transmitted to the latest posterity the General Assembly of Virginia, on the 20th. day of July A.D. 1771 Resolved with one united Voice, to erect this statue to his Lordships memory.

"Let Wisdom and Justice preside in any country the people will rejoice and must be happy."

On the East side, a very clumsy Brittania, and an illmade America unite the Olive and the laurel over the altar of Concord. (BHL, SKETCHBOOK II)

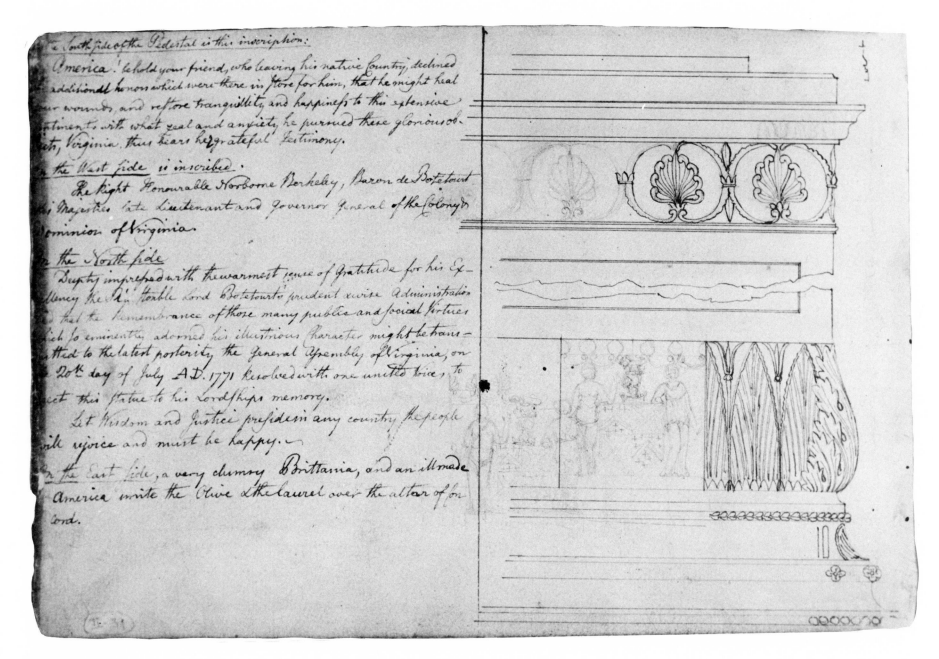

'e South side of the Pedestal is this inscription:

America! behold your friend, who leaving his native Country, declined additional honours which were there in store for him, that he might heal our wounds, and restore tranquillity and happiness to this extensive ntinent; with what zeal and anxiety, he pursued these glorious ob- cts, Virginia, thus bears her grateful testimony.

the West side is inscribed:

The Right Honourable Norborne Berkeley, Baron de Botetourt is Majesties late Lieutenant and Governor General of the Colony & ominion of Virginia.

the North side

Deeply impressed with the warmest sense of Gratitude for his Ex- llency the Ri. Honble Lord Botetourt's prudent & wise Administration d that the Remembrance of those many public and social Virtues ich so eminently adorned his illustrious Character might be trans- tted to the latest posterity the General Assembly of Virginia, on 20th day of July A.D. 1771 Resolved with one united voice, to ect this Statue to his Lordships memory.

Let Wisdom and Justice preside in any country the people ill rejoice and must be happy.

the East Side, a very clumsy Brittania, and an ill made America unite the Olive & the Laurel over the altar of Con cord.

26. "View of Greenspring house"

Undated [July 1796]
Pencil, pen and ink, watercolor
17.7 cm. × 27.8 cm. (6-15/16 in. × 10-15/16 in.)
SKETCHBOOK II

Map reference: Norge Quadrangle, Virginia
UTM coordinates: Viewing position: approximately 18.034008.412424; Green Spring:
 approximately 18.034020.412440
Orientation: Approximately 40°

An important center of social and political life in seventeenth-century Virginia, Green Spring, located three and one-half miles north and slightly west of Jamestown, was built by Governor Sir William Berkeley (1606–77) around 1649. After Berkeley's death, the estate passed to his widow, Lady Frances Berkeley, who then married into the Ludwell family. At this time, the mansion was most likely rebuilt. When Latrobe recorded this view of Green Spring, it belonged to William Ludwell Lee (1775–1803), son of William (1737–95) and Hannah Philippa (Ludwell) Lee.

Greenspring is well known in the history of the American war having been the Scene of an action [6 July 1781] between part of the American army under General Waine [Anthony Wayne] and the British under Lord Cornwallis in which the Americans were defeated. The British did no great damage to the building. They destroyed however a quantity of Tobacco which had been housed in a large br[*illegible*] barn, and having hauled out a boat which was also secured in the same place they set fire to it. The barn caught fire from the boat and the horse prevented the negroes from putting it out. This was all the injury done. The massive ruins of the barn remain a proof of the superior value of this plantation and former days when Jamestown was the Capital of Virginia. The principal part of Greenspring house was erected by Sir William Berkeley who was Governor of Virginia the latter end of the last Century. . . . It is a brick building of great solidity, but no attempt at grandeur. The lower story was covered by an arcade which is falled down. The porch has some clumsy ornamental brickwork about it of the stile of James the 1st. The Estate descended to the present possessor by Maternal descent. He is just of age. He was born in England, but

came out to Virginia very young. He seems activated by a spirit of improvement, and indeed the Estate wants it in every respect.

Greenspring lies about a mile in a strait line from James river. The ground is flat, but might be easily drained. All the watercourses are deep and run very freely and I judge that the lowest ground lies 10 or 15 feet above common tides in James river.

The wetness of the Season, and I may add the badness of the husbandry has much injured the Crop of Indian corn now growing upon the Estate. But where it has had a tolerable chance it is tall and vigorous, although the same land has been in perpetual cultivation since it was first cleared. . . .

Greenspring derives its name from a very copious Spring of excellent water which bursts from a gentle knoll upon which the house stands. . . .

It is Mr. Lee's intention to pull down the present mansion and to erect a modest Gentleman's house near the spot. The antiquity of the old house, if in any case, ought to plead in the [project?], but its inconvenience and deformity are more powerful advocates for its destruction. In it the oldest inhabited house in North America will disappear for it was built in the Year 16[. .]. (BHL, *Journals*, 1:181, 182)

One year after he recorded these notes, Latrobe again visited Green Spring.

On Saturday the 29th [of July 1797] I went down in the Stage to Williamsburg and from thence to Greenspring to Mr. Ludwell Lee's house. He has entirely pulled down his old mansion, and he wanted me for the 3d time to give him a *new* design to proceed upon. I did so, but as his meanness seemed to grow upon him daily, I found it

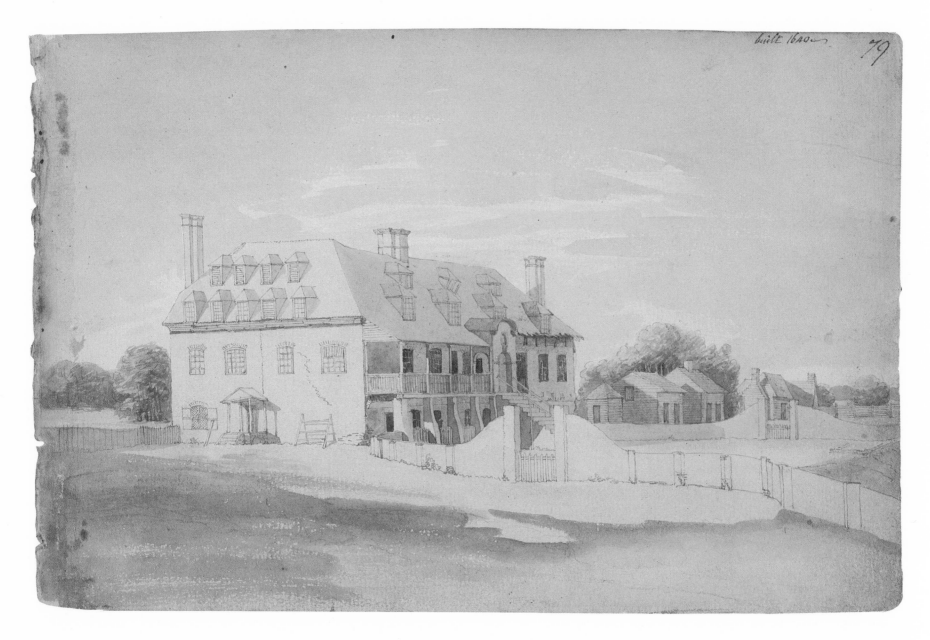

built 1640

79

NO. 26

impossible for me to bend my ideas, to a compliance with his mode of procedure with his workmen. I therefore declined any further connection with him and returned to Williamsburg on the 31st. (BHL, *Journals*, 1:247)

Portions of Latrobe's designs for Green Spring—the south front elevation and plan of the arcade—survive in the Lee–Ludwell Papers at the Virginia Historical Society. These drawings and the unfinished sketchbook watercolor shown here provide rare pictorial representations of the estate house. In 1954–55, excavations were conducted at Green Spring, which is now part of Colonial National Historical Park. The excavations, which discovered the location and orientation of the various buildings on the site, suggest that Latrobe was standing near the eastern edge of what was the nursery, looking northeast across the forecourt. The wall immediately in front of him was the west garden wall, while further in the background near the far end of the Mansion House stood the east garden wall. Connected to the east side of the Mansion House was the Old Manor House, while the freestanding building to the right was probably the kitchen.

27. "Preparations for the enjoyment of a fine Sunday among the Blacks, Norfolk"

4 March 1797
Pencil, pen and ink, watercolor
17.7 cm. × 27.8 cm. (6-15/16 in. × 10-15/16 in.)
B H Latrobe [*illegible*] del.
SKETCHBOOK II

Preparations for the enjoyment of a fine Sunday, accurately copied from the upper room of Drynane's tavern Norfolk. March 4th, 1797.
Process:
The Man lathered must remain sitting, or rather *lying almost* on his back during the whole time. Being properly lathered by the man with the tails, he must wait till the man in the Cap comes to shave part of his right Cheek. This being performed the Man on the Barrell takes his Seat and the Man with the tails takes the Razor. The Shaving then proceeds over the Lips and Chin and the Razor is then put by. In the mean time the Man on the Barrell has taken his hair out of twist, and spread his tail. The Man in the Cap reenters and having fixed his left hand firmly on the Nose and Eyes of the *Shavee* he proceeds with the operation, keeping his patient down by imprecations and manual exertion. The Man with the tails at the same moment begins combing and pulling the wool of the Man on the tub till he has compleated the Coiffure. The tail man and Cap man then end the scene by mutually shaving and dressing each other. (BHL, SKETCHBOOK II)

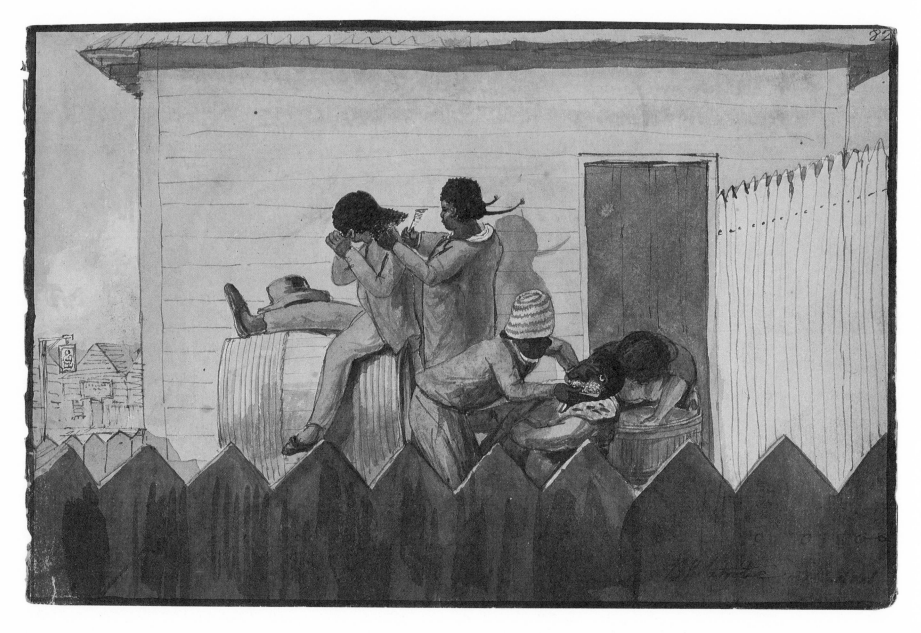

NO. 27

28. "Sketch of Major Watts little house on
 Shockoe Hill Richmond, drawn from
 memory, Norfolk"

4 March 1797
Pencil, pen and ink, wash
17.7 cm. × 27.8 cm. (6-15/16 in. × 10-15/16 in.)
SKETCHBOOK II

Map reference: Richmond Quadrangle, Virginia
UTM coordinates: Viewing position: approximately 18.028474.415785; Capitol:
 18.028484.415740
Orientation: Approximately 165°

In a draft of a letter inserted into his journal in February 1798, Latrobe wrote of the "unfortunate though cherished mixture of Gothic with more refined manners" current in the immature city of Richmond. (BHL, *Journals*, 2:352) He meant "Gothic" in the common eighteenth-century sense of "barbarous" or "uncouth" and intended no reference to the Gothic style of architecture. His unfinished drawing from memory of the Watts premises takes up the theme of this mix in a perceptibly humorous vein.

A board fence terminates the foreground, a graceless yard without a trace of ornamental planting. At the left, a black man saws wood next to a shed. At the right, a pet raccoon sits before its little house. From a window of the dwelling, in an incongruously genteel touch, a ladylike female figure—she wears a hat, and Latrobe may have meant her to appear fashionably dressed—reaches toward a birdcage, home to a somewhat daintier class of pet. Her house exhibits a remarkable degree of irregularity for its small size. Ostensibly Latrobe did not succumb to the English taste for the Picturesqueness of asymmetrical cottages. He must have disdained the Watts house for its irregularity, which belongs with "Gothic" rather than "more refined" manners. The house has a porch of early Gothic Revival style. Without a doubt Latrobe, an architect who worked in the Gothic Revival, had a low opinion of both the style of the porch and the attempt to dress up the inelegant little building by piecing on a fancy bit of woodwork off-center.

In pointed contrast with Major Watts's residence rises Jefferson's statehouse, a monumental re-creation of a Roman temple on a Virginia hill and the progenitor of a mighty line of nineteenth-century American civic and domestic architecture, including Latrobe's own Bank of Pennsylvania in Philadelphia. The vantage point and the distance conceal the clumsy and incomplete execution of the Capitol (see No. 37).

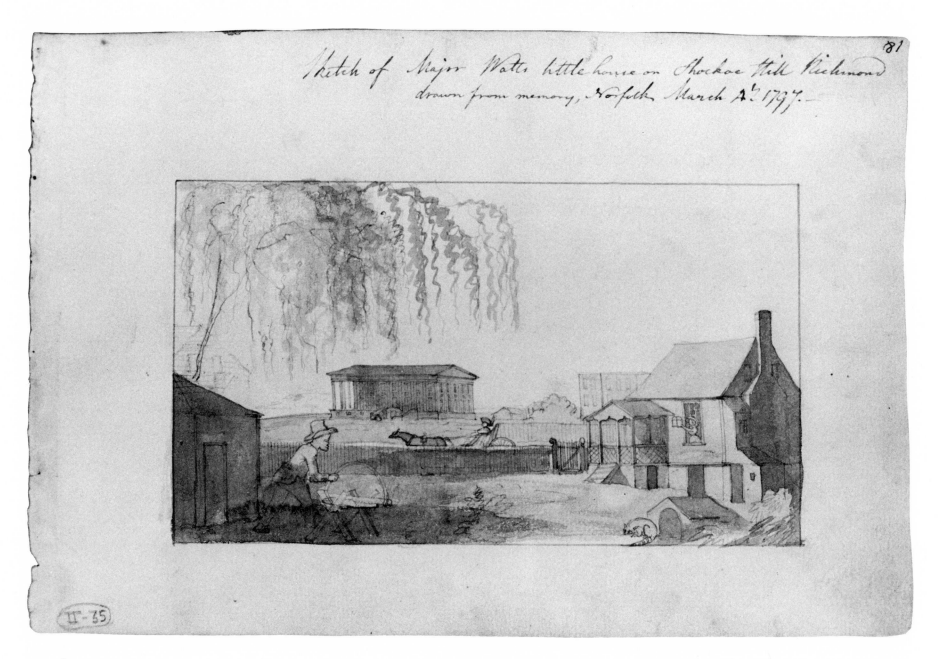

Sketch of Major Watts little house on Shockoe Hill Richmond drawn from memory, Norfolk March A.D. 1797.—

NO. 28

29. "A Conversation at Sea"

10 March 1797
Pencil, pen and ink, watercolor
17.7 cm. × 26.2 cm. (6-15/16 in. × 10-5/16 in.)
B H Latrobe delt. memoria March 10th 1797
SKETCHBOOK II

In this drawing, as in the previous two, Latrobe attempts to capture the peculiarities of his newly adopted homeland. Latrobe inscribed the phrase *del[ineavi]t memoria* (drew from memory) following his signature on the drawing, indicating that he witnessed this scene, or, more likely, a scene similar to this during his transatlantic voyage of a year earlier. The drawing features the *Tabitha,* a seventy-ton schooner whose home port was Salem, Massachusetts. The dialogue accompanying this drawing records an exchange between a rather haughty, evasive New England sea captain, ironically named Zerubabel Meek, and a second inquisitive but uninformed ship commander. Latrobe initially composed the conversation on the margin of his sketchbook page. Apparently dissatisfied with that effort, he revised and rewrote it on another sketchbook page. The scratched-out caption reads:

Question.	Hooooagh?
Answer.	Hooooagh.
Question.	Whence came ye?
Answer.	Salem.
Question.	Where bound?
Answer.	Savannah.
Question.	Who commands that Sloop.
Answer.	Zerubabel Meek.
Question.	What's your load?
Answer.	Only a few Notions.

The revised version of the dialogue:

Question.	Hoooooagh.
Answer.	Hoooooagh.
Question.	Whence came ye.
Answer.	From Stoningtown.
Question.	Where's that?
Answer.	You're a fine fellow for a Captain not to know where Stoningtown is.
Question.	(Aside—Damn your Yankee Soul) Where are you bound?
Answer.	To Savannah, if ye know where that is.
Question.	What have you in.
Answer.	Only a few Notions.
Question.	What's your Longitude.
Answer.	Right enough. Zebadiah make sail, up helm.

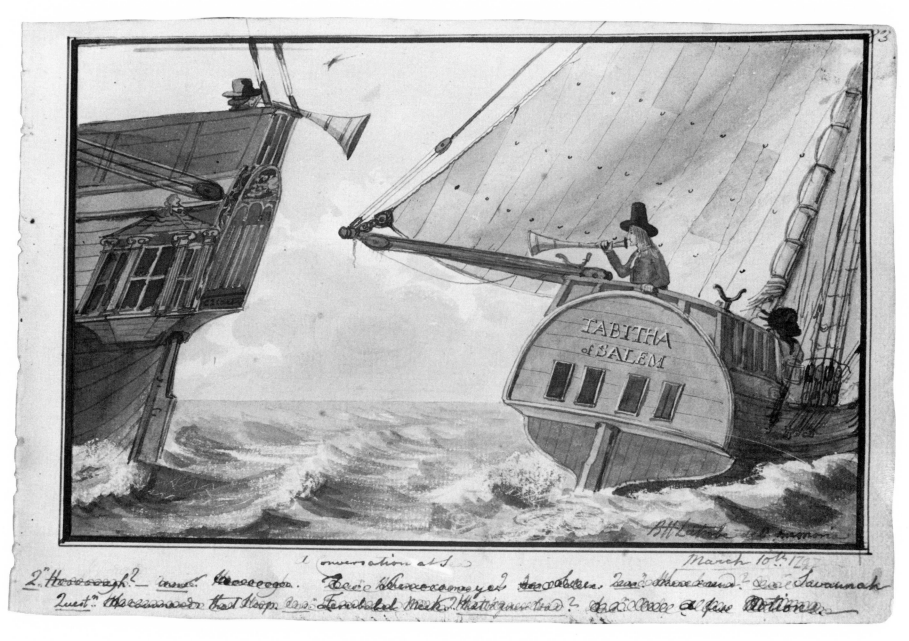

Conversation at S

March 10th 179...

2" Hooooogh?— inn*. Hooooogh. Row Wheeoooome ye? Ansr. Selem. 2nd where bound? Ansr. Savannah.
Quest" Hecessame that Hoop. Ansr. Tenebold Week? thot queer two? Answ of fine Bottone.

30. "Sketch of the Estate of Henry Banks Esqr. on York River"

Undated [March 1797]
Pen and ink, watercolor
15.4 cm. × 18.7 cm. (6-1/16 in. × 7-3/8 in.)
B H [L]
The Historical Society of Pennsylvania, Philadelphia

Map reference: Toano Quadrangle, Virginia
UTM coordinates: Area enclosed within the following coordinates: 18.033970.415120
 Northwest; 18.034280.415120 Northeast; 18.034280.414800 Southeast;
 18.033970.414800 Southwest
Orientation: Theoretically 180°

Airy Plain Estate, in New Kent County on the York River opposite West Point, Virginia, belonged to Henry Banks (1761–1836), a Richmond merchant and lawyer. Latrobe spent time at Airy Plain in March 1797 while recovering from an illness. The leisure afforded him by his enforced stay on the estate allowed him the time to execute the rough sketch of the estate as well as the succeeding four drawings. Latrobe gave the finished plan of Airy Plain to Banks as a token of friendship and as thanks for the help Banks had given Latrobe during his first year in America.

The sketchbook version of this drawing, at right, appears to have been made at one sitting, perhaps developed from field observations, discussions with the owner's family and other local people, and any available survey plats or sketches of the land. The views compare favorably with the actual topography of the area; the millpond, marshes, and forested area remain much the same today. Latrobe drew these plans with south to the top of the pages.

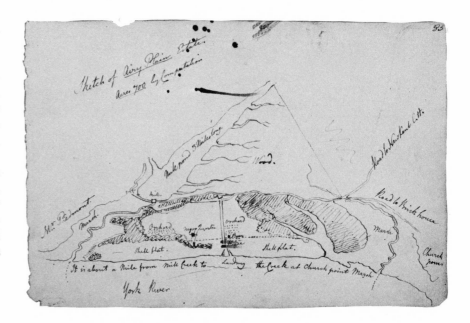

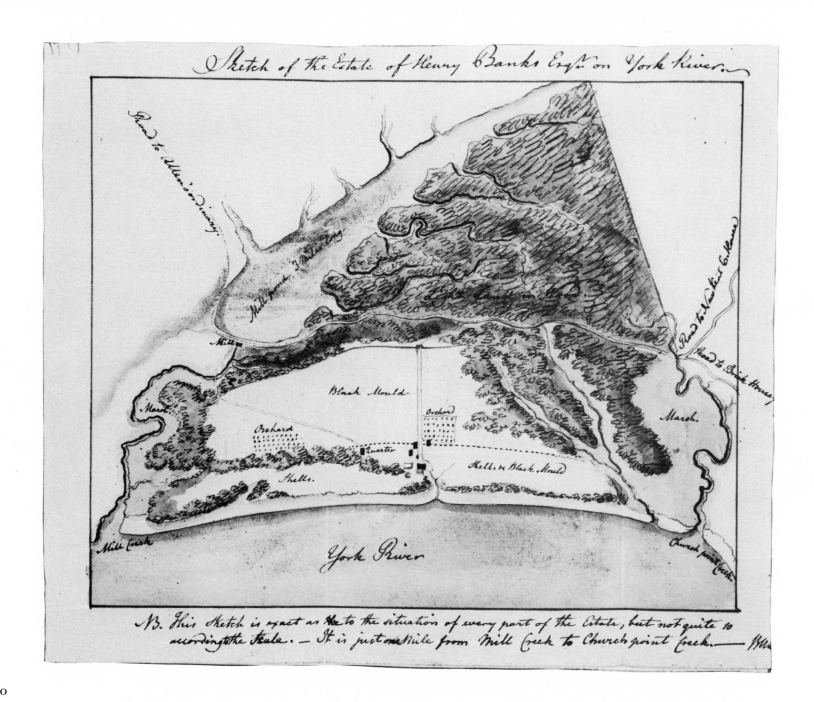

Sketch of the Estate of Henry Banks Esqr on York River.

Road to Allen's Ferry.

Mill pond, 3 Miles long

Mill

Marsh.

Black Mould

Orchard

Orchard

Quarter

Shells & Black Mould

Shells.

Mill Creek

York River

Road to New Kent C. House

Road to Brick House.

Marsh.

Church point Creek.

NB. This Sketch is exact as to the situation of every part of the Estate, but not quite
according to the Scale. — It is just one Mile from Mill Creek to Church point Creek. — JM

31. "York River, looking N.W. up to West Point"

Undated [March 1797]
Pencil, pen and ink, watercolor
Three pages: First page 17.7 cm. × 26.4 cm. (6-15/16 in. × 10-3/8 in.); second page 17.7 cm. × 26.1 cm. (6-15/16 in. × 10-1/4 in.); third page 17.7 cm. × 25.3 cm. (6-15/16 in. × 9-15/16 in.)
SKETCHBOOK II

Map references: Toano Quadrangle, Virginia; West Point Quadrangle, Virginia
UTM coordinates: Viewing position: 18.034174.415064; Pamunkey River: 18.034020.415538; West Point: 18.034137.415462; Extreme Point: 18.034166.415466; Mattaponi River: 18.034190.415580; Corbin Creek: 18.034296.415786; Goff Point: 18.034260.415317
Orientation: 0°

Latrobe made this triptych view looking north from the top of a bluff on the shore of the York River slightly downstream from the manor house of Airy Plain estate, which is seen at the far left. In the sketchbook Latrobe provided the following key to the letters visible just above the horizon in the third portion of the drawing:

From *a* to *e*, the Town of West point
a. Mr. Carter Braxton's house
b. Mrs. Druitt's
c. Bingham's tavern
d. Mr. Sullivan, a Merchant
e. is the extreme point
f. Mr. Francis Corbyn's Seat
g. The point at the mouth of the Matapony
h. Dudley's ferry
i. Goff's point

West Point is in King William County at the point where the Pamunkey and Mattaponi rivers converge to form the York River. In this drawing the mouth of the Pamunkey can be seen about two-thirds of the way across the second portion. The Mattaponi River divides King William County from King and Queen County; Dudley's ferry and Goff's Point (now Goff Point) were thus in King and Queen County.

Since 1797 the area in view has been adversely affected by erosion and sedimentation due to land clearance and to poor cultivation and land use practices. The result has been the creation of extensive marshes along the Pamunkey and Mattaponi rivers and a decrease in the depth of the Pamunkey, Mattaponi, and York rivers. The area is still highly wooded.

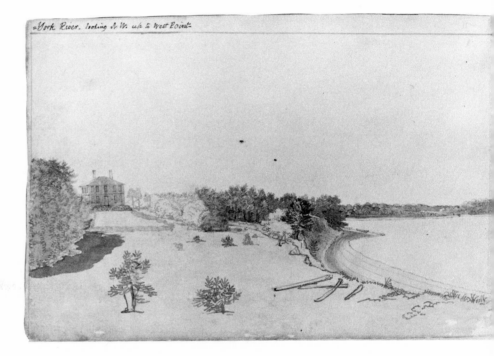

NO. 31

32. "View of the fishing Shore on York river at Airy plains . . ."

Undated [March 1797]
Pencil, pen and ink, watercolor
17.7 cm. × 27.8 cm. (6-15/16 in. × 10-15/16 in.)
SKETCHBOOK II

Map reference: Toano Quadrangle, Virginia
UTM coordinates: 18.034141.415069
Orientation: 100°

Latrobe noted in his sketchbook, "The House represented in this Drawing was burnt down about the latter end of the Year 1797." When making this drawing, Latrobe was slightly upstream from the manor house of Airy Plain Estate looking east-southeast down the southwestern bank of the York River. The stream flowing into the York in the foreground is visible just to the right and in front of the house in No. 31. There is now a tidal flat offshore, and the York River at this point is shallower now than in 1797 due to culturally accelerated rates of erosion and sedimentation.

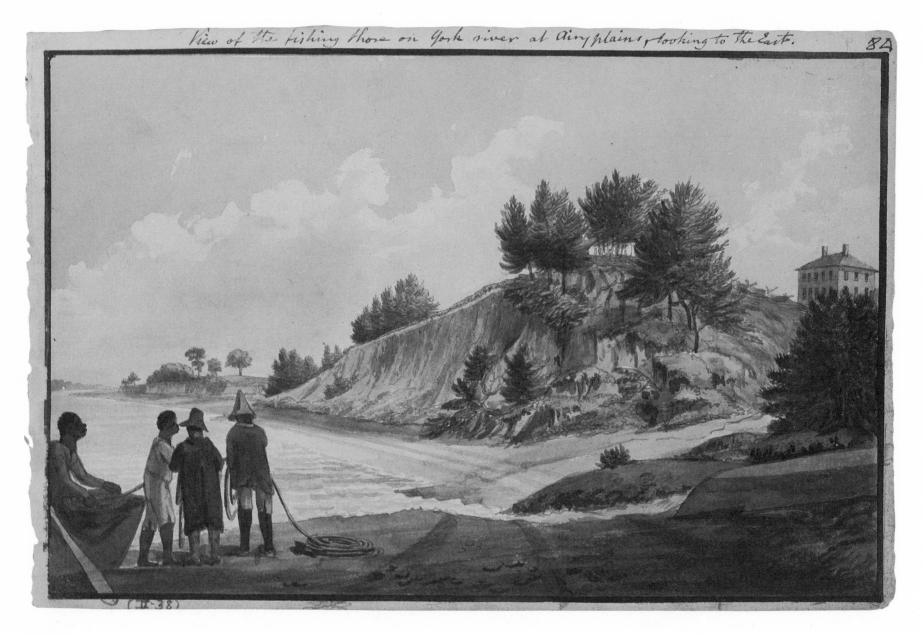

View of the fishing shore on York river at Airy plains, looking to the East.

NO. 32

33. "Sketch of the bay Alewife and the insect in his mouth"

Undated [March 1797]
Pencil, pen and ink, watercolor
17.7 cm. × 27.8 cm. (6-15/16 in. × 10-15/16 in.)
SKETCHBOOK II

Latrobe executed this drawing while illness confined him "for several days, at the house of a friend on York river in Virginia, during his absence." The friend was Henry Banks and the house was Airy Plain (see No. 30). The drawing served as a model for the plate accompanying his "A Drawing and Description of the *Clupea Tyrannus* and *Oniscus Praegustator*," a paper he read before the American Philosophical Society on 7 February 1800 and published in the fifth volume of the Society's *Transactions* (1802). That paper was the first technical description of the alewife, now *Alosa pseudoharengus*. Latrobe's specific name, *tyrannus*, is now used for a related species, the menhaden, *Alosa tyrannus*. Efforts are now under way to restore Latrobe's name to the alewife.

Latrobe's drawing of the alewife is not among his best; being ill, he worked under the disadvantage of having "a very weak hand." He has omitted the dorsal fin, and the mouth is not well drawn. The prominence of the dark spot indicates that his specimen was something less than fresh, for in the living fish overlaying silver pigment masks this spot. The alewife attains a size of ten to fifteen inches and formerly was a common table fish. It is a gregarious fish and is found along the seacoast from New York to Virginia near the mouths of the streams from which it emerges and to which it returns in the spring to spawn.

The drawing also depicts the fish louse, which Latrobe named *Oniscus praegustator* and which is now *Olencira praegustator* (Latrobe). In his paper Latrobe described the louse and its relationship to the alewife:

> In this season [March through May], each of these alewives carries in her mouth an insect, about two inches long, hanging with its back downwards, and firmly holding itself by its 14 legs to the palate. The fishermen call this insect *the louse*. It is with difficulty that it can be separated, and perhaps never without injury to the jaws of the fish. The fishermen therefore consider the insect as essential to the life of the fish; for when it is taken out, and the fish is thrown again into the water, he is incapable of swimming, and soon dies. I endeavoured in numerous instances to preserve both the insect and the fish from injury, but was always obliged either to destroy the one, or to injure the other. I have sometimes succeeded in taking out the insect in a brisk and lively state. As soon as he was set free from my grasp, he immediately scrambled nimbly back into the mouth of the fish, and resumed his position. In every instance he was disgustingly corpulent, and unpleasant to handle; and it seemed, that whether he have obtained his post, by force, or by favor, whether he be a mere traveller, or a constant resident, or what else may be his business where he is found; he certainly has a *fat* place of it, and fares sumptuously every day. (BHL, "*Clupea Tyrannus* and *Oniscus Praegustator*," p. 78)

This "louse" is not an insect, as Latrobe thought, but a crustacean, or more accurately a parasitic isopod, that can reach a length of an inch. The life cycle of this parasite is not well understood. When the isopod enters the mouth of an immature fish, it is a small, free-swimming male. Once attached to the alewife's palate, the male will develop into a female unless another more developed female is already present. Latrobe failed to observe that a single fish can commonly host two of these parasites. Although it is not thought to feed, the female does increase to the size indicated in Latrobe's drawing. In other respects, however, the drawing is poor. Latrobe must have damaged his specimen in removing it, for the two pairs of antennae, which he says "must have been very minute indeed," should have been visible to the unaided eye. The wormlike "Leaches fixed upon the Louse" drawn by Latrobe are probably the small males of these protandric hermaphrodites.

The Latin text in the drawing to the left and right of the louse was added later by Latrobe. At the time he made the drawing, he "had no books to refer to, then; but examining the *Systema Naturae* of Linnaeus, I was surprized to find so exact a description of the insect. . . ." Despite the similarities Latrobe noticed between his louse and the "insect" described by Linnaeus, the louse is in fact different from *Oniscus physodes*, a free-living marine isopod, and thus carries Latrobe's name as the first to describe it.

The Bay Alewife, or Oldwife, drawn to its full size with the Insect that inhabits its Mouth, — also drawn exactly the natural size. The fishermen call it the Louse. See Virginia N°. VII p. 78 & 83.

Generic description.

Oniscus. Pedes XIV

Antennae setaceae

Corpus ovale. The Louse.

I did not observe the Antennae. They must have been very minute indeed).

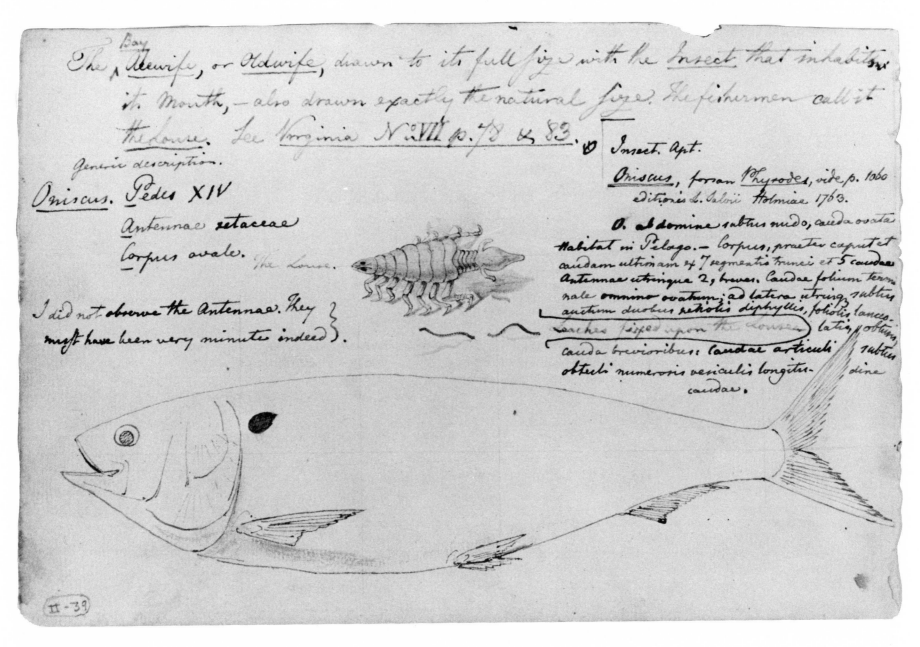

Insect. Apt.

Oniscus, forsan Phyrodes, vide p. 1060 Editionis L. Salvii Holmiae 1763.

O. Abdomine subtus nudo, cauda ovata Habitat in Pelago. — Corpus, praeter caput et caudam ultimam ex 7 segmentis trunci et 5 caudae Antennae utrinque 2, breves. Caudae folium terminale omnino ovatum; ad latera utrinq subtus auctum duobus setolis diphyllis, foliolis lanceolatis, piped upon the louses latis, obtusis, cauda brevioribus: caudae articuli subtus obtecti numerosis vesiculis longitudine caudae.

34. "Drawing of a Garfish caught in York river"

Undated [c. 25 March 1797]
Pencil, pen and ink, watercolor
17.7 cm. × 27.8 cm. (6-15/16 in. × 10-15/16 in.)
SKETCHBOOK II

Esox (osseus)? of *Linnaeus*. called Billfish on the Susquehanah.

The Garfish. The drawing on the other Side was made from a fish 3 feet 6 i. long from snout to tail, caught at *Airy plains,* Yorkriver March 25th, 1797.

This very singular fish lives equally in salt and in fresh water. Very large ones are caught in the Millpond. The whole of their structure is wond[er]fully adapted to their mode of life and the catching of their food in shallow water. Though they are satisfied with Minners, and other small fish, I am informed that the chief food found in their entrails are soft crabs. The whole of their head consists of bones the sutures of which appear in *Fig. 1*. The nose is shaped almost like that of a dog, it is cartilaginous and moveable, and is furnished with 4 Nostrils, two rather underneath, and two above. They lead into two cavities, which occupy each one half of the nose. (*Fig 3 & 4*) They are separated by a Cartilaginous septum, into which is inserted a nerve as thick as a small twine, that fills a tube extending into the skull, so that the Nostrils do not answer the purpose of breathing as might appear at first sight. In two, that I dissected I found the cavities full of sand, and as they are obliged to thrust their snouts into the sand after their prey, Nature seems wisely to have furnish[ed] each cavity with two Nostrils, by which the water may pass through and cleanse it. I have no doubt but that the end of tracing their food by the smell is answered by this Organ. On each side of the Middle Duct is another narrow tube also leading from the back of the Cavities. These contain each three or 4 Black threads which appear more like Veins or sinews than any thing else. They seem to belong to the teeth as they lie exactly over them, and as there are two similar ones belonging to the underjaw. Each jaw is furnished with a range of very close irregular teeth on its outer edge, as sharp as needles, and more like the prickles of the *prickly Pear,* (*Cactus*) than any thing else. Just within the Mouth is a regular range of upright teeth alternately in each jaw perfectly sharp and round. There were about 40 of them in each side. The roof and bottom of the mouth is covered with a hard membrane, *nappy*, if I may use the term, with very fine sharp points. Under the nose and in front of the underjaw are teeth, small and large, hooked back. Nothing seems capable of escaping so formidable a machine. The tongue is very short and adheres to the lower part of the mouth. It is little less hard than bone and very rough. The Gills are edged with a tough scaly substance which lays close to the body and acts as a valve when the Gill is raised suffering nothing to enter from behind. The Entrails consist of a single gut extending quite to the last fin, and having 2 or 3 folds. The skin is so tough and covered with such bony scales that it is necessary to throw the fish into the fire to get it off. It there shrinks from the flesh and then *see page 93.* [*The remainder of Latrobe's description is missing.*] (BHL, SKETCHBOOK II)

The longnosed gar, or gar pike, now *Lepisosteus osseus,* is found in freshwater from Quebec to Florida, and in the west from the Great Lakes to northern Mexico. Adults are frequently found in brackish water in the southern parts of its range, and less frequently in the sea, where Latrobe observed his specimens. They are olive brown above, white below, and often blotched. Young fish are more brightly colored and can have cinnamon stripes. Longnosed gar, which grow to a length of five feet, feed on fish and crustaceans by hanging still in vegetation and attacking by a single strike. The family to which the longnosed gar belongs are referred to as "living fossils" because they have retained several primitive features, namely, the elongated bodies and thick, diamond-shaped ganoid scales, which Latrobe emphasized in his drawing.

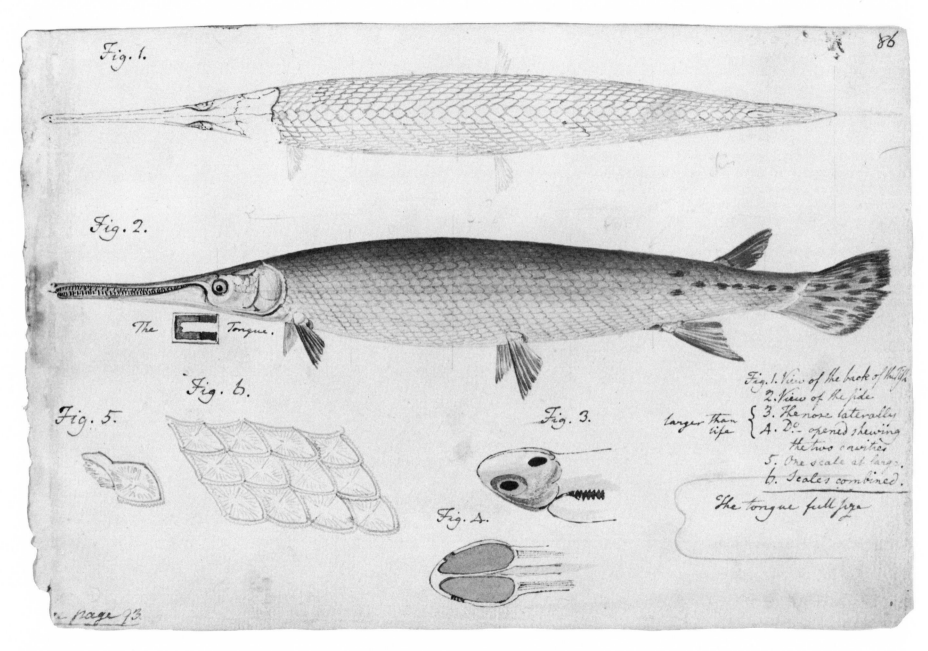

Fig. 1.

Fig. 2.

The ▭ Tongue.

Fig. 6.

Fig. 5.

Fig. 3.

Fig. 4.

Larger than life

Fig. 1. View of the back of the fish
2. View of the side
3. The nose laterally
4. D.º opened shewing the two cavities
5. One scale at large
6. Scales combined.

The tongue full size

page 93

86

35. "Spiraea"

10 May 1797
Pencil, pen and ink, watercolor
19.0 cm. × 23.7 cm. (7-7/16 in. × 9-5/16 in.)
SKETCHBOOK IV

A specimen and drawing of this member of the rose family were first sent to London from Virginia by John Banister in 1689. His drawing was reproduced by Leonard Plukenet in *Phytographia* (London, 1691–92), tab. 236, f.5. Johann Friedrich Gronovius published the record of John Clayton's specimen in *Flora virginica* (1739, 1743), no. 290. Linnaeus based his description of *Spiraea trifoliata,* now *Gillenia trifoliata,* on Plukenet and Gronovius. Latrobe had the second edition of Gronovius (1762), which followed Linnaeus's system of plant classification.

In addition to the charm of this white spring flower, its medicinal properties were highly regarded during the eighteenth century. The plant was known as ipecac or Indian physic and was cultivated in Virginia gardens, including Jefferson's. The British were also curious about its efficacy, and a market for the root bark developed quickly.

As the modern scientific name indicates, the root bark of ipecac is a rich source of gillenin, a powerful emetic or, when diluted, a sudorific. According to a British method, gillenin was obtained by mixing the powdered dry root bark in alcohol and evaporating the resulting red tincture. The residue was dissolved in water, filtered, and a purer form obtained by a second evaporation. Two to four grains were recommended for dyspepsia, rheumatism, costiveness, and dropsy.

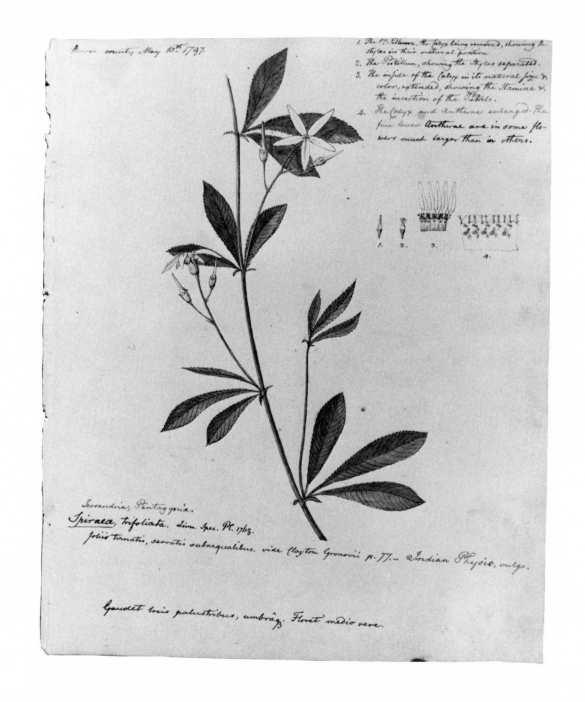

Monroe county, May 10th 1797.

1. The Pistillum, the Calyx being removed, showing the Styles in their natural position
2. The Pistillum, showing the Styles separated.
3. The inside of the Calyx in its natural size & color, extended, showing the Stamina & the insertion of the Petals.
4. The Calyx and Antherae enlarged. The five lower Antherae are in some flowers much larger than in others.

Icosandria, Pentagynia.

Spiraea, trifoliata. Linn. Spec. Pl. 1763.
foliis ternatis, serratis subaequalibus. vide Clayton Gronovii p. 77. – Indian Physic, vulgo.

Gaudet locis palustribus, umbrâgz. Floret medio vere.

36. "View of the North front of Belvidere, Richmond"

Undated
Pencil, pen and ink, watercolor
17.7 cm. × 27.8 cm. (6-15/16 in. × 10-15/16 in.)
SKETCHBOOK II

Map reference: Richmond Quadrangle, Virginia
UTM coordinates: Viewing position: 18.028333.415744; Belvidere: 18.028334.415736
Orientation: 165°

Belvidere, the home of Bushrod Washington, was a seventeen-acre estate on a hill near the lower end of the James River falls, across from the eastern tip of Broad Rock Island (now Belle Isle). The mansion was at the center of what is now the city block bounded by Belvidere, Laurel, China, and Holly streets. It was just west of the site of the state penitentiary that Latrobe was constructing.

Originally built by William Byrd III around the middle of the eighteenth century, Belvidere passed through the hands of several owners before Bushrod Washington purchased it from Henry ("Light-Horse Harry") Lee in June 1795. During his years in Richmond, Latrobe no doubt frequented this elegant estate of his friend. Washington retained possession of it only until February 1798, when he sold it to Col. John Harvie. In the early nineteenth century it again passed through the hands of several owners, the mansion finally being subdivided and rented to the families of workers at the Tredegar Iron Works and other workshops toward midcentury. In 1854 Belvidere was destroyed by fire.

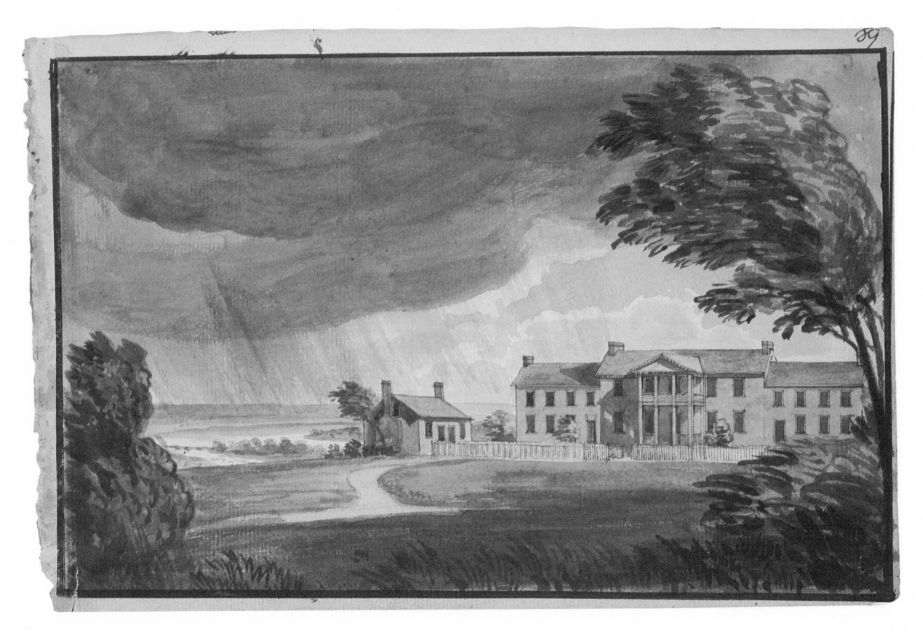

NO. 36

37. "View of the Capitol, Richmond, from Dr. James Macclurg's Dining room"

1 June 1797
Pencil, pen and ink, watercolor
17.8 cm. × 26.0 cm. (7 in. × 10-1/4 in.)
B H Latrobe del. June 1st 1797.
SKETCHBOOK III

Map reference: Richmond Quadrangle, Virginia
UTM coordinates: Viewing position: 18.028466.415725; Capitol:
 18.028484.415740; Governor's House: 18.028498.415735
Orientation: 45°

One year before Latrobe put pen to paper to record the Capitol at Richmond, another discerning traveler wrote:

From the opposite side of the river this building appears extremely well, as its defects cannot be observed at that distance, but on a closer inspection it proves to be a clumsy ill shapen pile. The original plan was sent over from France by Mr. Jefferson, and had great merit; but his ingenious countrymen thought they could improve it. . . . This building is finished entirely with red brick; even the columns themselves are formed of brick; but to make them appear like stone, they have been partially whitened with common whitewash. (Weld, *Travels*, p. 108)

Toward the middle of the nineteenth century a chronicler of Richmond described the site in detail:

The *Capitol Square* was originally as rugged a piece of ground as many of our hillsides in the country exhibit after a ruinous course of cultivation. Deep ravines furrowed it on either side, and May and Jamestown weeds decorated and perfumed it in undisturbed luxuriance. . . . In front of the portico stood an unpainted wooden belfry, somewhat resembling the dairys we see at good farmhouses. . . .

The *Capitol* itself, not then stuccoed exposed its bare brick walls between the columns or pilasters. . . .

The *Governor's House* preceding the present one, was a very plain wooden building of two stories, with only two moderate sized rooms on the first floor. It was for many years unconscious of paint, and the furniture was in keeping with the republican simplicity of the edifice. . . . The palings around the yard were usually in a dilapidated condition, and the goats that sported on the steep hill sides of the Capitol Square, claimed and exercised the liberty of grazing on his Excellency's grounds. (Mordecai, *Richmond in By-Gone Days*, pp. 57–59)

Latrobe's own graphic commentary on the Richmond Capitol was executed from the home of Dr. James McClurg (1747–1825), a European-trained physician and professor of medicine at the College of William and Mary. In 1797, his house stood southwest of the Capitol on Main Street between Tenth and Eleventh streets, the future site of the Bank of Virginia. This drawing shows the Capitol without the coat of stucco, the Ionic capitals, and the door- and window-frames added the same year, and with the stockinglike effect of the whitewash on the lower part of the red brick columns.

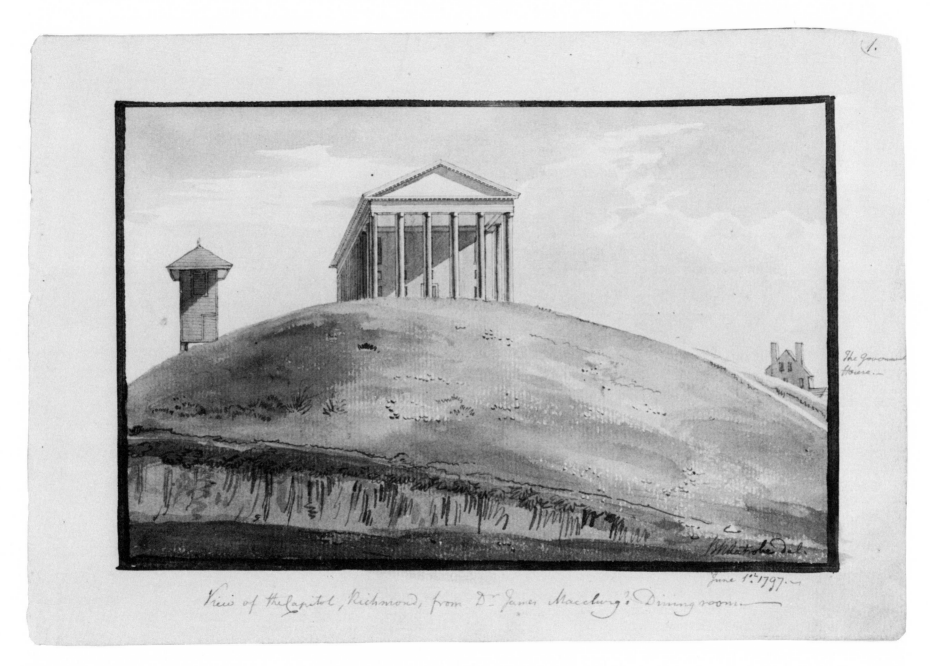

The Government House.

View of the Capitol, Richmond, from Dr James Macclurg's Dining room.

June 1st 1797.

38. "Remains of good old fashions, exhibited in the Foederal Court"

1 June 1797
Pencil, pen and ink, watercolor
17.8 cm. × 26.0 cm. (7 in. × 10-1/4 in.)
SKETCHBOOK III

In May 1796, Latrobe observed:

> I have had considerable pleasure, since my arrival here, in attending the different courts of Justice held in the Capitol: The foederal court, the district court, the court of Chancery, and the court of Appeals. The first singularity that must immediately impress itself upon the mind of a Europaean, and especially an Englishman, is the plain undecorated appearance of the court. Judges without Wigs or Robes, in the plain dress of farmers, and Council without Wigs or Gowns in the almost *slovenly* dress of a *town*-man of business. (BHL, *Journals,* 1:129)

Only one year later, Latrobe apparently found several exceptions to his rule, and he recorded them in this sketch as well as in No. 48. The "good old fashions" in this sketch would include the gown and falling band, or fur collar, worn by Mr. Wray of Hampton (most likely George Wray, collector of customs and inspector of the port of Hampton). Wray was presumably the court marshal, an officer who would have performed such functions as taking charge of the jury and striking the floor with his tipstaff on the judge's entrance. The judge, at the extreme right, also wears a wig and band. While these courtroom "fashions" remained in use in England, they became a rare sight in American courts by the end of the eighteenth century.

The quote in the lower right is from Shakespeare, *Othello,* act 5, scene 2, lines 341–42: "Speak of me as I am; nothing extenuate, / Nor set down aught in malice." A second quotation, though pictorial rather than literary, seems to occur in Latrobe's representation of the judge at the extreme right. The face of the judge appears to echo that of a justice who shows up three times in the later states of William Hogarth's print, *The Bench* (see No. 48). Light pencil outlines for an unfinished head on Mr. Wray's right also resemble the Hogarth judge.

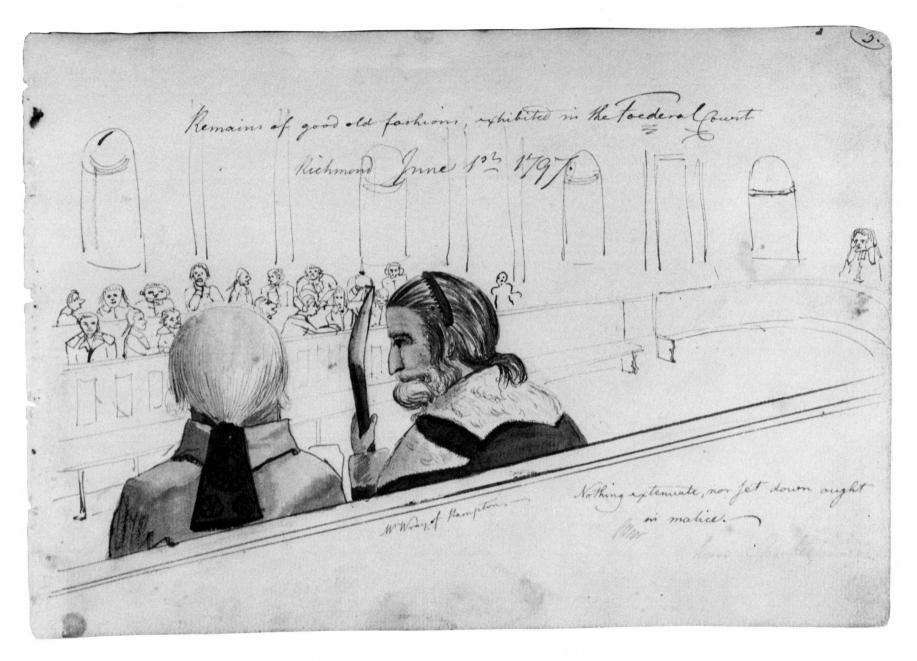

Remains of good old fashions, exhibited in the Foederal Court

Richmond June 1st 1797

Mr Wray of Hampton

Nothing extenuate, nor set down aught in malice.

39. "Sketch of Coll. John Mayo's house at the Hermitage near Richmond, Virginia"

10 July 1797
Pencil, pen and ink, watercolor
17.8 cm. × 26.0 cm. (7 in. × 10-1/4 in.)
B H Latrobe.
SKETCHBOOK III

Map reference: Richmond Quadrangle, Virginia
UTM coordinates: Viewing position: approximately 18.028190.415987; Hermitage:
approximately 18.028200.415988
Orientation: Approximately 85°

This sketch depicts the country seat of Col. John Mayo (1760–1818), a prominent Richmond planter and landowner. The Hermitage was west of the city, approximately on the site of what is today the Virginia Science Museum, formerly the Broad Street Station. While recording this scene, Latrobe stood to the west-southwest of the building and faced east. At the time Latrobe executed this drawing he was at work in Richmond "in setting out the foundation of the new Penitentiary house, and in getting forward the provisory steps for its erection." (BHL, *Journals*, 1:243)

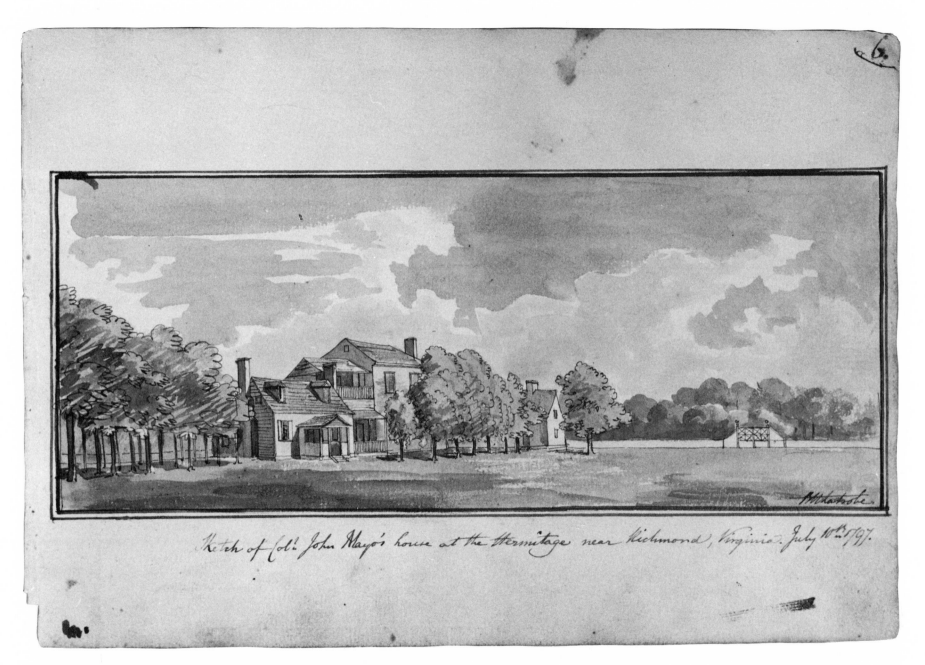

Sketch of Col.ᵒ John Mayo's house at the Hermitage near Richmond, Virginia. July 10ᵗʰ 1797.

40. "Extraordinary appearances in the Heavens, and on Earth"

2 August 1797
Pencil, pen and ink, watercolor
17.8 cm. × 26.0 cm. (7 in. × 10-1/4 in.)
B H Latrobe nat. del.
SKETCHBOOK III

Returning to Richmond from a brief trip to Williamsburg, Latrobe observed this "most perfect and singular" rainbow. At the time he saw it he was on Church Hill, one of the two hills upon which Richmond was built.

When on my return to Richmond I arrived in the stage on the top of Churchhill all the passengers were obliged to get out, as the road was stopped up by a waggon. This gave an opportunity of observing a Rainbow the most perfect and singular I ever saw. It was spread like a fan the circumsference being in many places connected with the center by many broad and luminous rays. (BHL, *Journals*, 1:248)

The appearance of the rainbow was for about 10 minutes nearly like the drawing. The Rays then began to play very much like those of the Aurora borealis. They appeared to be rather occasioned by a luminous, perhaps electrical fluid, than by the reflection of the solar light. However the center of the Rainbow was also the center from which they diverged.

I observed this Rainbow the more particularly, as all the passengers in the stage were obliged to get out, on account of a Waggon which stopped up the road down Church hill. One of the horses, had fallen down in convulsions and was to all appearance dead. He was dragged from under the pole, but the negroes attempting to throw him into a gulley, one of them laid hold of his tail to pull him away. In a moment however he revived, and trotted up the hill the Negroe still holding fast by his tail, lest he should escape. (BHL, SKETCHBOOK III)

The phenomenon of rays of light seemingly fanning out toward a double arc rainbow portrayed by Latrobe in this watercolor is certainly extraordinary and cannot be observed very often. Contrary to Latrobe's speculation concerning a luminous, electrical fluid, the fanlike rays did indeed emanate from the sun, appearing to converge at a point near the horizon opposite the sun. The rays were parallel to each other and their convergence was an optical illusion. The bright rays here depicted comprise the normal background illumination inside the primary rainbow because light from the raindrops is also reflected into that area. These rays were set off and highlighted by dark "rays," caused by shadows of clouds or cloud debris located between the sun and the observer's position.

The beauty and perfection of this heavenly appearance stand in bold contrast to the folly of the human exertions in the foreground. The earthly scene, in a sense, becomes more ludicrous by comparison with the natural backdrop, while at the same time, the human activity heightens the sense of nature's magnificence. Only a year later, Latrobe wrote: "For my part, I find nothing so instructive as the contemplation of the works of creation; and had I been appointed to settle the ceremonial of the arts, I believe I should have given the precedence to the representation of the Beauty of Nature, and not to that of the actions of Man." (BHL, "Essay on Landscape," *Journals*, 2:468)

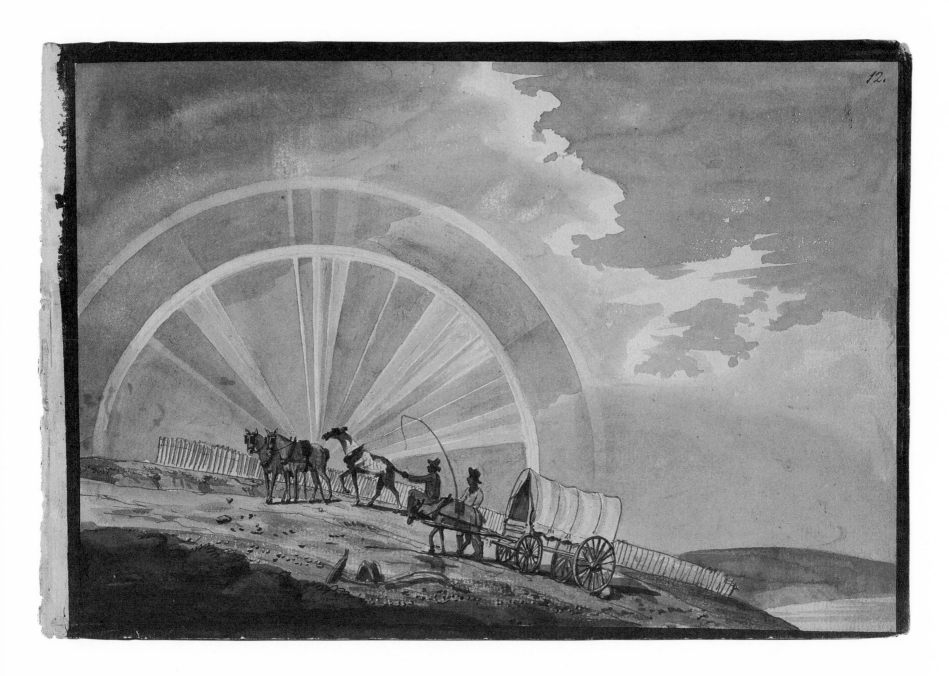

41. Billiards in Hanover Town, Virginia

Undated [November 1797]
Pencil, pen and ink, wash
17.8 cm. × 26.0 cm. (7 in. × 10-1/4 in.)
SKETCHBOOK III

In November 1797, Latrobe accompanied his friend Meriwether Jones, then a member of the Council of State, on a trip to Hanover Town, Hanover County, Virginia. Located on the south side of the Pamunkey River at the mouth of Totopotomoy Creek, Hanover Town was created on one hundred acres of Mann Page's land in 1762 by an act of the General Assembly. For several years, it served as an entrepôt for the tobacco trade in the area. However, with the rise of Richmond as an important trading center, the fortunes of Hanover Town rapidly declined. When Latrobe visited the town, he found it "in a miserable state of decrepitude," with only twenty-three white and fifty-two black inhabitants. Except for a few "very agreeable and most respectable men," the citizens of Hanover Town showed themselves

> more void of rational employment and sentiments; and though it seems invidious to condemn a town in the lump with so few exceptions, yet I think justice would not be done, if any commendation for industry, sobriety, understanding or good temper were conferred upon them. It is evidence enough against them, that they support two Billiard tables, at which it is impossible for the mind to catch the most distant entertainment or improvement. As every

face is known, and every acquaintance intimate, ceremony and even politeness have disappeared. (BHL, *Journals*, 2:327)

Isaac Weld also remarked on Virginians' predilection for billiards and gambling:

> Perhaps in no place of the same size in the world is there more gambling going forward than in Richmond. I had scarcely alighted from my horse at the tavern, when the landlord came to ask what game I was most partial to, as in such a room there was a faro table, in another a hazard table, in a third a billiard table, to any one of which he was ready to conduct me. Not the smallest secrecy is employed in keeping these tables; they are always crowded with people, and the doors of the apartments are only shut to prevent the rabble from coming in. Indeed, throughout the lower parts of the country in Virginia, and also in that part of Maryland next to it, there is scarcely a petty tavern without a billiard room, and this is always full of a set of idle low lived fellows, drinking spirits or playing cards, if not engaged at the table. (Weld, *Travels*, p. 109)

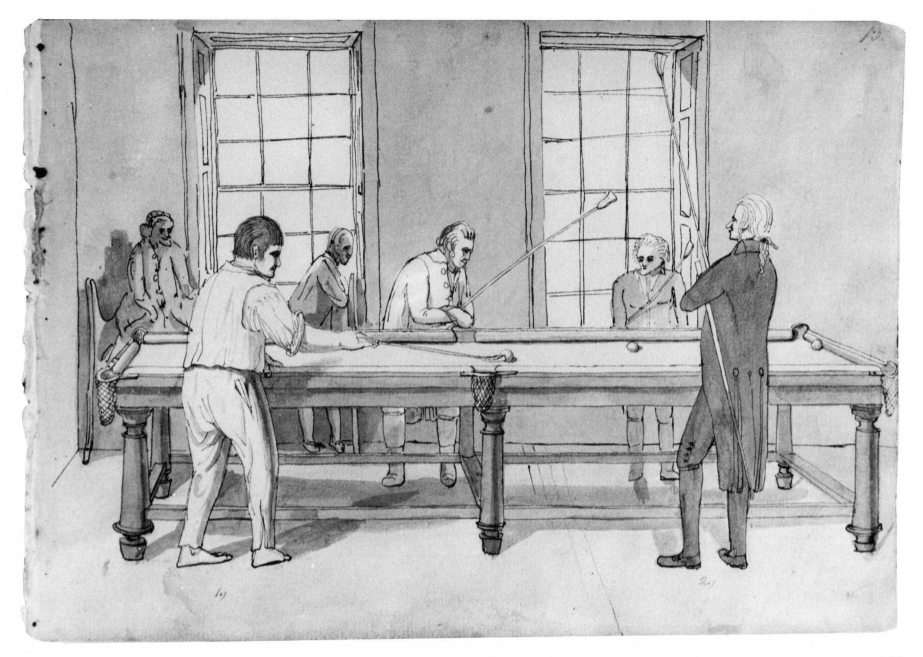

42. "An overseer doing his duty. Sketched from life near Fredericsburg"

13 March 1798
Pencil, pen and ink, watercolor
17.8 cm. × 26.0 cm. (7 in. × 10-1/4 in.)
SKETCHBOOK III

On 26 February 1798, Latrobe informed his friend Dr. Giambattista Scandella that he was planning to send to him "my remarks upon Slavery in Virginia as soon as I can transcribe them, and add whatever else occurs to me upon the subject." (BHL, *Journals,* 2:359; these remarks have not been found.) This drawing, then, was done during a period when Latrobe was attempting to crystallize his thoughts on slavery, having by that time observed the institution in the Old Dominion for two years. The scene of an overseer lazily smoking a cigar while watching two slave women work, and the sarcastic title that Latrobe gave to it clearly suggest Latrobe's sensitivity to the harshness and injustice of slavery. Although he wrote little about slavery in his Virginia journals, less than a year before he executed this watercolor, in a discourse on national manners and morals, Latrobe broke into an impassioned aside on the condition of blacks:

> Poor wretched Blacks! You are indeed degraded; not even considered as better for virtue, or worse for vice! Outcasts of the moral, as of the political world! Your *loves* on a level with those of the dogs and cats, denied protection to your affections, and deemed incapable of that sentiment, which, refining sexual desire into love melts soul into soul with a union not less rapturous than the embrace of wedded and *virtuous sensuality.* (BHL, *Journals,* 1:225)

For the figure of the overseer, Latrobe may have worked under the influence of John Flaxman's portrayal of Paris in "Hector Chiding Paris," a plate in Flaxman's *Iliad* (p. 32). Without being by any means identical, the two figures bear a marked resemblance to each other. Moreover, the two illustrations have comparable subject matter, for both pictures revolve around duty and the unmanly indolence of a male. Hector rebukes Paris for neglecting his duty; Paris has abandoned his countrymen in their war with the Greeks, which he himself caused, and has withdrawn into the company of his wife, Helen, and her handmaids at his princely house. The overseer does perform his duty, but it is the strange one of lounging while women labor. The fact that the American subject, like the Homeric one, concerns deviation from manly duty strengthens the possibility that Latrobe thought of the *Iliad* plate.

On the other hand, Latrobe's inscription identifies the "Overseer" as "Sketched from life." Taken at face value, the inscription implies that the overseer simply looked as we see him. Furthermore, in the case of all his direct and unmistakable Flaxman borrowings, Latrobe drew from Flaxman as an alternative to drawing from life—he did not have Nelly Custis (Figs. 3, 4, p. 24) or Armin (p. 35) in front of him when he drew them.

When Latrobe drew the "Overseer," however, he had already copied the figure of Paris in a drawing (Fig. 4, p. 24), and this may mean that he had stored up the image. That same drawing displays Latrobe's willingness to work variations on Flaxman's figures. Given these circumstances in addition to the similarity of form and the parallelism of content, it seems plausible that Flaxman's Paris did help Latrobe in handling the figure of the overseer, even if it cannot be determined how Flaxman's example modified what Latrobe saw in the field.

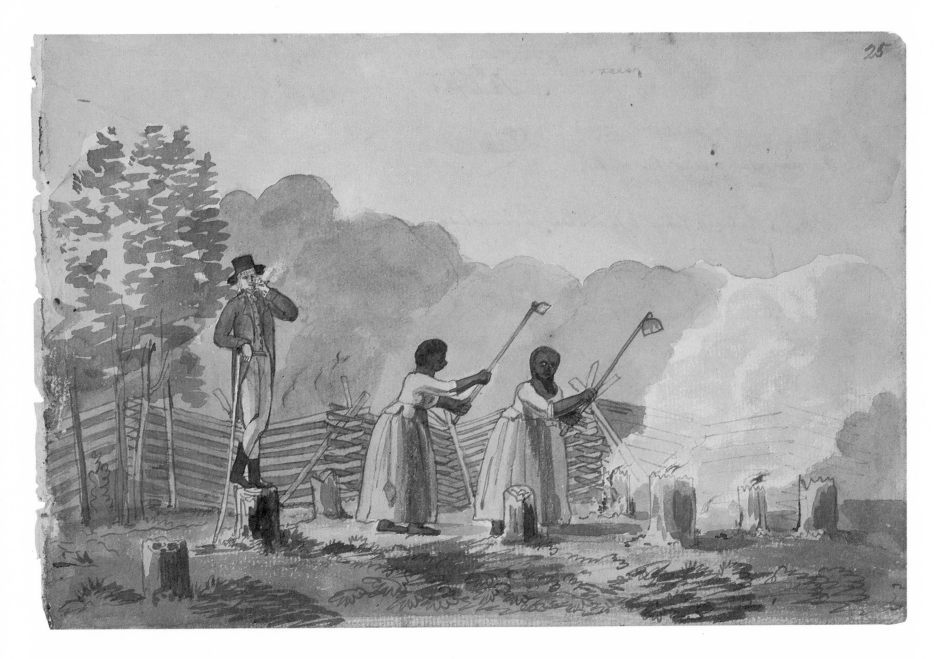

NO. 42

43. "... Sketch of the Bridge at the little Falls of the Potowmac ..."

16 March 1798
Pencil, pen and ink, watercolor
17.8 cm. × 26.0 cm. (7 in. × 10-1/4 in.)
B H Latrobe Boneval.
SKETCHBOOK III

Map reference: Washington West Quadrangle, District of Columbia–Maryland–Virginia
UTM coordinates: Viewing position: 18.031637.431090; Bridge: 18.031637.431076
Orientation: 345°

Rough Sketch of the Bridge at the Little Falls of the Potowmac about 3 miles above George town. The Span of the Bridge is about 120 feet. The higth of the King posts appeared to be about 15 feet. It was framed in New England of White pine, and brought hither by Water. (BHL, SKETCHBOOK III)

Three and a half years after Latrobe drew this scene, another traveler made further observations on the bridge:

Three miles from Georgetown, just at the head of tide water, and at what are called the little falls, a bridge of single arch crosses the Potomac. It is composed of wood; erected by one Palmer, from Connecticut. I was told that it was formed by him in Connecticut and shipped in pieces. The abutments are a huge pile of massy square stones bolted together with great iron pins, and melted lead, a novel sight to me, and I take it, capable of resisting the most swollen floods of water. The Virginia side a high bank, Maryland side, low base of immovable, large and deep rocks. The fact is, here the Potomac is narrow and deep. (John Shippen to Joseph Shippen, 13 December 1801, in Balch, ed., *Letters and Papers*, p. 311)

For this view, Latrobe was looking upstream from a spot in Arlington County on the Virginia, or southwest, bank of the Potomac, immediately below the mouth of Pimmit Run. The bridge, the first to be erected at the site of present-day Chain Bridge, was built in 1797 by the Georgetown Bridge Company, a group of merchants who wished to facilitate the transportation of goods from the upper country of Virginia into Georgetown via the Georgetown–Leesburg Road. The company contracted with "Timothy Palmer, an Artist, eminantly distinguished by the Bridges he has lately built over the rivers, the Merimick, in the State of Massachusetts, and Piscataqua, in New Hampshire," to design the bridge and supervise its construction. (*Columbian Chronicle* [Georgetown, D.C.], 19 June 1795, p. 4) In 1804, Palmer's bridge was replaced, and after the new bridge was washed out four years later, a chain suspension bridge designed by James Finley, with a span of one hundred twenty-eight feet between its stone towers, was erected in 1808. (For another of Finley's chain bridges, see No. 132.) This third bridge lent its name to all subsequent bridges built at this spot. The present Chain Bridge was constructed in 1937–38.

To the left of the bridge stood buildings that probably housed the components of an industrial center. At this location, Thomas Lee had established an official tobacco inspection warehouse in 1742. Between 1794 and 1815, a gristmill, a brewery, a distillery, and cooper and blacksmith shops were set up at the site. From the outcrop shown at the far left in the drawing, stone was later quarried and loaded into scows to be transported on the river. As a result of this quarrying, the outcrop is no longer extant. By 1850, the eastern shore of the Potomac, on the right side of Latrobe's view, had become the site of the Chesapeake and Ohio Canal.

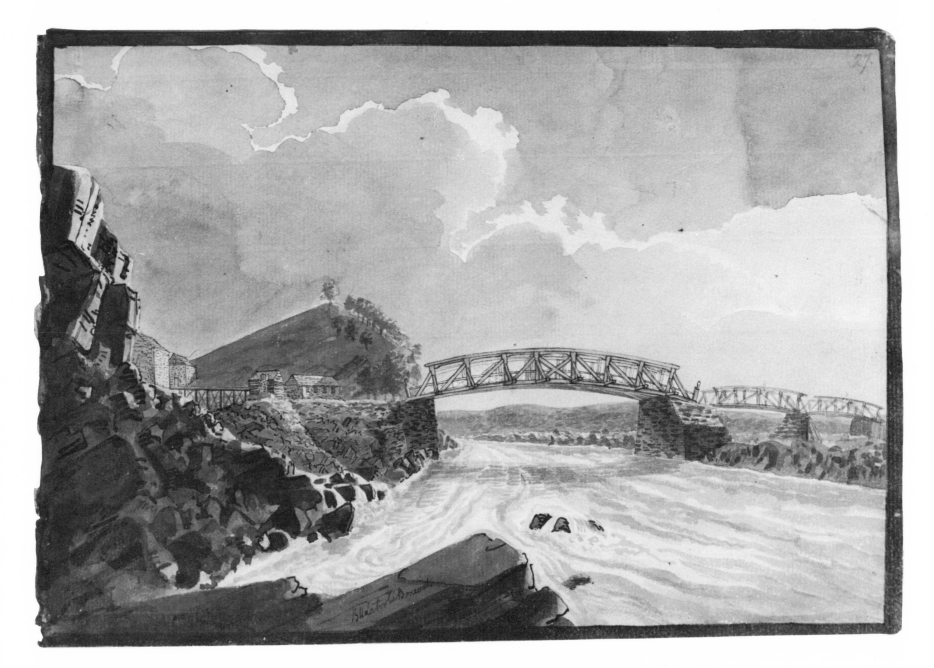

44. "A solemn humiliation under the reign of John Adams"

Undated [c. March–April 1798]
Pencil, pen and ink
9.8 cm. × 7.9 cm. (3-7/8 in. × 3-1/8 in.) on a page measuring 17.8
 cm. × 26.0 cm. (7 in. × 10-1/4 in.)
SKETCHBOOK III

This satirical sketch depicts what Latrobe presumed would take place on 9 May 1798, a day which President John Adams had proclaimed on 23 March to be one of "solemn humiliation, fasting and prayer." Adams's proclamation came in the midst of increasing diplomatic tensions between France and the U.S. After the Senate ratified Jay's Treaty with Great Britain, the French government began to seize American ships and confiscate their cargo under the assumption that the new American treaty with France's enemy, Britain, abrogated the Franco-American treaty of 1778. On 5 March 1798, President Adams notified Congress that the recent attempt by the United States to negotiate with France had failed, and two weeks later he called for stronger defense measures, arousing criticism by Jefferson. On 23 March, the same day he recalled diplomatic commissioners Charles Cotesworth Pinckney, John Marshall, and Elbridge Gerry from Paris following the XYZ Affair, Adams called upon Puritan tradition in a proclamation:

> As the safety and prosperity of nations ultimately and essentially depend on the protection and blessing of Almighty God, and the national acknowledgement of this truth is not only an indispensable duty which the people owe to Him, but a duty whose natural influence is favorable to the promotion of that morality and piety without which social happiness cannot exist nor the blessings of a free government be enjoyed . . . and as the United States of America are at present placed in a hazardous and afflictive situation by the unfriendly disposition, conduct, and demands of a foreign power, evinced by repeated refusals to receive our messengers of reconciliation and peace, by depredations on our commerce, and the infliction of injuries on very many of our fellow-citizens while en-

gaged in their lawful business on the seas. . . . I have therefore thought fit to recommend . . . that Wednesday, the 9th day of May next, be observed throughout the United States as a day of solemn humiliation, fasting, and prayer.

Latrobe derived his forecast of the response to Adams's proclamation principally from *The Sleeping Congregation*, a satirical print by the eighteenth-century English artist William Hogarth (at right). Unlike his borrowings from Flaxman's illustrations, this one does not follow Hogarth closely. It is likely that he did not have a copy of the print in front of him when he drew. But from Hogarth he took the fundamental idea of a cleric whose congregation responds to his preaching by falling asleep. From Hogarth came the construction of the right foreground as a pulpit in distorted perspective, with the reader in the lower deck, the preacher in the upper deck below the sounding board, and a portion of the congregation on the near side in the corner of the picture. And the inscription on Latrobe's pulpit points once more to his source, for Hogarth gave his preacher the same text, "Come unto me, all ye that labour and are heavy laden, and I will give you rest" (Matthew 11:28).

Latrobe's divine, however, differs altogether from Hogarth's droning cleric. In this figure and in other respects, the drawing echoes another Hogarth print of preaching, *Credulity, Superstition, and Fanaticism*. Influence from another artist shaped the gesture with which Latrobe's clergyman futilely attempts to exhort his congregation to an awareness of its sinfulness. No doubt with quite deliberate irony, Latrobe imitated the omnipotent right arm of God in Michelangelo's *Creation of Adam* on the Sistine Chapel ceiling. This detail suggests that Latrobe appreciated Hogarth's technique of burlesquing high art in his satirical prints.

William Hogarth, *The Sleeping Congregation*, 4th
state, 1762. Courtesy of the Print Collection,
Lewis Walpole Library, Yale University.

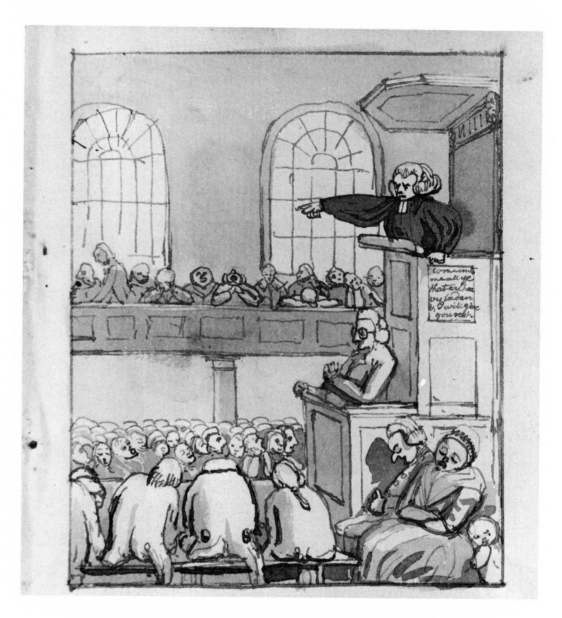

NO. 44

137

45. "View of the great Falls of Niagara . . ."

1 April 1798
Pencil, pen and ink, watercolor
17.8 cm. × 26.0 cm. (7 in. × 10-1/4 in.)
B H Latrobe Bon[eval]
SKETCHBOOK III

Map reference: Niagara Falls Quadrangle, Ontario–New York
UTM coordinates: Theoretical viewing position: 17.065606.477117
Orientation: Approximately 58°

View of the great Falls of Niagara, drawn from a Sketch and description by Dr. Scandella, and corrected from his recollection.

The view is taken from the road above the fall, from a bank elevated about 120 feet above the Water. The Edge of the Cataract being an internal Curve across which the view is taken only about one half of the Fall appears. (BHL, SKETCHBOOK III)

Unlike most of Latrobe's drawings, this view was not made from life. Rather, he drew it from a "Sketch and description" of Niagara Falls that he had received from his friend and intimate correspondent, the Venetian physician Giambattista Scandella (c. 1764–1798). Scandella, like Latrobe, possessed a wide-ranging curiosity, especially in regard to the country to which they had both only recently come. Latrobe had met Scandella in Richmond during the latter's travels in Virginia, and he saw him again in Philadelphia in late March and early April of 1798. Latrobe had traveled there from Richmond in order to study the Walnut Street Jail.

The watercolor shows the falls from a road above Table Rock, on the Canadian side. The view is to the northeast, with Horseshoe Falls in the foreground and Goat Island in the middle of the river, looking across to American Falls and the New York shore.

Accompanying the view, Latrobe drew a rough plan of the falls.

This plan is incorrect in several respects. It shows only two of the three islands known as the Three Sisters, and they improperly appear extending upstream from Goat Island rather than toward the Canadian shore. It also omits the islands between Goat Island and the American shore, perhaps attributable to Scandella's viewing the falls solely from the Canadian side.

On the verso of the watercolor Latrobe copied an Italian poem "di Dottore Scandella di Verona," an English translation of which accompanies the Italian text.

NIAGARA

Giunta al confin dove il petroso letto
In voragin si cangia ampia e profonda,
Curva a un salto precipita giù l'onda,
Da non salsi Ocean spinta allo stretto.
 Rotto con fragor cupo in suso è astretto.
Il flutto rimbalzav', che l'a innonda.
Disciolto in fumo, è al Ciel par sì confonda,
Sotto i piè trema il suol, l'alma nel petto.
 Con passo incerto quell'abisso immenso
Da una rupe a mirar fommi, e a gugli'imi;
Orror rimane istupidito il senso.
 Sul nebbioso volume indi a sublimi.
Voli m'ergo, e calcar natura io penso,
Tal che in mei di mortal più nulla estimi.

NIAGARA

Having come to the place where the stony bed
Changes itself into a wide and deep chasm,
The flood arcs into a sudden leap,
As the Ocean never leaped, squeezed into the strait.
 Broken with a dark roar, it is drawn out on high,
The flood was rebounding as it drowns the air,
Dissolved into mist, and seems so confused to the Heavens,
The earth trembles beneath the feet, the soul in the breast.
 With uncertain step this immense abyss
We came to view from a cliff, and we went to the spire
With dread our senses remained stunned.
 On the cloudy mass there up to the heights
I tried to stand forth, and I think Nature is treading,
So that in myself as mortal I no longer esteem me.

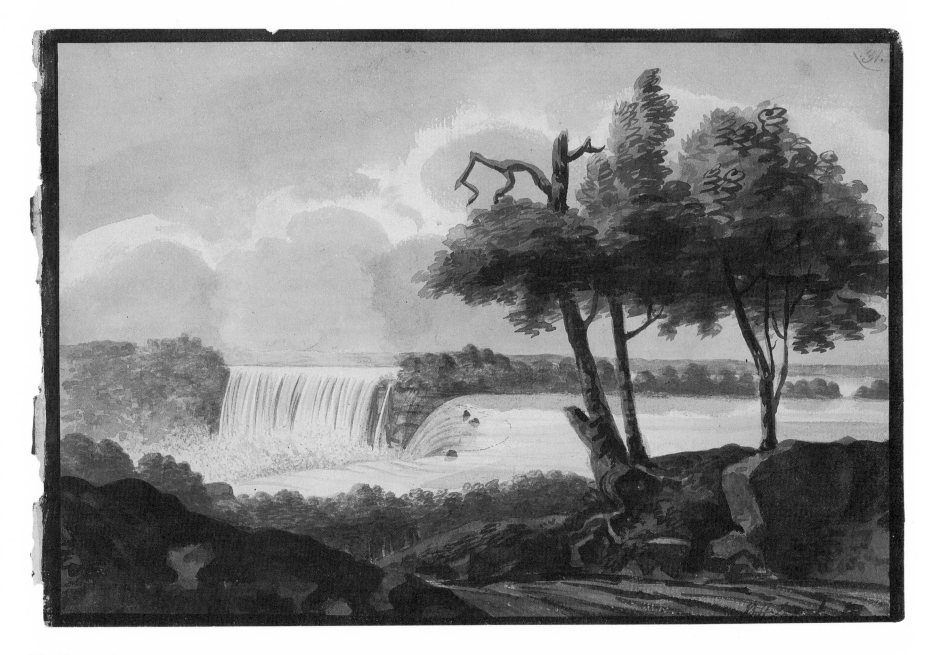

NO. 45

46. "Cyprepedium acaule"

Undated [early spring 1798]
Pencil, pen and ink, watercolor
17.8 cm. × 26.0 cm. (7 in. × 10-1/4 in.)
SKETCHBOOK III

47. Lady Slipper

Undated [early spring 1798]
Pencil, pen and ink, watercolor
17.8 cm. × 26.0 cm. (7 in. × 10-1/4 in.)
SKETCHBOOK III

The lady slipper, *Cyprepedium acaule*, is a member of the orchid family. The earliest American report of the plant, with an illustration, appeared in Jacques Cornut's *Canadensium plantarum aliarumque nondum editarum historia* (Paris, 1635), as *Calceolus marianus canadensis*. John Banister sent a Virginia specimen to London botanists about 1689, and Leonard Plukenet illustrated this species in his *Phytographia* (London, 1709), plate 418. Lady slippers, called moccasin flowers by the Indians, flower from April to July in moist woodlands throughout the United States. Due to the difficulty of growing this fragile plant from its minute seeds, there was in the eighteenth century a great interest in transplanting and cultivating the pink lady slipper as a garden species.

The true stem of the lady slipper is underground. The leaves and flower stalk arise together, achieving a height of twenty inches. During growth, the stalk twists so that what was originally the upper petal, or nectar-producing lip, becomes lowermost. As Latrobe has shown, the leaves are not exactly opposite. The two sepals that form the calyx and the two lateral petals are brown. The prominent veins of the spiralled lateral petals act as nectar guides for insects. Above the flower is a single green bract, or spathe.

The flower of the pink lady slipper is one to three inches long. In No. 46, Latrobe has correctly shown the lip with a definite cleft. In the "Lateral view" in No. 47, however, he seems to have confused the two lateral petals with the two sepals that form the calyx, and he mistakenly

believed the uppermost sepal to be one of a pair of spatha, or leaf bracts. In fact, the lady slipper has only one spathe, the tip of which appears behind the flower in the "Front View."

Latrobe has dissected this lovely flower because the arrangement of the stamens (male organs) and the position of the ovary are important for plant identification. In orchids, this arrangement is particularly interesting since the stamens and the pistil are not separate. As Latrobe has shown in view *b* in No. 47, they form a column with the stamens on the side.

Furthermore, lady slippers differ from all other orchids in having only two fertile or pollen-bearing stamens at the slipper's opening (view *a* in No. 47). Each fertile stamen is a short filament or stalk topped by a pollen sac, or anther (view *c* in No. 47). A third rudimentary stamen forms a glistening central shield, visible in the upper left of the "Lateral view," which covers the slipper's opening and which Latrobe has taken for a "Floral leaf."

The stigma is the top of the pistil, or female organ, on which the pollen lands. In the lady slipper, the stigma projects downward (views *a*, *b*, and *d* in No. 47), reflecting the spiral development of the plant mentioned earlier. The ovary of the lady slipper is embedded in the ends of the flower stalk. In the upper right of No. 47, Latrobe has opened a ripe ovary, or pericarp, to show the numerous small ovules which give rise to the tiny seeds typical of the species.

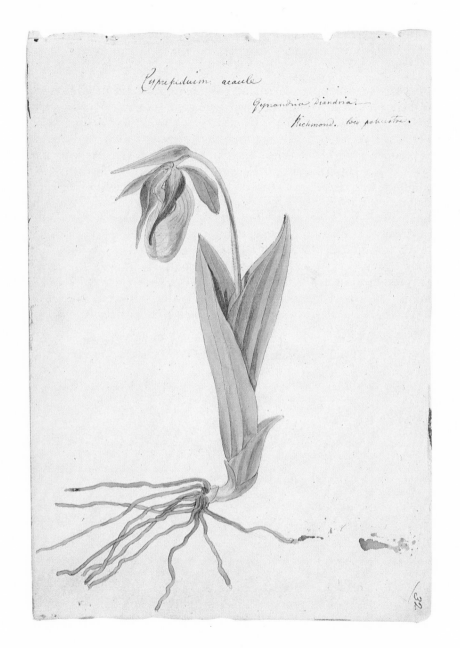

Cyprepedium acaule

Gynandria diandria.

Richmond. locus palustre.

NO. 46

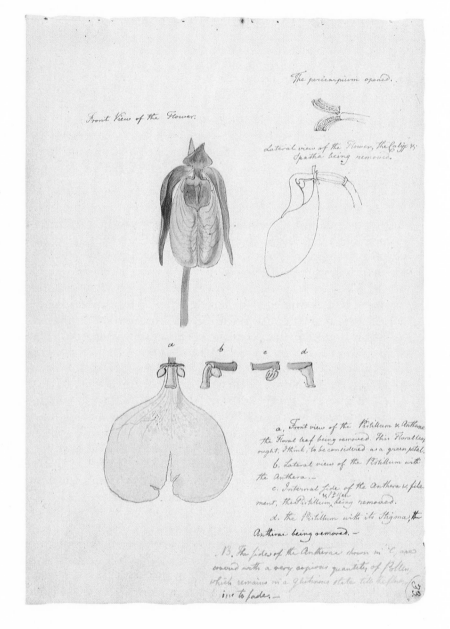

Front View of the Flower.

The pericarpium opened.

Lateral view of the Flower, the Calyx & Spatha being removed.

a. Front view of the Pistillum & Anthera the Floral leaf being removed. This Floral leaf ought, I think, to be considered as a green petal.

b. Lateral view of the Pistillum with the Anthera.

c. Internal side of the Anthera & filament, the Pistillum being removed.

d. the Pistillum with its Stigma; the Antheræ being removed.

B. The sides of the Antheræ shown in C, are covered with a very copious quantity of Pollen which remains in a glutinous state till the flower is to fade.

NO. 47

141

48. "Sketch in the Court of Appeals"

16 May 1798
Pencil, pen and ink, watercolor
17.8 cm. × 26.0 cm. (7 in. × 10-1/4 in.)
B H L B. May 16th 1798.
SKETCHBOOK III

In this drawing, as in No. 38, Latrobe depicts a judicial costume that he previously claimed to be absent from Virginia's courts. As in the earlier drawing, he may well have been interested in capturing "remains of good old fashions." The wig, so prominently displayed here, held a special fascination for him:

A *resuscitated* Grecian would not easily see the connection of Law and Wigs, but an Englishman scarcely conceives their separation to be possible but by the horrors of a divorce. . . . About a century ago a full bottomed wig, was in England as necessary to a Beau, as at present a tight pair of Pantaloons are in Virginia. The veneration for wigs was then a passion, a disease of the mind of a most singular nature. Of all the objects that have ever filled the human mind with awe, [a] wig seems to possess the least visible or probable powers. . . . A king, a statesman, or a general, a century or two ago could neither have laid claim to power, wisdom or courage without the assistance of a flowing wig. The inconvenience of the wig to the pleasures of the king, the scribbling of the statesmen, or the activity of the motions of a general induced them I believe *first* to discharge the incumbrance. The Cloud hovered longer over the head of foppery, still longer over that of Religion, and still obnubilates that of Law on the other Side of the Atlantic. To the Fop it must soon have become burthensome after the *great* had discarded, and the Spectator ridiculed it. While *Orthodoxy* clouded enquiry in religious matters, the clerical wig was sufficiently emblematic to be retained. The present infidel clergy of England have however found means to preserve or increase the value of their livings without sticking very hard by the good old size of their wigs, or the good old toughness of their doctrines, and even the episcopal wig, has already portentously shrunk to the limits of the faith of the bishops. In a case, in which it is impossible to reason from theory, experience is the only guide. We may therefore, very fairly, I think conclude, that whenever we see wigs decrease or vanish in any profession, bigotry and obscurity will lessen and cease, and good sense and liberal principles gain Ground and become general in the same ratio. (BHL, *Journals*, 1:129–30)

Latrobe's memory of William Hogarth's print *The Bench* very likely influenced this drawing. Published in a succession of states (that is, versions) beginning in 1758, Hogarth's engraving (below) serves as an illustration to an extended caption and mercilessly characterizes four bad judges. (In its later states, the print bears, across the top, an added band of heads pertaining to Hogarth's discussion of caricature in the caption.) A reference in Latrobe's journal (17 June 1796) to the caption establishes that *The Bench* had made an impression on him. In addition, the features of the judge in "Remains of good old fashions, exhibited in the Foederal Court," a drawing dated 1 June 1797 (see No. 38), appear to imitate those of the judge whom Hogarth drew three times in *The Bench*, specifically the caricatured version of the features at the center of the added row of heads. Latrobe's disapproval of wigs may have caused him to take special notice of the print, with its contrast between the dignity of judicial costume and the unworthiness manifested by the judges' faces.

(continued)

William Hogarth, *The Bench*, 5th state, c. 1764.
Courtesy of the Print Collection, Lewis Walpole Library, Yale University.

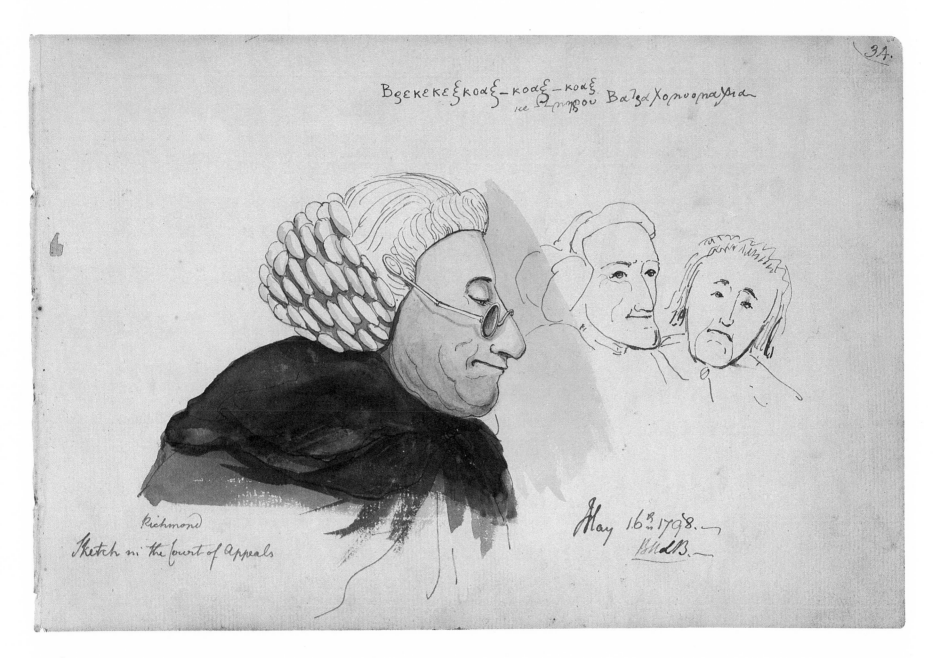

Βρεκεκεξκοαξ – κοαξ – κοαξ
κε Σμηβου Βαλχορυορααια

34.

Richmond
Sketch in the Court of Appeals

May 16th 1798.

The likeness between Hogarth's group and Latrobe's is strongest between the nearest heads in each, between Hogarth's most prominent judge, with his double chin, his downturned mouth, and his supercilious gaze, and Latrobe's similarly conceived interpretation of an unidentified Virginian. But the architect, a weak figural draftsman, chose a profile view, a less demanding choice than the three-quarter view of the head that the English artist had used. Latrobe's milder satire rests upon the resemblance of his dignitary to a frog, and an inscription at the top of the drawing spells out the comparison. The first line of Greek reads: "Brekekex, ko-ax, ko-ax," the sounds uttered by the frogs' chorus in Aristophanes' play *The Frogs*, and words that Latrobe has put into the mouth of his principal figure. The second line translates "see Homer's *Batrachomyomachy* [The Battle of the Frogs and the Mice]," a reference to a mock epic formerly attributed to Homer. It would seem that, in attempting to identify the source of his quotation, Latrobe recollected the wrong Greek work featuring frogs. Still, he may also have had in mind a comparison between the appearance of his principal figure and the effect of the frogs in the *Batrachomyomachy* when they, in arming for battle, have put on ludicrous costumes of leaves, shells, and the like.

49. "View of the City of Richmond from the Bank of James River . . ."

24 May 1798
Pencil, pen and ink, watercolor
17.8 cm. × 26.0 cm. (7 in. × 10-1/4 in.)
SKETCHBOOK III

Map reference: Richmond Quadrangle, Virginia
UTM coordinates: Viewing position (Quaker Meeting House): 18.028548.415626;
 Belvidere: 18.028334.415736; Ross's Mill: 18.028460.415686; Capitol:
 18.028484.415740; Governor's House: 18.028498.415735; Mouth of Shockoe Creek:
 18.028520.415625; Falls of the James: 18.028479.415630
Orientation: 315°

View of the City of Richmond from the Bank of James River near the Quakers' Meeting house, East of Shockoe Creek.

Beginning at the left hand. The part of the falls of James which is seen, is about 1/4th of their whole width. The distant building on the summit of the hill over, *a*, is Belvidere, late the seat of Mr. Bushrod Washington, now of Colonel Harvie, below Belvidere nearer the edge of the river is Coll. Harvie's Mill. Further to the right upon the hill is the Mr. Hopkins house (late Coll. Harvie's). On the bank of the river is Ross's Mill. Between the two Trees is seen the Backstreet of Richmond. The Capitol is about the Center of the Drawing. The House close to right is the Governor's. The next is Mr. Swan. That between two clumps of trees is the house of Jo. Mayo, now inhabited by Mr. McRae of the Council of State. The last House upon the hill to the right is Mr. Lewis Burrell's. The Houses in the foreground are part of the City, now much neglected, East of Shockoe Creek. Schockoe Creek now discharges itself into James River at the Rocks over *c*. Formerly it ran close under the Bank, (where the old Channel still appears) and had a channel deep enough for any Vessels which could pass Harrison's bar. It is now choaked up to the great injury of Richmond. (BHL, SKETCHBOOK III)

This scene was taken near the Quaker Meeting House, which was at Cary and Nineteenth streets. It provides us with a rare and valuable depiction of the contours of old Richmond. In its youth, Richmond was a city of two hills, the steep Church Hill and Shockoe Hill, divided by the deep valley through which coursed Shockoe Creek. Most of the residences in the city were situated on or around Shockoe Hill. A contemporary traveler described the arrangement of the city:

Though the houses in Richmond are not more than seven hundred in number, yet they extend nearly one mile and a half along the banks of the river. The lower part of the town, according to the course of the river, is built close to the water, and opposite to it lies the shipping; this is connected with the upper town by a long street, which runs parallel to the course of the river, about fifty yards removed from the banks. The situation of the upper town is very pleasing; it stands on an elevated spot, and commands a fine prospect of the falls of the river, and of the adjacent country on the opposite side. The best houses stand here, and also the capitol or statehouse. (Weld, *Travels*, p. 108)

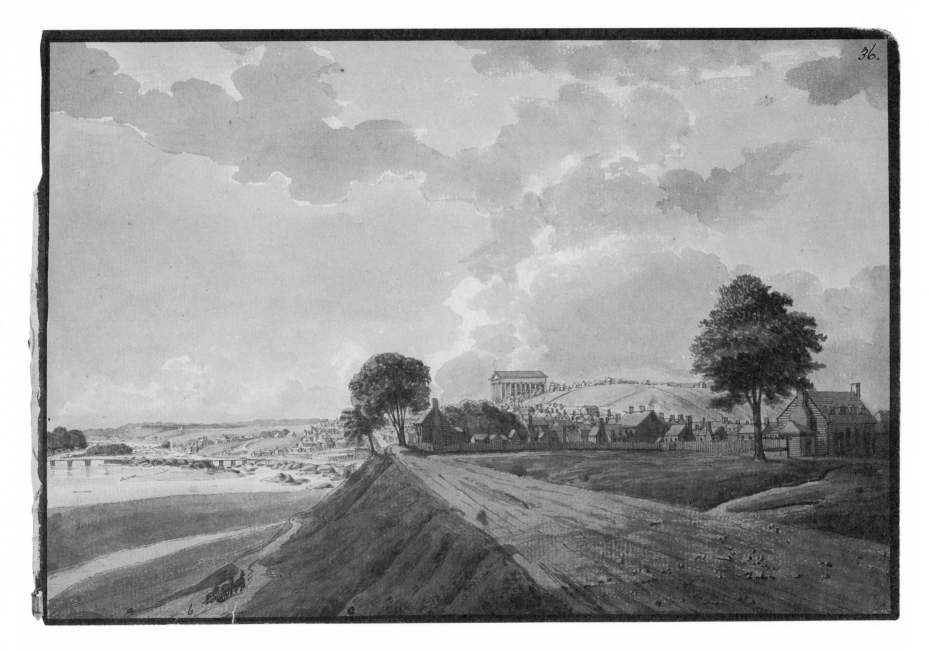

NO. 49

50. Dobsonfly

26 May 1798
Pencil, pen and ink, watercolor
17.8 cm. × 26.0 cm. (7 in. × 10-1/4 in.)
SKETCHBOOK III

Latrobe was in Richmond when he drew and dissected a dobsonfly, *Corydalis cornutus*. This large insect reaches a length of two to three inches. Its grayish spotted wings can measure four to five inches across. Both sexes of the adult form are short-lived, and although they possess strong jaws, they eat nothing. The specimen Latrobe has drawn is a male. Its remarkable tusklike mandibles are used for holding the female in mating.

The widely spread larval stage, or dobson, is aquatic. Living under stones in the swiftest part of rapid streams, these fierce predators feed upon mayflies and stoneflies. After three years, they crawl out of the streams in May to pupate. Fishermen know the dobsons as hellgrammites, an excellent fish bait.

I never met with an insect the examination of which so much distressed me, on account of its invincible tenacity of life. When it was brought to me, it was so furious, strong and active, that I could not manage it at all. I then pierced with the point of a pen knife, the spine at each joint. I hereby so far lamed it, as to render it incapable of flying or walking, but it seemed otherwise as lively as ever, and snapt at every thing which touched its forceps. In this condition it remained 30 hours. I repeated the incisions, and thrust a needle into its head without effect. Having made the annexed drawing, I divided it at the joints below and above the Thorax, leaving two legs on each segment. The legs continued to move for an hour on the two lower joints and then ceased. I then cut off the neck from the head. The palpae and antennae were in strong motion during the operation and afterwards. I next divided the head in two parts along the middle suture, the antennae quiver'd still strongly. More than half the head is filled with brain. I took out the brain from one half. The antenna still moved, and is now alive 34 hours since the first wound was given. The half of the head which still contains brain, moves its antenna freely. (BHL, SKETCHBOOK III)

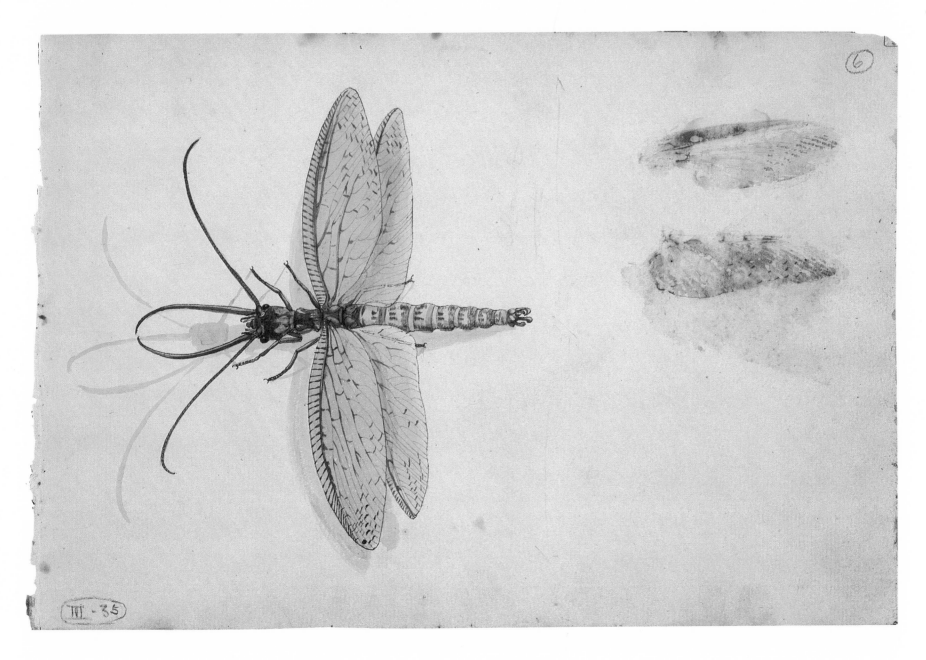

NO. 50

51. Log Dam on Virginia River

Undated [May–early summer 1798]
Pencil, pen and ink, watercolor
17.8 cm. × 26.0 cm. (7 in. × 10-1/4 in.)
SKETCHBOOK III

"Mem. The Shadow of the fall forms a straight blue line upon the White foam. Ivy in blossom." (BHL, SKETCHBOOK III)

Latrobe probably painted this scene during the late spring or early summer of 1798. His reference to the flowering of the ivy, as well as the location of the drawing in his sketchbook, evinces the season. This man-made dam was probably on the James River, and it may have backed up the river to form a millpond, with water drawn off by a canal. It was a crib dam, made of horizontal timbers placed at right angles to one another, probably notched to lock together.

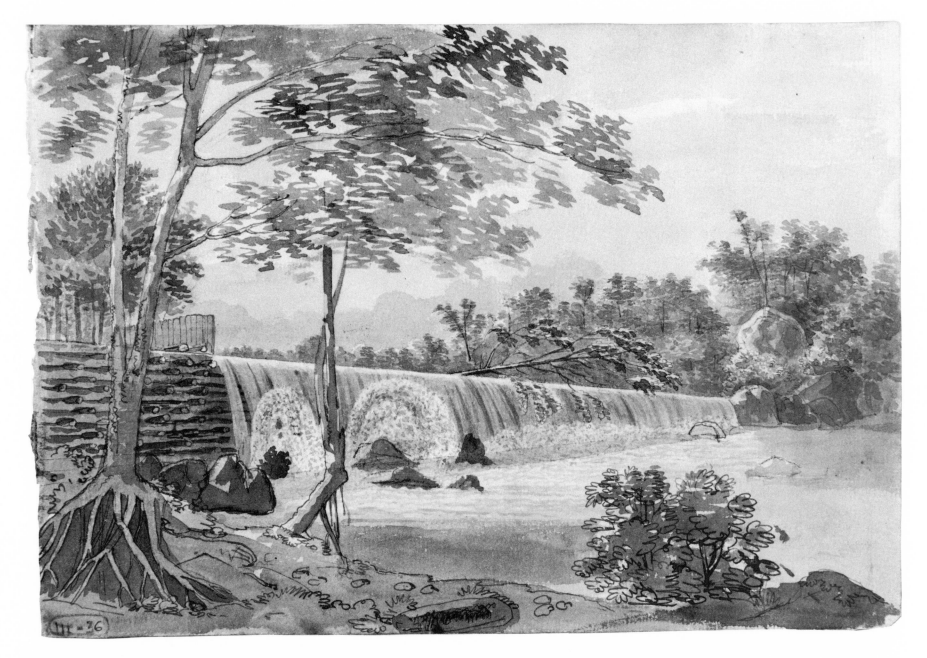

52. "Section of the Coast of Virginia at Cape Henry"

Undated
Engraving
10.5 cm. × 23.4 cm. (4-1/8 in. × 9-3/16 in.)
American Philosophical Society *Transactions* 4 (1799)

53. "Section of the Coast of Virginia at Cape Henry"

[24 July 1798]
Pencil, pen and ink, watercolor
19.0 cm. × 23.7 cm. (7-7/16 in. × 9-5/16 in.)
SKETCHBOOK IV

Map reference: Cape Henry Quadrangle, Virginia
UTM coordinates: Lighthouse: 18.041009.408688
Orientation: Theoretical cross section view, general orientation: from northeast at left to
 southwest at right

NB. The red part of the Hill shows its form at the time the Lighthouse was built 1791 or 92.

The lighter color shows the accumulation of sand, and its encroachment upon the desart since that time. The sand has risen at the Lighthouse about 20 feet. The eddy of wind occasion'd by the buildings keeps clear a kind of ditch of 20 feet wide around them. The heighth of sand above the water in the desart cannot be less than 100 feet. (BHL, SKETCHBOOK IV)

The sketchbook drawing of this scene served as the basis for the engraving that was published with Latrobe's "Memoir on the Sand-hills of Cape Henry in Virginia" in the American Philosophical Society's *Transactions* for 1799. The drawing is a hypothetical cross section of the northern tip of the Cape Henry area, looking from west to east. Today the shoreline is four-tenths of a mile from the lighthouse, a considerably greater distance than in 1798. (The shoreline appears to be about two-tenths of a mile away in Latrobe's drawing.) In the legend beneath the engraving, the year 1783 is an error for 1793.

In his "Memoir" Latrobe wrote:

The shore, and the bed of the Atlantic near the shore, consist of a fine sand. The daily action of the flood tide carries a certain quan-

tity of this sand above high water mark, which being dried by the sun and air, is carried further in land by the winds. The most violent winds on this coast, blow from the points between the N. West and the East; and besides, a gentle easterly breeze prevails the whole summer, during some part of almost every day. . . . These easterly winds blowing during the driest and hottest season of the year, carry forward the greatest quantity of sand, and have amassed hills, which now extend about a mile from the beach. (BHL, "Memoir on the Sand-hills," p. 440)

The title at the bottom of the sketchbook version refers to No. 54; the date may refer to No. 53 or No. 54, or both.

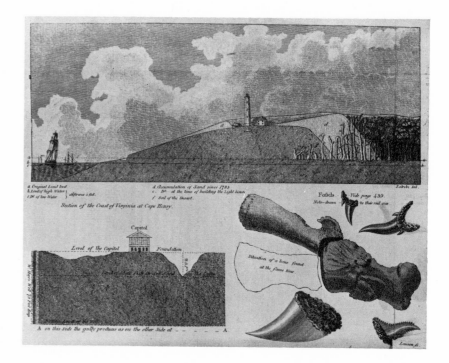

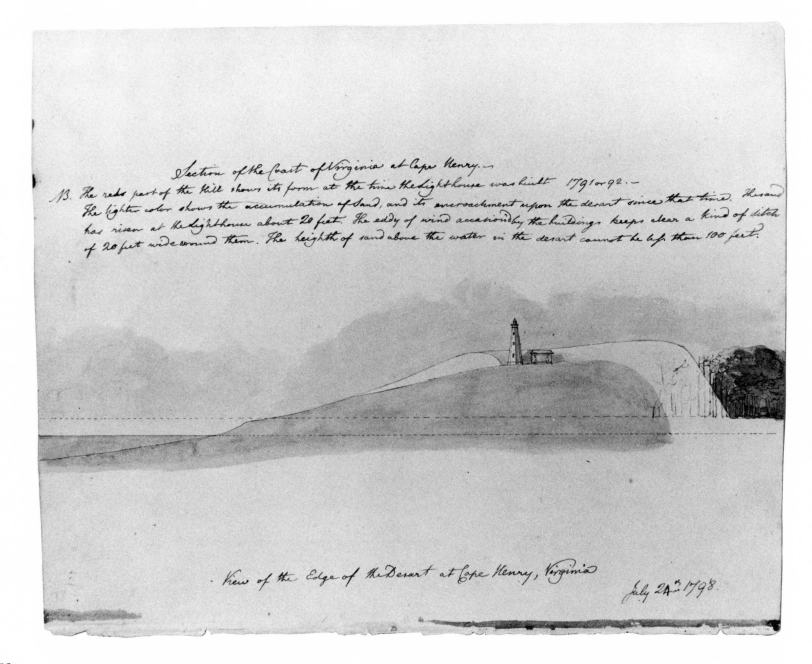

Section of the Coast of Virginia at Cape Henry.—

13. The reds part of the hill shows its form at the time the light house was built 1791 or 92.—
The lighter color shows the accumulation of Sand, and its encroachment upon the desart since that time. The sand
has risen at the lighthouse about 20 feet. The eddy of wind occasioned by the buildings keeps clear a kind of ditch
of 20 feet wide around them. The heighth of sand above the water in the desart cannot be less than 100 feet.

View of the Edge of the Desart at Cape Henry, Virginia

July 24 1798.

54. "View of the Edge of the Desart at Cape Henry, Virginia"

[24 July 1798]
Pencil, pen and ink, watercolor
19.0 cm. × 23.7 cm. (7-7/16 in. × 9-5/16 in.)
SKETCHBOOK IV

Map reference: Cape Henry Quadrangle, Virginia
UTM coordinates: Near lighthouse: approximately 18.041009.408688
Orientation: Cannot be determined from drawing

The swamp, or as the neighbouring inhabitants call it, the Desart, is overgrown with aquatic trees and shrubs; the gum [sweetgum], (L[iquidambar] styraciflua), the cypress (cup. disticha) [bald-cypress, Taxodium distichum], the [red] maple (acer rubrum), the tree improperly called the sycamore [American plane tree] (pla[n]tanus occidentalis), the magnolia glauca [sweetbay, Magnolia virginiana], the wax myrtle (myrica cerifera), and the reed (ar. tecta) [switch or small cane, Arundinaria gigantea tecta] are the principal. Of these many thousands are already buried in the sand, which over-tops their summits, and threatens the whole forest with ruin. Their destruction is slow, but inevitable. Upon the extreme edge of the sand hills towards the swamp, the wind opposed by the tops of the trees, forms an eddy: the sand carried along with it is precipitated, and runs down the bank into the swamp. Its slope is very accurately in an angle of 45°. By gradual accumulation, the hill climbs up their trunks, they wither slowly, and before they are entirely buried, they die. Most of them lose all their branches, and nothing but the trunk remains to be covered with sand, but some of the cypress retain life to the last.

The Desart abounds in deer, bears, racoons, and opossums. Its skirts are more thickly peopled than the sterility of the soil would give reason to suppose; but the inexhaustible abundance of fish and oysters in the creeks, and the game, render it easy to support a family. . . .

. . . The height of the hill at the swamp, is between 70 and 80 feet perpendicularly. It is higher nearer the sea, the inner edge being rounded off, and I think at its highest point, it cannot be less than 100 feet above high water mark. If the hills advance at an equal ratio for 20 or 30 years more, they will swallow up the whole swamp, and render the coast a desert indeed, for not a blade of grass finds nutriment upon the sand.

Should this event take place, and some future philosopher attend the digging of a well *in the high sandy country, on the coast of Virginia,* his curiosity would be excited by fossile wood, 100 feet below the surface. He would there discover a bed of vegetable and animal exuviæ, and going home, he might erect upon very plausible ground, a very good-looking hypothesis of a deluge, sweeping the whole upper country of its sand, and depositing it along the line of its conflict with the waves of the ocean. (BHL, "Memoir on the Sandhills," pp. 441–43)

The area in view is now within Fort Story Military Reservation. "The Desart" remains on modern maps as a marsh area.

153

55. "View of the Lighthouse at Cape Henry Virginia, Looking to the North"

Undated [July 1798]
Pencil, pen and ink, watercolor
19.0 cm. × 23.7 cm. (7-7/16 in. × 9-5/16 in.)
SKETCHBOOK IV

Map reference: Cape Henry Quadrangle, Virginia
UTM coordinates: Viewing position: 18.041007.408683; Lighthouse: 18.041009.408688
Orientation: Approximately 15°

The lighthouse at Cape Henry was the first such structure authorized and constructed by the U.S. government. Designed and built by John McComb, Jr. (1763–1853), the lighthouse was planned as a memorial marking the site of the first landing of Capt. John Smith in Virginia in 1607. It began operation in 1792 and served until 1881, when a new lighthouse was erected nearby. The lighthouse still stands as a Registered National Historic Landmark and is owned by the National Park Service.

In his "Memoir on the Sand-hills of Cape Henry in Virginia," Latrobe described the lighthouse and its site in some detail:

The light house,* which was built about sixteen [that is, six] years ago, is an octangular truncated pyramid of eight sides, rising 90 feet to the light, and sunk 18 feet below the basement course. Within a few yards of the light house, is the keeper's dwelling, a wooden building of two stories. Both are surrounded by a platform of plank, and, without any such design in the architect, this platform has preserved both these buildings from being buried in the sand.

When the light house was built, it was placed upon the highest sand hill at the Cape. Its distance from the beach may be 6 or 7 hundred yards, and the elevation of its base above high water, not less than 90 feet. At that time there was from the foot of the building, the most expanded view of the ocean, the Desart, the Chesapeak and its eastern shore. At present, a mount of sand surrounds them, which overtops the keeper's dwelling, and has buried his kitchen to the eaves. The platform, which was laid upon the former level of the sand, is an accurate standard from whence to ascertain its accumulation. The winds meeting in their course the elevated tower of the light, form a perpetual whirl around it, which licks up the sand from the smooth surface of the timber, and heaps it around in the form of a bason. Where the platform ceases, the sand accumulates. The sandy rim, while it protects the keeper from the storms, renders his habitation one of the dreariest abodes imaginable. This rim is sometimes higher, at others lower, according to the direction and strength of the wind. Since the establishment of the light, the hills have risen about 20 feet in height (measuring from the platform). (BHL, "Memoir on the Sand-hills," pp. 442–43)

Latrobe was standing south-southwest of the lighthouse looking north-northeast along the top of the sand ridge behind the lighthouse.

*It is a good solid building of Rappahannoc freestone, but has the unpardonable fault of a wooden stair case, which being necessarily soaked with oil, exposes the light to the perpetual risk of destruction by fire. Such an accident might be attended with an incalculable loss of lives and property, the mouth of the Chesapeak being perhaps the inlet to more ships than any other in the United States.

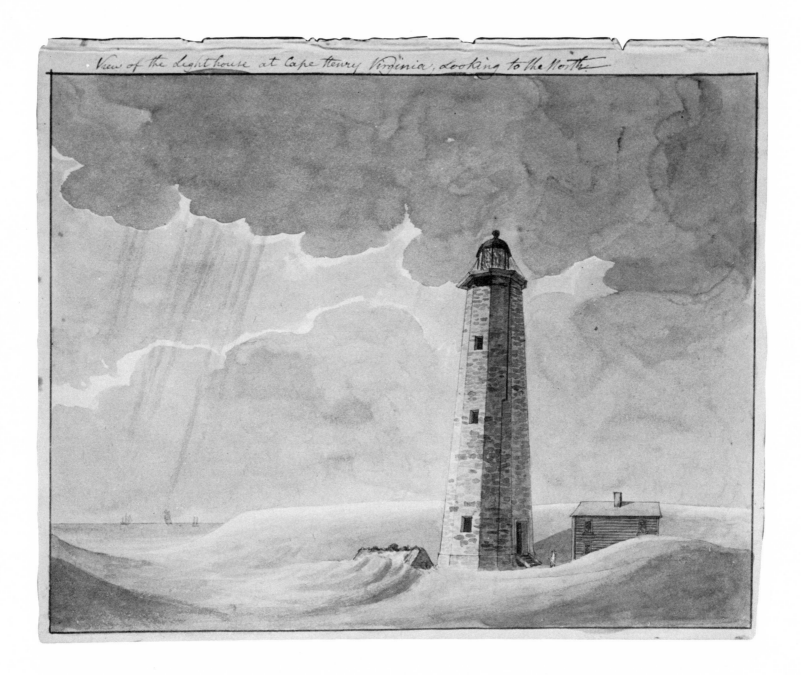

View of the Light house at Cape Henry Virginia, looking to the North

NO. 55

56. "Sketch from the Inn at Hampton"

Undated [July 1798]
Pencil, pen and ink, watercolor
13.7 cm. × 23.7 cm. (5-3/8 in. × 9-5/16 in.) on a page measuring
19.0 cm. × 23.7 cm. (7-7/16 in. × 9-5/16 in.)
SKETCHBOOK IV

Map references: Hampton Quadrangle, Virginia; Norfolk North Quadrangle, Virginia
UTM coordinates: Approximately 18.038044.409807
Orientation: Approximately 160°

The placement of this drawing in the sketchbook argues for a date of July 1798, although surviving documents cannot corroborate Latrobe's presence in Hampton then. He had visited Hampton, though, in April 1796, at which time he entered the following observations in his journal:

Hampton lies on the North side of the common Mouth of the James and Elisabeth rivers, and has good Anchorage in its road. It is the rendezvous of all Vessels coming in and going out of the Chesapeak, which have occasion to wait for a fair Wind, and is the station of the cruizers of the English on this coast. Under the English government, Hampton was the place where all vessels going up the contiguous rivers were obliged to make their entries, and became in consequence a place of much business and resort. It is regularly planned, and the innumerable navigable creeks which intersect the town and near neighbourhood have great convenience. Since the removal however of the general Custom house, Hampton has declined, its streets are covered with grass, little or no business is done, and many of the houses are uninhabited and are tumbling down. . . .

The inn of Hampton lies a little way up a *many-branched* creek, a safe harbor for boats drawing 8 or 9 feet of Water. It is a building like all the rest showing the symptoms of decay. Mr. Kirby the landlord is a good natured man. He has good beds, in bad rooms, bad attendance and bad victuals and drink. Butter is every where wretched. Fresh butter I have very seldom seen in this country. (BHL, *Journals*, 1:80, 83)

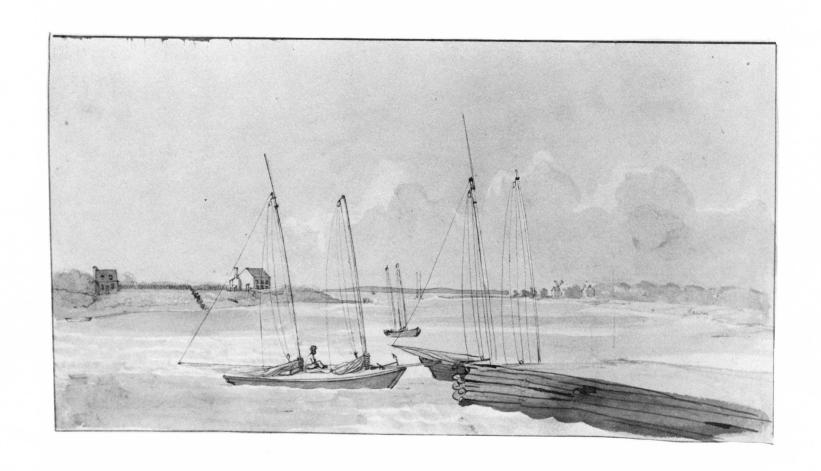

57. "Sketch of York town, from the beach, looking to the West"

Undated [July 1798]
Pencil, pen and ink, watercolor
19.0 cm. × 23.7 cm. (7-7/16 in. × 9-5/16 in.)
SKETCHBOOK IV

Map references: Clay Bank Quadrangle, Virginia; Yorktown Quadrangle, Virginia
UTM coordinates: Viewing position: 18.036681.412160; Nelson House:
18.036630.412168
Orientation: 320°

Sketch of York town, from the beach, looking to the West. The first house that appears on the hill to the West, is that of Secretary Nelson (see [No. 58]). Along the top of the bank appear other houses of the upper town, and the ruins of the British works commanding the river, the embrassures of which are almost filled up. The work on the last hill to the right is seen *en profil*. The foreground exhibits a work thrown up, upon the beach, which commanded the lower town, (under the third hill) and the whole river. The bank consists of sandy loam, upon a hard red shell-rock. (BHL, SKETCHBOOK IV)

While traveling between Richmond and Norfolk, Latrobe frequently stopped and lodged overnight at Yorktown. These visits afforded him the opportunity to observe closely the topographical and geological character of the community. "The York shore is a bold gravelly cliff on a basis of loose shell rock commanding a very extensive view down the river almost as far as the Chesapeak. . . ." (BHL, *Journals*, 1:86)

At Yorktown however famous for the Surrender of Cornwallis . . . a concrete Mass of small Shells forms a very solid Rock of great extent under 15 or 20 feet of sand and clay. . . . All the Shells composing this rock are extremely small. They appear cemented together by a red ferruginous substance, mixed with a white spar and minute regular chrystals. It moulders away in the Frost, and although tolerably hard when taken out of the bank, it decays in the Water, and is therefore unfit either for building or making Wharves. But in situations where the frost has suddenly been broke up by heavy [rain], and the surface of this rock has been washed down in a sort of mud, and has settled at the bottom of the rock on the beach it has once more become rock, harder than in its first state. Successive accumulations of the hardened Rock-Mud to use the expression are seen by the side of the River, which has the appearance which everybody has seen of frozen Mud in a Road. (BHL, *Journals*, 2:412)

By the time of Latrobe's visits, Yorktown had lost most of its pre-Revolutionary commercial life, and the town's physical appearance had greatly deteriorated. "York like Hampton is half deserted. Trade has almost entirely left this once flourishing place, and none of the ravages of the War have been repaired." (BHL, *Journals*, 1:86) "York town is going very fast to decay. It has an excellent harbor, safe from every Wind, but the East. But of what use is an harbor without a trade. The town is now famous only for the best fish and oysters, and the best tavern in Virginia, and for the hospitality and friendliness of its inhabitants." (BHL, "Essay on Landscape," *Journals*, 2:489)

When he viewed this scene, Latrobe was standing below what is at present the Yorktown Monument and was looking up the York River to the northwest. On the right side of this view is Gloucester Point, Gloucester County, which is now connected to the York County shore (left middle ground) by the Coleman Memorial Bridge. The land on the left is now the Yorktown Battlefield section of the Colonial National Historical Park, administered by the National Park Service.

Sketch of York town, from the beach, looking to the West.

The first house that appears on the hill to the West, is that of Secretary Nelson (see p. farther on). Along the tops of the bank appear other houses of the upper town, — and the ruins of the British works commanding the river, the embrasures of which are almost filled up. The work on the last hill to the right is seen on profil. — The foreground exhibits a work thrown up, upon the beach, which commands the lower town, (under the third hill) and the whole river. — The bank consists of sandy loam, upon a hard red shell-rock.

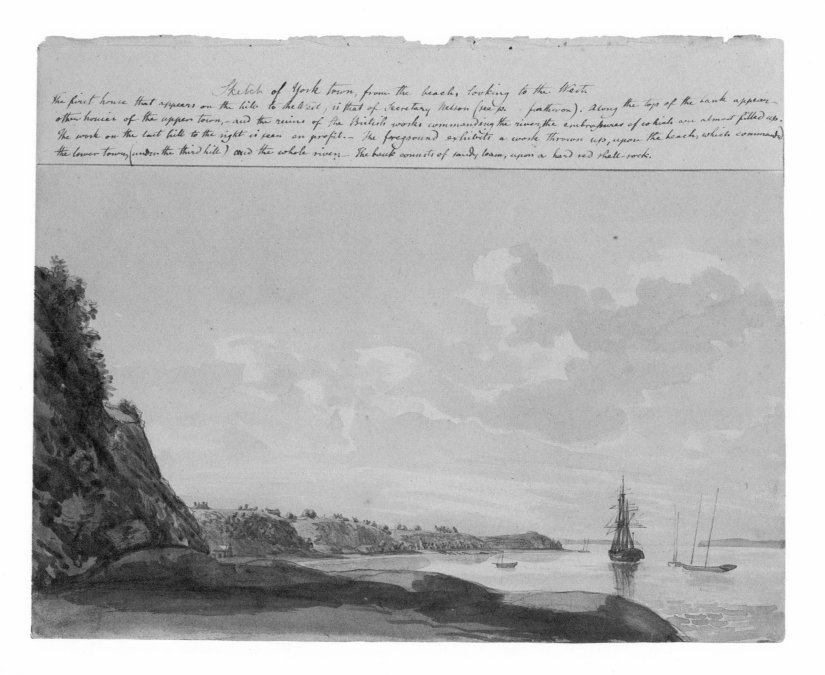

58. Nelson House and Fortifications, Yorktown

Undated [July–August 1798]
Pencil, pen and ink
15.0 cm. × 23.7 cm. (5-7/8 in. × 9-5/16 in.) on a page measuring
19.0 cm. × 23.7 cm. (7-7/16 in. × 9-5/16 in.)
SKETCHBOOK IV

Map references: Clay Bank Quadrangle, Virginia; Yorktown Quadrangle, Virginia
UTM coordinates: Viewing position: 18.036640.412164; Nelson House:
 18.036630.412168
Orientation: 335°

59. "View at Little York in Virginia"

[August] 1798
Pencil, pen and ink, watercolor
Cover size of volume: 19.5 cm. × 26.5 cm. (7-3/4 in. × 10-1/2 in.)
Virginia State Library, Richmond

"York is remarkable for having been the place where Lord Cornwallis surrendered his army to the combined forces of the Americans and French. A few of the redoubts, which were erected by each army, are still remaining, but the principal fortifications are almost quite obliterated." (Weld, *Travels*, p. 93) The redoubts noted by Weld are visible in the foreground of these views. The house, which had served for a time as Cornwallis's headquarters, was the mansion belonging to Thomas Nelson (1716–82), councillor and secretary of the colony. The house

> stood so much exposed, and afforded so good a mark to the enemy, that he [Cornwallis] was soon forced to quit it. Neilson, however, it seems, was determined to stay there till the last, and absolutely remained till his negro servant, the only person that would live with him in such a house, had his brains dashed out by a cannon shot while he stood by his side; he then thought it time to retire, but the house was still continually fired at, as if it had been head quarters. The walls and roof are pierced in innumerable places, and at one corner a large piece of the wall is torn away; in this state, however, it is still inhabited in one room by some person or other equally fanciful as the old secretary. (Weld, *Travels,* p. 94)

Latrobe made the sketchbook drawing (No. 58) from a spot along the top of the bluff above the York River, looking northwest. In the distance in each rendering is the Gloucester County shoreline. The Nelson house, recently renovated, stands on Main Street in Yorktown. No. 58 served as the basis for the finished watercolor (No. 59) which Latrobe included as part of his "Essay on Landscape." In the "Essay," he commented on both the artistic merits and the subject of his drawing:

> As a composition this View of York town is wholly destitute of merit. All that can be said for it is, that it is an accurate representation of a scene of great political importance. But the exclusion of Trees, and the Works of fancy, which is the law of this collection, has rendered the admission of some objectionable Landscapes necessary. I have attempted to make the most of the subject, by collecting the Light in
>
> a Mass upon the Ravelin and the opposite
>
> river; but though this produces *stillness*, the piece wants contrast both in coloring and composition. It is too green, and too much made up of parallel lines. It has nothing of what the painters call, pittoresque.
>
> The history of the Siege of York is well known to everybody. The Works were badly constructed and well attacked. Those represented in the drawing, were thrown up by the french after the town was taken, by way of keeping their army in exercise. They are now gone much to decay, but still betray the design of a skilful engineer.

(continued)

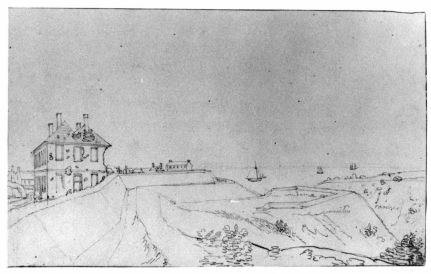

NO. 58

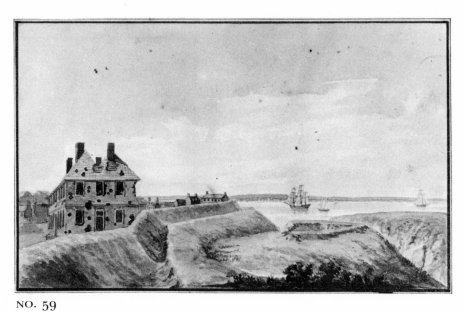

NO. 59

A Gentleman who was present during the siege, observing my original drawing [No. 58], told me the following anecdote of the hole in Secretary Nelson's house, which appears between the window and door on the left hand. The duke de Vioménil came into the American lines and visited a Battery. He observed an American canoneer who appeared to point his Gun with great care. "Sir," said the Duke, "I will give you a Dollar if you at the first attempt throw a Ball to strike the fascia that runs round that house." (The fascia is a string of projecting Brickwork between the first and second stories.) "Will you give me a dollar," replied the American, "for every Ball I throw to strike the fascia, and I will give you two for every miss." It was agreed. The American then threw thirteen successive Balls, and made the hole in question without missing once. The Duke paid his 13 Dollars, and begged to be excused any more experiments. (BHL, "Essay on Landscape," *Journals*, 2:487–88)

60. "Collection of small Moonlights"

Undated [1799 or after]
Pencil, pen and ink, watercolor
17.7 cm. × 27.8 cm. (6-15/16 in. × 10-15/16 in.)
SKETCHBOOK II

This trompe l'oeil drawing represents four pieces of paper, three small watercolors strewn across what appears to be a letter. Unlike the "Breakfast Equipage" featured in No. 6, the watercolors seen here seem to have no thematic connection with the text that serves as their background. Latrobe probably drew the central "Scene at Hampton, Virginia" from memory and perhaps invented the other two small moonlight scenes. The satirical text refers to the defeat of Jean-Baptiste Jourdan (1762–1833) by Archduke Charles of Austria (1771–1847) on 29 March 1799 at Stockach, in Baden, where the French lost 4,000 men. It reads:

Nothing however appears more probable than that the Archduke Charles having beaten Jourdain to a mummy, and worked up [his] Army to an Oil, should push his victorious troops across the Rhine at a Dash, as he has hardly lost a man, and so go straight forward to Paris, swallow up the City and [its inhabi]tants at a Gulp, and throw the Convention as an Englishman does the Beard of his Oysters into the Seine. In the mean time General Wurmser seeing what is [going] forward will make a Snap at Buonap[arte] and [*illegible*] of his Army. All this being proved as plain as the Nose on [a] Face, I am aston[ished] you should so doubt that peace will be immediately concluded between England and France, the Stadholder restored and religion order and subordination put upon its old proper footing.

Nothing however appears more probable than that the Archduke Charles having beaten four
dain to a mummy, and worked up ... my to an oil, should push his victorious troops a—
'ross the Rhine at a Dash, as he has ... hardly lost a man, and so go straight forward
to Paris, swallows up the City & ... tants at a Gulps, and throw the Convention
as an Englishman does the Be ... ard of his Oysters into the Seine In
the mean time General N... ... ser seeing what ... forward
will make a Snap ... at Br...
snap ... and ...
... renno...
of his ... Army.
All thi... ... prove...
a plain ... being ... Face...
I am aston... as the Nose ... doubt
at peace ... you should ... diately
... clude be... will be imm...

tween England & France, the Stadholder restored and religion or...
... subordination put upon its old proper footing.

PENNSYLVANIA

NEW JERSEY

N.Y.

Susquehanna R.

Little Schuylkill R.

Schuylkill R.

BLUE MTN.

Port Clinton

OLEY MTNS.

Perkiomen Cr.

Reading

Delaware R.

Passaic R.

Paterson

Newark

N.Y.

Kingston

Harrisburg

Carlisle

Warwick

French Cr.

Collegeville

Norristown

Cr. R.

Lancaster

Columbia

Downingtown

Philadelphia

Mt. Holly

Darby

Brandywine Cr.

Gettysburg

Del. Cr.

Md.

Scale: 1 in. = 20.2 mi.

III. Travels in New Jersey, 1799–1800

Falls of the Passaic

Latrobe's residency in Virginia ended in the closing months of 1798. Having just been appointed architect of the Bank of Pennsylvania, he moved to Philadelphia in December of that year to assume his duties there. Not long after his arrival, Latrobe received a second major commission—the design and construction of a waterworks system for the city of Philadelphia. Attempting to secure steam engines for that project, Latrobe traveled to Belleville, New Jersey, the site of Nicholas Roosevelt's Soho Works, in October 1799. While in northern New Jersey, Latrobe journeyed to the falls of the Passaic, a site which attracted many travelers of the period. Fascinated by the geology and Picturesque scenery of the falls, he made several drawings of the area (Nos. 62, 63, 65). Seven months later he returned to the falls on his honeymoon trip, and again sketched several views (Nos. 61, 64). On these two trips, Latrobe made ten drawings of the falls, representing the largest number of drawings devoted to a single subject in the sketchbooks. On his second visit, Latrobe recorded his artistic response to the landscape:

> The falls of Passaick lie 12 miles to the N.W. and by N. of this Place [Laurel Hill, New Jersey], and about 15 Miles in the same direction from Newark in the State of New Jersey.
>
> Considering them in a picturesque point of view, they are to those of Niagara and Montmorency what a cabinet painting of the first merit, is to a painting of Raphael in the Vatican. They combine every thing in themselves and in the magic circle of which they are the Center, of which Nature forms her sublimest Land-

scapes, excepting the ocean. Every thing indeed is upon a small scale, but nothing is wanting. A school of Landscape, established at Patterson would have within a mile around, all the Examples upon which to form, Artists of the highest rank in their profession. Not a single picture need be bought nor a mile travelled, unless it be to the Sea coast. Little groups of Rock and Water, still or in agitation, or tumbling, overshadowed with luxuriant, or crowned with decayed trees, exist in innumerable modes and characters of composition, bold foregrounds, backed by soft distances, or by bold back scenes, gentle character of fore middle and back grounds, soft scenes in front, and mountains or perpendicular cliffs behind, water in every form of agitation, or resting in tranquillity, every combination of every kind of scenery, are to be met with in a thousand different arrangements. The Cataract itself presents so many and so different points of view, that it affords a new picture at every Step. As to light and Shades, the perpendicular Rocks, and narrow Gullies, produce effects of contrast scarce ever met with in Nature in degree, so like the artificial efforts of the best painter. The Coloring of every scene is brilliant, and the natural color of the Rocks, a rich brown, is that which Claude Lorraine would have chosen had he created them. With such magnificent foregrounds as nature has here collected, she seldom has combined extensive distance. But here she has made an exception. A rich cultivated country extends to the distance of at least 20 Miles. (BHL, SKETCHBOOK V)

Other travelers of the period shared Latrobe's fascination with the falls. François Jean Chastellux wrote:

I had the astonishing spectacle of a great river which hurls itself down a height of seventy feet and is then engulfed in the hollow of a cliff, which seems to swallow it up, but from whence it escapes by

turning sharply to the right, as if it were slipping through a secret doorway. It seems to me impossible to give an idea of this waterfall, except by a drawing. Let us however attempt the picture, leaving the finishing to the imagination, which is the rival of Nature, and sometimes also her friend and interpreter. Let the reader imagine, then, a river flowing between mountains covered with spruces, the dark green of which contrasts with the color of its waters and renders its course more majestic; let him then represent to himself an immense rock, which would totally close up the passage, had it not, by some earthquake or other subterranean revolution, been rent in several pieces, from its summit to its base, thus forming long and perfectly vertical crevices. One of these crevices, the depth of which is unknown, may be twenty-five or thirty feet wide. It is into this sort of caldron that the river, after clearing a part of the rock noisily hurls itself; but as this rock crosses its whole bed, it can only escape by that end which offers it an outlet. There a fresh obstacle appears; another rock opposes its flight, and it is obliged to form a right angle and turn sharp to the left. What is most extraordinary, after this tremendous fall, the river neither froths, nor boils, nor forms whirlpools, but quietly slips off through the channel open to it, and in silence reaches a deep valley, where it pursues its course to the sea. (Chastellux, *Travels in North America*, 1:104–05)

The site appealed to promoters of industrialization as well. In 1791, the state of New Jersey chartered the Society for Establishing Useful Manufactures (SUM), and the infant organization decided on the Falls of the Passaic as the best location for its new manufacturing town. The SUM named the planned town Paterson in honor of New Jersey governor William Paterson. At the insistence of Alexander Hamilton, who was one of the guiding forces of the SUM, the society engaged the French engineer Pierre Charles L'Enfant to superintend

the design and construction of the town, the mills, and the water raceway which would provide power for the mills.

In designing the raceway, the principal obstacles to be overcome were a ravine adjoining the river, and a rock ridge beyond the ravine which blocked the way to the proposed mill sites. L'Enfant planned to open a channel to the river through the rock using an aqueduct to cross the ravine, and blasting a gap in the rock ridge to the east. Despite progress on the aqueduct and blasting operation, however, the society directors became impatient with the slow pace and excessive costs of L'Enfant's work. In 1793, they dismissed L'Enfant and hired Peter Colt to replace him. Colt modified L'Enfant's plans so as to hasten the progress of the project and keep costs low. Instead of carrying water across the ravine through an aqueduct, Colt utilized the ravine as a channel. From the channel water passed through the gap in the rocks and into a single raceway which extended to the mill site. By the summer of 1794, Colt's raceway supplied water power for the society's cotton mill. Further expansion of the raceway did not take place until after 1800, so that at the time of Latrobe's visits to the area, only the single raceway extending to one mill site would have been constructed. This single raceway, however, represented the first water supply system developed for manufacturing purposes in the United States. Even so, Latrobe, an experienced engineer, found the geological and aesthetic dimensions of the falls far more compelling than the technical, as the following sketchbook drawings and notations indicate.

Reproduced opposite is a map showing the state of the area of the falls at the time Latrobe saw it. The map depicts the first raceway plan originally designed by L'Enfant and modified by Colt. Water from the Passaic was diverted into the raceway system by a wooden dam. Water fell into a reservoir and then passed through the raceway to the first SUM mill. After leaving the mill, water flowed back into the Passaic through a drainage channel. (Map courtesy of the Historic American Engineering Record)

PATERSON RACEWAYS, [1792-99]

61. "View of the Old Cascade of the Passaick . . ."

28 May 1800
Pencil, watercolor
21.3 cm. × 47.5 cm. (8-3/8 in. × 18-11/16 in.)
SKETCHBOOK V

Map reference: Paterson Quadrangle, New Jersey
UTM coordinates: Viewing position: 18.056896.452978; Site of Old Cascade:
 18.056885.452970
Orientation: 235°

View of the Old Cascade of the Passaick, as from the present state of the Rocks and of the River it must have appeared.

The Rocks are drawn as exactly as possible considered the difficulty of getting a single view of them on account of the Trees that grow luxuriantly upon and among them. (BHL, SKETCHBOOK V)

This view and map depict Latrobe's conception of the contemporary and historic geology of the Falls of the Passaic. A keen scientific observer, well versed in geological and hydrological theory, Latrobe here attempts to suggest the basic geological configuration of the area in order to demonstrate the shift in the position of the falls over the course of time from the position on the map marked "Old Cascade" to that marked "Present fall." In the past, according to Latrobe, the narrow cataract did not exist, and the path of the Passaic, therefore, would not have been diverted, but would have passed over the area labeled "old bed of the River. Rock Water worn." In this path, as the rock surface clearly indicated, the Passaic would then have fallen into the area labeled "Old Cascade" and "Old Bason . . ." As Latrobe explained in his sketchbook:

Nothing is more evident to the Senses than that the River has at some distant period Cascaded over the very front of the Rock into the open Country, and that in two separate Cascades, either at the same time, or at two separate periods. The very Scene yet remains, but without the Water. It is exactly in front of the present fall, at the distance of 100 Paces. It appears also evident, that while the river fell in this old Cascade, it had time to wear back the rock to the distance of 100 Yds. or there abouts as in the View and plan.

The view represents Latrobe's reconstruction of the "Old Cascade" as "it must have appeared." His vantage point for this imaginary scene was the north bank of the Passaic River at the edge of the area labeled "Old Bason, now a flat soft piece of ground full of fragments of Rock." He was looking to the southwest, toward what he labeled "Old Cascade" and "Rock." Today, the former position of the cascade has been covered with waste rock, rubble, and debris, making it no longer generally visible. The area in the view has been converted into a public park, further modifying the site as it existed in Latrobe's time.

To the left of the "Old Cascade," across the river in the area labeled "Mountain" on Latrobe's plan, was Morris Mountain. This mountain was blasted away in the nineteenth century for the construction of canals and the expansion of the Paterson industrial district. What Latrobe labeled "Canal" was the reservoir of the SUM raceway system. For Latrobe's further comments on the geology of the area, see Nos. 63 and 65.

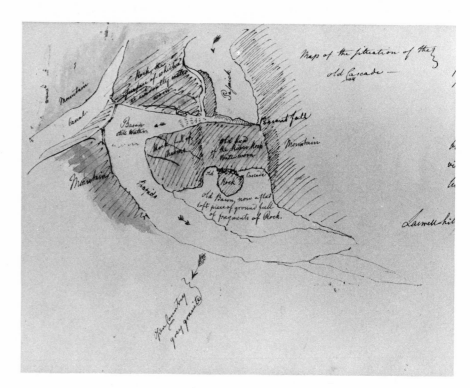

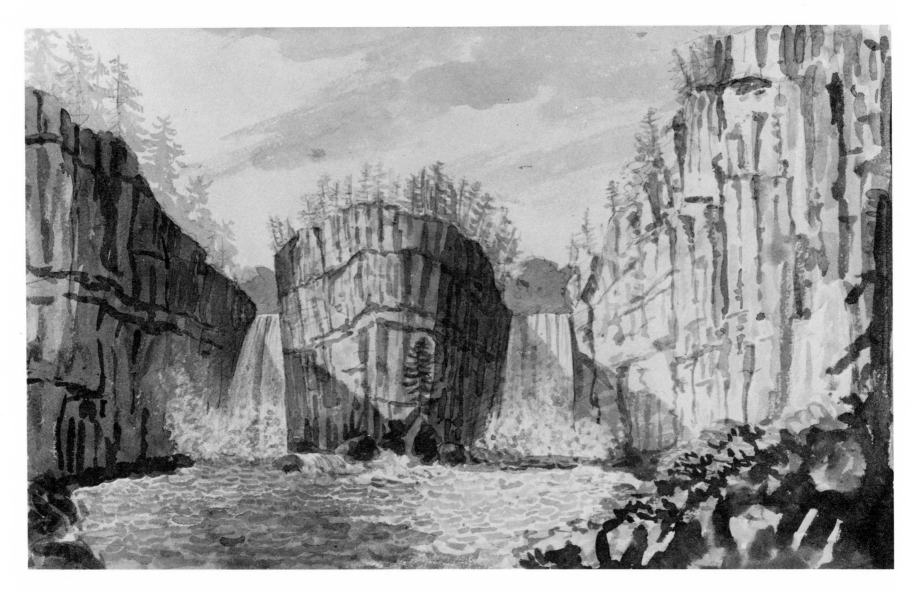

NO. 61

173

62. "View of the Falls of Passaick, New Jersey . . ."

18 October 1799
Pencil, pen and ink, watercolor
21.3 cm. × 47.5 cm. (8-3/8 in. × 18-11/16 in.)
SKETCHBOOK V

Map reference: Paterson Quadrangle, New Jersey
UTM coordinates: 18.056900.452950
Orientation: 350°

In this view, the falls are seen "from the edge of the Bason," which Latrobe labeled "Bason still Water" in the map accompanying the preceding drawing. Latrobe was looking to the north-northwest up the river channel from the earthen embankment between the basin and the "Canal." The rapids that he noted on the map flow to the right in this drawing.

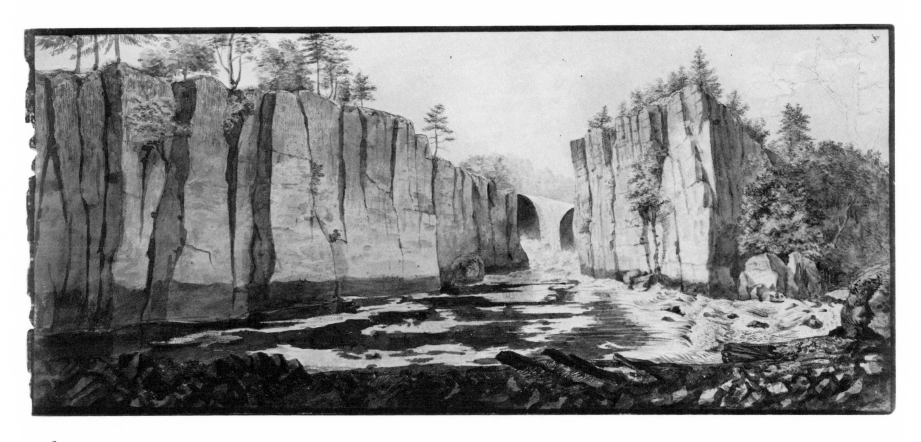

NO. 62

175

63. "View at the Falls of Passaick"

18 October 1799
Pencil, pen and ink, watercolor
21.3 cm. × 47.5 cm. (8-3/8 in. × 18-11/16 in.)
SKETCHBOOK V

Map reference: Paterson Quadrangle, New Jersey
UTM coordinates: 18.056900.452950
Orientation: 190°

It is highly probable that at some period the river took its course where the water of the Canal appears, and discharged itself on the left hand into the open country. The rock peeping from the woods on the left hand, bears also marks of wear by water, which render it not unlikely, that at a still more distant period the river fell over its edge as it now does, more to the right, over the rocks represented in the preceding page [No. 62].

The river was introduced into the chasm on the left by Monsr. L'enfant, for the purpose of forming a Mill race for the Cotton Mills at patterson. He intended to force a Channel through the perpendicular rock on the Right where the Ladders are, and has actually removed all that appears to be cut down at that place. The hole in the rock to the left of the Ladders was made for the purpose of containing a Barrell of Gunpowder, by means of which he intended to blow up the whole Rock above, at once. But the neighbouring Inhabitants fearfull of mischief, and with a view to prevent the Cascade from being spoiled, stopped the Workmen. (BHL, SKETCH-BOOK V)

Because of alterations to the area this view cannot be replicated. Latrobe was standing on the earthen embankment between the channel and the basin, as in the preceding drawing, this time looking south-southwest. The channel, now filled, is in the right middle ground, and the prominence in the center of the drawing is what is today known as Point of the Rock, the top of which can still be seen.

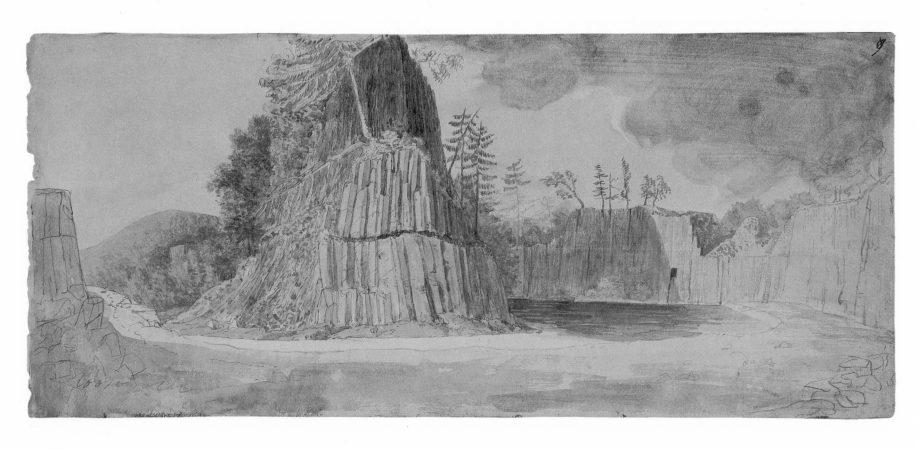

NO. 63

64. "Falls of the Passaic from the foot of the stairs"

28 May 1800
Pencil, watercolor
21.3 cm. × 47.5 cm. (8-3/8 in. × 18-11/16 in.)
SKETCHBOOK V

Map reference: Paterson Quadrangle, New Jersey
UTM coordinates: 18.056895.452952
Orientation: 35°

As in the previous drawing, the area has been so altered that the scene is no longer recognizable. Latrobe was looking northeast across the basin and down the river as it flowed past the rapids. He was at a point near the extreme right hand of the preceding drawing, that is, on the embankment at the foot of the "Rock, the surface of which is evidently water worn" shown in the map on p. 172. The falls would have been on his left, around the promontory in the center of the drawing.

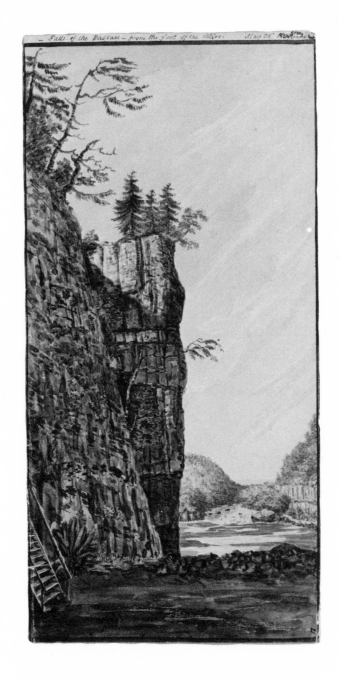

Falls of the Passaic — from the foot of the stairs. May 28. 1806

65. "View of the Falls of Passaick from the top of the Rock"

18 October 1799
Pencil, pen and ink, watercolor
21.3 cm. × 47.5 cm. (8-3/8 in. × 18-11/16 in.)
SKETCHBOOK V

Map reference: Paterson Quadrangle, New Jersey
UTM coordinates: 18.056890.452952
Orientation: 150°

This View gives by far the distinctest idea of the Fall which is into a *Crack* of a Rock, beginning in the foreground and widening into a Gulph of considerable width, as represented [by the plan on p. 172]. It is so narrow at its commencement that the water runs over it, and returns further down, and across the whole fall the Chasm is so confined, that all the Drift wood which comes down in the freshes is thrown across, and lies on the opposite Rock. That the river once ran across this Chasm is very evident, and even now in a great Fresh, the Water runs forward near 100 Yds. in the channel formerly sunk by the stream. (BHL, SKETCHBOOK V)

Latrobe was standing above the falls looking southeast along the crest. The mountain in the background is Garrett Mountain, a section of First Watchung Mountain. To the left of the falls are bare rocks that Latrobe described in his plan of the falls as "Old bed of the River Rock Water worn." He identified the wooded area beyond the bare rock as "Rock full of Chasms," and he described the rock outcrop in the center middle ground of the view just to the right of the falls as "Rock, the surface of which is evidently water worn."

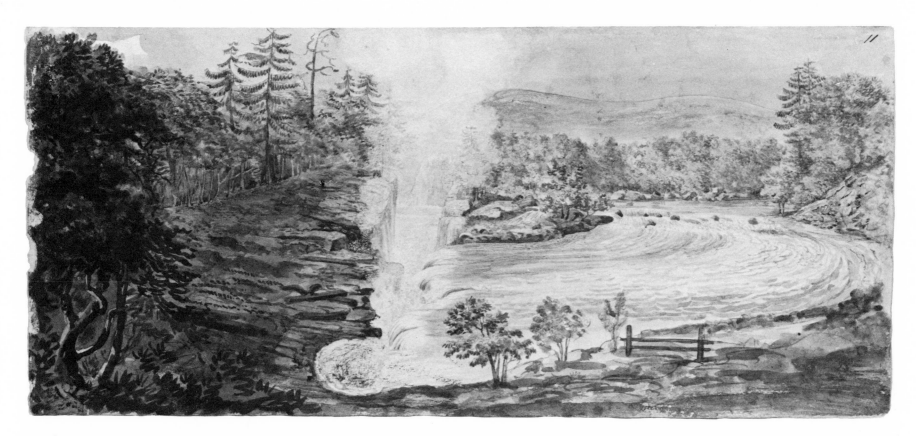

NO. 65

66. "Adventures on a trip to the Northward"

24 May 1800
Pencil, pen and ink
21.3 cm. × 47.5 cm. (8-3/8 in. × 18-11/16 in.)
SKETCHBOOK V

Latrobe sketched these scenes in and around Kingston, New Jersey, while he and his bride, Mary Elizabeth Hazlehurst Latrobe, were on their honeymoon. The couple had been married on 1 May 1800 in Philadelphia. During their honeymoon travels, the newlyweds visited several spots in the New York–New Jersey area. After stopping in Newark, they stayed with Nicholas Roosevelt at his nearby home, Laurel Hill. Next they journeyed to Paterson, where they marveled at the sight of the falls of the Passaic (see Nos. 61–65). They then traveled to New York City, and from there they went to the Bronx, where they visited Gouverneur Morris at his home, Morrisania. After stopping at Laurel Hill for another brief sojourn with Roosevelt, they returned to Philadelphia.

Latrobe casually sketched the "Adventures on a trip to the Northward" in writing ink, rather than India ink, over some preliminary pencil work. Probably all the sketches represent humorous experiences, but a good deal of their significance is lost. At upper left, Latrobe's unnamed "cousin," ironically designated as "enjoying the Country air on the Frankfort road," bowls along at the center of a miniature dust storm of his own making. The next vignette records an experience that occurred at a place identified only as "Washington tavern." Latrobe, who avoided drinking spirits, evidently requested cider—hard cider—at this establishment. The caption reports his host's bluff reply: "Cyder? no, damn Cyder! I can give you good spirits!" A black head finishes the row. Below, at left, Latrobe drew the "Property of Richard Bache Esqr.," who, whatever the full import of the sketch, apparently did not incline to overfeed the old animals seen here. Aged, starved, but articulate, "Carlo," paraphrasing Romans 7:24, inquires, "O wretched dog that I am who shall deliver me from this body of death," while the bony, swaybacked, mute, and nameless horse prepares to deliver a kick. Pencil marks left of the dog show that at some point Latrobe intended a human figure in this area. Near the center of the page, the "Stable Helper at Kingston" looks like a man out to claim a tip. The "Drunken cripple near Princeton" communicates no anecdote. "Mrs. Van Tilburg," clearly the proprietress of an inn at Kingston, makes the request "Please to look at the Beds Ma'am." In a period of chancy accommodations at hostelries, it is understandable that a landlady would encourage her prospective guests to examine her beds. But one gathers the existence of a private joke between the Latrobes about the effect of the request on a very new and well-brought-up bride.

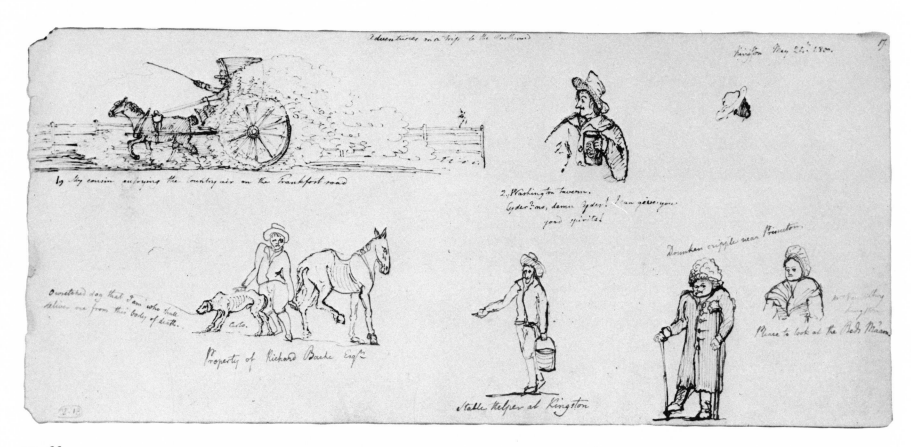

NO. 66

67. "View on the Road from Newark to Patterson, New Jersey"

28 May 1800
Pencil, pen and ink, watercolor
21.3 cm. × 47.5 cm. (8-3/8 in. × 18-11/16 in.)
SKETCHBOOK V

Map reference: Paterson Quadrangle, New Jersey
UTM coordinates: Viewing position: approximately 18.057236.452790; Falls:
 18.056890.452956; High Mountain: 18.056740.453552
Orientation: Approximately 295°

"This view shows the Gap in the Mountains through which the Passaick finds its way to the Ocean. The falls are at the foot of the Mountains on the left hand, where the Vapor ascending from them is faintly seen."
(BHL, SKETCHBOOK V)

When he drew this panorama, Latrobe probably was on the Old Wessel Road facing west-northwest. On today's map his position would be on Interstate 80 in Paterson, between McLean Boulevard on the east and Madison Avenue on the west. In this view, which today would show the heart of a highly developed urban industrial area, Latrobe presented a pastoral scene highlighted by Garrett Mountain to the left, the mist from the falls of the Passaic River just to the right of the mountain, and High Mountain, a section of the Second Watchung Mountain, still further to the right.

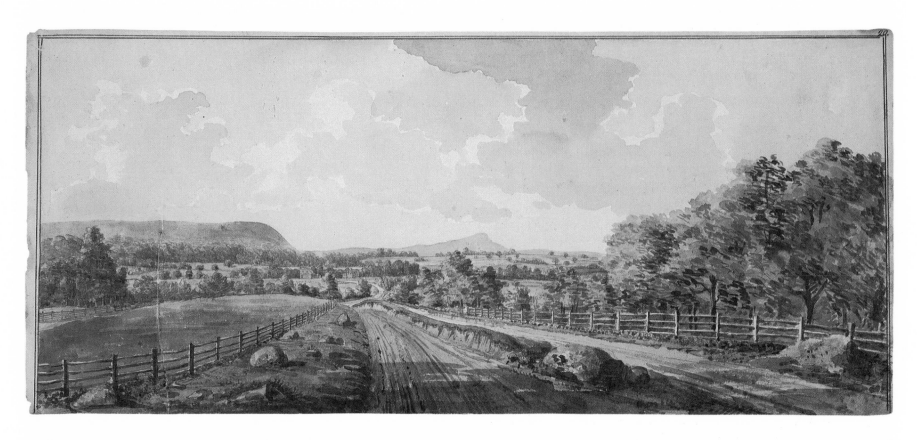

NO. 67

68. "Cloverhill, Seat of Isaac Hazelhurst Esq."

1800
Pencil, pen and ink, watercolor
27.0 cm. × 37.8 cm. (10-9/16 in. × 14-7/8 in.)
Sketch from Nature by B. H. Latrobe 1800
Private collection

Map references: Bristol Quadrangle, New Jersey–Pennsylvania; Mount Holly
 Quadrangle, New Jersey
UTM coordinates: Viewing position: approximately 18.051913.442718; Clover Hill:
 approximately 18.051908.442767; Mount Holly: 18.051802.442784
Orientation: Approximately 325°

Latrobe drew a preliminary, pencil and wash version of this scene, dated
20 July 1800, in his sketchbook. (For a reproduction of this sketch, see
BHL, *Journals,* 3:133.) Accompanying the sketchbook version were the
following remarks:

> The hill in the back Ground is the very remarkable eminence from
> which the town of Mount Holly derives its name. It is part of the
> estate of Mr. Hazlehurst.
> The road from Mount Holly to Monmouth passes along the
> line from the left to the right, then reaches below the woods across
> the picture. The view is taken from the East bank of the meadow
> looking to the West. (BHL, SKETCHBOOK VI)

Constructed in 1774 and situated on a 500-acre estate across the
Delaware River from Philadelphia, Clover Hill was the summer home of
Mary Elizabeth Latrobe's parents, Isaac Hazlehurst (1742–1834), a
prominent Philadelphia merchant, and his wife, Juliana (Purviance)
Hazlehurst (1741–1804). Clover Hill stood until 1857, when it was re-
placed by the Ashurst Mansion, still extant, a Gothic Revival house built
by Lewis Richard Ashurst for Mary Hazlehurst, granddaughter of Isaac
and Juliana. In 1948, the estate passed from family hands. The view of
Mount Holly depicted by Latrobe is today obscured by housing and
extensive reforestation in the area.

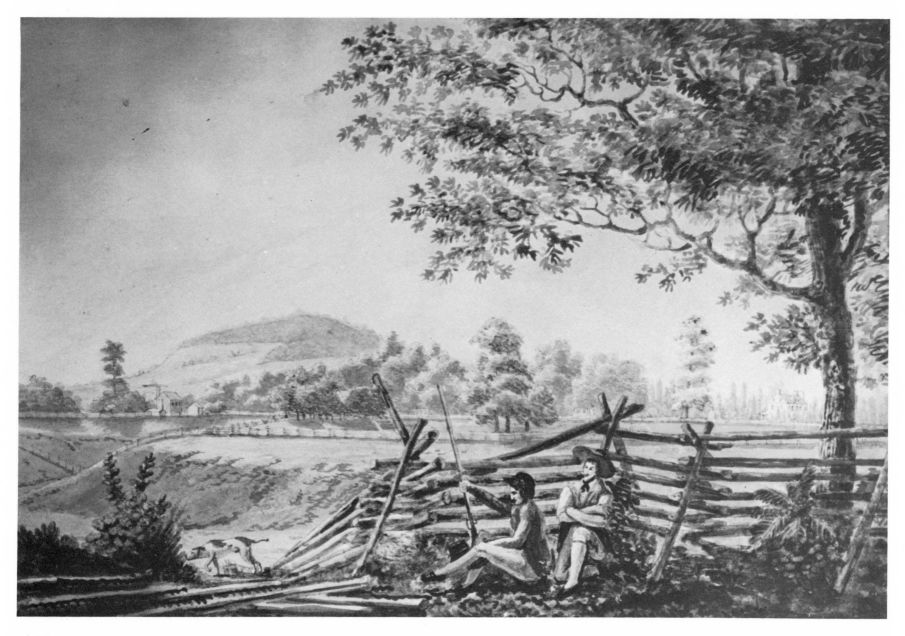

NO. 68

IV. Along the Susquehanna River, 1798, 1801

The Susquehanna River Improvement
and Survey Map

In August 1801, Pennsylvania governor Thomas McKean appointed Latrobe surveyor and assistant to Frederick Antes, his maternal uncle, to improve the navigation of the Susquehanna River from Columbia, Pennsylvania, to tidewater. The appointment was authorized by a Pennsylvania statute of 1799 incorporating the Chesapeake and Delaware Canal Company and providing for the improvement of the lower Susquehanna River. The improvement project was a joint venture of the Pennsylvania government, whose agents were Antes and Latrobe, and the Susquehanna Canal Company (a Maryland corporation building a canal along the Susquehanna from the Pennsylvania boundary to tidewater), whose agents were Sebastian Shade and his engineering assistant, Christian P. Hauducoeur. Shortly after his arrival at the Susquehanna to begin his duties, Latrobe learned of Antes's serious illness. Upon his uncle's death on 20 September 1801 Latrobe assumed control of the Pennsylvania half of the project and worked with his Maryland counterparts in accomplishing two separate and sequential tasks: the clearing of the natural obstacles for safe downstream navigation in spring freshets; and a complete survey of the river from Columbia to the river mouth at Havre de Grace. Channel clearance began in August 1801 and appears to have been near completion by late October. In this phase of the project, Latrobe functioned as the general contractor and coordinator with individual improvements executed under the immediate supervision of local farmers and rivermen.

Latrobe undertook his survey of the Susquehanna south of Columbia between 28 October and 12 November 1801. His survey party consisted of two assistant surveyors as well as chainbearers, axemen, and canoemen. They progressed downstream, sometimes backtracking to improve observation points and to strengthen the survey tri-

angulation network. Latrobe recorded his survey notes in two note-books, which still survive. Of particular interest in these notebooks are the field sketches he drew to supplement and clarify field observations and measurements. While these illustrations served the technical ends of the survey, Latrobe also employed them as models for artistic treatment in his sketchbooks. Preliminary versions of several sketchbook entries (including Nos. 77 and 79 below), as well as compositional elements of others, can be found in Latrobe's field books. (Representative pages of the field books have been published in BHL, *Engineering Drawings,* pp. 75–108.)

Upon completing his survey, Latrobe presented a report to the governor on the improvements he made, and in the report's appendix he provided a guide for navigators descending the river. During the winter of 1801–02 he completed his map of the river, compiled primarily from his field survey notes and sketches, and from a series of large-scale rough drawings made during the survey of October and November 1801. Latrobe also relied heavily on Christian Hauducoeur's *Map of the Head of Cheseapeake Bay and Susquehanna River* (1799) in developing the Maryland portion of the map. By mid-March 1802, Latrobe had brought his map to the governor in Lancaster and had begun a lobbying effort in the Pennsylvania legislature to secure $2,000 to complete the river improvements he had nearly finished the previous fall. Latrobe's efforts were successful, the appropriation was passed, and the improvements were completed in 1802.

Latrobe's Susquehanna River Survey Map represents a rare and valuable profile of the physical and cultural features of a part of Pennsylvania and Maryland just beginning to feel the impact of extensive agricultural and commercial development. Covering the river area from Columbia, Pennsylvania, south to the mouth of the Susquehanna at Havre de Grace, Maryland, the map is a large-scale, triangulated, strip-type map, approximately seventeen feet long and two feet wide. Prepared for navigational purposes, the map clearly delimits

shorelines, tributary streams, falls, rapids, and navigational courses, as well as the vegetation and geology of the land surfaces along the river. The map was rendered in pencil, pen and ink, and watercolor on six and one-third sheets of white paper, each sheet measuring 22 inches by 32-3/4 inches, glued to a continuous sheet of linen, and rolled as a scroll with two handles. In composing the map, Latrobe followed the cartographic conventions of the period with regard to depicting relief, physical and cultural features, and coloring. For an in-depth discussion of Latrobe's achievement on this project, see BHL, *Engineering Drawings*, pp. 75–108.

The landscape so meticulously portrayed by Latrobe has changed drastically since he surveyed it. Tilled fields have returned to woodlands, alluvial islands have been continuously modified by flood and ice, and roaring gorges have given way to power dams. The sediment in the channel, formerly a golden sand, is now a mixture of sand, slag, and fine coal dust derived from upstream mining wastes. The channel itself is reduced in width, while the adjacent floodplain level has risen rapidly in elevation due to the massive influx of coal-laden sediment. Approximately 60 percent of the river channel mapped by Latrobe is submerged by the reservoirs of three twentieth-century dams.

69. Susquehanna River Survey Map, Section 1

[1801–02]
Pencil, pen and ink, watercolor
55.9 cm. × 82.5 cm. (22 in. × 33 in.)
Maryland Historical Society, Baltimore

Map references: Columbia East Quadrangle, Pennsylvania; Columbia West Quadrangle, Pennsylvania; Red Lion Quadrangle, Pennsylvania; Safe Harbor Quadrangle, Pennsylvania
UTM coordinates: North: 18.037176.443388; East: 18.037639.442286; South: 18.037423.442146; West: 18.036862.443226
Orientation: Theoretically 60°

This portion of the map, depicting seven miles along the Susquehanna from Columbia to Kendricks' Bottom and Stoney Run, represents approximately 17 percent of the total map length. For this stretch of the Susquehanna, Latrobe advised navigators:

After leaving the ridge called the Chicksalunga hills, and the falls which extend through them, the course of the river is not interrupted by any material obstructions from Columbia to Pattons hill. This hill consists of Granite and Sand stone, and the river falls over below the Mill run, in a strong rapid to the next limestone stratum below Stahl's Tavern.

. . . The dangerous rocks at Gallaghers riffles above Stahl's tav-

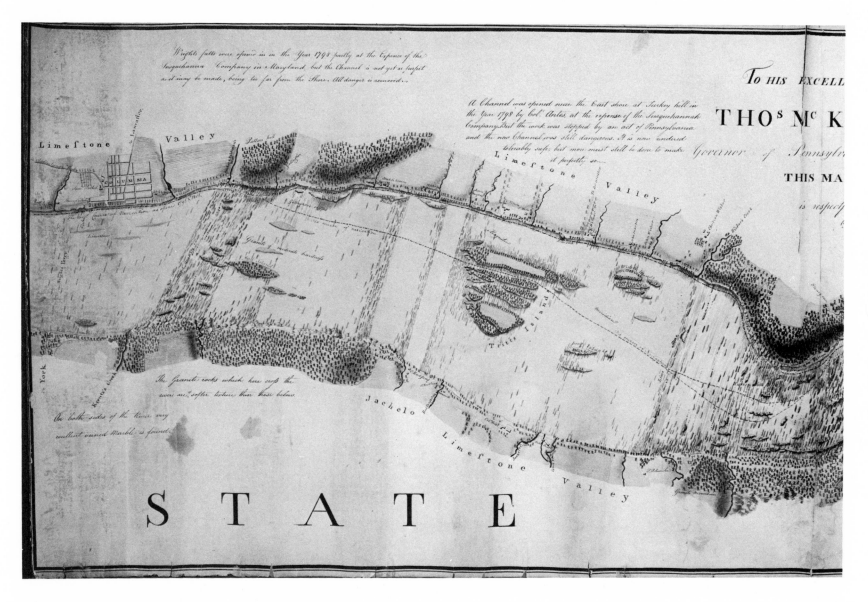

Wrights falls were opened in the Year 1798 partly at the Expence of the Susquehanna Company in Maryland, but the Channel is not yet as perfect as it may be made, being too far from the Shore. All danger is removed.

A Channel was opened near the East shore at Turkey hill in the Year 1798 by Col. Antes, at the expense of the Susquehannah Company. But the work was stopped by an act of Pennsylvania and the new Channel was still dangerous. It is now rendered tolerably safe; but more must still be done to make it perfectly so.

Limestone Valley

Limestone Valley

Limestone Valley

COLUMBIA

Pollers hill

Turtle Island

The Granite rocks which here cross the river are of softer texture than those below.

On both sides of the River very excellent veined Marble is found.

Jachelo

York

To HIS EXCELL

THOS McK

Governor of Pennsylv

THIS MA

is respectf

STATE

ern are lowered, and nothing need be apprehended from them, nor from Stahls riffles. The Channel indeed is narrow, but may be very easily hit. In passing thence to Turkey hill, it is perfectly safe to keep any part of the river East of all the Islands. (BHL, Appendix to Susquehanna Report, 28 November 1801, Pennsylvania Historical and Museum Commission, Harrisburg)

The area on the left of the map labeled "To York" is today the site of the town of Wrightsville. At Wrightsville, the Susquehanna is spanned by bridges, as it has been since 1814. The large islands in the river, which Latrobe labeled "Tritts Islands," have been washed away by floods and ice jams, but have been replaced by other islands in a continuous process of destruction and regeneration. The current islands in this reach of the Susquehanna are no longer cultivated. The series of small falls, or riffles, in the river in the vicinity of Turkey Hill, at the extreme right-hand portion of the map, have been placed under water by the upper portion of the Lake Clarke Reservoir.

70. Susquehanna River Survey Map, Section 2

[1801–02]
Pencil, pen and ink, watercolor
55.9 cm. × 82.5 cm. (22 in. × 33 in.)
Maryland Historical Society, Baltimore

Map references: Airville Quadrangle, Pennsylvania; Safe Harbor
 Quadrangle, Pennsylvania; Conestoga Quadrangle, Pennsylvania;
 Holtwood Quadrangle, Pennsylvania
UTM coordinates: North: 18.037616.442472; Northeast:
 18.038230.442080; East: 18.038444.441622; South:
 18.038162.441274; Southwest: 18.038058.441790; West:
 18.037424.442184
Orientation: Theoretically 30°

Section 2 of the map overlaps slightly with the southernmost area of Section 1. Beginning with Kendricks' Bottom and Stoney Run on the Lancaster County shore, it depicts the Susquehanna River as it continues its southeastward flow approximately eight miles down to just below Pequea and Otter creeks, on the east and west shores, respectively. This map section represents about 19 percent of the entire map. Latrobe here advised navigators:

> At the Wheeling falls [labeled on the map across from "Sauer's bottom" near the Lancaster County shore] below Sauers point the rocks project from the shore but the Channel is so wide that it cannot be mistaken. From the Wheeling falls, the shore must be gradually approached so as to be close in with it at the Mouth of Conestogo. Below Conestogo are Wussingers falls, which though almost impracticable when the river is low, are scarcely perceptible at the time of a fresh. The Shore must be kept here without any regard to the old Channel, as a clear straight Channel forty feet wide and level in the bottom has been cut quite to the Point falls below Burkhalters ferry. (BHL, Appendix to Susquehanna Report, 28 November 1801, Pennsylvania Historical and Museum Commission, Harrisburg)

The development of hydropower and flood control dams at Holtwood (1910) and Safe Harbor (1931) has rendered this area of the Susquehanna very different from the time when Latrobe surveyed it. The extensive series of bedrock islands and riffles shown in this map section have been submerged under Lake Clarke Reservoir (left half) and Holtwood Reservoir (right half). The axis of Safe Harbor Dam crosses the center of the map section from slightly upstream of Conestoga Creek, across Conestoga Island to the York County shore. A portion of Conestoga Island (present-day Else Island) protrudes from under the downstream end of the dam, and a large portion of Stoners Island (present-day Weise Island) remains above the level of Holtwood Reservoir.

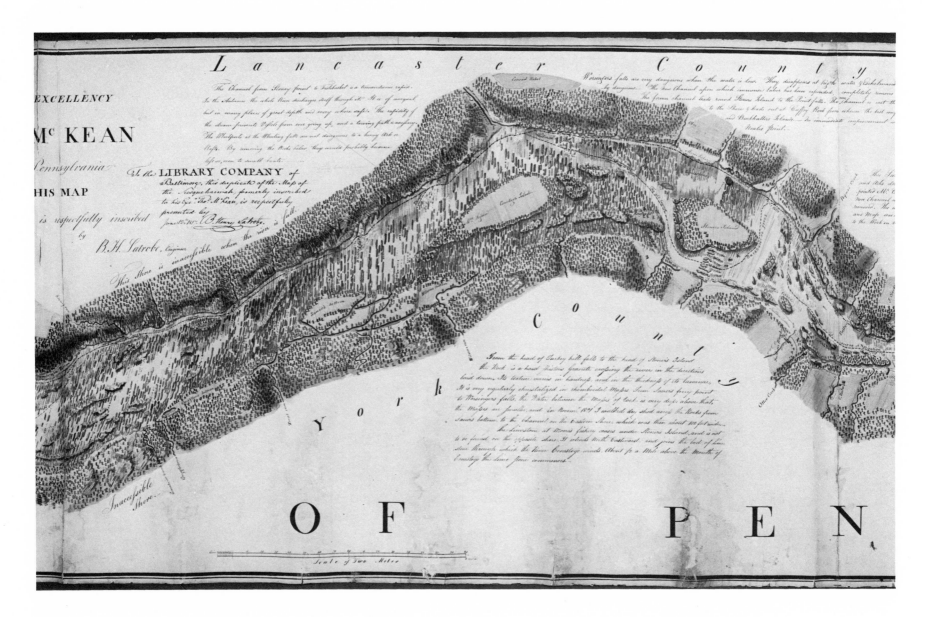

NO. 70

71. "View of Chickisalunga Rocks looking to the Southward"

Undated [29 October 1801]
Pencil, wash
20.3 cm. × 32.2 cm. (8 in. × 12-11/16 in.)
SKETCHBOOK VIII

Map references: Columbia West Quadrangle, Pennsylvania; Columbia East Quadrangle, Pennsylvania; Safe Harbor Quadrangle, Pennsylvania
UTM coordinates: 18.036966.443456
Orientation: 152°

The Chiquesalunga Rocks, along the eastern shore of the Susquehanna north of Columbia, Pennsylvania, are at the extreme left on Section 1 of Latrobe's map (see No. 69). The rocks, also called Chickies Rock or Chickies Ridge, sit at the mouth of Chiquesalunga Creek, which derived its name from the Indian word *Chickiswalungo,* "place of the crawfish." There were many variant spellings of the name in the eighteenth century; Latrobe's spelling appears on Reading Howell's *Map of Pennsylvania* (Philadelphia, 1792).

This view is from the eastern shore looking southeast, with the Turkey Hills in the background. Chickies Rock is the end of a quartzite ridge cut by the Susquehanna. Its northern extent is the near-vertical rock in the foreground, and it terminates one and one-quarter miles downstream with a second ridge, visible in the middle ground. The rocks in the river channel are a continuation of the ridge across the Susquehanna and create a series of riffles. The embayment between the two ridges was filled in during the construction of the Eastern Division of the Pennsylvania Canal; the far ridge had a railroad tunnel cut through it. The canal's right of way was later purchased by the Pennsylvania Railroad, and tracks were laid over the filled-in canal. Chickies Ridge is now a county park.

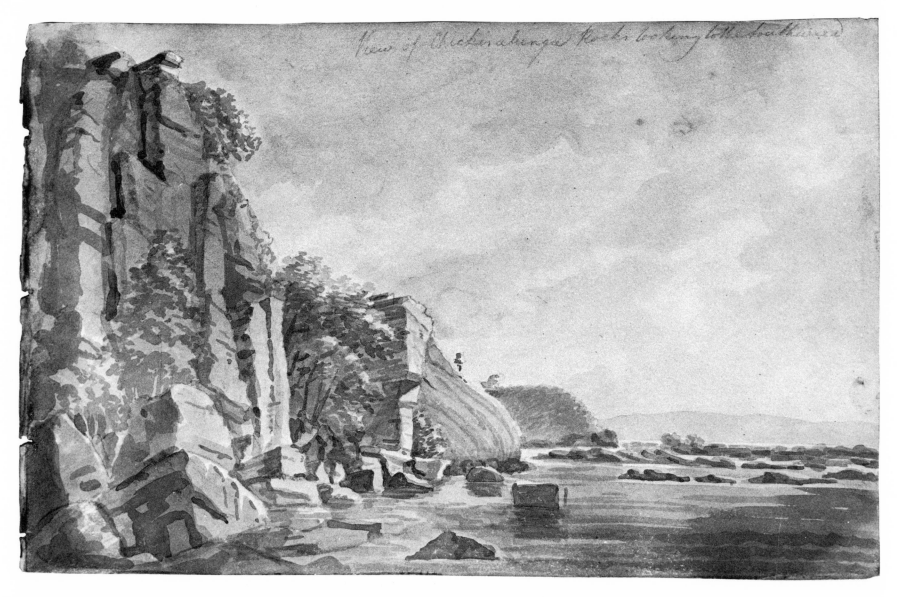

View of Bücheraberga Kock looking to the Southward

NO. 71

72. "View of the Susquehannah from the foot of the falls above Columbia"

Undated [29 October 1801]
Pencil, watercolor
20.3 cm. × 32.2 cm. (8 in. × 12-11/16 in.)
SKETCHBOOK VIII

Map reference: Columbia West Quadrangle, Pennsylvania
UTM coordinates: 18.037062.443286
Orientation: 282° to Round Top; 310° to point of the Hellam Hills

Chickies Ridge extends across the Susquehanna, forming the falls seen in this drawing. The ridge continues on the western shore, in York County, as the Hellam Hills, visible in the center of the drawing. Immediately beyond the Hellam Hills is Marietta, an old river town. The peak in the far distance in the center is Round Top (elevation 800 feet/244 meters). This view is just to the north of the place on the Susquehanna where Latrobe's map begins.

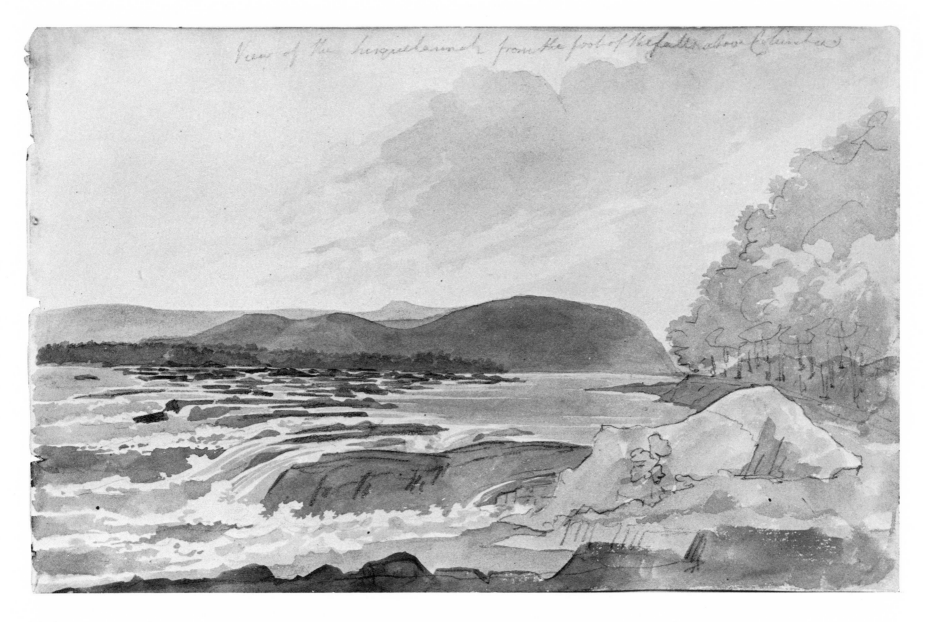

View of the Susquehannah from the foot of the falls above Columbia

NO. 72

73. "Anderson's Mill, below Wrights Ferry, drawn in a Fog"

Undated [last week of October 1801]
Pencil, watercolor
20.3 cm. × 32.2 cm. (8 in. × 12-11/16 in.)
SKETCHBOOK VIII

Map references: Columbia East Quadrangle, Pennsylvania; Safe Harbor Quadrangle,
Pennsylvania
UTM coordinates: 18.037254.443115
Orientation: 150°

"This drawing shows the head of Wright's fall looking down the River."
(BHL, SKETCHBOOK VIII)

This mill was built by James Barber about 1780 near the mouth of Barber's Run on the Susquehanna River, at the southern boundary of the borough of Columbia. In 1795 Alexander Anderson became part owner of the mill, but in August 1801 he and the other owners sold it to John Haldeman (1753–1832) and Jacob Strickler (1763–1812), Lancaster County merchants. Haldeman and Strickler were interested in improving the Susquehanna River below Wright's Ferry. In late December 1801 they navigated the new channel, opened under Latrobe's direction, from Columbia to tidewater and "found it perfectly safe, and easily kept." (BHL to Thomas McKean, 17 January 1802, in BHL, *Correspondence,* 1)

Although Haldeman and Strickler had bought the mill more than two months before this sketch was made, Latrobe styled it after its previous owner. In early 1802, however, when he drew the survey map of the river, Latrobe labeled the structure with the names of its new owners (see No. 69). The mill is no longer standing. The hills behind the mill are the Manor Hills.

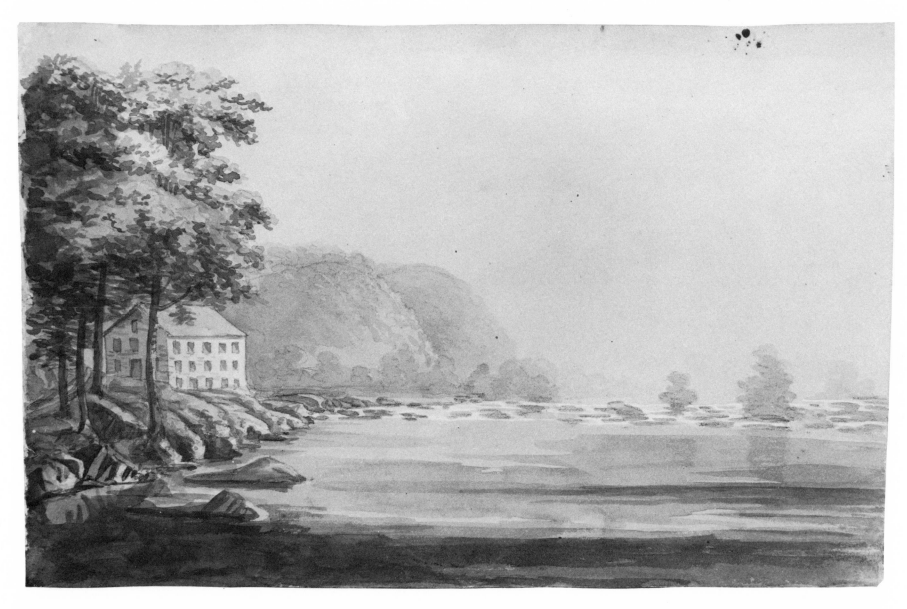

NO. 73

74. "From Turkey hill"

Undated [last week of September 1801]
Pencil, watercolor
20.3 cm. × 32.2 cm. (8 in. × 12-11/16 in.)
SKETCHBOOK VIII

Map references: Safe Harbor Quadrangle, Pennsylvania; Red Lion Quadrangle,
Pennsylvania; Columbia East Quadrangle, Pennsylvania; Columbia West Quadrangle,
Pennsylvania
UTM coordinates: 18.037550.442400
Orientation: 330°

Turkey Hill [is] so-called from having formerly been famous for wild turkey shooting, tho' now, thanks to the boundless liberty of killing game at all seasons and the total lack of protection from game laws, these excellent birds are scarcely ever to be met with in this part of the country. Turkey Hill is situated six miles to the left [southeast] of Columbia and twelve [southwest] from Lancaster. This road is in general very stoney and it took me near two hours to reach the river. . . . At about two miles from the river one descries it in looking down through the trees, and suddenly you feel as if transported into a new climate, a strange and a luscious fruit all at once appearing to grow in the greatest abundance, the papaw trees spreading in profusion on every side. . . . The channel is shallow elsewhere and there are several islands covered with trees in it, while the opposite coast is high and shows some cultivation. . . . Turkey Hill is very steep and covered with fine woods but the view was imperfect from the difficulty of seeing over the trees. On the top of it lived a family of the name of Frey who furnished us with bread and eggs. Land hereabouts is worth as much as $200 the acre. (Davis, ed., *Jeffersonian America*, pp. 222–24)

While drawing this view Latrobe was on Turkey Hill (at the far right of No. 69) looking to the northwest up the river. Visible in the middle distance are Round Top and the point of the Hellam Hills, on the York County shore, and Columbia, on the Lancaster County shore. The large islands in the river are Tritts Islands (for which see No. 69). The area in the right middle ground (present-day Washingtonboro) is now cultivated rather than forested. The river in view has become the extreme upper portion of Lake Clarke Reservoir. The channel is reduced in width while the adjacent floodplain level has risen due to the increase in coal-laden sediment caused by upstream mining wastes.

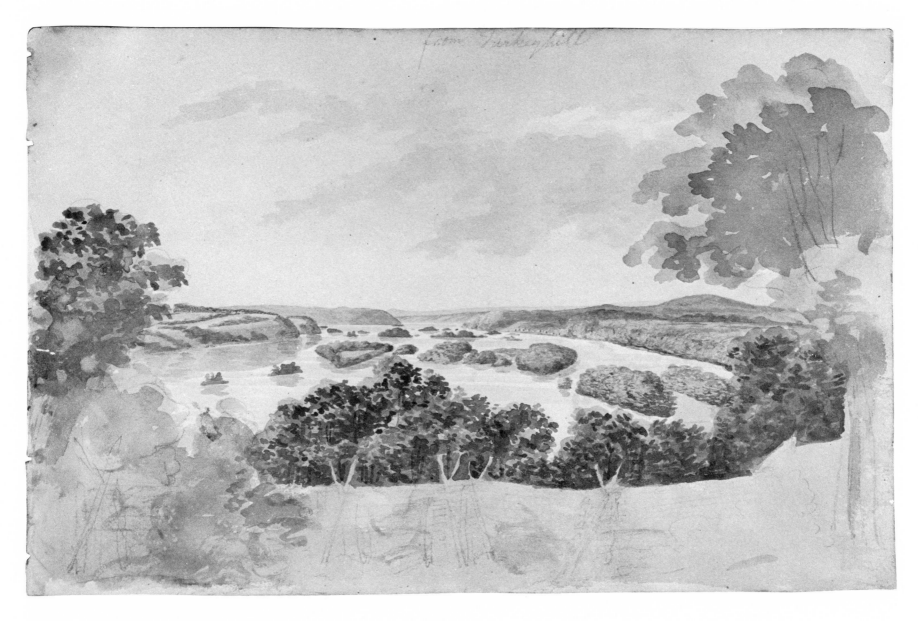

from Turkeyhill

NO. 74

75. "Stoney point"

Undated [last week of September 1801]
Pencil, pen and ink, watercolor
20.3 cm. × 32.2 cm. (8 in. × 12-11/16 in.)
SKETCHBOOK VIII

Map references: Safe Harbor Quadrangle, Pennsylvania; Conestoga Quadrangle,
 Pennsylvania
UTM coordinates: 18.037627.442268
Orientation: 130°

Stoney Point was at the mouth of Stoney Run in Lancaster County, Pennsylvania, opposite Stoney Island (see far left of No. 70). Latrobe made this drawing from above Stoney Point looking down the Susquehanna to the southeast. Stoney Island (with the trees) is seen in the center. The low-lying area at the foot of the hills at the right, on the York County shore, is Quiggler's Bottom. The rough outline of Quiggler's house can be seen at the edge of the water within the fork of the tree that Latrobe outlined in pencil. The narrow chasm beyond Stoney Island is the site of Safe Harbor Dam (built in 1931), which has placed the area in view under the waters of Lake Clarke Reservoir.

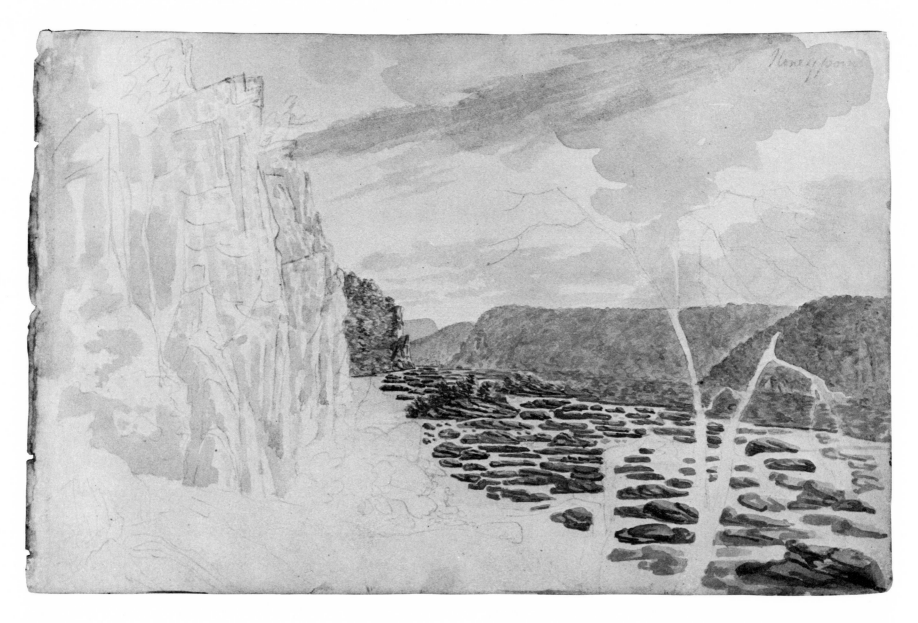

NO. 75

76. "Susquehannah at Stoney point"

Undated [last week of September 1801]
Pencil, watercolor
20.3 cm. × 32.2 cm. (8 in. × 12-11/16 in.)
SKETCHBOOK VIII

Map references: Safe Harbor Quadrangle, Pennsylvania; Conestoga Quadrangle,
 Pennsylvania
UTM coordinates: 18.037642.442252
Orientation: 130°

Latrobe made this drawing from further down the river and closer to
the shore than the previous drawing, but he was again looking down the
Susquehanna to the southeast. Running from the center middle ground
to the right middle ground is Stoney Island. In the center foreground
between Stoney Island and Stoney Point is the "Whirlpool," probably a
large circular eddy, that Latrobe noted on the map (see No. 70 and map
detail at right). Rising in the distance beyond Stoney Island is the York
County shore of the river. Visible again is the site of Safe Harbor Dam,
which has placed the area in view under water.

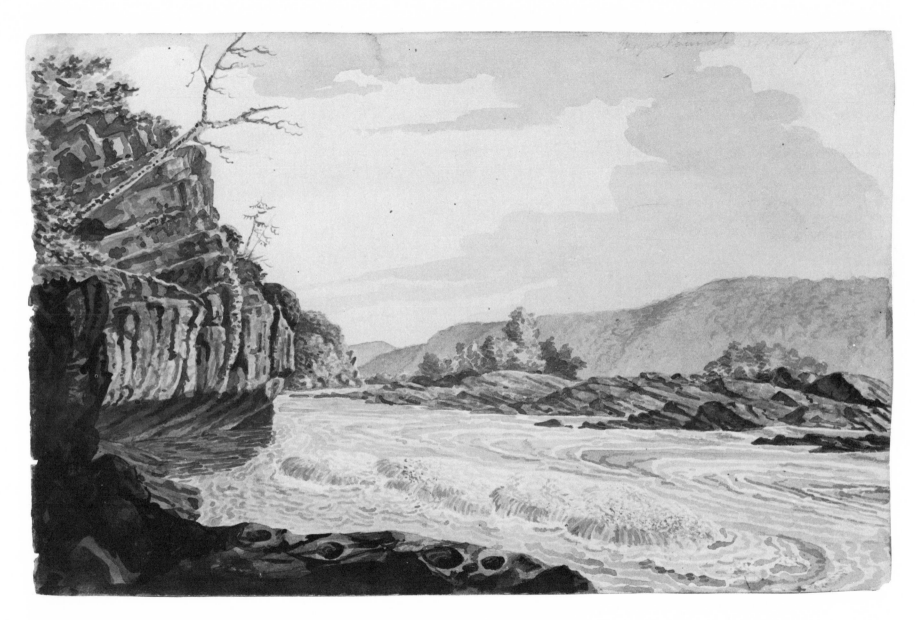

NO. 76

77. Log House on the Susquehanna River

Undated [4 November 1801]
Pencil
20.3 cm. × 32.2 cm. (8 in. × 12-11/16 in.)
SKETCHBOOK VIII

Map reference: Safe Harbor Quadrangle, Pennsylvania
UTM coordinates: Approximately 18.037596.442166
Orientation: Approximately 125°

This is probably Quiggler's house on the western shore of the Susquehanna in York County near Quiggler's Bottom and the mouth of Quiggler's Run (see left side of No. 70). Latrobe drew a preliminary sketch for this drawing in his field book on 4 November 1801, at the end of the day's survey entries. The last measurements for the day were taken from Quiggler's house.

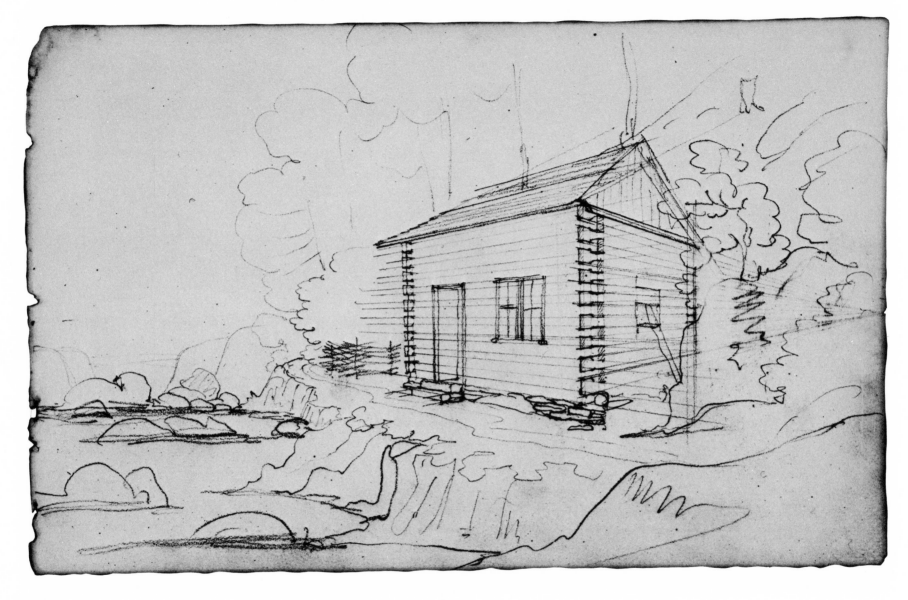

NO. 77

78. "Geo. Stoners on Pequai Creek, Buckhalter's ferry Susquehannah"

Undated [last week of September 1801]
Pencil, pen and ink, watercolor
20.3 cm. × 32.2 cm. (8 in. × 12-11/16 in.)
SKETCHBOOK VIII

Map reference: Conestoga Quadrangle, Pennsylvania
UTM coordinates: In the vicinity of: 18.038362.441574
Orientation: Approximately 160°

Pequea Creek flows into the Susquehanna from Lancaster County at the extreme right of No. 70. George Stoner (b. ante 1754), probably the son of Lancaster County clockmaker Rudy Stoner, was a Conestoga Township farmer who served as a supervisor in 1810. Latrobe employed Stoner as a contractor to supervise improvements on the Susquehanna near his home. Latrobe thought Stoner

> a man of strict probity, and attention to business. He has amply deserved that Character since I have known him, and the works at Burkhalter's speak sufficiently for him. By their means the most dangerous part of the river, next to Turkey hill falls, comprising Eschelman's Sluice, Burkhalters falls, and the point falls, is now among the safest parts of the Navigation. Without Mr. Stoner's exertions in superintending them daily they would scarcely have been completed this season. (BHL to Thomas McKean, 27 January 1802, in BHL, *Correspondence,* 1)

A quarter century after Latrobe drew this scene a traveler described Lancaster County barns in words that Latrobe himself might have used to accompany his drawing:

> I was particularly struck with the barns, which often look better than the dwelling-houses; the houses are generally of wood, and not handsome, whereas the barns are generally built of stone, at least the lower parts containing the stabling, and the two gable-ends. Between these, the barn is built of wood; a broad ascent leads to the entrance on one side, and on the other, the barn forms a broad shed over the entrances of the stables. (Bernhard, *Travels,* pp. 175–76)

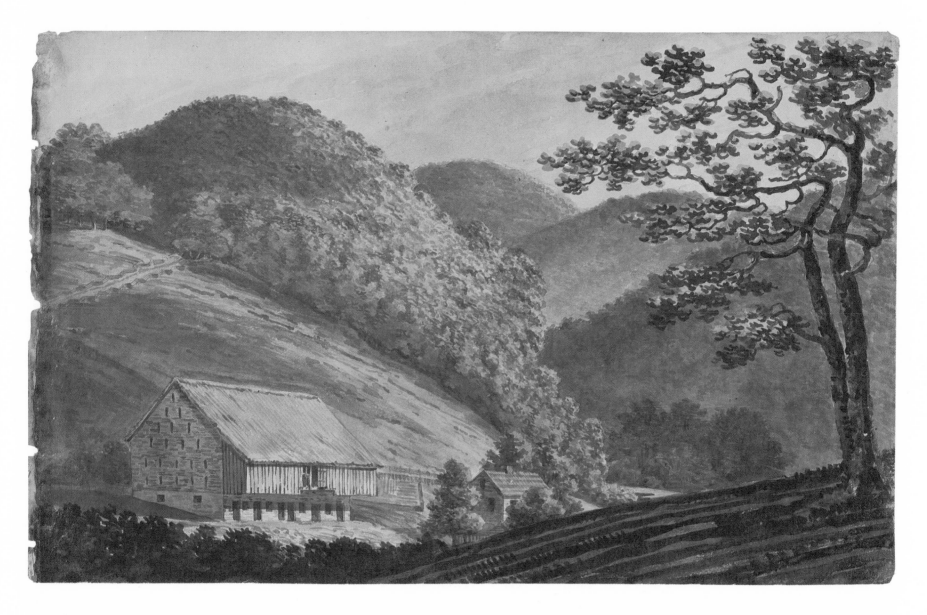

NO. 78

79. "Fultons ferry house West shore"

Undated [11 November 1801]
Pencil
20.3 cm. × 32.2 cm. (8 in. × 12-11/16 in.)
SKETCHBOOK VIII

Map reference: Safe Harbor Quadrangle, Pennsylvania
UTM coordinates: Viewing position: 18.038182.441494; Ferry house:
 18.038178.441502
Orientation: 330°

Fulton's Ferry House was in Chanceford Township, York County,
Pennsylvania. It appears on Latrobe's map (No. 70) at the far right, just
above Otter Creek, and next to Fulton's Bottom and Fulton's Island.
The eastern terminus of the ferry is also marked, just south of Pequea
Creek. Latrobe sketched virtually the same scene with pen and ink in his
field book.

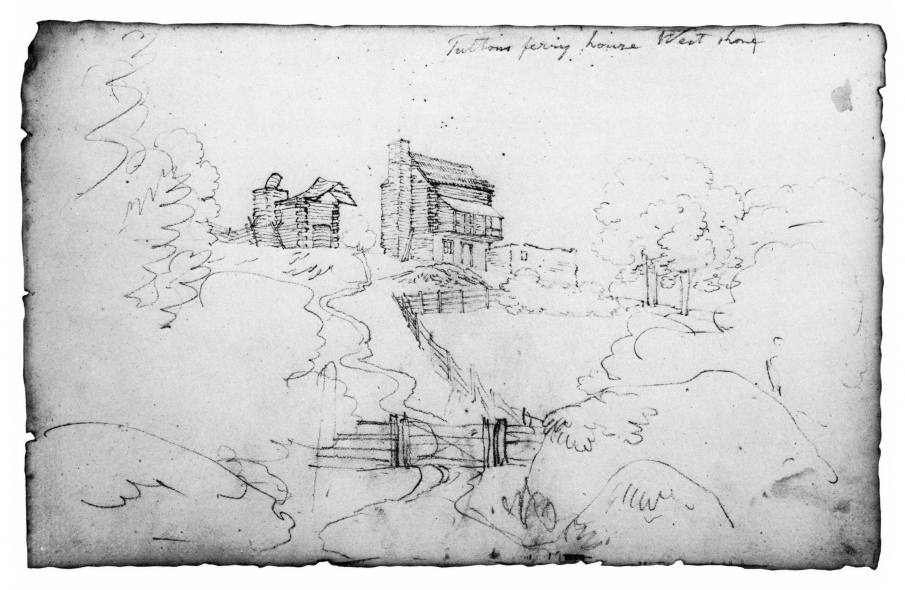

Tuttons ferry house West shore

NO. 79

213

80. Susquehanna River

Undated [fall 1801]
Pencil, watercolor
20.3 cm. × 31.1 cm. (8 in. × 12-1/4 in.)
Peter Latrobe Heyrman, Baltimore, Md.

Map reference: Safe Harbor Quadrangle, Pennsylvania
UTM coordinates: In the vicinity of: 18.037375.442352
Orientation: 120°

While Latrobe did not identify this scene, field and topographical inves-
tigations indicate that this was most likely a view taken from the western,
or York County, shore looking southeastward down the Susquehanna
toward the site of the present-day Safe Harbor Dam. On the left is
Turkey Hill. The rapids created by the rocks in the foreground are the
result of the highly resistant schist rock which crosses the river at this
point. Portions of this view, including the bedrock islands, are sub-
merged under the waters of Lake Clarke Reservoir.

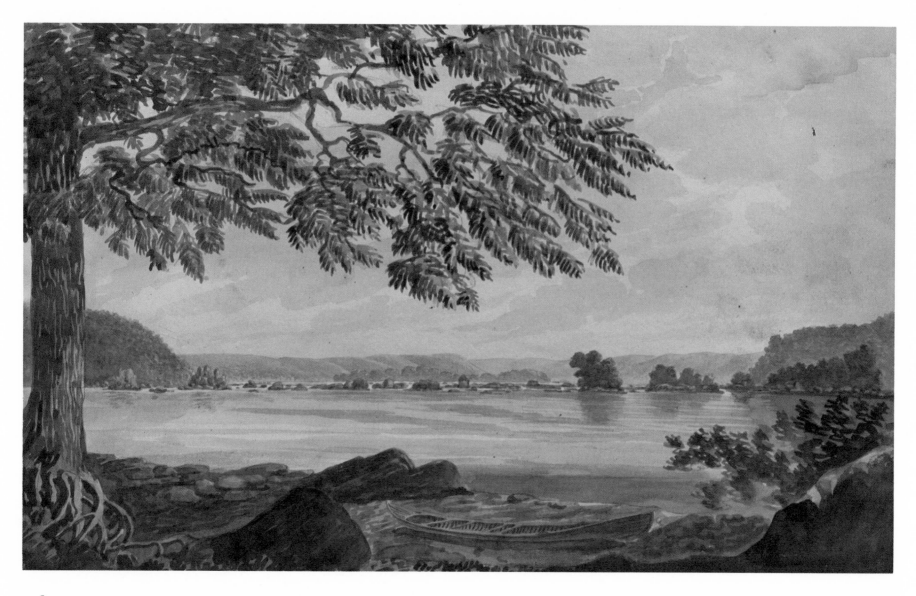

NO. 80

81. "View at Havre de Grace, the Mouth of the Susquehannah looking up the River"

22 March 1798
Pencil, pen and ink, watercolor
17.8 cm. × 26.0 cm. (7 in. × 10-1/4 in.)
SKETCHBOOK III

Map reference: Havre de Grace Quadrangle, Maryland
UTM coordinates: Viewing position: 18.040617.437838; Mt. Ararat: 18.040530.438275;
 Garrett Island: 18.040634.437965
Orientation: 345°

Latrobe executed this watercolor on his first trip from Virginia to Phila-delphia at the Havre de Grace ferry that crossed the Susquehanna on one of the major routes between Baltimore and Philadelphia. The ferry itself appears in the unfinished pencil and pen and ink sketch in Latrobe's sketchbook, at right; the route is shown on Christian P. Hauducoeur's *Map of the Head of Chesapeake Bay and Susquehanna River* (Philadelphia, 1799), a portion of which is also reproduced at right. Three years earlier, another traveler wrote: "The Susquehanna river is crossed, on the way to Baltimore, at a ferry five miles above its entrance into the Chesapeak. The river is here about a mile and quarter wide, and deep enough for any vessels; the banks are high and thickly wooded, and the scenery is grand and picturesque." (Weld, *Travels*, p. 25)

 Latrobe was looking northward from a point just north of Havre de Grace, Harford County, Maryland, across the river to Cecil County, Maryland. The prominence in the center background on the Cecil County shore is Mt. Ararat (elevation 250 feet; labeled "Mount Ararat Rock" on Hauducoeur's map) at a distance of about two and a half miles. On the right is Garrett Island (formerly Palmer's Island), featuring a hill of 100 feet elevation, at a distance of about three-quarters of a mile. For a perspective of Havre de Grace from Chesapeake Bay, see No. 103.

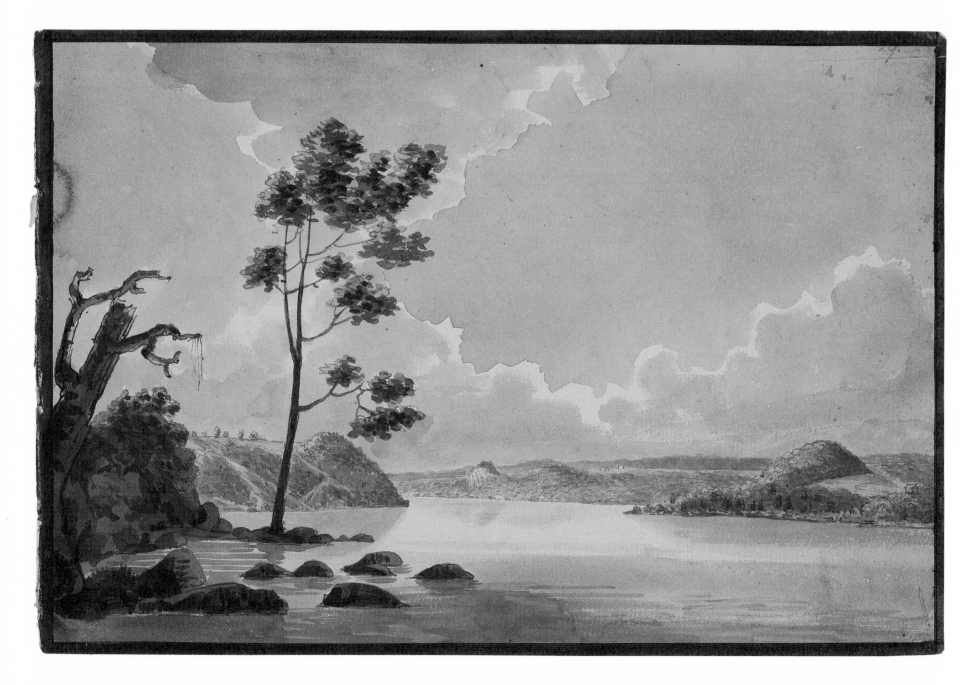

NO. 81

V. Travels in Eastern Pennsylvania and New Jersey, 1799–1808

82. Lancaster County Courthouse, Lancaster, Pennsylvania

Undated [September 1801]
Pencil, pen and ink, watercolor
20.3 cm. × 32.2 cm. (8 in. × 12-11/16 in.)
SKETCHBOOK VIII

Map reference: Lancaster Quadrangle, Pennsylvania–Lancaster County
UTM coordinates: Viewing position: 18.038847.443246; Courthouse: 18.038850.443249
Orientation: 20°

This courthouse, no longer extant, was built after the original courthouse was destroyed by fire in 1784. It stood in Centre Square (now Penn Square) at the intersection of King and Queen streets. This view is from the southwest corner of the square looking to the northeast. The two facades in view are the West King Street facade (left) and the South Queen Street facade (right), which was the main entrance. The courthouse, completed in 1787 at a cost of over £5,900, was primarily of brick with the eight corners, the lintels, and the windowsills of cut stone. From late 1799 until 1812, Lancaster was the capital of Pennsylvania, and the county courthouse served as the statehouse when the legislature was in session.

The ground story of the courthouse contained the courtroom, while the second story had three rooms that were used for holding the District and Orphans' courts and meetings of juries, city councils, and the school board. When the courthouse served as a statehouse, the Senate met in the upper story while the House of Representatives met on the ground floor. The courthouse was demolished in 1852, and the square now has a statue commemorating Civil War heroes as well as statues of four prominent Lancaster County natives.

While on his survey of the Susquehanna River in the fall of 1801, Latrobe made Lancaster his headquarters, and it was from here that he secured the state-appropriated funds to pay the contractors supervising the river improvements. He returned to Lancaster in March 1802 to lobby the state legislature for additional funds to complete the Susquehanna improvements. While working to secure the appropriation, Latrobe recorded his impressions of the Pennsylvania assembly in a letter to his wife:

> Depend upon it, it is the true original ugly Club. Some of the figures there exhibited, are *morceaux* fit only for the pencil of Hogarth. I counted only 12 combed heads, and 2 woolen nightcaps. . . . There is neither form nor comeliness in them that we should desire them. Some of the countenances unite coarseness and brutality with stupidity in a superior degree. And yet I was most disappointed in hearing sound sense proceed from many of the least promising in appearance, though dressed in very uncouth language.

All these are strong likenesses, and not caricatured. (BHL to MEL, 18 March 1802, in BHL, *Correspondence*, 1)

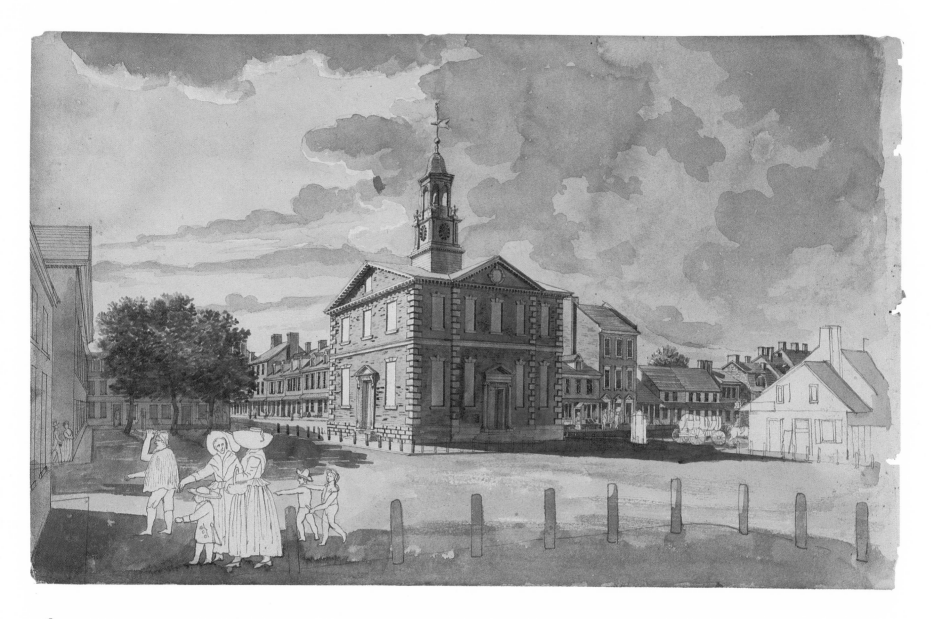

NO. 82

83. "Conestogo bridge"

Undated [fall 1801]
Pencil, wash
20.3 cm. × 32.2 cm. (8 in. × 12-11/16 in.)
SKETCHBOOK VIII

Map reference: Lancaster Quadrangle, Pennsylvania
UTM coordinates: Viewing position: 18.039133.443242; Bridge: 18.039128.443246;
 Conestoga Tavern: 18.039120.443250
Orientation: 305°

This stone bridge over Conestoga Creek was just east of Lancaster on the old Philadelphia and Lancaster Turnpike (present-day King Street). It was completed shortly before Latrobe drew it. Abraham Witmer (d. 1818) built the nine-arch toll bridge in 1799–1800 to replace the wooden structure that the Pennsylvania legislature had authorized him to build in 1787. Witmer's brother David sold the bridge to the Lancaster County commissioners in 1827 for $26,000. The bridge was still in use in the early twentieth century, but in 1932 it was replaced by a four-lane, three-arch concrete bridge. The dedication stone from the bridge shown here was incorporated into the north side of the present structure, along with a marker indicating the distances to Lancaster (one mile) and to Philadelphia (sixty-one miles).

Latrobe was standing downstream looking upstream to the northwest. Henry Dering's 1777 stone tavern, known today as the Conestoga Inn and now coated with formstone, can be seen to the west of the creek on the north side of King Street (the second of the three structures shown).

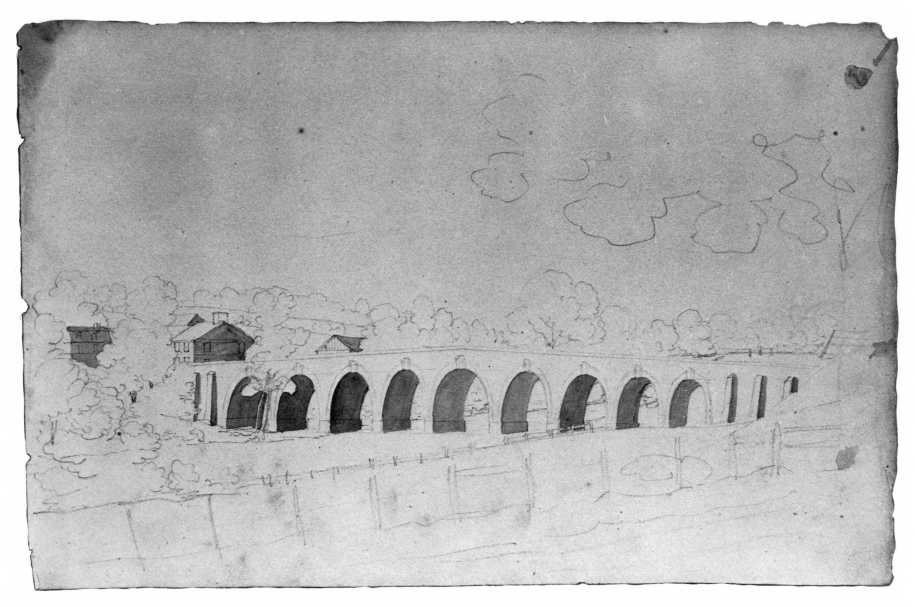

NO. 83

84. "Bridge over the Brandywine at Downing's town, Pennsa."

September 1801 [or later]
Pencil, watercolor
27.9 cm. × 35.2 cm. (11 in. × 13-7/8 in.)
B H Latrobe Septr. 1801
Maryland Historical Society, Baltimore

Map reference: Downingtown Quadrangle, Pennsylvania
UTM coordinates: Viewing position: 18.043991.442840; Bridge: 18.043976.442848
Orientation: 300°

Latrobe began a view of the stone bridge over Brandywine Creek at Downingtown, Chester County, Pennsylvania on the road from Philadelphia to Lancaster (later known as the Lancaster Avenue Bridge) in Sketchbook VIII in September 1801. He did not complete the sketchbook drawing, instead choosing to prepare a separate watercolor. On this second drawing, featured here, he wrote the date that he originally drew the scene from nature, but he may have made this drawing at any time thereafter.

The bridge had nearly reached completion when Latrobe first drew it. The centering (the wood framework used in constructing the arches) had been removed from the left arch but was still in place under the center and right arches. According to Latrobe, the center arch had a sixty-foot span and the side arches had forty-foot spans. The erection of the bridge resulted from a 1795 petition from "sundry inhabitants" of Chester County to the judge and grand jury of the Court of Quarter Sessions and to the county commissioners. The commissioners contracted with Samuel Hains for the construction of the bridge for the sum of £400, and Hains began construction in 1801. On the bottom margin of his drawing, Latrobe named one John [Lewis?] as builder. This seeming discrepancy concerning the identity of the builder very likely reflects a division of labor between, say, a carpenter-contractor, and a mason in the construction of the bridge. The bridge was replaced in 1921; however, the marble datestone of 1801 was incorporated into the new bridge.

Latrobe drew this scene from the eastern bank of the Brandywine, looking upstream to the North Valley Hills. Portions of this view have remained basically as Latrobe saw them, despite the growth of Downingtown over the years. The area has retained an open, wooded appearance with the Dr. Edward Kert Memorial Park on the east bank and with a series of well-landscaped backyards on the west bank. The area in the foreground of the drawing, however, has been developed for commercial and municipal use and no longer possesses the parklike serenity of this view.

Latrobe's ideas for the view underwent some little evolution. On the page facing the sketchbook version, he made an ill-considered study of a seated woman with a parasol under a tree, and this looks like an alternative treatment for the left-hand foreground tree. The second version of the landscape differs from the first in a variety of details, which seem to have a common denominator in heightened pictorial effect. Thus, in the second version, the foreground trees blend with each other to complete a four-sided frame for the view, the buttresses of the bridge have grown rougher, the coach and horses provide at the center of the scene a judicious dark accent that further serves to set off the distance of the pertinent part of the background, and the more pronounced mountains develop a favorite Picturesque element, the blueness of distant ridges. The view records nothing momentous; no doubt the first version showed Latrobe satisfying possibilities simply for a landscape composition, and he therefore pursued these possibilities in his idyllic second rendition. Latrobe's love of Claude played into his decision to shape a landscape around an arched bridge in the middle ground. In a later discussion of single-arched versus triple-arched bridges, apropos of the National Road, he would remark on the Picturesque effect of the latter type of structures, noting that they added "greatly to the beauty of the landscape." (BHL, *Journals*, 3:325) Latrobe's son John H. B., too, liked the composition, finding it a suitable basis for a plate in Fielding Lucas's *Progressive Drawing Book* (see p. 39 and Fig. 17).

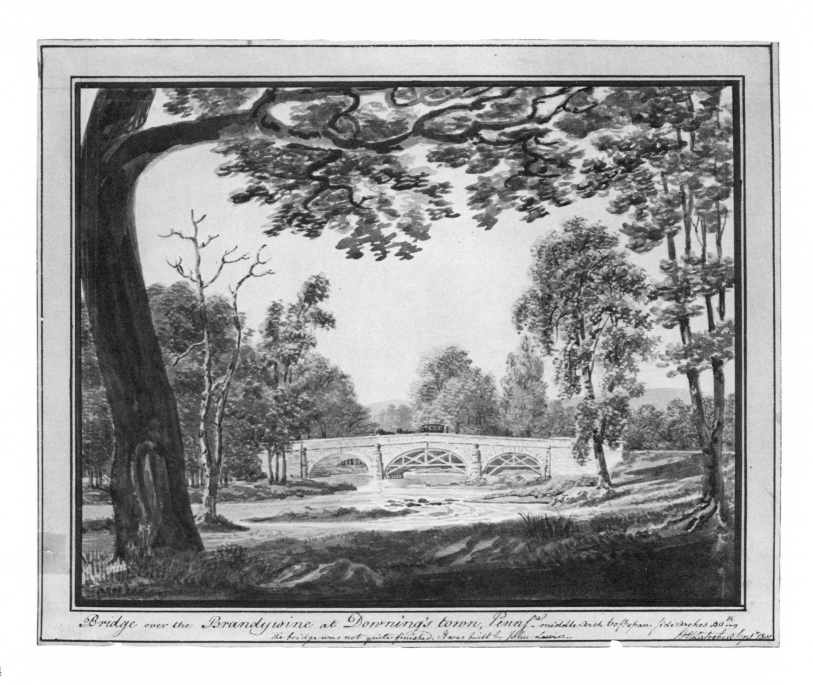

Bridge over the Brandywine at Downing's town, Penn[a] middle Arch 60 ft span. Side Arches 30 ft [...]
The bridge was not quite finished. It was built by John [...]

B H Latrobe Sept 1801

85. "From the tavern beyond Ege's forge"

22 October 1802
Pencil, watercolor
20.3 cm. × 32.2 cm. (8 in. × 12-11/16 in.)
SKETCHBOOK VII

Latrobe traveled north through the Schuylkill River valley in October 1802, most likely to secure wrought iron for his rolling mill at the Schuylkill Engine House in Philadelphia. His trip led him to two Berks County, Pennsylvania, iron forges, Schuylkill Forge and Spring Forge. The Schuylkill Forge was owned by George Ege (1748–1829), an iron-master, associate judge, and reputedly the largest landholder in Berks County at this time. Ege established the forge in 1796 near Port Clinton, Berks (now Schuylkill) County, along the Little Schuylkill River. Latrobe made three drawings near this forge (Nos. 85, 86, 87) at the vent in Blue Mountain where the Little Schuylkill merges with the Schuylkill River. In No. 86, the view is from the western bank of the Schuylkill looking toward West Mountain, the southwest face of Blue Mountain. For No. 87, Latrobe moved several miles downstream to capture a more distant view of the mountain bisected by the Schuylkill. Latrobe then traveled south in Berks County to George Lorah's Spring Forge, situated in Earl Township near present-day Boyertown Pike (Route 562) and Man-atawny Road. From the vicinity of this forge, Latrobe looked north-easterly to sketch the Oley Mountains and the rolling fields below them (No. 88).

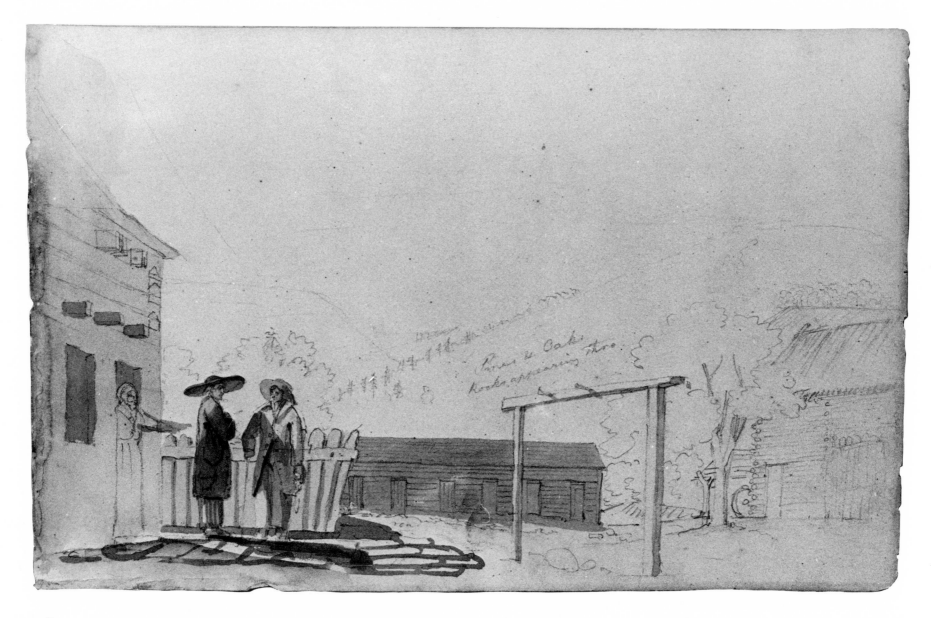

Pines & Oaks
Rocks appearing thro'

NO. 85

86. "From under the West Mountain, Ege forge"

22 October 180[2]
Pencil
20.3 cm. × 32.2 cm. (8 in. × 12-11/16 in.)
SKETCHBOOK VII

Map reference: Auburn Quadrangle, Pennsylvania
UTM coordinates: Viewing position: approximately 18.041328.449214; Base of
 mountain: 18.041328.449198
Orientation: 185°

87. "Vent of the Schuylkill from the Blue [Mountain]"

23 October 1802
Pencil, watercolor
20.3 cm. × 32.2 cm. (8 in. × 12-11/16 in.)
SKETCHBOOK VII

Map reference: Auburn Quadrangle, Pennsylvania
UTM coordinates: Viewing position: approximately 18.041530.449175; Vent:
 18.041340.449198
Orientation: Approximately 270°

88. "Oley Mountains near the Spring Forge (Lokran's)"

23 October 1802
Pencil
20.3 cm. × 32.2 cm. (8 in. × 12-11/16 in.)
SKETCHBOOK VII

Map reference: Boyertown Quadrangle, Pennsylvania
UTM coordinates: In the vicinity of: 18.043800.446333
Orientation: Approximately 25°

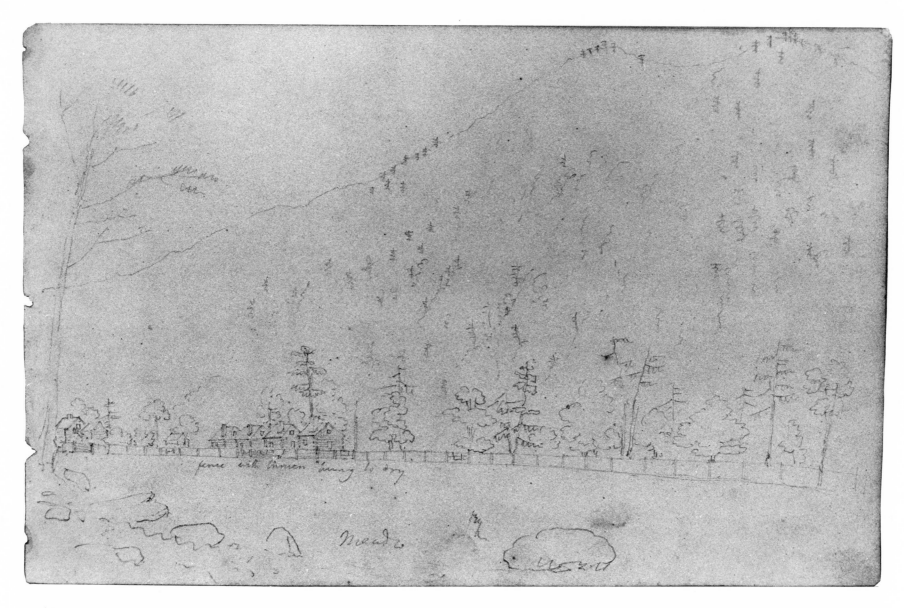

fence with timber laying to dry

Meado

NO. 86

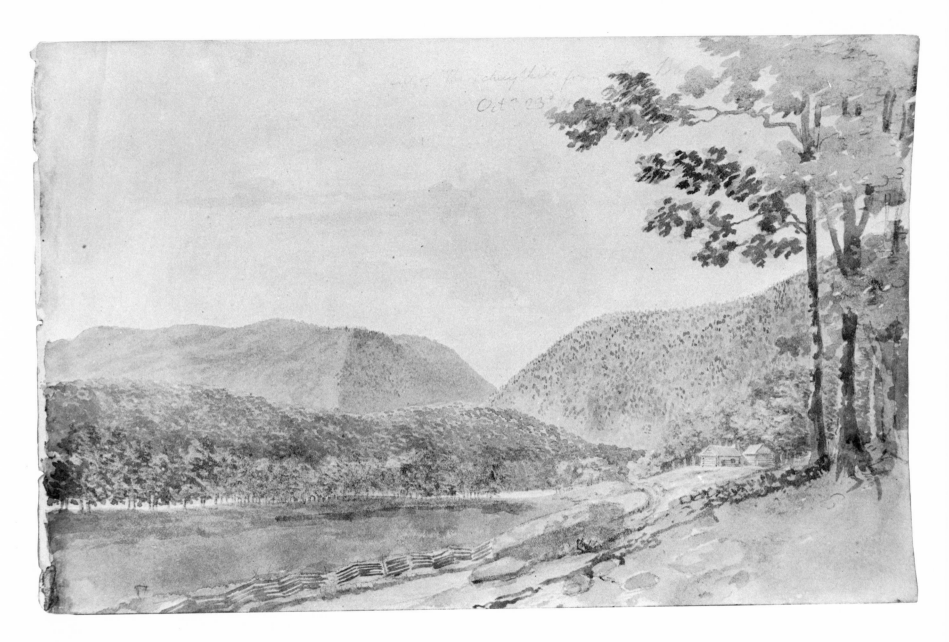

NO. 87
230

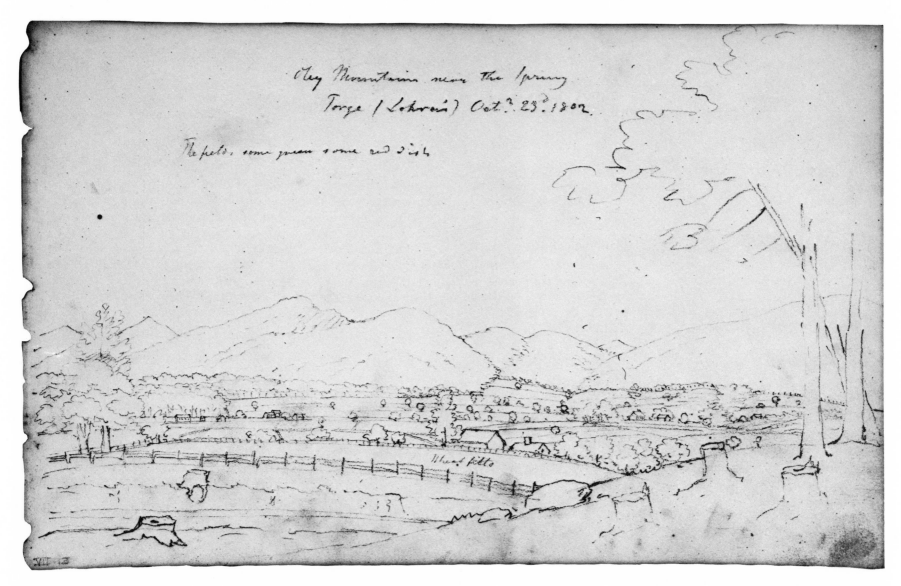

NO. 88

89. "View of the Schuylkill . . ."

31 August 1799
Pencil, pen and ink, watercolor
21.3 cm. × 47.5 cm. (8-3/8 in. × 18-11/16 in.)
B. H. Latrobe B. 1799
SKETCHBOOK V

Map reference: Philadelphia Quadrangle, Pennsylvania–New Jersey
UTM coordinates: 18.048428.442373
Orientation: 310°

View of the Schuylkill, taken Augt. 31st, 1799, looking up the river from a spot on the East Shore, a little below the Falls.

The house on the left hand, behind the lombardy poplars is Mr. Dallas's. That in the back ground on the hill, has just been finished by Mr. Dorsey.

The houses on the shore belong to Governor Mifflin's farm.

To the right of them, a little up the hill, is an hexangular tower, built by Dr. Smith, of Canal eminence. It is called Dr. Smith's folly.

The Schuylkill falls over part of a ledge of Rocks, reaching quite across the river which rocks, are the most distant ledge in the drawing. The fall is only of a few feet, and when the river is full, may be easily passed by the boats coming from the upper country. (BHL, SKETCHBOOK V)

The countryside surrounding the Falls of the Schuylkill was one of the most desirable residential areas outside of Philadelphia during the late eighteenth and early nineteenth centuries. Well-to-do Philadelphians created elegant country estates, to which they could retreat from the city during the summer, in the area of what is today Fairmount Park, part of the city of Philadelphia. Among the residents at the falls were Thomas Mifflin (1744–1800), governor of Pennsylvania from 1790 until 1799, and his trusted lieutenant, Alexander James Dallas (1759–1817), who served as secretary of the Commonwealth throughout Mifflin's administration, and who later became a good friend of Latrobe.

The Rev. Dr. William Smith (1727–1803), an Episcopal clergyman and educator influential in the development of the College of Philadelphia (forerunner of the University of Pennsylvania), completed his country house on the banks of the Schuylkill in the early 1760s. The building was distinguished by a polygonal bay, and this element, rather than the hexagonal tower, caused his estate to be popularly known as "Smith's Folly," as well as "Smith's Octagon." Smith was an active promoter of canals in Pennsylvania, particularly of the Delaware and Schuylkill Canal Navigation Company. In 1799 he wrote a pamphlet which mocked Latrobe's Philadelphia Waterworks plan and defended the Delaware and Schuylkill Company's interests against previous attacks by Latrobe.

The Mr. Dorsey to whom Latrobe refers was most likely John Dorsey (c. 1759–1821), an important amateur architect who designed the Pennsylvania Academy of the Fine Arts (constructed 1805–06) and built a Gothic mansion on Chestnut Street (c. 1810). As a professional architect, Latrobe keenly felt the competition offered by the talented but unpaid amateur Dorsey. As he complained to his father-in-law:

As to private business, I *shall get none*. . . . John Dorsey has no less than 15 plans now in progress of execution, because he charges nothing for them. The public affront put upon me as a professional Man in the erection of the Academy of Arts from the design of John Dorsey—by the vote of all the Men who pretend to patronize the arts in this city—would have driven any Artist from it, but one held by the strongest family ties and affections. (BHL to Isaac Hazlehurst, 21 July 1806, in BHL, *Correspondence*, 2)

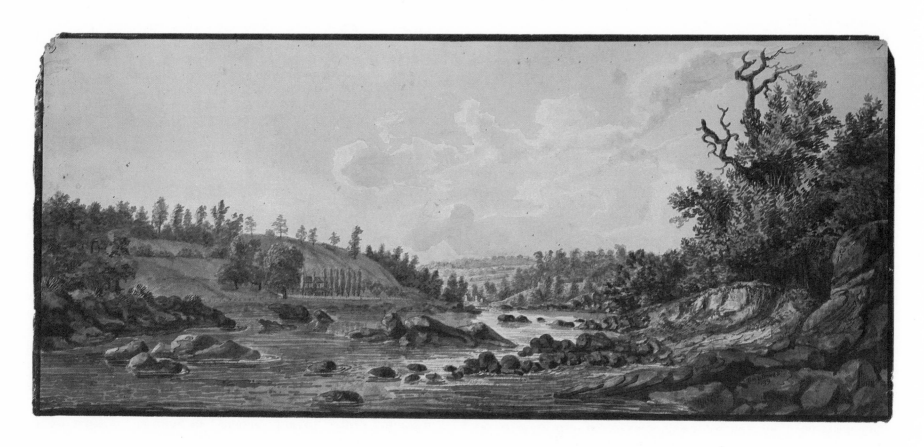

NO. 89

90. "View on the Schulkill, at the unfinished Canal at Norristown"

Undated [c. fall 1799–spring 1800?]
Pencil, watercolor
21.3 cm. × 47.5 cm. (8-3/8 in. × 18-11/16 in.)
SKETCHBOOK V

Map reference: Norristown Quadrangle, Pennsylvania
UTM coordinates: Viewing position: 18.047228.443919; Face of outcrop:
 18.047238.443914; Ivy Rock: 18.047274.443772
Orientation: 160°

On 10 April 1792, the Delaware and Schuylkill Navigation was established to connect Norristown with the Delaware River at Philadelphia. The proposed canal, along with another proposed to link the Schuylkill and Susquehanna rivers, was to provide continuous passage for boats traveling between Philadelphia and the interior of the state. The Delaware and Schuylkill Canal was also to supply Philadelphia with water from the Schuylkill River by means of a gravity aqueduct. At the close of 1798, Latrobe questioned the wisdom of the latter plan, and his own Philadelphia Waterworks, constructed between 1799 and 1801, rendered such a use for the proposed canal unnecessary.

Englishman William Weston served as superintending engineer of the Delaware and Schuylkill Canal, and his deputy engineer was Robert Brooke, who would later assist Latrobe as clerk of the works on the Chesapeake and Delaware Canal. By the end of 1794, about £52,500 had been expended on the Delaware and Schuylkill project and about one-third of the canal had been completed. However, financial difficulties among some of the principal stockholders forced suspension of the construction, and the excavation at Norristown remained unfinished. Today a railroad track runs over the path Latrobe depicted.

When Latrobe drew this scene, he was standing on the northeast bank of the Schuylkill River, opposite Christ's Old Swedes Church (1760), looking downstream to the southeast, toward Ivy Rock. He was immediately upriver from the ferry which crossed Swedes Ford, where today the Pennsylvania Turnpike and a major railroad bridge span the river. The house in the center of the scene is no longer extant.

Shortly before Latrobe made this view, the Duc de la Rochefoucauld Liancourt visited Norristown and left the following account of the canal:

The canal, intended to join the Schuylkill with the Delaware, begins at Norris Town, and half a mile of it on this side is completely finished. Its bed, which was parallel to the river, is about eighteen or twenty feet in breadth, and three feet deep. The canal is opened about three miles farther. Here marble rocks are to be cut through, which slope down to the river. This is a laborious, as well as very expensive, undertaking; as every cubic toise of rough stone costs nine shillings, and fifty workmen only are employed in this work. The canal, when finished, will be of great advantage to Philadelphia; but when will it be finished! It is begun near the town on a very bad plan; in some places it is filled up with sand that has been washed together to the height of ten feet, which can never keep water. It is reported, that Mr. Watson [Weston], an English engineer, who superintends the construction of this canal, very particularly recommended that it might be dug on the opposite bank of the Schuylkill, as it would be much more solid there; but as it was much to the interest of the directors of the company, that the canal should pass through their estates, they were deaf to every other proposal, and the canal is now executed on the most difficult and the most circuitous plan, with little prospect of success. The money for constructing the canal, began already to fall short of the sum required, and several subscribers kept back their subscriptions beyond the limited time of payment, even at the hazard of forfeiting the sum already paid, as well as all claims to the advantages resulting from the completion of the canal, rather than they would incur the risk of sinking a further sum, when the legislative power, apprised of the obstacles which obstructed the completion of the work, granted a lottery to raise a sum of four hundred thousand dollars, intended for the execution of all practicable plans of inland navigation, one hundred and thirty-three thousand dollars of which are to be appropriated to the completion of the Schuylkill canal. . . . But among a corrupt people, crimes and vices are generally encreased by the institution of a lottery; and can the legislature of Pennsylvania flatter itself, that it will not considerably add to the corruption and immorality of the inhabitants by an establishment so extremely dangerous, and of which a very immoderate use has already been made in America? (Rochefoucauld Liancourt, *Travels*, pp. 28–30)

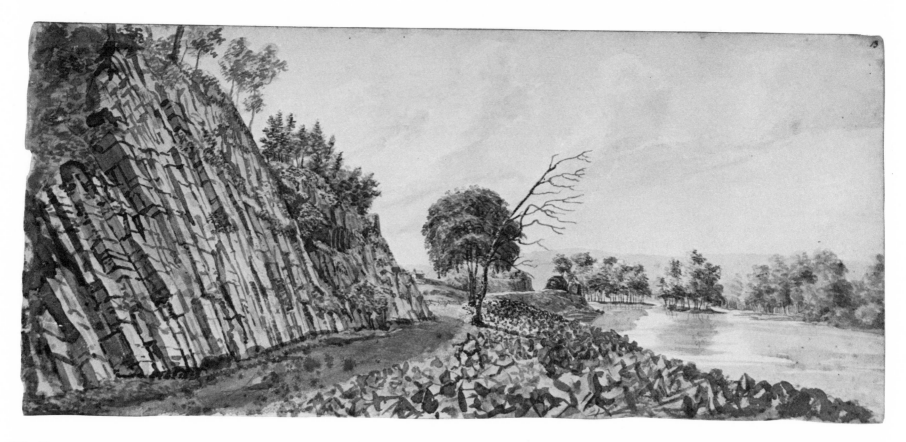

NO. 90

235

91. "Perkioning bridge"

Undated [post 4 November 1799]
Pencil, watercolor
21.3 cm. × 47.5 cm. (8-3/8 in. × 18-11/16 in.)
SKETCHBOOK V

Map reference: Collegeville Quadrangle, Pennsylvania
UTM coordinates: Viewing position: 18.046175.444804; Bridge: 18.046178.444813
Orientation: 30°

Perkiomen Bridge is a stone structure crossing Perkiomen Creek at present-day Collegeville, Montgomery County, Pennsylvania. On the main road from Philadelphia to Reading, the bridge was an important link in the commercial route connecting Montgomery County with Philadelphia, particularly after the completion of the Germantown and Perkiomen Turnpike in 1804.

Construction of the bridge was funded by state and county governments. The first appropriation, by the state legislature in 1794, was enlarged the following year by an additional grant from the county court. In 1797, the state legislature authorized a lottery to raise an additional $20,000. The necessary funds were raised, and the foundation stone was laid on 4 July 1798. After all the funds had been expended, however, the bridge was only half completed, so the state legislature passed an act in March 1799 authorizing commissioners to complete the bridge and collect tolls until the debt—about $60,000—was paid. The bridge opened on 4 November 1799, and five years later became a free, county bridge.

In his sketchbook, Latrobe noted some of the measurements of the bridge:

	High from water	Width	Length
Center arch	30	75	75
Piers		10.6	21
Two side arches	26.6	60.0	120
Piers		10.6	21
Two Land arches	20.6	30	60
Piers		6	12
Wings		52	104
From the Wing to the first arch		100	100
Arch		60	60
Wing		250	$\underline{250}$
			823
Width at top clear			27
Parapets 1f. 6i. each			$\underline{3}$
			30
Piers at X the Bridge bottom			$\underline{4}2$

Foundation stone laid July 4th, 1798
Opened Novr. 4th, 1799.
(BHL, SKETCHBOOK V)

When Latrobe painted the bridge, he was standing on the west bank of the creek, looking upstream toward the northeast. The bridge is still extant, although it has been modified with a three-lane arrangement and some repairs of concrete. The creek appears to have contracted since Latrobe's time as the water now flows under only three arches.

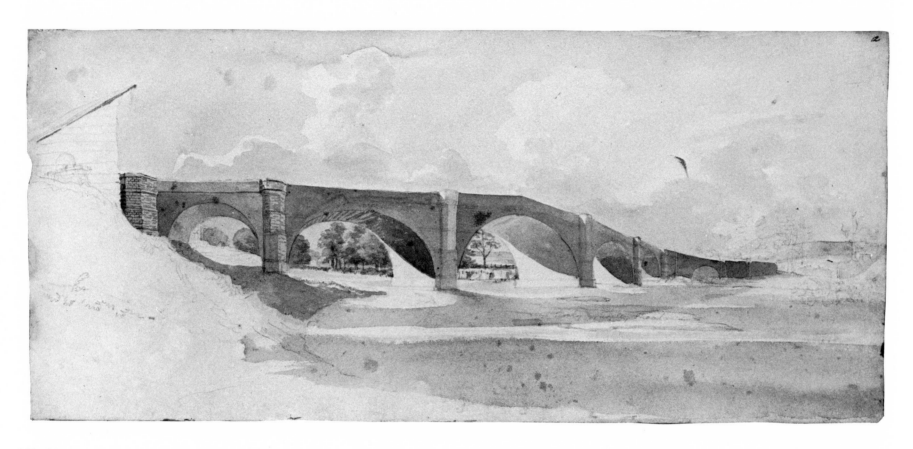

NO. 91

237

92. "Warwick furnace Chester Cy. Pensa."

26 May 1803
Pencil, watercolor
20.4 cm. × 32.2 cm. (8 in. × 12-3/4 in.)
SKETCHBOOK VI

Map references: Elverson Quadrangle, Pennsylvania; Pottstown Quadrangle,
 Pennsylvania
UTM coordinates: Viewing position: 18.043700.444446; Warwick Furnace:
 18.043690.444445
Orientation: 260°

The Warwick Iron Furnace, typical of eighteenth-century "blast" or "high" furnaces, was located on the South Branch of French Creek, southeast of Warwick in Chester County, and operated between 1737 and 1867. The furnace was part of an industrial/agricultural site that today is known as the Warwick Furnace-Farms complex. Latrobe may have made this trip to the furnace to procure wrought iron for the rolling mill at the Schuylkill Engine House of the Philadelphia Waterworks.

Robert Grace (1709–66), one of the original members of Benjamin Franklin's celebrated Junto, became a manager of the Warwick Furnace in the 1740s. Because of his association with Franklin, he was commissioned to cast the iron plates for Franklin Stoves. During the American Revolution, the Warwick Furnace also became well known for its production of cannon and other munitions for the Continental Army. It was there, during the war, that Latrobe's uncle, Col. Frederick Antes (1730–1801), cast the first four-pound cannons made in America. The furnace also cast bells, pots, and other iron implements in mahogany molds. When Latrobe visited the furnace it was managed by David Potts. During the nineteenth century the relative importance of the furnace declined, although it did provide iron for numerous steam engines as well as producing pig metal for various iron works. In addition, it furnished iron for the *Monitor,* the Union's first ironclad ship of the Civil War.

The stone furnace depicted in this watercolor was 32 feet high, 21-1/2 feet square at the base, and 11 feet square at the top. As was typical, the Warwick Furnace was built into the side of a small hill and was loaded from the top through a door that opened into the wooden "bridge" between the hill and the furnace. Horse-drawn wagons carried the iron ore up the road to the top of the hill, from where the ore was carried in baskets across the bridge to the furnace. The blast was furnished by long leather bellows driven by a waterwheel. At the front of the furnace was the "casting house"; here the molten metal ran out from the bottom of the furnace into a trough ("pig bed"), from where the slag that floated to the top could be drawn off. The Warwick Furnace produced about thirty tons of pig iron a week by burning charcoal, limestone flux, and iron ore. In a year it could burn the equivalent of 240 acres of woodlands. The depletion of wood, along with the increasingly widespread use of coal instead of charcoal, contributed significantly to the abandonment of the furnace's operation around 1867.

When drawing the Warwick Furnace, Latrobe stood on a slight incline on the grounds of the manor house, to the east of the furnace. The stream in the foreground is a small tributary of the South Branch of French Creek. The South Branch itself runs on the southwest side of the complex, out of this view. The stone structure to the right in the foreground was probably the springhouse. Today, all but the heavy fieldstone walls have disappeared from the main furnace structure, while among the other buildings in this scene only the springhouse and the stone remnants of several outbuildings remain.

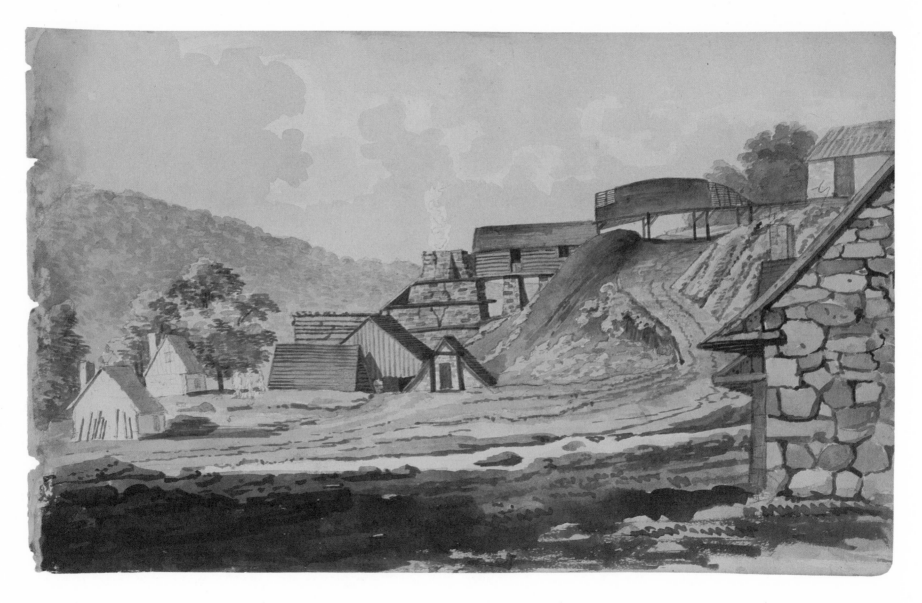

NO. 92

93. "Blue bell near Derby looking North"

6 June 180[3?]
Pencil, wash
20.4 cm. × 32.2 cm. (8 in. × 12-3/4 in.)
SKETCHBOOK VI

Map reference: Philadelphia Quadrangle, Pennsylvania–New Jersey
UTM coordinates: Viewing position: 18.047880.441833; Blue Bell Tavern:
 18.047889.441837; Bridge: 18.047884.441833
Orientation: 90°

This view features the humpbacked stone bridge over Cobb's Creek by the Blue Bell Inn near Darby, Pennsylvania. The bridge was part of the Darby Road, the heavily traveled route heading south from Philadelphia. The Blue Bell Inn (whose front porch and signpost are visible in the background) was a popular establishment along that route. Erected in 1766, it stood adjacent to the site of Johan Printz's Mill, the first mill in Pennsylvania. Sitting in front of the inn and serving as its carriage stepping-stone was one of the first millstones.

When Latrobe made this drawing, he stood on the west bank of Cobb's Creek, looking downstream and eastward. The creek now serves as the boundary between Philadelphia and its neighboring counties. The land and part of the bridge in the background of the scene, as well as the tavern, lie in what is now Philadelphia, while the bank in the foreground sits in Darby, Delaware County. The road that runs past the inn today is called Woodland Avenue, while the bridge that currently sits at this spot was constructed in 1909.

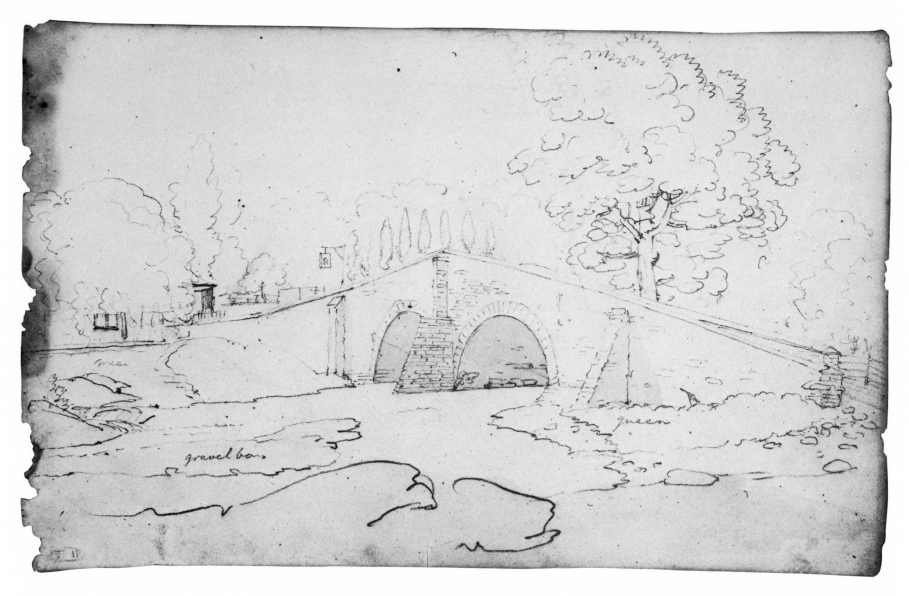

gravel bar

queen

NO. 93

94. "Mountholly N.J. from the old Episcopal Church Yard"

6 October 1806
Pencil
Two pages, each 20.3 cm. × 32.4 cm. (8 in. × 12-3/4 in.)
SKETCHBOOK IX

Map references: Bristol Quadrangle, New Jersey–Pennsylvania; Mount Holly
 Quadrangle, New Jersey
UTM coordinates: Viewing position: 18.051821.442626; Courthouse: 18.051798.442712;
 Mount Holly: 18.051802.442784
Orientation: 345°

At the time he made this sketch, Latrobe and his children were recovering from severe illnesses. Dysentery had only a few weeks before brought both Latrobe and his three-year-old son John close to death in Philadelphia. As soon as they were well enough, the family went to Clover Hill, the Mount Holly, New Jersey, country estate of Latrobe's father-in-law, Isaac Hazlehurst, in order to recuperate (see No. 68). During his stay at Clover Hill, Latrobe visited St. Andrew's Episcopal Church, where his second daughter, Juliana (29 June 1801–11 August 1801), was buried. St. Andrew's was situated on Iron Works Hill in Mount Holly. Constructed in 1742, the frame structure fell into disuse after the erection of a new church in 1786 on Church Street. It was demolished in 1807 by order of the vestry.

Latrobe extended this drawing over a portion of the verso of the preceding sheet. Although rather faint, the left-hand portion shows the outlines of the monument marking his daughter's grave. Latrobe had himself designed the monument, while Adam and James Traquair, stonecutters from Philadelphia, had cut the stone for it. The drawing shows the tomb topped by a pointed ornament at each of the corners. Not long after this drawing was done, the tomb was vandalized, and the monument survives without the four pointed ornaments. In subsequent years, other members of the Hazlehurst family, including Mary Elizabeth Latrobe and her parents, Isaac and Juliana Hazlehurst, were buried alongside the Latrobe infant under the white oak in front of the old church. In the background to the right of St. Andrew's are the house tops of Mount Holly. The Burlington County Courthouse, topped by an octagonal cupola, overlooks the town. Built in 1796, this courthouse is still in use today.

Church Yard

x very white

NO. 94

243

95. "Ferry men, Columbia, Susquehannah"

14 January 1808
Pencil, pen and ink, watercolor
20.3 cm. × 32.3 cm. (8 in. × 12-3/4 in.)
SKETCHBOOK X

Left Phila. Jany. 11th [1808]. Slept at Downingstown. Lancaster 12th, staid there. 13th. Terrible storm of snow and wind accompanied us to Columbia. It cleared up with a violent NW wind. Attempted to cross the river, but after an hours work, returned to Gosler's. Staid there the whole of the 15th. The wind rendering it impossible to get over. The Columbia side open, the York side frozen half across the river. (BHL, SKETCHBOOK X)

Latrobe made this entry into his sketchbook during a trip from Philadelphia to Washington via Lancaster, where he had represented his friend, frequent business collaborator, and future son-in-law Nicholas J. Roosevelt in an effort to sell swords to the Pennsylvania legislature. After leaving Lancaster, he traveled to Columbia but had to delay his crossing of the Susquehanna River due to foul weather, as he explained in a letter to Jefferson written soon after his arrival in Washington: "I arrived here on Wednesday evening, having been 11 days on the road, 3 of which were spent in waiting till it was practicable to cross the Susquehannah." (BHL to Jefferson, 23 January 1808, Jefferson Papers, DLC) To pass the time during this enforced sojourn, Latrobe sketched genre subjects, such as this drawing of ferrymen and the following drawing of Conestoga wagons (No. 96).

Columbia was founded on the site of Wright's Ferry. In 1730 John Wright obtained a patent for a ferry to cross the Susquehanna, and fifty-eight years later his grandson, Samuel Wright, laid out the town of Columbia. An important link in the road west, the ferry continued in operation until it was replaced by a bridge during the second decade of the nineteenth century.

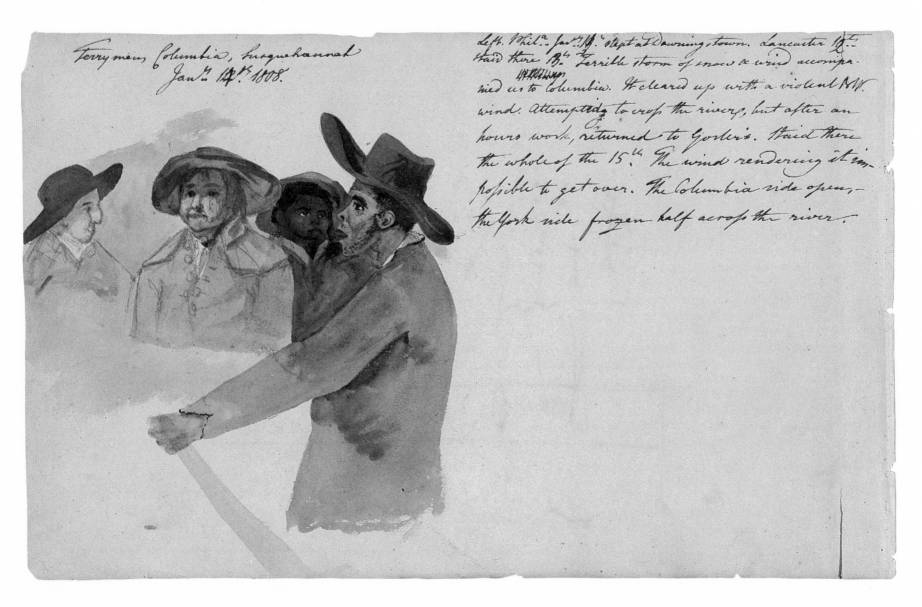

Ferrymen, Columbia, Susquehannah
Jan.ʸ 14ᵗʰ 1808.

Left. Phil.ᵃ Jan.ʸ 10. slept at downing town. Lancaster 12ᵗʰ
staid there 13ᵗʰ Terrible storm of snow & wind accompa-
nied us to Columbia. It cleared up with a violent N.W.
wind. Attempted to cross the rivers, but after an
hours work, returned to Gosters. Staid there
the whole of the 15ᵗʰ The wind rendering it im-
possible to get over. The Columbia side open,—
the York side frozen half across the river.

NO. 95

96. Conestoga Wagons and Draft Horse at Columbia, Pennsylvania

14 January 1808
Pencil, watercolor
20.3 cm. × 30.9 cm. (8 in. × 12-1/8 in.)
SKETCHBOOK X

The Conestoga wagon was developed along Conestoga Creek in Lancaster County, Pennsylvania, and first achieved measurable popularity during the 1750s. In 1755 the Pennsylvania Assembly sent Benjamin Franklin to Lancaster to procure wagons and horses for Major-General Edward Braddock's expedition against the French at Fort Duquesne. Ideally suited for hauling freight rather than passengers, the basic design of the Conestoga wagon included broad wheels that did not sink in mud, a floor that was curved at each end to help stabilize its center of gravity and prevent any shifting of its contents, and a white canvas cover stretched over a bent wood frame to protect against bad weather. Four to six horses pulled the wagon, which could hold up to six tons of freight. In 1820, it took about two months for four men to construct one of these wagons, which sold for nearly $250.00.

By the middle of the 1760s, an estimated ten thousand Conestoga wagons were in operation in the colony. Benjamin Rush and Isaac Weld in particular noted their ubiquitousness in Pennsylvania.

A large and strong waggon covered with linen cloth, is an essential part of the furniture of a German farm. In this waggon, drawn by four or five large horses of a peculiar breed: they convey to market over the roughest roads, between 2 or 3 thousand pounds weight of the produce of their farms. In the months of September and October, it is no uncommon thing, on the Lancaster and Reading roads, to meet in one day from fifty to an hundred of these waggons, on their way to Philadelphia, most of which belong to German farmers. (Rush, *An Account of the Manners of the German Inhabitants of Pennsylvania*, pp. 9–10)

It is scarcely possible to go one mile on this road without meeting numbers of waggons passing and repassing between the back parts of the state and Philadelphia. These waggons are commonly drawn by four or five horses, four of which are yoked in pairs. The waggons are heavy, the horses small, and the driver unmerciful; the consequence of which is, that in every team, nearly, there is a horse either lame or blind. The Pennsylvanians are notorious for the bad care which they take of their horses. Excepting the night be tempestuous, the waggoners never put their horses under shelter, and then it is only under a shed; each tavern is usually provided with a large one for the purpose. Market or High-street, Philadelphia, the street by which these people come into the town, is always crowded with waggons and horses, that are left standing there all night. This is to save money; the expence of putting them into a stable, would be too great, in the opinion of these people. Food for the horses is always carried in the waggon, and the moment they stop they are unyoked, and fed whilst they are warm. By this treatment, half the poor animals are foundered. The horses are fed out of a large trough carried for the purpose, and fixed on the pole of the waggon by means of iron pins. (Weld, *Travels*, pp. 115–16)

Contrary to Weld's description, most observers described the Conestoga horse as being large and bulky, usually more than sixteen hands high and weighing around 1,650 pounds.

By the middle of the nineteenth century, streams of the descendants of Conestoga wagons, the prairie schooners, crossed the Mississippi River, carrying thousands of migrants into the western states and territories. In the East, however, the development of canals and railroads rendered the Conestoga wagon obsolete.

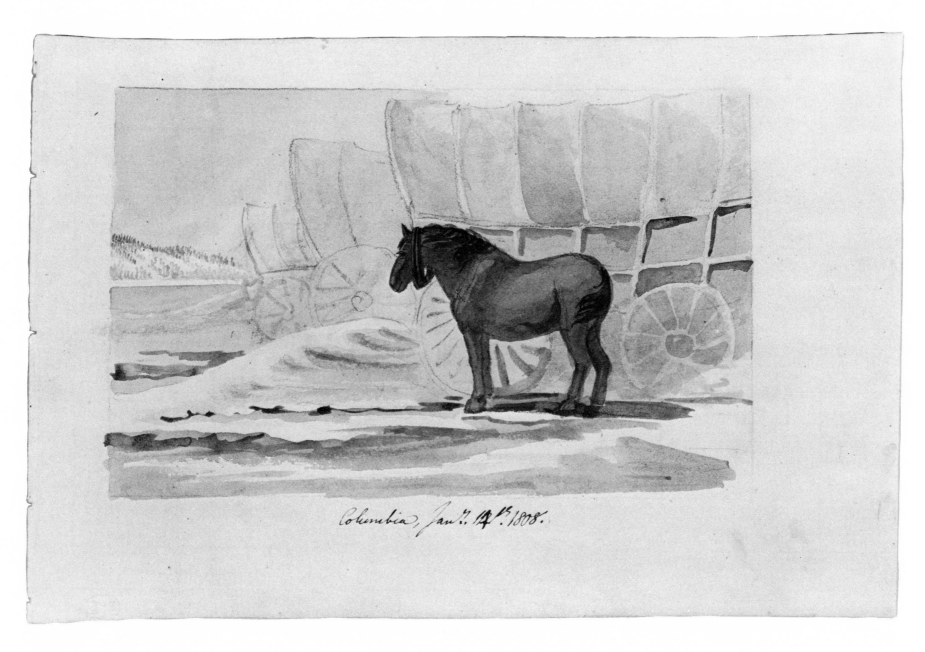

Columbia, Jan.ry 14th 1808.

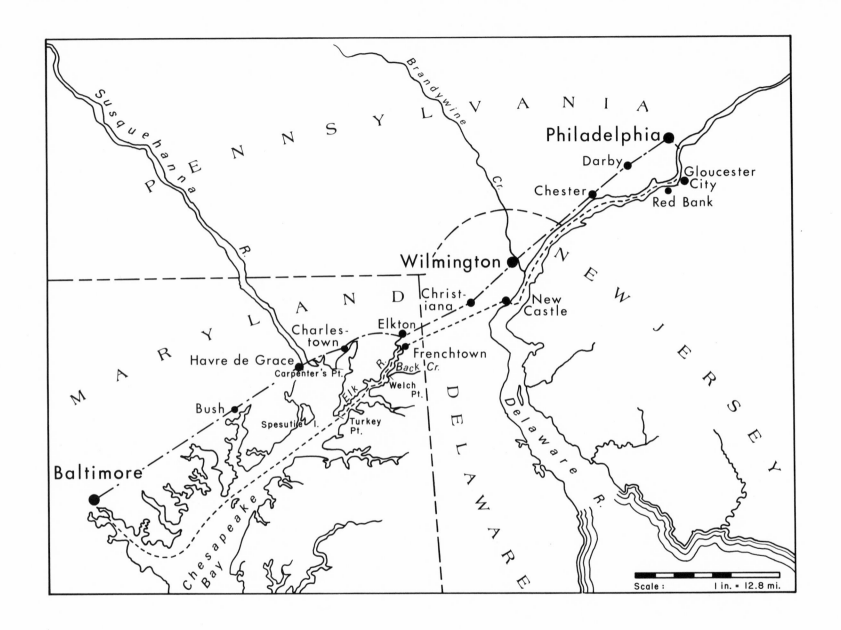

Scale: 1 in. = 12.8 mi.

VI. Journey from Philadelphia to Washington, 1806

97. "View looking towards Philadelphia a little below Gloucester point"

3 August 1806
Pencil, watercolor
20.3 cm. × 32.4 cm. (8 in. × 12-3/4 in.)
SKETCHBOOK IX

Map reference: Philadelphia Quadrangle, Pennsylvania–New Jersey
UTM coordinates: Viewing position: approximately 18.048812.441586; Christ Church:
 18.048745.442219; Kensington: 18.048866.442366
Orientation: 4°

At the time he made this view, Latrobe was traveling from Philadelphia to Washington, the first part of the journey being a trip in a packet boat down the Delaware River from Philadelphia to New Castle. Latrobe wrote of this view that it "is picturesque tho' no object of prominence distinguishes it, the city with Christ church steeple seen over the meadows of Gloucester point, and the long range of blue distance with the *dots* of Houses in Kensington closing the river." (BHL, *Journals,* 3:36) As he looked up the river towards Philadelphia, the boat was near the western, or Pennsylvania, bank of the river, perhaps at what is now Windy Point. Gloucester Point, seen on the western bank in the middle ground, was opposite Gloucester City, Camden County, New Jersey. Kensington is a section of Philadelphia four miles upriver from the center of the city. The area in view on the left has since been filled in and the islands in midstream have been removed through dredging.

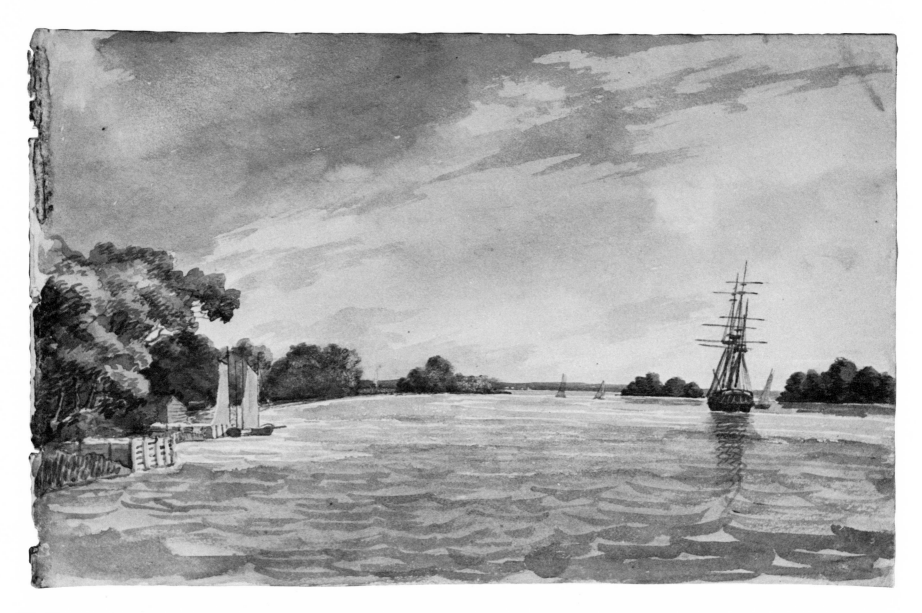

NO. 97

98. "Sketch of Redbank and Fort Mifflin"

3 August 1806
Pencil, watercolor
20.3 cm. × 32.4 cm. (8 in. × 12-3/4 in.)
SKETCHBOOK IX

Map references: Philadelphia Quadrangle, Pennsylvania–New Jersey; Woodbury
 Quadrangle, New Jersey–Pennsylvania
UTM coordinates: Viewing position: 18.048465.441446; Ft. Mifflin: 18.048171.441371;
 Red Bank: 18.048364.441319
Orientation: 235°

Redbank is celebrated for the brave attack and defeat of the Hessians under Coll. Donop. Fort Mifflin (called then Mudfort) for the resistance given to the whole British fleet by the fortress under the Command of Genl. S. Smith, whose merit in holding the fort as he did, is among the first, that signalise the American forces. (BHL, SKETCHBOOK IX)

Fort Mercer at Red Bank, New Jersey, was the scene of a battle between Hessian and American forces on 22 October 1777. The Americans, commanded by Col. Christopher Greene, inflicted heavy casualties on Col. Carl Emil Kurt von Donop's attacking force. About a third of the 1,200 Hessian troops were killed or wounded. The following day, Lt. Samuel Smith of Maryland led the Americans at Fort Mifflin, on Mud Island in the Delaware River, as they severely damaged six British men-of-war. But the British soon recovered and forced the Americans to abandon both forts in November 1777, thus leaving the way open for the invasion of Philadelphia that winter.

This view was made from mid-channel looking down the Delaware River. Unlike his "View looking towards Philadelphia . . ." (No. 97), which Latrobe characterized as "picturesque," this second drawing that he made on his trip south was "a mere topographical view." (BHL, *Journals*, 3:36) Fort Mifflin, an earthworks still in existence, is to the right. As a result of landfill, Mud Island is now part of the western shore of the Delaware in Philadelphia County. To the left is the Red Bank Battlefield in Gloucester County, New Jersey. In the distance is the New Jersey shore in the vicinity of Mantua Creek, Gloucester County.

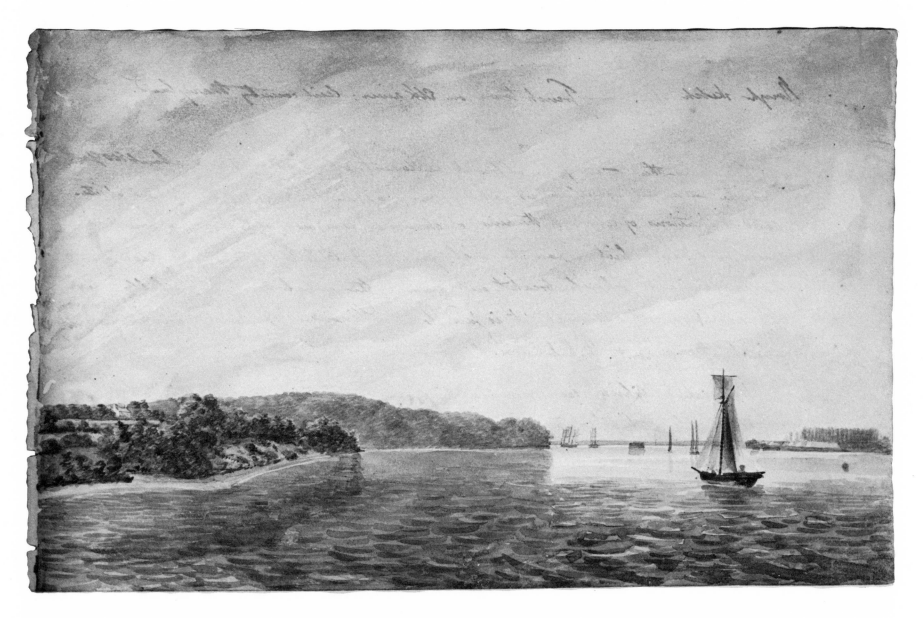

NO. 98

99. "Section of Front Street," Survey of New Castle, Delaware

Undated [fall 1805]
Pencil, pen and ink, watercolor
Approximately 28.2 cm. × 35.2 cm. (11 in. × 13-3/4 in.) on a page
 measuring 40.6 cm. × 50.8 cm. (16 in. × 20 in.)
Hall of Records, Dover, Delaware

Map reference: Wilmington South Quadrangle, Delaware–New Jersey
UTM coordinates: Northeast end of block (Harmony Street and Front Street/The
 Strand): 18.045184.438992; Southwest end of block (Delaware Street and Front
 Street/The Strand): 18.045168.438975
Orientation: Theoretically 315°

Latrobe's New Castle survey resulted from Delaware legislation in 1797 that established self-government in New Castle and provided for a survey to establish town boundaries and to show street layout. In 1804 the act was supplemented to include street gradients in the survey so that street levels could be determined for proper drainage and future building. The New Castle commissioners hired Latrobe to perform the survey in 1804. With the assistance of his pupils Robert Mills and William Strickland, who did most of the drafting work, Latrobe produced a survey of the town (fourteen pages, each 16 in. × 20 in.) that included every house that stood in 1805, with a section of each street showing both the existing gradient and that proposed by Latrobe. The architect also wrote an essay in which he explained his survey and discussed the future growth of the town.

The portion of the survey reproduced here is the section of Front Street (now the Strand), which shows the facades of structures on the northwest side of the street. The names of owners, tenants, or proprietors of some of the buildings on both sides of the street, as well as the names of alleys and streets intersecting Front, have been noted between the rows of houses. The following, with two exceptions, are the extant buildings:

A. Zachariah Van Leuvenigh House. Named for its late eighteenth-century owner, who was chief magistrate of New Castle during the Revolutionary period, this structure was identified with the name Mandle on Latrobe's plan of the town.
B. Gunning Bedford House. Built around 1730 by John Van Gezel, this house is associated with its late eighteenth-century owner, who was a Revolutionary soldier and governor of the state (1796–97). At the time of Latrobe's survey, the building served as the Delaware Hotel, owned by another Revolutionary patriot and state governor (1833–36), Caleb Prew Bennett. Latrobe wrote of Bennett: "He is a good man, a great politician, a flaming democrat, and an adorer of Buonaparte. His understanding is infinitely inferior to his

heart, which is made of the kindest stuff. He is loved and laughed at by every body, and though he keeps a very bad tavern, he makes money in it, and much good may it do him."
C. George McIntire House. Thought to have been built about 1690, this was the residence of Rebecca and Richard McWilliam at the time of Latrobe's survey. The house's name derives from a later owner who was a Delaware state senator.
D. George Read House. This was the home of George Read (1733–98), signer of the Declaration of Independence. It was destroyed by fire in 1824. In 1847, Andrew Jackson Downing designed an elaborate decorative garden for this site.
E. George Read II House. The son of the Signer, Read (1765–1836) designed and supervised the building of this late Georgian house between 1797 and 1801. Latrobe commented on the house and its owner in his journal: "He [Read] has built an enormous house, in bad taste, and I think, in a very bad situation. For he is close by the water, of which to enjoy a scanty view he sacrifices a range of the most valuable lots in town, by not building upon them, and he has then planted a range of Lombardy populars which exclude the prospect as effectually as a brick Wall. This Lawyer is a little man, but exceedingly pompous. . . . He however gets money, as do all the Lawyers in Deleware who can get business, and tho' he both *neglects* his clients, and sometimes after recovering a debt *forgets* them is a great and honorable Man."
F. Tile House. Long known as New Castle's most unusual building, this house stood from around 1687 until 1884. Reflective of New Castle's Dutch origins, the house was distinguished by the thin, apricot-colored bricks of its walls, by a very steep roof covered with Dutch tile, and by a stepped gable facing the street.
G. James McCallmont House. At the time of Latrobe's survey, this was the residence of Dr. James McCallmont, a prominent New Castle physician.
H. Immanuel Parish House. This house was built as a combined hotel and dwelling for the Charles Thomas family about 1801 by Peter Crowding, a contractor for the Read House and other New Castle buildings. For the most part, however, the building has served as a private residence. In 1891, a Thomas descendant donated it to the Immanuel Church.

Latrobe privately evaluated the character and prospects of New Castle in his journal:

It is no wonder indeed that talents and worth should be rare here. Newcastle cannot be a commercial town while Philadelphia exists. As soon as a merchant acquires capital, the field of Newcastle is too small for him and he removes to Philadelphia. . . .

The County court which is held here attracts two Judges and some Lawyers. But Wilmington is only six miles off and is a more healthy and agreeable residence. . . .

Newcastle is the *Gravesend* of Philadelphia. Of course the usual conveniences for the accomodation of seafaring men are found here in plenty and of the coarsest sort. And as a *little* country town it has all the petty scandal, curiosity, envy and hatred which distinguishes little towns all over the world. (BHL, *Journals*, 3:38, 39)

A B C

Section of Front Street.

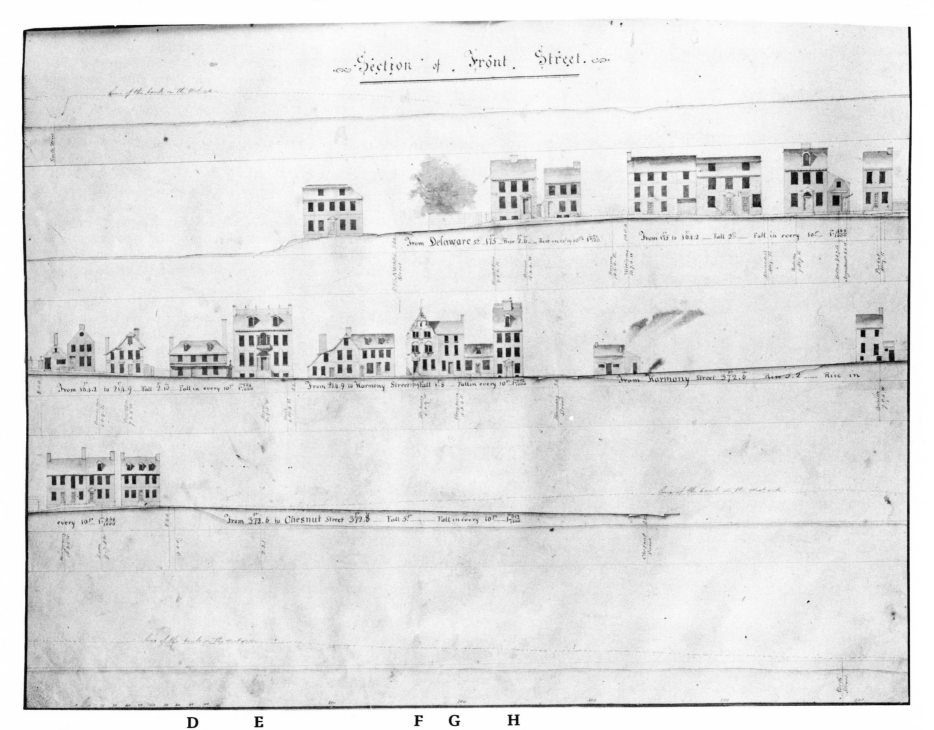

From Delaware st 175 _ Rise 2.6 _ Rise in every 10ᶠᵗ 1ᶠᵗ⁵⁶₍₁₀₀₀₎ From 175 to 104.2 _ Fall 2ᶠᵗ _ Fall in every 10ᶠᵗ 1ᶠᵗ⁴⁵⁹₍₁₀₀₀₎

From 104.2 to 214.9 _ Fall 2.10 _ Fall in every 10ᶠᵗ 1ᶠᵗ⁵⁸⁸₍₁₀₀₀₎ From 214.9 to Harmony Street _ Fall 1.8 _ Fall in every 10ᶠᵗ 1ᶠᵗ⁸⁷²₍₁₀₀₀₎ From Harmony Street 372.6 _ Rise 5.2 _ Rise in

every 10ᶠᵗ 1ᶠᵗ⁰⁵⁶₍₁₀₀₀₎ From 372.6 to Chesnut Street 372.8 _ Fall 5ᶠᵗ _ Fall in every 10ᶠᵗ 1ᶠᵗ⁰¹³₍₁₀₀₀₎

D E F G H

100. "View from the Packet Wharf at French town . . ."

[After 4] August 1806
Pencil, pen and ink, watercolor
21.6 cm. × 30.5 cm. (8-1/2 in. × 12 in.)
B Henry Latrobe Augt. 2d. 1806.
Jack Latrobe

Map reference: Elkton Quadrangle, Maryland–Delaware
UTM coordinates: 18.042766.438088
Orientation: 145°

101. "Rough sketch of French town, on Elk river, Cecil county Maryland"

[4] August 1806
Pencil, watercolor
20.3 cm. × 32.4 cm. (8 in. × 12-3/4 in.)
SKETCHBOOK IX

Map reference: Elkton Quadrangle, Maryland–Delaware
UTM coordinates: 18.042766.438088
Orientation: 0°

French town was thus called from a french settlement which existed here about 100 Years ago. The settlement, (of which no remains now appear excepting the almost obliterated indications of cellars, and the ruins of chimnies) was not on the spot where the tavern now stands but upon the high ground just to the right of the picture. An epidemical sickness breakt out among the inhabitants, (probably a severe autumnal fever) they removed, it is said to the Illinois. These accts. are indistinctly given by the present Inhabitants.

The packets which sail from hence for Baltimore render frenchtown a place of some trifling importance. The houses are only the tavern, a store and Mr. Frisby Henderson's dwelling. He is the proprietor of the whole estate. (BHL, SKETCHBOOK IX)

Frenchtown, like so many other small towns in America, existed as a link in a transportation network. It survived as long as the route of which it formed a part facilitated the movement of travelers and freight, and it died when that route was abandoned. For many years, Frenchtown was an important transfer point on the packet route between Philadelphia and Baltimore. The traveler starting from Philadelphia would sail south along the Delaware River to New Castle, Delaware. From there, he would journey west by stage across the Delmarva Peninsula to Frenchtown at the head of Elk River two miles south of Elkton. At Frenchtown, he would board a packet boat and sail south down the Elk River to the Chesapeake Bay, and then head further southward along the bay to Baltimore.

The site of Frenchtown was first settled by Swedes before 1700. In 1755, French Acadians expelled from Nova Scotia migrated to this area and named their new village *la ville Francaise*. Latrobe became well acquainted with Frenchtown when he surveyed the area in planning for the Chesapeake and Delaware Canal. (See detail of survey map opposite.) From his survey map, it is possible to identify the sites featured in the drawings.

For "View from the Packet Wharf" (No. 100), Latrobe looked southeastward in order to sketch the landscape stretching down the Elk River. Pate's Creek, now called Perch Creek, flows in from the left. In the distance is the upper part of Back Creek Neck. In the foreground, Latrobe animated the scene with three figures clustered about a cabin, several barrels, and a hanging fishing net.

For "Rough sketch of French town" (No. 101), Latrobe simply turned around on the wharf and looked northward up the Elk River. The two-story structure to the right in the drawing would be "Sewell's Tavern," also known as Frenchtown Tavern, which stood from around 1800 until 1964. The one-story frame building in the center would be the "Old Store House." The buildings on the map assigned to Cecil County landowner Frisby Henderson (c. 1767–1845) are not depicted in the drawing.

Latrobe erroneously dated both of these drawings 2 August 1806. According to his journal, he was in Philadelphia on that day. He left Philadelphia on the third and stayed at New Castle that night. At four o'clock on the morning of the fourth he traveled overland to Frenchtown, arriving at eight o'clock. Later that morning he sailed for Baltimore. At that time, he made the "Rough sketch" of Frenchtown (No. 101), as well as a small sketch of the view from the packet wharf which later served as the basis for No. 100. (For this sketch, see BHL, *Journals*, 3: plate 7.)

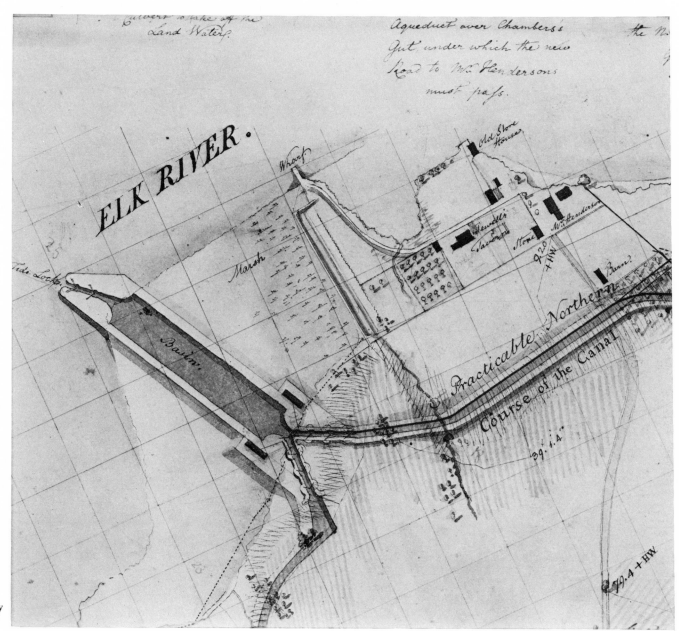

Detail of Chesapeake and Delaware Canal survey map, 3–10 August 1803. Geography and Map Division, Library of Congress.

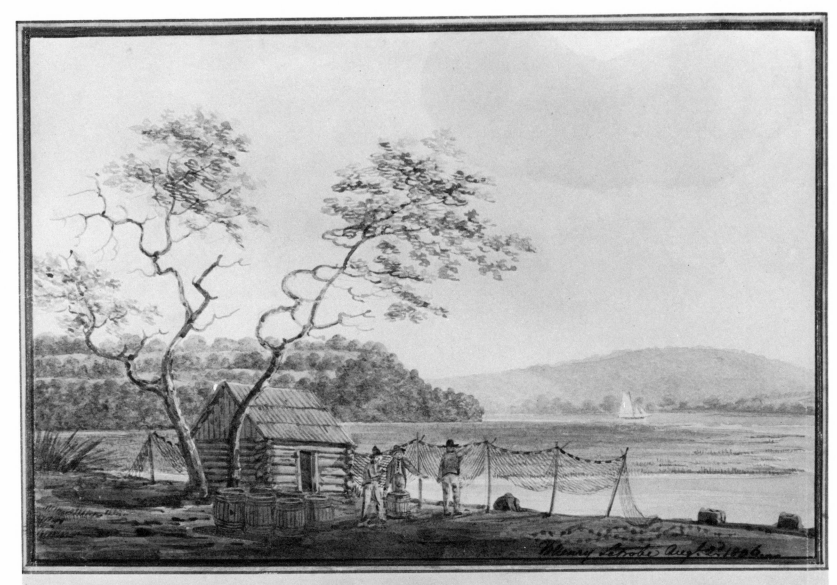

View from the Packet Wharf at French town looking down Elk Creek, showing the Mouth of Pates' Creek

NO. 101

102. "View of Welch point and the Mouth of Backcreek . . ."

[After 4 August] 1806
Pencil, watercolor
29.0 cm. × 38.4 cm. (11-3/8 in. × 15-1/8 in.)
B H Latrobe 1806.
Maryland Historical Society, Baltimore

Map reference: North East Quadrangle, Maryland
UTM coordinates: Viewing position: 18.042426.437568; Welch Point:
 18.042418.437540
Orientation: Approximately 180°

Latrobe left Frenchtown on the morning of 4 August 1806 on board the packet for Baltimore. As he sailed south on the Elk River, he made a small sketch, which he titled "View of Welch point at the distance of 1/2 a Mile looking Southwd." This sketch (for which see BHL, *Journals,* 3: plate 7) served as the basis for the drawing featured here. In his sketchbook, Latrobe noted:

> Welchpoint is a very narrow promontory, forming the North Cape of Backcreek. It would probably have been long ago washed away, were it not protected by a Mass of ferruginous Sandstone lying at the point. The Chesapeake and Delaware Canal is proposed to terminate here. The name of *Welchpoint* is derived from the Circumstance of a Ship, in which many Welch were passengers, having landed them here while a great mortality prevailed among them, and a great number were buried at this place." (BHL, SKETCHBOOK IX)

Latrobe devoted much time and energy to studying this shoreline in 1803–04 to find a suitable deep water location for the western terminus of the Chesapeake and Delaware Canal. The Canal Company's board of directors agreed to his choice of Welch Point as the western terminus in May 1804.

Below the bottom margin of the finished drawing, Latrobe labeled the main feature of the view. Welch Point is the farthest promontory, depicted in the center of the landscape. Beyond Welch Point is the mouth of Back Creek, which flows into the Elk River from the northeast. In the background distance is Town Point Neck. Although Latrobe noted that he took this view from Locust Point, the place now known as Locust Point is three and one-half miles further upriver, near the site of the Frenchtown wharf (see Nos. 100, 101).

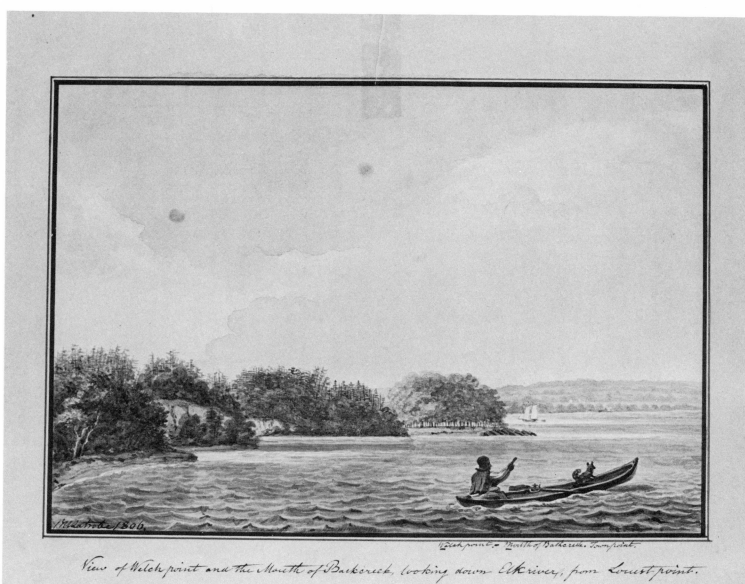

Welch point. — Mouth of Backcreek. Town point.

View of Welch point and the Mouth of Backcreek, looking down Elk river, from Locust-point.

103. "Mouth of the Susquehannah, passing Turkey point"

[After 4] August 1806
Pencil, watercolor
16.5 cm. × 30.5 cm. (6-1/2 in. × 12 in.)
B H Latrobe Augt. 3d 1806
Leonard P. Weston, Alexandria, Va.

Map references: Havre de Grace Quadrangle, Maryland; Spesutie Quadrangle, Maryland
UTM coordinates: Viewing position: 18.041294.436608; Spesutie Island: 18.040735.436774; Havre de Grace: 18.040612.437748; Palmer's Island (now Garrett Island): 18.040662.437994; Carpenter's Point: 18.041340.437683; Turkey Point: 18.041320.436690
Orientation: Approximately 335°

As Latrobe proceeded southwestward down the Elk River in the packet from Frenchtown to Baltimore, he passed Turkey Point, situated at the tip of the Elk Neck peninsula, where the Elk empties into the Chesapeake Bay. Several miles below Turkey Point, he looked northward from his vantage point in the bay and made the preliminary sketch for this panoramic view of the headwaters of the Chesapeake. In the preliminary sketchbook drawing (at right), Latrobe labeled the main geographical features in this scene. To the north of Turkey Point (featured at right) is Carpenter's Point, in the North East district of Cecil County, Maryland, at the mouth of the Northeast River. To the west of Carpenter's Point, the Susquehanna River empties into the Chesapeake. Palmer's Island, now known as Garrett Island, lies in the middle of the Susquehanna just north of Havre de Grace, Harford County, Maryland. Spesutie Island is situated in the bay five miles south of Havre de Grace.

Several years earlier, Latrobe had commented on the commercial potential of this area's major town:

Havre de Grace necessarily has all the advantage of the improved navigation of the Susquehanna, *in the first instance,* and without the expence of freight and time at which Baltimore obtains it. This is already so fully perceived that one Million of Bricks were laid during the year 1801 in building stores and houses in Havre de Grace and double that number is expected to be laid this year. I have omitted to mention, what is of the first importance namely, that Havre has on the east side as deep a harbor as Baltimore. On the advantage which the [Chesapeake and Delaware] Canal will produce to Havre de Grace there is no occasion to dwell. In the first period it will render Havre de Grace a store house to Philadelphia, as well as to Baltimore. By degrees like every other entrepot, of which the history is recorded, it will enrich itself by the Trade of the Cities to which it is subservient, and set up for itself. Palmyra is the most magnificent instance of this kind. When Havre is thus advanced the Canal will then shorten her eastern and northern Coasting trade, about 600 miles, and open to her the whole of the Trade of south Jersey, an important Timber and Iron Country, to which it will be as contiguous as is Philadelphia. (BHL to Thomas Jefferson, 27 March/1 June/24 October 1802, in BHL, *Correspondence,* 1)

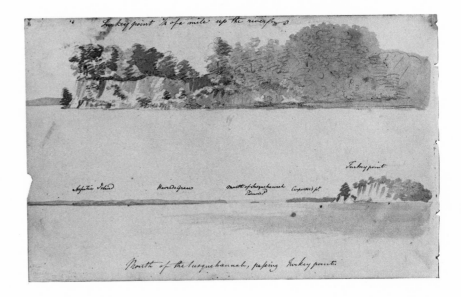

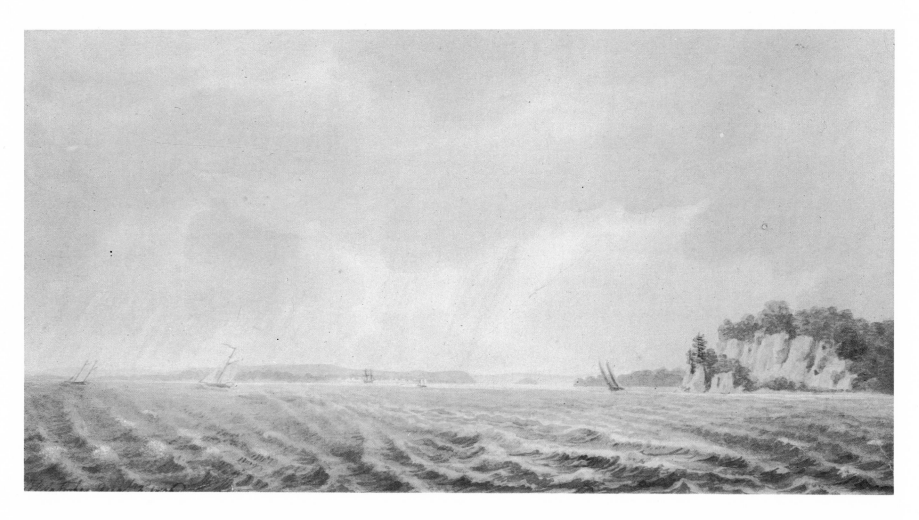

NO. 103

104. "Sketch of Bladensburg, looking Northward"

Undated [6 August 1806]
Pencil, watercolor
20.3 cm. × 32.4 cm. (8 in. × 12-3/4 in.)
SKETCHBOOK IX

Map reference: Washington East Quadrangle, Maryland–District of Columbia
UTM coordinates: Viewing position: 18.033192.431136; Bridge: 18.033170.431145
Orientation: 335°

Bladensburg, a small town several miles northeast of Washington, D.C., was established on the east bank of the head of the Anacostia River (also formerly known as the Eastern Branch of the Potomac) in 1742 by an act of the Maryland General Assembly. The site, where the Northwest and Northeast branches form the Anacostia, was known as Garrison's Landing. This location was initially favorable for serving Maryland's inland tobacco farms, but Bladensburg's future as a major commercial center was aborted by the irregularities produced by a one-crop economy, by heavy siltation, which resulted in the loss of port facilities, by Baltimore's increasing importance as a trade center, and by the advent of modern transportation, which effectively bypassed the town.

John H. B. Latrobe described Bladensburg as "a favorite afternoon drive from the City [Washington], where there was a spa or mineral spring which was the attraction of the place. It bubbled from the eastern branch of the Potomac, a very small spring shaded by some fine old trees." (Semmes, *John H. B. Latrobe and His Times*, p. 35)

On the day Latrobe visited Bladensburg and drew this scene, he was on his way from Baltimore to Washington. He had left Baltimore early in the morning and arrived in Washington at 5:00 P.M., probably passing through Bladensburg about midafternoon. As he drew this scene, Latrobe stood on the eastern shore of the Anacostia and faced north toward the town upstream. The mast tops at the center and right of the drawing are those of small ships operating on the Northeast Branch. The bridge on the left over the Anacostia was a substantial structure that limited the operation of large vessels to either side of it. The buildings to the left of the bridge were on the western bank of the Northwest Branch, while those in the center of the drawing fronted on Market Street (present-day Annapolis Road, Maryland Route 450). Most of these structures have been replaced by the development of a warehouse and light industry district, the construction of U.S. Alternate Route 1, and the erection of large-scale flood control dikes. On the wooded hill in the distance now lies the suburban community of Hyattsville, Maryland.

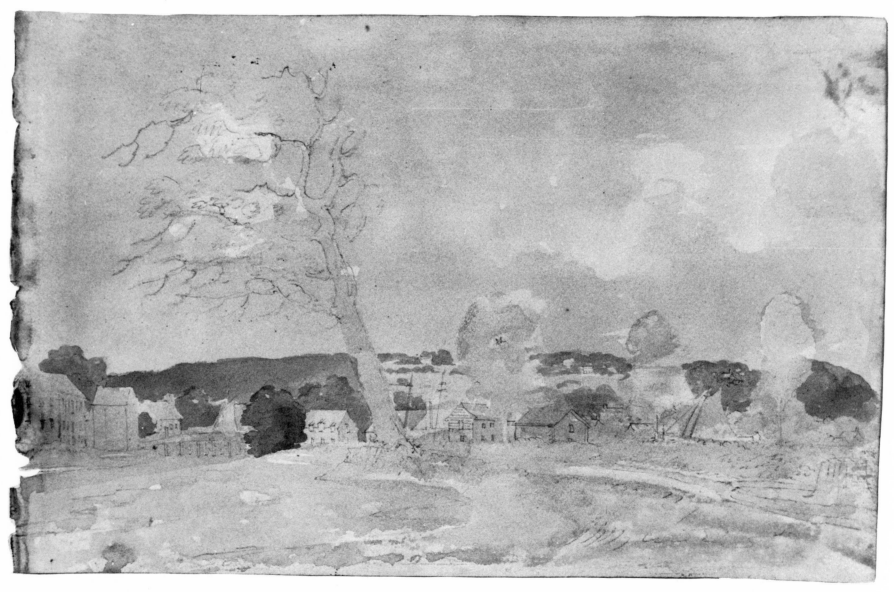

NO. 104

VII. Scenes in Washington, Northern Virginia, and Maryland, 1806–1813

105. The U.S. Capitol under Construction

Undated [probably begun August 1806]
Pencil, pen and ink
20.3 cm. × 32.4 cm. (8 in. × 12-3/4 in.)
SKETCHBOOK IX

Map reference: Washington West Quadrangle, District of Columbia–Maryland–Virginia
UTM coordinates: Viewing position: 18.032577.430635; Capitol: 18.032568.430623
Orientation: 210°

Latrobe made this unfinished drawing of the Capitol from memory, and his memory deceived him. The view presents the Capitol and the Capitol stonecutters' yard from the northeast. The architect began this landscape drawing to show the general appearance of the building while he had the south wing (at center) under construction, but (at right) he represented the north or Senate wing (completed in 1800, some three years before Jefferson put the Capitol into Latrobe's hands) inaccurately. To approximate its actual appearance, one must mentally extend its north wall so as to hold seven rather than five windows across its length. The stage of construction at the south wing, destined for the Hall of Representatives, does not accord with what Latrobe could have seen on any of his visits to Washington. When he left the city in August 1806, work had not advanced as far as he showed it here, and by the time he returned in October, the great dome over the hall, not present in the drawing, had gone into place.

The position of the drawing in a sketchbook almost entirely datable to August, together with the chronology of Latrobe's activities, suggests that he began the view between August and October. From Philadelphia, on 1 September 1806, he wrote to John Lenthall, his Washington clerk of the works, or second-in-command, to request a plan of the Capitol for use in making an architectural drawing in perspective, most likely the drawing that he gave Jefferson in November (p. 28). This would seem to mean that he had begun No. 105, that he had recognized the failings of his memory, and that one can narrow the probable dating of No. 105 to August.

At some point, Latrobe cropped his view so that it would focus on the building. With a pencil he indicated new margins (not wholly visible in reproduction), the most important of which cuts off about one quarter of the scene on the left-hand side. He had thus turned his landscape into what he used as the general compositional model for his earliest known architectural perspective of the Capitol, the Jefferson drawing, and in all likelihood he made the change specifically for the preparation of that drawing. (In the Jefferson drawing, under the portico steps, even the motif of the horse-drawn carriage survives from the sketchbook, approximately in its original place, but in abbreviated form.) The same format provided the basis for Latrobe's subsequent Capitol perspectives. The Latrobe perspectives, in turn, spawned a family of prints published on both sides of the Atlantic for half a century after the architect began his landscape. (For further discussion of this drawing, see pp. 27–28.)

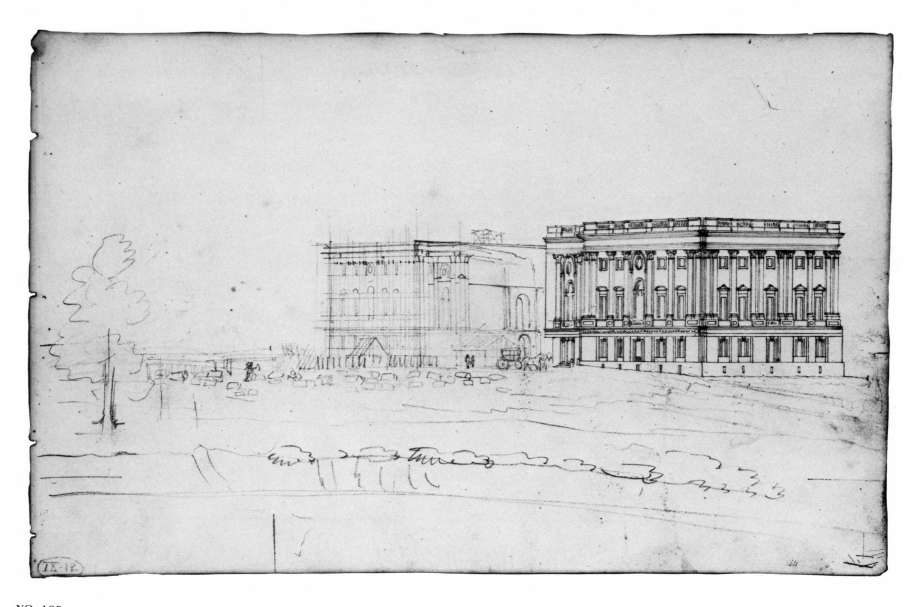

NO. 105

106. "Wm. Robertson's house near his quarry on Acquia Creek"

21 August 1806
Pencil
20.3 cm. × 32.4 cm. (8 in. × 12-3/4 in.)
SKETCHBOOK IX

Map reference: Stafford Quadrangle, Virginia
UTM coordinates: House: 18.028848.425732
Orientation: 0°

William Robertson was a quarrier with whom Latrobe had entered into an agreement in 1804 for the provision of stone for the U.S. Capitol. Latrobe's visit to Robertson's house in Stafford County, Virginia, in August 1806 was prompted by the short supply of stone then at the Capitol. In his journal the architect recorded his impressions of Robertson's house:

> Mr. Robertson the quarrier lived at Acquia last Year about 3 miles from his quarry. This was inconvenient. He therefore fixed upon a beautiful little knoll in the midst of the woods close to his quarry, and determined to form a settlement there. In the true Virginia style, he first levelled every tree on the spot in a circle of about 150 Yards diameter, in the center of which he built a little log house 24 feet by 18, two stories high, each divided into two small rooms. A loghouse kitchen, a d[itt]o stable, smithshop, hen house, meat house, and tool house, sprinkled irregularly over the knoll, gave to the whole a some what romantic appearance.

Robertson's house, no longer extant, was on an unnamed tributary of Austin Run, itself a tributary of Aquia Creek, one and a half miles northwest of Stafford, Virginia.

Latrobe recorded as well an amusing account of the night he spent at Robertson's:

> I arrived with him at this place in the afternoon and after transacting my business with him, proposed going to bed about nine o'clock. Mrs. Suttle his manager's wife a good natured fat woman, warned me not to be afraid of the rats, who would indeed make not a little noise in the night, but who were at the same time perfectly harmless. I am not afraid of rats, and therefore laughed at her caution. I was

put to bed on the ground floor. The bed occupied exactly one half of the room, a large Chest, a trunk, one Chair, and a very smartly filled up toilet took up nearly all the remainder. Before I went to bed I amused myself by reading part of the Story of Maugraby the enchanter in the Arabian nights entertainments, an odd volume of which happened to be sticking in a chasm of the Logs. Scarce was my head reclined on the pillow before I fell fast asleep. I may perhaps have slept an hour, when I was waked by a noise in the room, which it seemed beyond the power of any thing but Maugraby to excite. In my first awakening I fancied he and twenty enchanted princesses, on whom he was committing violence must surround me, and I was ready to fly to their assistance. But soon the enchantment dissolved and I recollected Mrs. Suttle's rats. Under the bed, around it, over the trunks, on the chair, among the things on the toilet, the hurry of animals was incessant. The chief noise however was under the bed, and upon the floor. I shook the bed stead, rattled the chair by my side. A momentary pause was produced, but in the next instant the noise was renewed, and fearing no mischief to myself, I turned round and tried to fall asleep. But this was impossible. However, in the course of what appeared to me a very long time, the uproar in my room was at an end, but upstairs among the family, it raged with double violence. It seemed as if all the furniture was in motion. Mrs. Suttle was laughing, a negro girl crying, and the men talking. At last somebody went out for a light and soon returned. Nobody slept for some hours, and at day light we were all up.

> All this happened without the assistance of a Necromancer. Under my bed happened to be placed, a basket of eggs. The rats had discovered the treasure, and storming the basket threw off the covering and got out all the eggs. Whether they quarrelled about the prey or were celebrating the memorable event with noisy joy, at a feast, I cannot tell; but they covered the floor with the shells and the marks of their gluttony. Upstairs, a negro girl had laid down to sleep, with a piece of Hoecake in her hand. The rats having sufficiently regaled upon eggs made the discovery, and one of them carried off the bread. He was pursued by others who gallopped over the girl without ceremony, waked her, and set her crying. In his hurry to appropriate the prize to himself, the rat darted into the open drawer of a writing desk which stood on the table, and was drawn out over the edge of it. His weight overset the desk and it fell

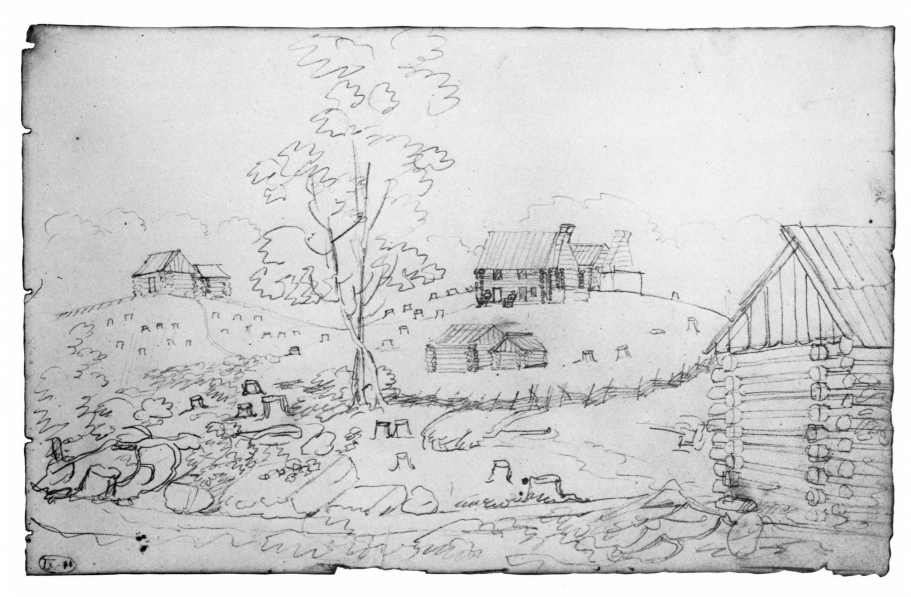

NO. 106

on the floor, shutting up the rat in the drawer. The noise and the cries of the girl waked every body. Mr. Robertson groped about, got hold of the desk, and in opening the drawer his finger was bit by the rat, who then made his escape. He went for a light, and put an end

for a short time to the confusion; but there was an end of all possibility of sleeping for the remainder of the night. (BHL, *Journals*, 3:78–80)

107. "Mr. Robertson's Quarry near Acquia Virginia"

[21] August 1806
Pencil, wash
20.3 cm. × 32.4 cm. (8 in. × 12-3/4 in.)
SKETCHBOOK IX

Map reference: Stafford Quadrangle, Virginia
UTM coordinates: Quarry: 18.028862.425734
Orientation: 0°

Latrobe characterized Aquia freestone as "a calcareous sand stone of very excellent quality, and the quarries are in appearance inexhaustable." He recognized its deficiencies, such as its being "subject to clay-holes, to nodules of iron ore (pyrites) and to masses of flint, and the hardness and durability of the rock is often very various, in the same stratum. It also suffers expansion and contraction from moisture and dryness to a greater degree than any stone with which I am acquainted." But Latrobe added that "if it once becomes dry, and remains sound, it has never been known afterwards to fail." (BHL, Report of the Surveyor of the Public Buildings to the President of the United States, 22 December 1805, in BHL, *Correspondence*, 2)

The architect found William Robertson's quarry to be of special merit. Shortly after he visited Robertson's quarry in August 1806, he described its features:

> The best quarry now in work, lies two miles S. W. from Acquia creek, and belongs to Mr. Robertson. Like all others, it is on the top of the slope of a valley, and the face shews as follows:
> Mould. .1 ft. 0
> Clay, very hard, and some gravel.2 0

Rough disrupted sandstone. .2 0
Loose sand. .2 0
Sound and excellent rock. .15 0
Under the rock fine loose sand.

In this rock, which runs N. E. and S. W. there is no joint horizontal or perpendicular, and columns of any size, not exceeding 15 feet diameter, might be got out of it, if they could afterwards be removed. The largest blocks however which I have had taken out, do not exceed in weight four tons.

In working these quarries, the workmen having cut the face perpendicularly, first undermine the rock; an easy operation, the substratum being loose sand. If the block is intended to be 8 feet thick, they undermine it 5 feet, in a horizontal direction, in order that it may fall over when cut off. They then cut two perpendicular channels on each hand, 1 ft. 6 in. wide, at the distance from each other of the length of their block, having then removed the earth and rubbish from a ditch or channel along the top of the rock, they cut into the rock itself, a groove, and put in wedges along its whole length. These wedges are successively driven, the rock cracks very regularly from top to bottom, and it falls over, brought down partly by its own weight. Blocks have been thus quarried 40 feet long, 15 feet high, and 6 feet thick. The block which was quarried at my last visit to the quarry [*seen, with its dimensions marked, in the center of the drawing*], was of the following dimensions:

26 feet long, × 8 feet deep, × 14 feet high = 2912 feet, which at 15 feet to the ton, agreeably to the quarry rate, amounts to near 200 tons. These masses are then cut by wedges into the sizes required. (BHL, "An Account of the Freestone Quarries on the Potomac and Rappahannoc Rivers," pp. 290–91)

NO. 107

108. On the Potomac River Four Miles below the Mouth of Quantico Creek, Looking to the South

Undated [21 August 1806]
Pencil, watercolor
20.3 cm. × 32.4 cm. (8 in. × 12-3/4 in.)
SKETCHBOOK IX

Map reference: Widewater Quadrangle, Virginia–Maryland
UTM coordinates: 18.029786.426074
Orientation: 170°

This view was probably taken from what is today known as Clifton Point, in Stafford County, Virginia. In the distance beyond the fishermen is the Potomac River estuary. Latrobe noted that "the shore consists of Freestone rock," a term used to describe rock (such as limestone and sandstone) that cuts easily without splitting. The cracks in the rocks shown in this scene are characteristic of freestone.

Latrobe also noted that the drawing was made "below Coll. Cook's." This was probably Col. John Cooke (c. 1755–1819), who was married to Mary Thomson Mason, daughter of George Mason. Cooke owned a quarry in the vicinity in partnership with Daniel Carroll Brent (1760–1815). The occasion of Latrobe's trip to the area was to procure stone for the public buildings in Washington.

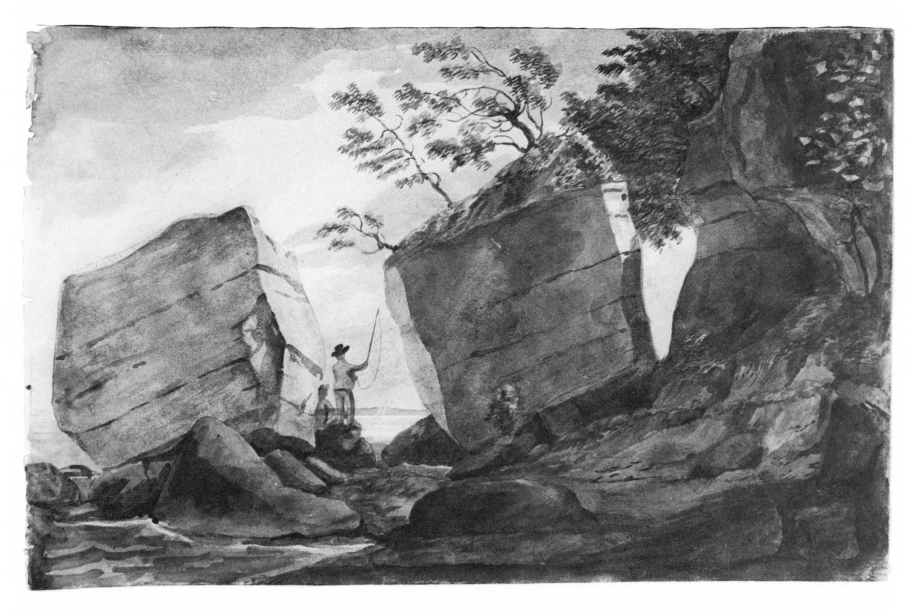

NO. 108

109. "Bunn, the black smith, at a Campmeeting near Georgetown"

Undated [6 August 1809]
Pencil, pen and ink
20.3 cm. × 32.3 cm. (8 in. × 12-3/4 in.)
SKETCHBOOK X

I have always endeavored to prevent my wife from being led by her curiosity to attend the meetings of the Methodists. With the most rational, but very pious and sincere religious sentiments, she joins a warmth of imagination, which might receive a shock, if not an impression from the *incantations* which form the business of their assemblies. A Camp meeting however is a thing so outrageous in its form and in its practices, that I resolved to go to one held a few miles from Georgetown in Virginia, under the auspices of some very good citizens, principally of Mr. Henry Foxall the great Iron founder. . . .

We entered the enclosure and were proceeding towards the stage when a Constable whose office was designated by a Label upon his hat stopped us, and told us that no Ladies could be admitted to that side. I accordingly went back and passing between the two rows of tents arrived at the upper part of the Theatre from whence every thing could be seen and heard. Here I staid about an hour during which Mr. Bunn, a blacksmith at G. Town, one of the most eminent Preachers of the Methodists spoke with immense rapidity and exertion to the following effect. . . . "Temperance, Temperance, Temperance, I say and so says St. Paul *temperance*, not self denial no he asks no favors of you, no, only temperance. And what is temperance, Paul had no communication with women, none at all, Peter carried about with him a sister named Lucilla, I suppose she was his wife, else he had no business with her, this I call temperance; one woman was enough for Peter, St. Paul wanted none at all; this is temperance in woman, faithfulness to one woman your wife; then temperance in eating; eat enough and drink enough to enjoy it, not to gluttony or drunkenness, St. Paul asks no favors of you, eat while it does you good;" &c. &c. Then he spoke of the judgement to come, "that's the pinch, the judgement to come, when the burning billows of hell wash up against the Soul of the glutton and the miser, what good do all his Victuals and his wine, and his

bags of gold; do they allay the fiery torment, the thirst that burns him, the parching that sears his lips, do they frighten away old Satan who is ready to devour him, think of that: this is the judgement to come, when hell gapes, and the fire roars, Oh pour sinful damned souls, poor sinful souls all of ye, will ye be damned, will ye, will ye, will ye be damned, no, no, no, no, don't be damned, now ye pray and groan and strive with the spirit." (a general groaning and shrieking was now heard from all quarters which the artful preacher immediately suppressed by returning to his text.) "And so it was with Festus, he trembled, he trembled, he trembled." (During these words the Preacher threw out both his arms sideways at full length, and shook himself violently, so as to make his arms quiver with astonishing velocity. He must have practised this trick often for he introduced it with great success and propriety several times afterwards.) "He trembled, every bone shook he strove, he strove with the spirit, and he was almost overcome, but he conquered, he was afraid of the Jews, saving grace was not for him," &c.

At this part I was turned out. On reaching the upper part of the Camp, I found him further advanced in his business. A general groaning was going on, in several parts of the Camp, women were shrieking, and just under the stage there was an uncommon bustle, and cry, which I understood arose from some persons who were under conversion. . . .

Enthusiasm has its charms, and as this is the only public diversion in which the scattered inhabitants of the country can indulge, it would be a pity to suppress it, even by the ridicule to which it is so open. The night scenes, the illumination of the woods, the novelty

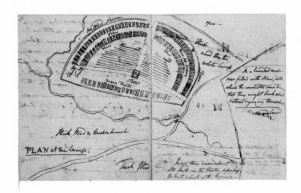

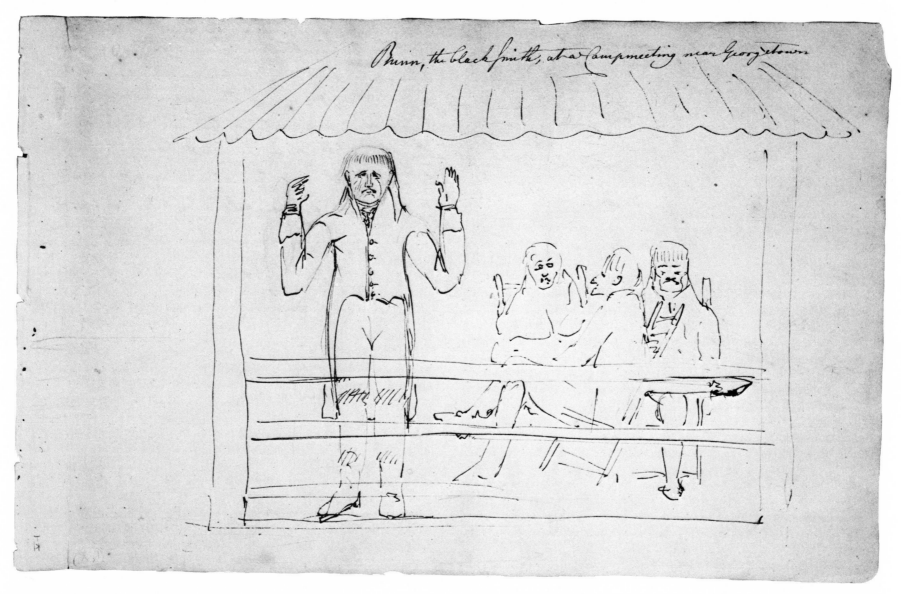

Bunn, the blacksmith, at a Campmeeting near Georgetown

NO. 109

of a camp especially to the women and children, the dancing and singing, and the pleasure of a crowd, so tempting to the most fashionable, are in fact enjoyments which human nature every where provides for herself, in her most savage as well as most polished state. Let the congregation rejoice and well come. But as to the Preacher, who lives by such dishonest means, *"to his own Master he standeth or falleth."* (BHL, *Journals,* 3:108–13)

110. "Sphex sumac"

15 September 1809
Pencil, watercolor
20.3 cm. × 32.2 cm. (8 in. × 12-11/16 in.)
SKETCHBOOK XI

Representation of a leaf of the Shumac with the Nidi of an Hymenopterous insect, some hundreds of which occupied a large Tree of this plant.

Under the Wall of the Canal of the great Falls of Potowmac grow some of the largest *Shumacs,* I have ever seen. One of these Shrubs, or Trees, had absolutely no leaves, and in their room the leaf Stalks were hung with the nidi here represented. The tree had an uncommon but beautiful appearance. It cannot have been less than 20 feet high. Fig. 1, is the exact representation of a single leaf, of the natural size. Fig. 2. represents a part of the tree, a branch, as it appeared altogether. Fig. 3. The natural appearance the same branch ought to have had. Fig. 4. is one of the nidi opened, exhibiting the insect within it. They were covered with thousand of small white shred[s] apparently the shell of the chryssalides, or the excrement of the worm. Fig. 5. shows the fly in its natural size. Fig. 6, the same as it appears in a microscope. The body brown, thorax dark chesnut with yellow spot, the head very much resembling that of the *sphex Penna.* with a long beak. Fig. 7. is a pair of Wings as marked and nerved. Fig. 8, a larva of the insect, of which there were many in each nidus.

The Nidus consists of a thin fleshy, tough substance, of a pale yellowish, and flesh colored exterior, spotted with dark red and covered with a short down. It has a pedicle of its own, growing out of the middle nerve of the leaf.

The name of this insect should be, *Sphex Sumac minimus* Hymenopt. *Corpore fusco, thorace punctis flavis signato, antennis erectis, rostro deflexo* [Small hymenopterous sumac wasp. Having a dark-colored body, a thorax marked with a yellow spot, antennae standing erect, and a downard pointing beak]. (BHL, SKETCHBOOK XI)

The sumac tree, *Rhus glabra,* that Latrobe saw was infested with the galls of the gallfly, *Pemphigus rhois.* Plant galls result from the irritation of plant tissue caused by the minute larvae of a variety of insects. In this case, the female gallfly pierces young growing leaves in the host tree and deposits her eggs. These hatch in two to three weeks, and as the maggotlike larvae feed upon sap, the gall, or nidus, develops. The life of the galls ends with the leaves in autumn, when they dry and harden. The larvae then pupate, and when the new leaves appear the adult gallflies emerge by burrowing through the gall walls.

As Latrobe has shown in Fig. 5, the gallfly is small, no longer than one-third of an inch. It has four clear wings, with few but prominent veins, as shown in Fig. 7. However, the larval form of the gallfly is legless. The insect Latrobe has shown under magnification (Fig. 8) is probably a wingless aphid, *Macrosiphum rosae.* Aphids are among the forty-one parasitic species that can use the galls produced by gallflies, and their infestation leads to the red patches on the gall which Latrobe noted in his description.

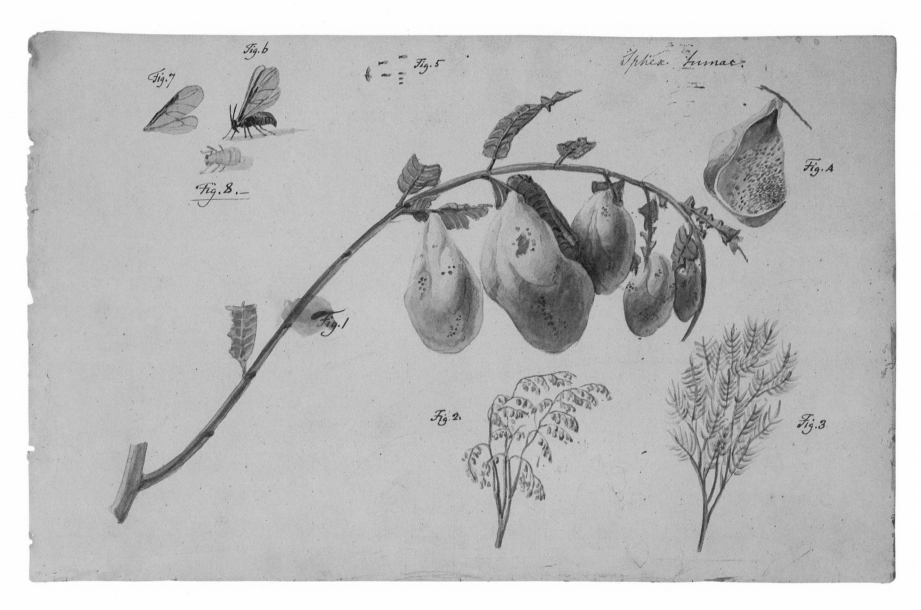

Fig. 7 Fig. 6 Fig. 5 Sphex lunæ

Fig. 8.—

Fig. A

Fig. 1

Fig. 2 Fig. 3

NO. 110

279

111. "Great Falls of the Patowmac, one miles distant as seen from the road South of the river"

15 September 1809
Pencil, watercolor
20.3 cm. × 32.2 cm. (8 in. × 12-11/16 in.)
SKETCHBOOK XI

Map references: Falls Church Quadrangle, Virginia–Maryland; Rockville Quadrangle, Maryland–Virginia; Seneca Quadrangle, Maryland–Virginia; Vienna Quadrangle, Virginia–Maryland
UTM coordinates: Approximately 18.030476.431760
Orientation: Approximately 5°

On 14 September 1809, the day before he executed this watercolor, Latrobe wrote to Superintendent of Public Buildings Thomas Munroe that he was "going tomorrow in haste to the country but shall return in the evening." (BHL, *Correspondence,* 2) He did not state the nature of his hurried visit, but the existence of this and the following drawing shows that he found time for more than business. This view is from the southwest side of the Potomac, in Fairfax County, Virginia, probably from the hill along present-day Old Dominion Drive, which leads from the Old Georgetown Pike to the Great Falls. Latrobe was looking almost due north across the Potomac to Montgomery County, Maryland. The view of the river that Latrobe enjoyed may not be had today, however, due to the great increase in wooded area that accompanied the decline of local agriculture and the incorporation of this area into the Great Falls Park, administered by the National Park Service.

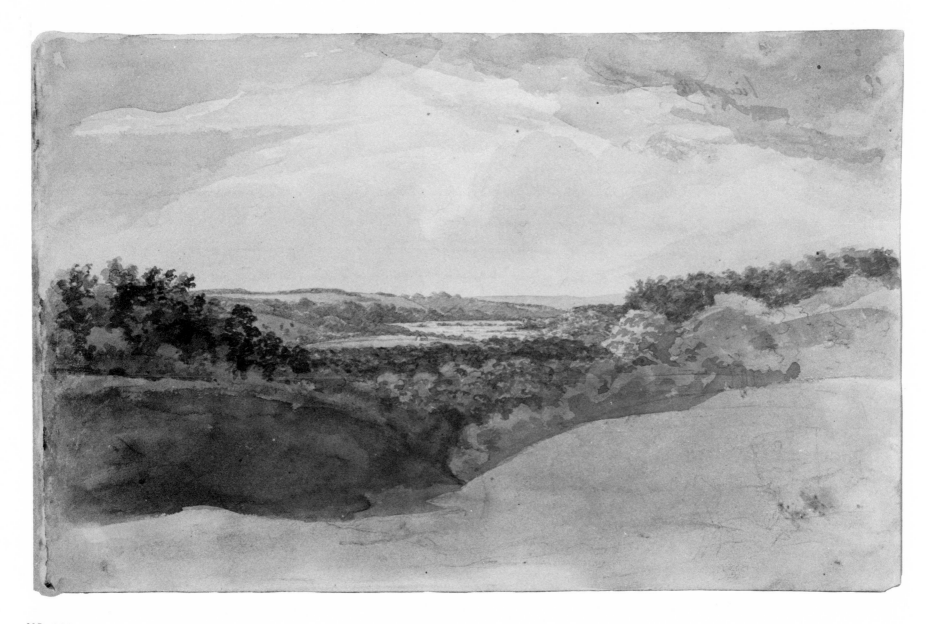

NO. 111

112. "View of the great Falls of Potowmac. Taken from a Rock on the South side"

15 September 1809
Pencil, watercolor
20.3 cm. × 32.2 cm. (8 in. × 12-11/16 in.)
SKETCHBOOK XI

Map reference: Seneca Quadrangle, Maryland–Virginia; Vienna Quadrangle,
 Virginia–Maryland
UTM coordinates: 18.030500.431842
Orientation: 325°

The ruined building on the left hand is what remains of a forge which appears to have been destroyed by fire. The Water was very low when this View was taken. From the drift wood lying on the top of the large Rock over which the tall trees are growing it is evident that the Water rises frequently over its top. The low rocks on the right are much below the Range of Rocks on the left, and below others to the right which bound the river and form two Walls of Rock extending a great distance below.

At this visit I could stay little more than an hour, and had time only to take this hasty sketch, which however is perfectly correct as far as it goes. (BHL, SKETCHBOOK XI)

Latrobe made this drawing from what is now the furthest downstream of four constructed overlooks on the southwest side of the Potomac, in Fairfax County, Virginia, looking to the north-northwest. Since the boundary between Maryland and Virginia is the southern shore of the river, the Great Falls and the landscape visible on the right (Falls Island) are in Montgomery County, Maryland.

Latrobe's vantage point was at the northern end of Matildaville, which Henry ("Light-Horse Harry") Lee founded in 1790 and named after his wife. Lee had purchased the site in the hope that a canal around the Great Falls would funnel vast amounts of goods from the interior through his projected town, and that the establishment of the national capital on the Potomac would make the land's value soar. But the town did not thrive. Lee sold no more than twenty-five lots, and the town never boasted more than six buildings. The drawing provides the only known depiction of this forge, which has been the object of recent archaeological excavations.

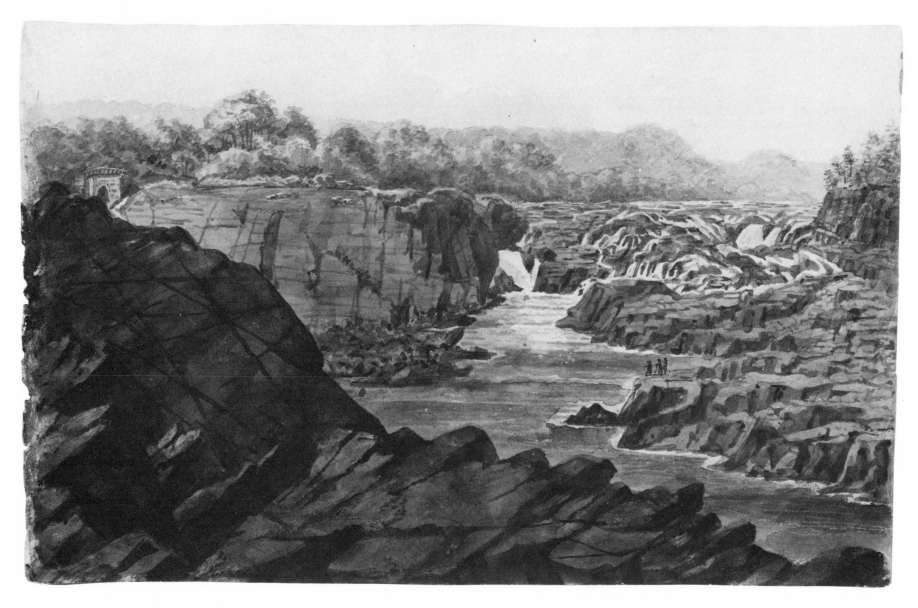

NO. 112

113. "Clarksburg, and Sugar loaf Mountain"

2 August 1810
Pencil
20.3 cm. × 32.2 cm. (8 in. × 12-11/16 in.)
SKETCHBOOK XI

Map references: Buckeystown Quadrangle, Maryland–Virginia; Urbana Quadrangle,
 Maryland; Germantown Quadrangle, Maryland; Poolesville Quadrangle,
 Maryland–Virginia
UTM coordinates: Viewing position: 18.030346.434533; Sugar Loaf Mountain:
 18.029345.434837
Orientation: 300°

In late July 1810 Latrobe informed a friend, "The indisposition under which I have for some time past labored appears to require a few days removal from business, and I propose accompanying Mr. [Joel] Barlow as far as Frederic and perhaps to Harper's ferry from whence I shall return in 4 or 5 days." (BHL to Elias B. Caldwell, 31 July 1810, BHL Letterbooks) On his doctor's orders, Latrobe did absent himself from Washington during the first week in August, seeking relief from the demands of his public and private work as well as from poor health.

Traveling to Harpers Ferry, Latrobe followed the Georgetown to Frederick Road (now known as Frederick Avenue and Rockville Pike, Route 355) north from Washington through Montgomery County, Maryland. Clarksburg was situated along that road in the northern part of the county. Founded around 1780, Clarksburg was a small town whose inns and taverns served the numerous travelers passing through by stage on their way west. Latrobe most likely drew this sketch from nearby Scholl's Tavern (formerly Dowden's Ordinary), just south of Clarksburg (see No. 118).

Sugar Loaf Mountain, depicted in the background to the left, lies to the northwest of Clarksburg, in Frederick County, Maryland. Rising to a height of 1,282 feet, Sugar Loaf stands alone as an outstanding topo-graphical feature amidst the level farmlands of Frederick Valley, approximately forty miles northwest of Washington, D.C. An outpost of the Appalachian chain of mountains, Sugar Loaf has attracted the attention of geologists, who believe that it may reveal much about the age and structural relationships of rocks of the Piedmont Province. In recognition of the mountain's geological significance, the U.S. Department of the Interior has designated it a Registered Natural Landmark.

Over the years, Sugar Loaf has proved a source of fascination to many. Some, like Latrobe, have admired it from afar. Others have sought to possess it. In the 1830s, William Wilson Corcoran, the Washington banker and philanthropist, purchased the summit of the mountain. In the early decades of the twentieth century, Gordon Strong, a wealthy Chicagoan, purchased the approximately 2,700-acre mountain area for use as a summer retreat. Eventually, he opened his mountain estate to the public and established a nonprofit corporation, Stronghold, to administer and maintain the park after his death. The mountain is still owned by the Stronghold Corporation and is carefully preserved as a park open to the public. (For a drawing done by Latrobe on Sugar Loaf Mountain, see No. 140.)

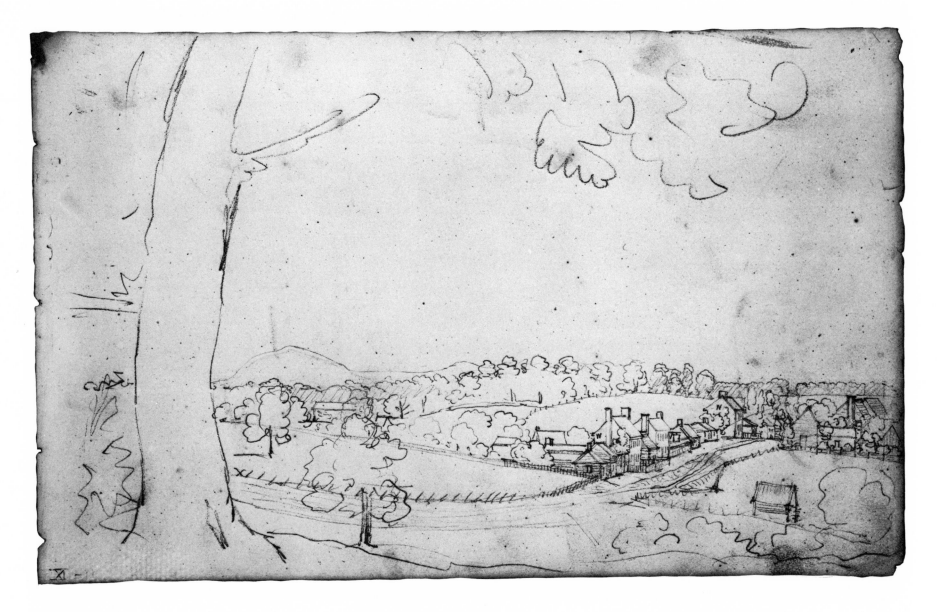

NO. 113

114. "Jefferson Rock"

3 August 1810
Pencil, watercolor
20.3 cm. × 32.2 cm. (8 in. × 12-11/16 in.)
SKETCHBOOK XI

Map reference: Harpers Ferry Quadrangle, Virginia–Maryland–West Virginia
UTM coordinates: 18.026400.435598
Orientation: 240°

Thomas Jefferson was very much awed by the view from the rock bearing his name that overlooks Harpers Ferry, the Blue Ridge Mountains, and the confluence of the Potomac and Shenandoah rivers. In his *Notes on the State of Virginia* he wrote:

> The passage of the Patowmac through the Blue ridge is perhaps one of the most stupendous scenes in nature. You stand on a very high point of land. On your right comes up the Shenandoah, having ranged along the foot of the mountain an hundred miles to seek a vent. On your left approaches the Patowmac, in quest of a passage also. In the moment of their junction they rush together against the mountain, rend it asunder, and pass off to the sea. The first glance of this scene hurries our senses into the opinion, that this earth has been created in time, that the mountains were formed first, that the rivers began to flow afterwards, that in this place particularly they have been dammed up by the Blue ridge of mountains, and have formed an ocean which filled the whole valley; that continuing to rise they have at length broken over at this spot, and have torn the mountain down from its summit to its base. The piles of rock on each hand, but particularly on the Shenandoah, the evident marks of their disrupture and avulsion from their beds by the most powerful agents of nature, corroborate the impression. But the distant finishing which nature has given to the picture is of a very different character. It is a true contrast to the fore-ground. It is as placid and delightful, as that is wild and tremendous. For the mountain being cloven asunder, she presents to your eye, through the cleft, a small catch of smooth blue horizon, at an infinite distance in the plain country, inviting you, as it were, from the riot and tumult roaring around, to pass through the breach and participate of the calm below. Here the eye ultimately composes itself; and that way too the road happens actually to lead. You cross the Patowmac above the junction, pass along its side through the base of the mountain for three miles, its terrible precipices hanging in fragments over you, and within about twenty miles reach Frederick town, and the fine country around that. This scene is worth a voyage across the Atlantic. Yet here, as in the neighbourhood of the natural bridge, are people who have passed their lives within half a dozen miles, and have never been to survey these monuments of a war between rivers and mountains, which must have shaken the earth itself to its center. (Jefferson, *Notes on the State of Virginia*, pp. 19–20)

As Latrobe made this view he was looking to the southwest toward the Potomac and its confluence with the Shenandoah. On the far shore of the river are the Blue Ridge Mountains. Although he has shown the rock formation slightly out of scale, all of the elements are present today. Since 1860, the finely balanced uppermost rock has been supported by four red sandstone supports.

The overhead view that Latrobe titled "Plan of the Cave removing the upper Rock" was theoretically a downward view of the rock complex, the intention of which was to illustrate the base rock on which the balanced rock rests.

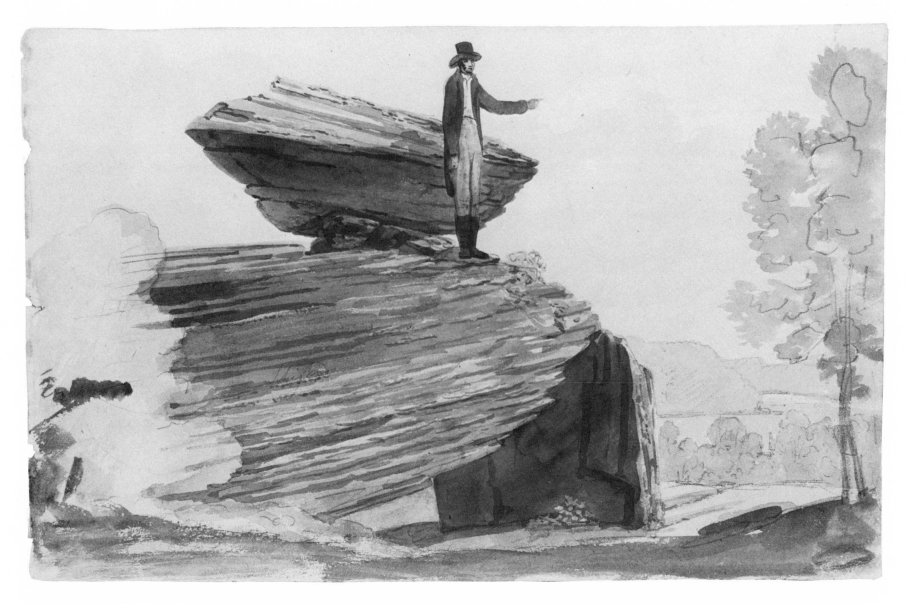

NO. 114

115. "Harper's ferry Armory looking South"

Undated [first week of August 1810]
Pencil
20.3 cm. × 32.2 cm. (8 in. × 12-11/16 in.)
SKETCHBOOK XI

Map reference: Harpers Ferry Quadrangle, Virginia–Maryland–West Virginia
UTM coordinates: 18.026442.435598
Orientation: 125°

The federal government purchased land at Harpers Ferry, Virginia (now West Virginia), for an arsenal and armory in 1796. Latrobe at one time contemplated trying to get the commission for the design and construction of the complex of buildings, but as he related to Vice-President Thomas Jefferson, the prejudices of the Federalist administration discouraged him:

> I had understood that it was the intention of the Government to erect an Arsenal and a Manufactory of arms at Harpers ferry, and as I am now engaged in Virginia, in the Penitentiary house, and am consulted by several of the Canal companies, to have designed and directed a Work of such magnitude as, I suppose, this Arsenal will be, would have at once decided me to sell my Pensylvanien property and consider myself as a Virginian for the rest of my life. But upon some previous enquiry, I am told, that although I have very strong recommendations to several Gentlemen highly in the confidence of the President [John Adams], I am not likely to succeed, should I apply; and that it will not avail me to have had an education entirely directed to the object of becoming useful as an Engineer and Architect, and to have given proofs of some degree of skill, for I am guilty

of the crime of enjoying the friendship of many of the most independent and virtuous men in Virginia, and even was seen at the dinner given to Mr. [James] Monroe. I have therefore resolved not to run the risk of a refusal. (BHL to Jefferson, 28 March 1798, *Journals*, 2:366)

By September 1798 Joseph Perkin, a Philadelphia gunmaker, was engaged as superintendent of construction of the Harpers Ferry facilities. The large arsenal, the front of which is shown in the drawing, was completed in December 1799 and was fitted out and in production the following year. The small arsenal, the end of which is shown, was built about the same time. By 1810 the armory was producing 10,000 muskets a year. In October 1859 John Brown and his followers seized the facilities in an ill-fated attempt to liberate slaves. In 1861 Union troops burned the arsenal and armory to keep them from falling into Confederate hands.

Latrobe was looking to the southeast when he made this drawing. To the left is the confluence of the Shenandoah and Potomac rivers and in the distance behind the arsenals are the Loudoun Heights.

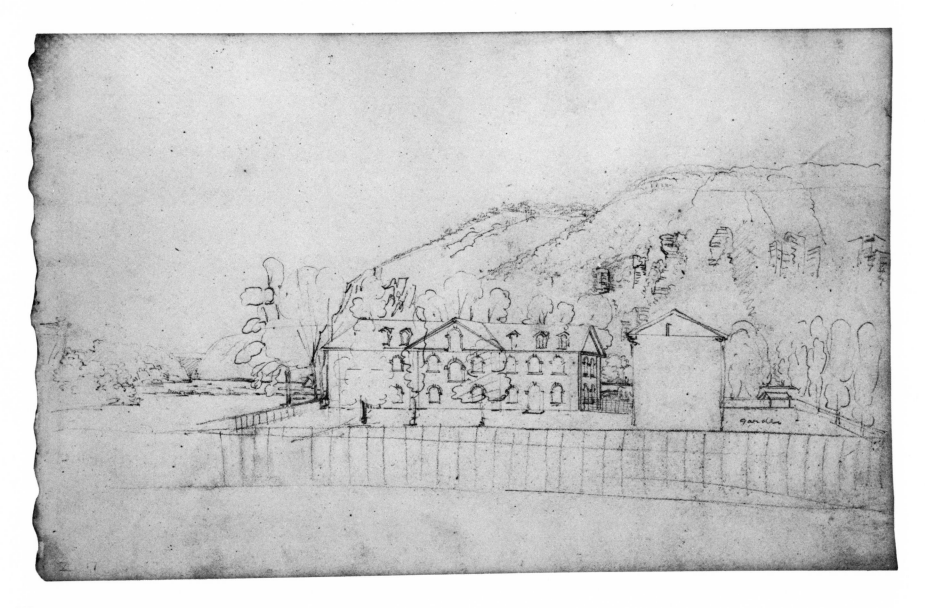

NO. 115

116. "Out of Robb's window Montgomerry Courthouse"

9 October 1811
Pencil, watercolor
20.4 cm. × 32.2 cm. (8 in. × 12-3/4 in.)
SKETCHBOOK VI

Map reference: Rockville Quadrangle, Maryland–Virginia
UTM coordinates: Viewing position: approximately 18.031390.432800; Tavern:
 18.031387.432793
Orientation: Approximately 215°

The occasion of Latrobe's trip to Montgomery Courthouse, now Rockville, Maryland, was the illness of his son John, who "is more subject to fits of dejection than ever and does not seem to improve in strength or appetite as he ought. The removal into other air appears absolutely necessary to him." (BHL to Henry S. B. Latrobe, 5 October 1811, BHL Letterbooks) John's brother Benjamin had not been well either, and Latrobe himself had suffered from a "bilious fever" in late September. (BHL to Erick Bollmann, 26 September 1811, BHL Letterbooks)

When he made this drawing, Latrobe may have been at the home or establishment of Adam Robb, a Scotsman believed to have opened a tavern about 1794. Robb's tavern may have been situated near what became the southeast corner of Washington Street and Commerce Lane (present-day Montgomery Avenue), in which case it would have faced north on Commerce Lane. Adam Robb is thought to be the man who bought the original "Uncle Tom," Josiah Henson, and brought him to Montgomery County about 1795, when Henson was about five or six. Henson wrote, "I was bought by a stranger named Robb. . . . Robb was a tavern keeper, and owned a line of stages with the horses, and lived near Montgomery court-house." Robb subsequently sold Henson to a Montgomery County resident named Isaac Riley, who owned Henson's mother. (Henson, *Father Henson's Story*, pp. 13–14)

The building in view was probably the Hungerford Tavern, opened in 1769 at the crossroads of the highways from Georgetown to Frederick and from Bladensburg to the mouth of the Monocacy River. The tavern was the scene of many committee meetings and elections during the Revolutionary period, and it served as Montgomery County's first courthouse. As the town grew, the tavern came to be on the northwest corner of the intersection of South Washington and Jefferson streets, facing east on South Washington. The tavern was demolished early in this century.

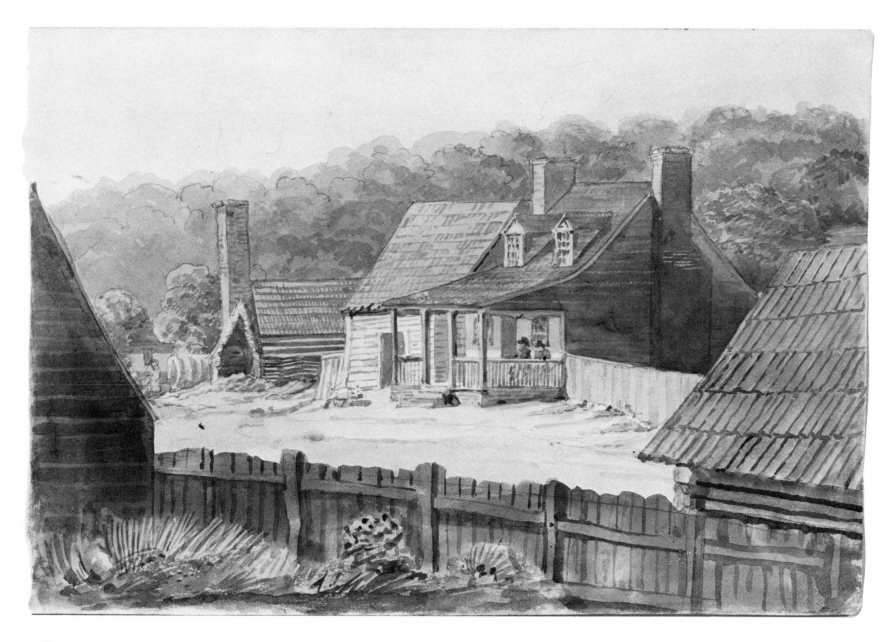

NO. 116

291

117. Two Views of an Elephant, Clarksburg, Maryland

10 October 1811
Pencil, watercolor
20.4 cm. × 32.2 cm. (8 in. × 12-3/4 in.)
SKETCHBOOK VI

Shall's tavern Octr. 10th. 1811. Dial[ogue].

"You, hi, Mr. Elephant, how did you contrive when you kotch him out of the Water."

"Do you think he came out of the water."

"Why, are not them his fins? (his ears)"

Another. "I don't think he's at all like a Camel."

An old Negroe Woman. "If I wur to meet such a beast at night in the woods, I should lie down at once and die myself dead for fright."

This Elephant, a female, is ten Years old, 8 feet 6 inch high. Her tusks have been broken off, but are growing again, having lengthened about an inch in the last 3 Months. She amused herself often by running them into the Nostrils of her proboscis. She lies down every night regularly to sleep. Her ears lost 6 inches in breadth last winter being frost bitten at States borough S. Carolina. She takes a whip and cracks it; eats 2 Bushels of Corn in the Cob a day, when she conveys to her mouth and cracks, then rubs off the grains from the Cob with the finger of her Proboscis, collects them within the trunk and then throws them into her mouth. She draws a Cork from a bottle with her finger, empties it into her trunk and then pours, or rather blows into her mouth. (BHL, SKETCHBOOK VI)

This elephant, the first to be brought to America, arrived in 1796. She had been purchased in Bengal as a two year old by Captain Jacob Crowninshield. After a man named Owen bought the elephant from Crowninshield in New York City for $10,000, her active road career began. No other elephant was to be seen in this country until the arrival in 1808 of Old Bet, an African elephant.

The elephant Latrobe saw was advertised in cities from Boston to Charleston for almost a quarter of a century. She could be viewed for twenty-five or fifty cents in marketplaces and tavern yards, where she apparently became quite a toper. She was reputed to have consumed thirty bottles of porter on some days.

In June 1808, the elephant appeared in the New York City Park Theatre production of "Blue Beard." Like that of many great ladies of the stage, her age did not change with time, so it is not surprising that Latrobe thought she was ten, rather than seventeen, years old.

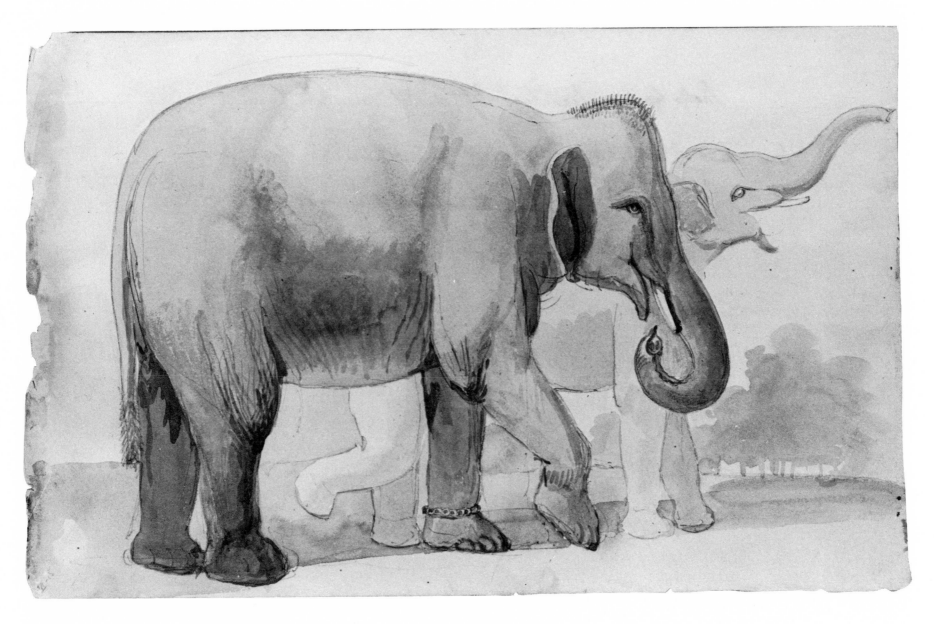

NO. 117

118. "Sholl's tavern Clarksburg"

10 October 1811
Pencil, watercolor
20.4 cm. × 32.2 cm. (8 in. × 12-3/4 in.)
SKETCHBOOK VI

Map reference: Germantown Quadrangle, Maryland
UTM coordinates: Tavern: 18.030346.434522
Orientation: 315°

"View about 10 o'clock of the Elephant, going towards Georgetown. Showing the position of the Comet at the time." (BHL, SKETCHBOOK VI) As shown here, the elephant troupe, which was probably heading south for the winter, traveled at night to avoid spooking horses and providing any free looks at the elephant.

The Comet of 1811 was the first great comet of the nineteenth century. It was independently discovered by Pierre-Gilles-Antoine Honoré Flaugergues (1755–1830), of Viviers, France, and by the young American astronomer and instrument maker William Cranch Bond (1789–1859), of Boston. The comet was visible in the northern skies throughout the night during the autumn of 1811. Because of its unusual brightness, the comet was widely observed in America and Europe. Few other comets have been one-tenth as bright, and only two comets with longer tails have been recorded.

The comet attained some notoriety when London vintners prepared the Comet Wine of 1811. And Napoleon, expecting the imminent outbreak of war between Britain and America, declared the comet a good omen for his ill-fated campaign against Russia. The comet is the one seen by Pierre in Tolstoy's *War and Peace*.

In a letter to Daniel Carroll Brent of Richland, Virginia, concerning an order for thirty-five cords of hickory, Latrobe wrote: "Pray have mercy upon us as soon as possible for November is at hand and I am unwilling to rely upon the Comet for warmth this winter." (16 October 1811, BHL Letterbooks)

Scholl's Tavern was owned by Frederick Scholl, who had purchased it in November 1800. The inn had been known as Dowden's Ordinary since 1750, when Michael Ashford Dowden received a license to keep an ordinary at his home. Frederick Scholl obtained a tavern keeper's license soon after buying the property, and he and his wife Catherine operated the inn until his death in 1815. The tavern remained in the hands of the Scholl family until 1834. The hill upon which the tavern stood was for many years known as Shaw's Hill, after a later owner of the property.

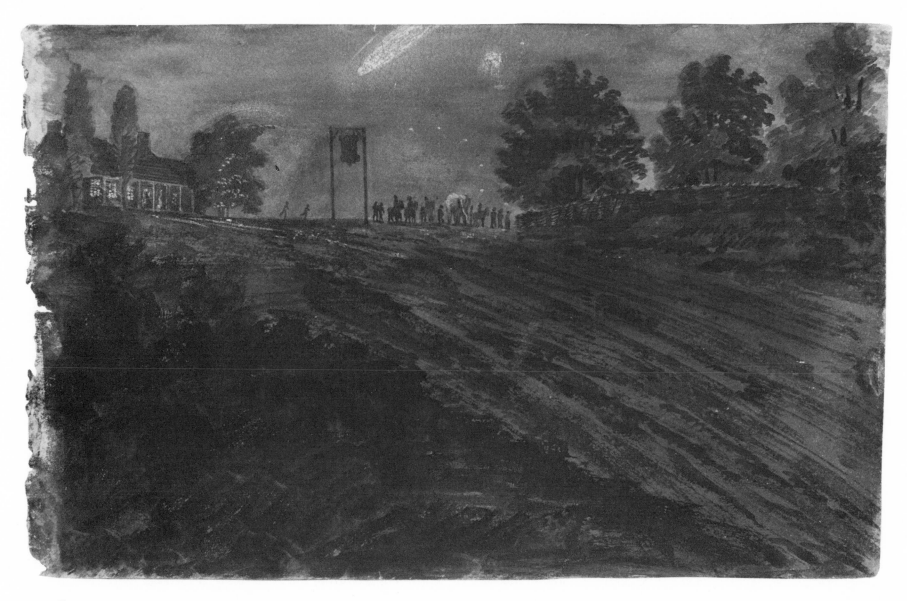

NO. 118

119. "View of the Capitol from my Shop, square 419"

20 May 1813
Pencil, pen and ink
21.3 cm. × 48.8 cm. (8-3/8 in. × 19-3/16 in.)
SKETCHBOOK XII

Map reference: Washington West Quadrangle, District of Columbia–Maryland–
 Virginia
UTM coordinates: Viewing position: 18.032485.430658; Capitol: 18.032568.430623
Orientation: 115°

In 1881, Latrobe's son John H. B. remembered Washington as it had appeared in 1811:

> The Pennsylvania Avenue, in those days, was little better than a common country road. On either side were two rows of Lombardy poplars, between which was a ditch often filled with stagnant water, with crossing places at intersecting streets. Outside of the poplars was a narrow footway, on which carriages often intruded to deposit their occupants at the brick pavements on which the few houses scattered along the avenue abutted. In dry weather, the avenue was all dust, in wet weather, all mud; and along it "The Royal George"— an old-fashioned, long bodied four horse stage—either rattled with members of Congress from Georgetown in a halo of dust, or pitched, like a ship in a seaway, among the holes and ruts of this national highway.
>
> The Capitol itself stood on the brink of a steep declivity, clothed with old oaks and seamed with numerous gullies. Between it and the Navy Yard, were a few buildings, scattered here and there over an arid common. (John H. B. Latrobe, *Capitol and Washington,* p. 25)

This drawing shows the Capitol in its final state of progress under Latrobe's initial period of supervision. The right-hand part of the Capitol is the pilastered facade of the south wing, built by Latrobe. Principally containing the Hall of Representatives, this wing went into use in 1807. In the gap to its left, the cluster of small forms represents the back of the south recess, an area of vestibules and staircases, built with the south wing. A temporary covered passage joins that element to its northern mate, seen as a blank rectangle next to the north wing. In 1808–10, Latrobe had remodeled the interior of the north recess and much of the interior of the north wing, which housed the Senate and the judiciary.

Work on the Capitol ceased and Latrobe's tenure as surveyor of the public buildings ended in July 1811. Latrobe made this drawing shortly before he left Washington for Pittsburgh, where he was to be the agent for the Ohio Steamboat Company.

The drawing was taken not from Square 419, as Latrobe noted, but from Square 491, on which Latrobe had bought lot 15 in 1812. His property fronted on C Street, just above Pennsylvania Avenue between Fourth and Sixth streets, NW. The view is to the southeast, showing Pennsylvania Avenue as it nears the Capitol. During his administration Jefferson had planted poplars along Pennsylvania Avenue in an attempt to beautify the city; but as the sketch demonstrates, Washington was still in a greatly unfinished state. Partially obscured by the poplars in the center of the drawing is a bridge across Tiber Creek, which widened into a tidal marsh in the area of the present-day Mall.

Flanking the Capitol were some of the centers of social life for the early nineteenth-century legislative community. The large building behind and to the left of the Capitol in the drawing was likely that built by Daniel Carroll of Duddington, who owned a great deal of land in the eastern part of the city. Under a succession of proprietors and names such as the American House and Indian Queen Hotel, it was a popular meeting place and residence for some members of Congress. Sitting unoccupied a year later when the British invaded Washington, it was one of the few pieces of private property they burned. Most legislators in the early years lived during sessions of Congress in boardinghouses rather than in hotels or private homes. Many of these boardinghouses were in the cluster of buildings south of the Capitol (to the right of the Capitol in the drawing), along New Jersey Avenue and B Street, SE. There legislators generally slept two to a room, took their meals at a common table, and in the evenings often gathered in the parlor for political discussions which functioned as unofficial caucuses. Thomas Law, an early Washington developer, had erected many of these buildings along New Jersey Avenue. Among his many building projects was a row of houses further south on New Jersey Avenue, popularly known as Ten Buildings. (*continued*)

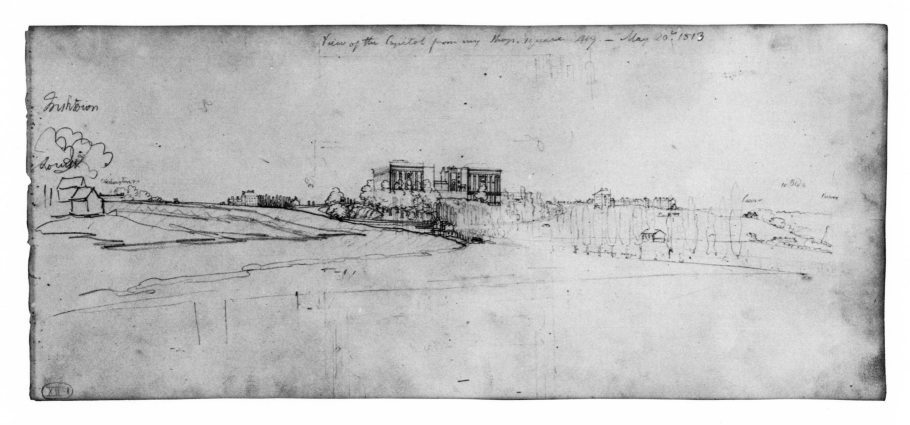

NO. 119

To the southeast of the New Jersey Avenue buildings is Daniel Carroll's Duddington Manor (at the far right of the drawing), its roof and the oak trees from its fine gardens barely seen over the slope of the hill. It was one of the most distinguished Washington mansions of the time.

On the far left are several roughly sketched buildings, labeled "Irishtown," which most likely housed some of the Irish laborers employed in the construction of the Capitol. A little behind these can be seen the roofline of a brick building, actually two connected houses on North Capitol Street, built by George Washington in 1798 to encourage construction on Capitol Hill.

120. View from Pennsylvania Avenue, Washington, D.C.

Undated [May 1813]
Pencil
21.3 cm. × 48.8 cm. (8-3/8 in. × 19-3/16 in.)
SKETCHBOOK XII

Map reference: Washington West Quadrangle, District of Columbia–Maryland–Virginia
UTM coordinates: Viewing position: 18.032405.430682; Van Ness House:
 18.032402.430678
Orientation: 225°

About the same time that Latrobe made the previous sketch of the Capitol, he recorded this view of a more developed section farther west on Pennsylvania Avenue, looking southwest toward the intersection of Twelfth and D streets, NW. The large brick house in the center of the drawing, on the southwest corner of that crossing, had been built in 1808 for General John Peter Van Ness (1770–1846), for whom Latrobe later designed a widely praised mansion. Van Ness and his wife, heiress Marcia Burnes (1782–1832), were active in Washington politics and society, and noted for their lavish hospitality. They were, however, provident enough to construct this building as two attached townhouses. They thus received additional income by renting out the left-hand side (partially hidden by the poplars), the ground floor of which housed a store.

The mixture of residential and commercial properties was common in Latrobe's day. Across D Street from the Van Ness house (at the far right of the drawing) was a frame building which originally housed Morin's Tavern, but by the time Latrobe made his sketch it had become a grocery store. In the background of the drawing, Tiber Creek widens and flows west into the Potomac River. In the distance beyond the Potomac rise the hills of Arlington, Virginia, now the site of the Arlington National Cemetery. The label "arlington" identifies George Washington Parke Custis's incomplete and barely visible hilltop mansion, to which the architect George Hadfield added the porticoed main block after the War of 1812.

Today one of Washington's few significant Richardsonian Romanesque structures, the Old Post Office (1899) stands on the southeast corner of Twelfth and D streets. The area west of Twelfth Street, from Pennsylvania Avenue south to Constitution Avenue, is now occupied by the Post Office Department (1934) and the Interstate Commerce Commission (1935) buildings.

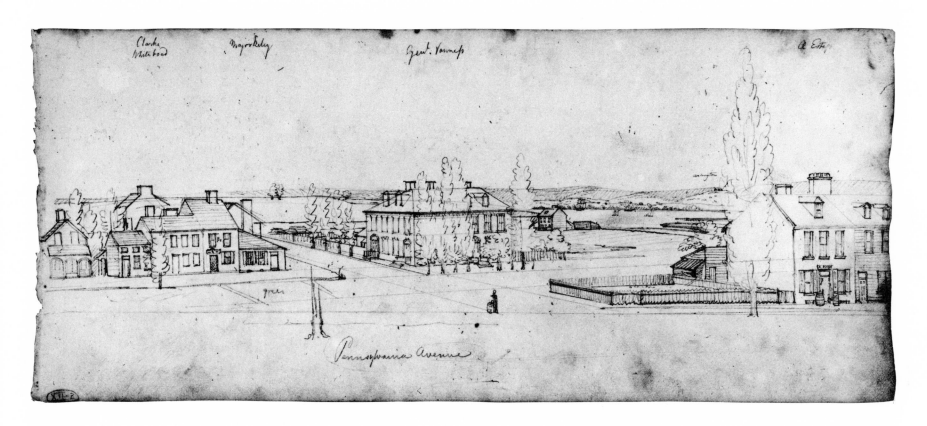

Clarke
White boad

Major Kelly

Gent. Vanness

A. Estep

Pennsylvania Avenue

NO. 120

121. "Marlborough Myld. on Patuxent"

27 June 1813
Pencil, wash
20.3 cm. × 32.2 cm. (8 in. × 12-11/16 in.)
SKETCHBOOK XI

The town of Upper Marlboro was established in Prince George's County, Maryland, in 1706, on the Western Branch of the Patuxent River some twenty miles east of what would become the District of Columbia. Originally called Marlborough, the town later became known as Upper Marlboro to distinguish it from another town of the same name in Calvert County, present-day Lower Marlboro. Fifteen years after the town was formed, it became the county seat. Long an entrepôt for Maryland's tobacco trade in the eighteenth century, Upper Marlboro was a lively social center for planters who stopped to enjoy dancing, theater, cockfighting, cardplaying, and especially horse racing. In the summer of 1813, Latrobe visited Marlborough in order to design minor changes to the county courthouse.

Approximately fifteen years after Latrobe sketched this scene, his son John H. B. used the picture as a model for a series of instructional drawings featured in *Lucas' Progressive Drawing Book* (see Fig. 18, p. 39). The younger Latrobe entitled his drawing "Mill at Marlborough, Maryland," and further noted in the accompanying text: "The principal features of the view, here given, are taken from the banks of the creek at Marlborough, Maryland."

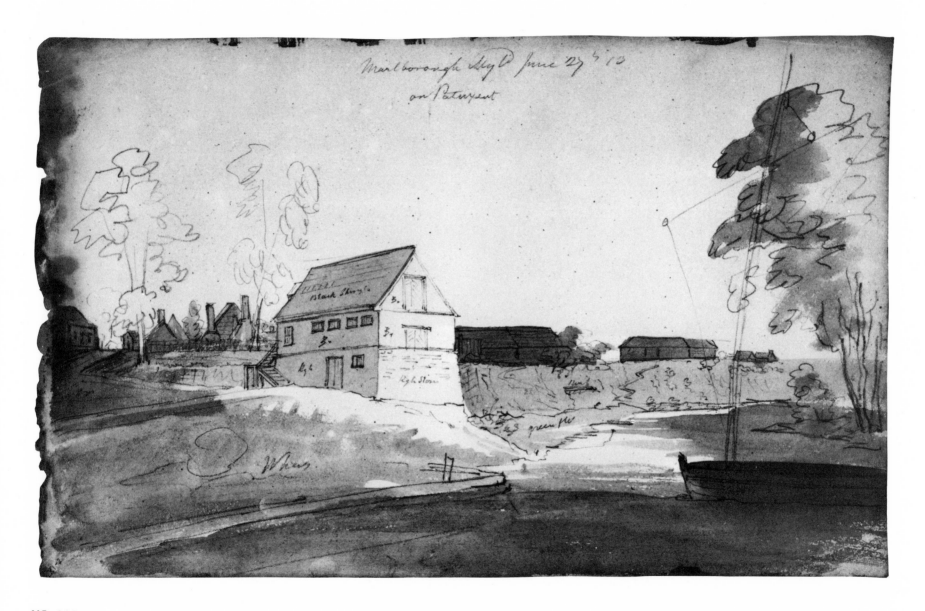

NO. 121

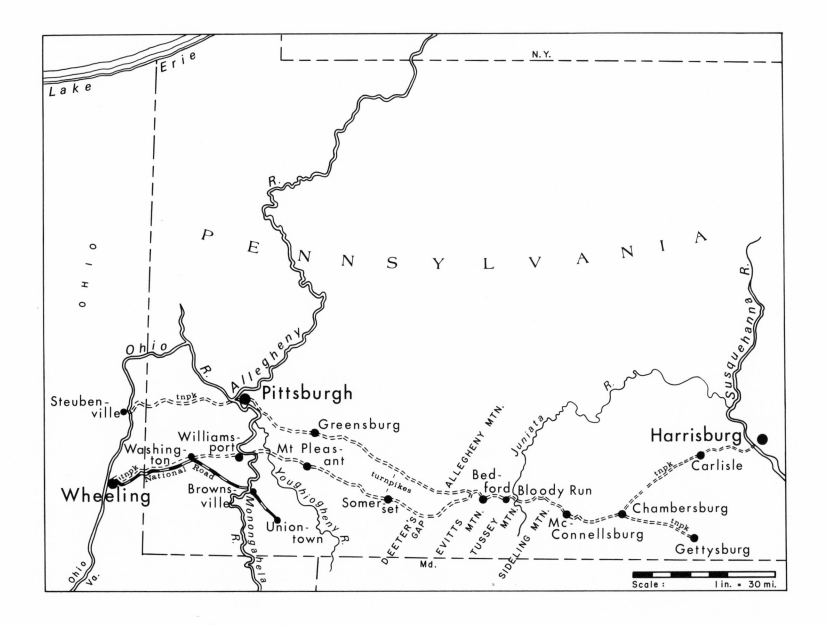

Lake Erie

N.Y.

OHIO

PENNSYLVANIA

R.

Allegheny

Ohio

R.

Steuben-
ville

tnpk

Pittsburgh

Greensburg

Williams-
port

Mt Pleas-
ant

Washing-
ton-

tnpk

National Road

Wheeling

Browns-
ville

Youghiogheny R.

Union-
town

Monongahela R.

Somer-
set

turnpikes

DEETER'S GAP

Md.

Ohio
Va.

ALLEGHENY MTN.

Juniata R.

Bed-
ford

Bloody Run

EVITTS MTN.

TUSSEY MTN.

SIDELING MTN.

Mc-
Connellsburg

Chambersburg

tnpk

Gettysburg

Susquehanna R.

Harrisburg

tnpk

Carlisle

Scale: 1 in. = 30 mi.

VIII. Travels between Washington, Philadelphia, and Pittsburgh; Washington and Vicinity, 1813–1816

122. "Red lion, Baltimore road"

28 September 1813
Pencil
21.3 cm. × 48.8 cm. (8-3/8 in. × 19-3/16 in.)
SKETCHBOOK XII

Map reference: White Marsh Quadrangle, Maryland
UTM coordinates: Viewing position: 18.037762.436033; Red Lion Inn:
 18.037764.436043
Orientation: 25°

With his architectural work in Washington at a virtual standstill due to the onset of war, Latrobe made plans to enter into the business of constructing steamboats with Robert Fulton in Pittsburgh. Optimistic about his prospects there, he wrote to his brother: "If I live to finish what I have now undertaken and which will occupy three or four Years, I shall very probably be able to sit down at my leisure for the rest of my life." (BHL to Christian I. Latrobe, 15 January 1813, in BHL, *Correspondence*, 3) The Latrobe family left Washington for Pittsburgh by way of Philadelphia in the middle of September 1813.

On the first day of their journey they stopped at the Red Lion Inn, a well-regarded hostelry in Baltimore County, Maryland. Situated at the head of Bird River on the old Baltimore to Philadelphia Post Road (on a section known as Red Lion Road), thirteen and a half miles northeast of Baltimore, the inn was originally built about 1760 and was known at different times as the Stone Tavern and Skerrett's Tavern. From descriptions of the structure and its foundation, it appears that Latrobe did not sketch the eighteenth-century inn, which may have been destroyed by the time he passed through in 1813, but another inn building of the same name constructed near this site. In this panoramic view, Latrobe is looking north, with the Old Post Road running northeast to the Bird River (in the right background).

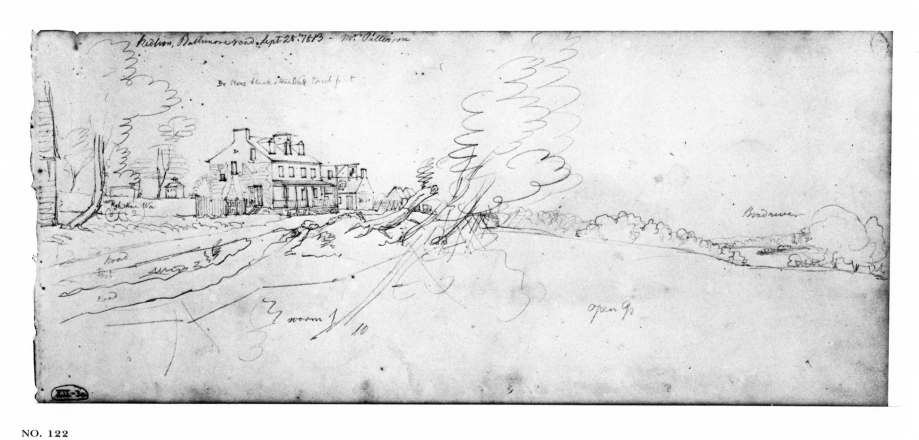

NO. 122

123. "Bush [Maryland]"

28 September 1813
Pencil
21.3 cm. × 48.8 cm. (8-3/8 in. × 19-3/16 in.)
SKETCHBOOK XII

Map reference: Edgewood Quadrangle, Maryland
UTM coordinates: Viewing position: approximately 18.039117.436996; Bush:
 approximately 18.039128.436988
Orientation: Approximately 125°

From the Red Lion Inn, the Latrobes continued their journey to the northeast, arriving on the same day at Bush, also known as Harford Town, in Harford County, Maryland, another stagecoach stop on the Old Post Road between Baltimore and Philadelphia. A small town situated at the head of the Bush River, Bush was the county seat from the time of Harford County's creation in 1773 until 1782. During that brief period, Bush was the site of several critical county political meetings, among the most important being the March 1775 gathering of elected county representatives at a tavern. There, they signed what was later known as the "Bush Declaration," one of the earliest declarations of independence from Great Britain made in the colonies.

During the eighteenth century several important industries were located in and around Bush, including a gristmill, the Bush River Iron Works, and a tannery. The tannery, portions of which Latrobe has depicted in the foreground, was run by Benjamin Nowland, partner of the wealthy landowner John Stump, Jr., who owned the Bush mill and much of the surrounding land.

Latrobe's sketch provides the sole graphic representation of the early town of Bush, whose site today is identified only by a few houses and roadside markers. The drawing's perspective is southeastward, with Bush River and a few sandbars in the center background. The Old Post Road, also known as the Old Philadelphia Road (present-day Route 7), is indicated by the word "road" at the center right.

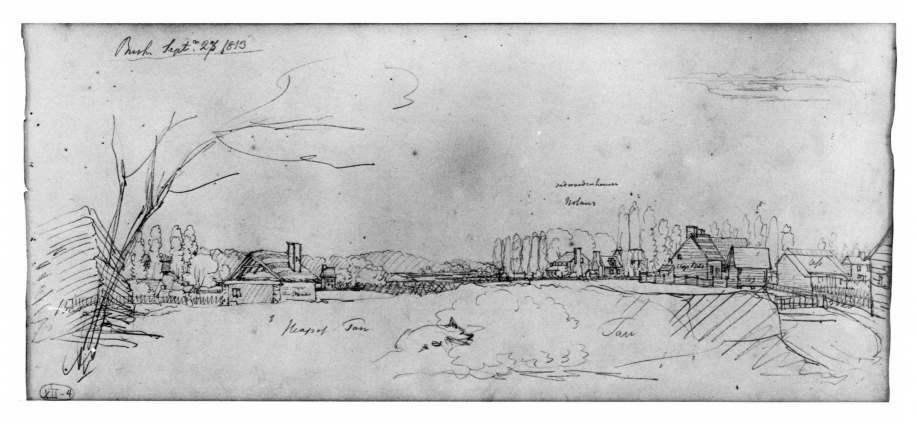

NO. 123

124. "Charleston [Maryland]"

29 September 1813
Pencil
21.3 cm. × 48.8 cm. (8-3/8 in. × 19-3/16 in.)
SKETCHBOOK XII

Map reference: North East Quadrangle, Maryland
UTM coordinates: Viewing position (Paca House): 18.041610.438070; Davis House
(E): 18.041622.438062; Eagle Point (J): 18.041631.438042; Still House (G):
18.041646.438046
Orientation: 135°

Further to the northeast along the old Baltimore to Philadelphia Post Road, the Latrobes passed through Charles Town, situated on the west side of the Northeast River in Cecil County. Founded in 1742, Charles Town was a small town whose heyday came and went in the mid-eighteenth century. It was established by the Maryland Assembly as a shipping center for the head of the Chesapeake Bay; its designation as a regional flour inspection and warehousing site as well as a site for semiannual merchant fairs promised future prosperity. Until the time of the Revolution, Charles Town was a major rival of Baltimore Town. Following the Revolution, however, its economic viability diminished due to the loss of its status as a designated shipping center, as well as the growing domination of the port of Baltimore. In the 1780s, the county seat was moved from Charles Town to Elkton, and many residents tore down their houses and rebuilt them in Baltimore. In the early years of the American republic, Charles Town was already in decline. A visitor in 1793 remarked: "This place must be very pleasant in Summers, but it consists only of poor fishing Huts, and looks in wretched decay and Soil and Houses bear every aspect of Poverty and Ruin. It is however one of the greatest *herring* fishery places in the U.S., and 2,000 Waggons are loaded annually in the Spring with the fish, and transport them into all the back Country." ([Kent], "A New Yorker in Maryland," p. 137)

Latrobe's drawing of Charles Town is the earliest known pictorial representation of the town. The sketch was made from a position by the Paca House (A), looking southeast across the town and toward the Northeast River. The drawing depicts the following sites:

A. Paca House (still standing). The first owner of this house was John Paca, father of William Paca (1740–99), signer of the Declaration of Independence and governor of Maryland (1782–85).
B. Alison-Key House (no longer standing) was better known in the eighteenth century as the home and shop of saddler John Smith.
C. Market House (removed in 1830).
D. Key-Ramsay House (destroyed in 1834). Originally the home of Francis Key, grandfather of Francis Scott Key, this house in 1771 became the home and law office of the Revolutionary hero Nathaniel Ramsay (1741–1817). In this house, Ramsay and his brother-in-law, Charles Willson Peale, attempted to manufacture gunpowder for the Revolution. The town purchased the house from Ramsay and used it as a town meeting place, church, and school.
E. Davis House (still standing) was built by Jacob Northerman for David Davis, a Philadelphia cooper, in 1762.
F. Tully House (no longer standing) was built by Edward Tully, a carpenter, in 1746.
G. Still House (still standing, though altered). In this structure, sugarcane products, which Charles Town merchants obtained from the West Indies trade, were converted into rum.
H. Morrow House (no longer standing) was owned and occupied by Captain Jonas Owens in 1813.
I. Bladen House (no longer standing) was built for Governor Thomas Bladen (1698–1780) before 1752.
J. Eagle Point (still standing) was built in 1792 by William Graham.
K. Fairground. Charles Town held its first semiannual fair on these grounds in 1744. The town reenacts the fair each year on this site.
L. Cunningham House (still standing, though altered). The original structure, completed in 1790, is now incorporated into a modern house on the site.

A B C D E F G H I J L

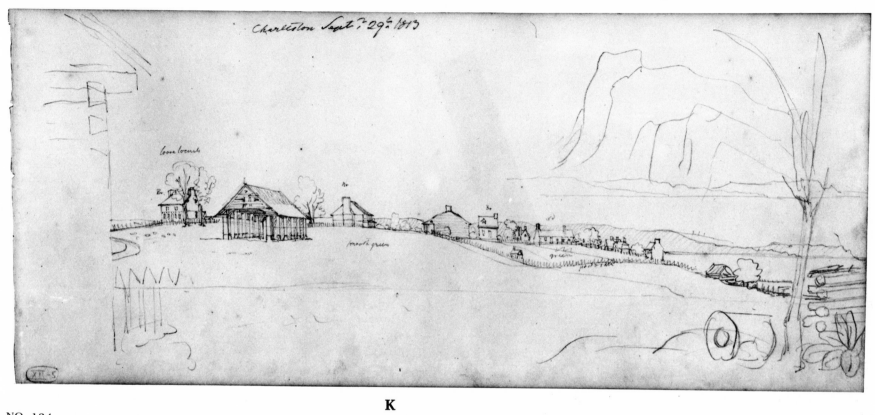

K

NO. 124

125. "Milligan & McClean's New Mills Brandywine"

Undated [1 October 1813]
Pencil
21.3 cm. × 48.8 cm. (8-3/8 in. × 19-3/16 in.)
SKETCHBOOK XII

Map reference: Wilmington North Quadrangle, Delaware–Pennsylvania
UTM coordinates: Viewing position: 18.045027.440234; Milligan and McLane's Mill:
 18.045032.440228
Orientation: 130°

126. Milligan and McLane's Mill, Brandywine Creek

1 October 1813
Pencil
21.3 cm. × 48.8 cm. (8-3/8 in. × 19-3/16 in.)
SKETCHBOOK XII

Map reference: Wilmington North Quadrangle, Delaware–Pennsylvania
UTM coordinates: Viewing position: 18.045034.440246; Milligan and McLane's Mill:
 18.045032.440228
Orientation: 170°

The mills depicted in these scenes belonged to George Baldwin Milligan (b. 1791), a Cecil County, Maryland, landowner, and his brother-in-law Louis McLane (1786–1857), a prominent Wilmington lawyer who represented Delaware for many years in the U.S. Congress and who served in the cabinet of Andrew Jackson. Milligan and McLane purchased this millseat, situated on the west bank of the Brandywine at Pancake Run just below E. I. du Pont's Hagley Yards in northern Delaware, in March 1813. At the same time, they purchased an old three-story gristmill already on the site, depicted in the background of No. 125, from Vincent Gilpin. They then erected the stone textile mill depicted in the center of No. 125. In 1815 the millseat, which they called Rokeby, consisted of "10 acres of land improved with 5 stone tenements, Cotton factory and old Merchant Mill." (Assessment List, Christiana Hundred, cited in Boatman, "Brandywine Cotton Industry," p. 13) At the time of the 1820 census, the mills housed 2,300 spindles, 10 hand looms, and 20 power looms. Seventy-nine men, women, and children were then employed at Rokeby.

Milligan and McLane never managed the mills themselves, but instead rented them to several individuals over the years. One of their tenants, William Breck, together with Joseph Dixon bought Rokeby in 1836. They owned it until 1839, when they sold it to Breck's uncle by marriage, Charles I. du Pont. Breck remained with the textile mills as manager until 1854, when they ceased operation forever. In the 1890s, the mill built by McLane and Milligan, which had come to be called Breck's Mill, was reopened as a recreation center and dance hall. Breck's Mill still stands, although its external appearance has been altered since Latrobe made this sketch. Following a fire in 1846, the mill's clearstory was replaced by a simple gable roof. The smaller mill, which continued to be known as Rokeby, was used as a laboratory (the forerunner of the du Pont Company Experimental Station) beginning in 1903. The mill burned in 1906 and was never rebuilt.

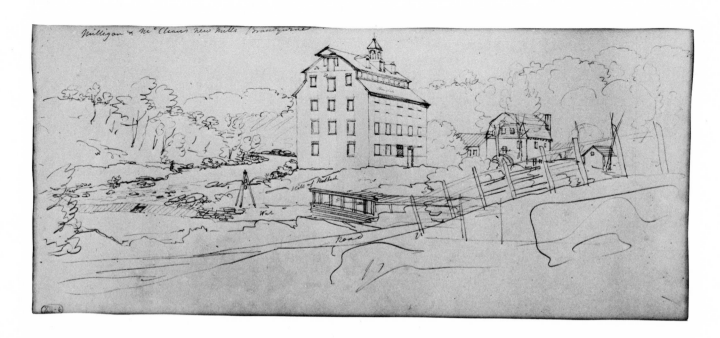

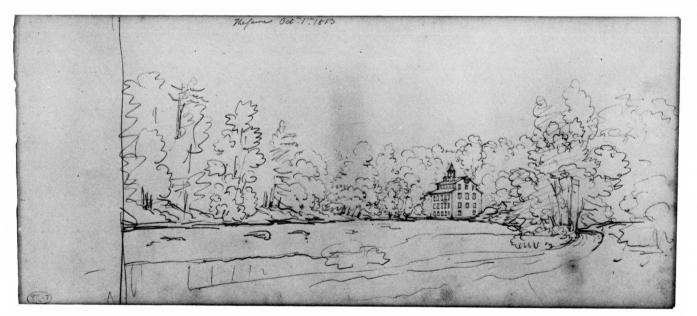

127. "Ferry Harrisburg"

12 October 1813
Pencil
21.3 cm. × 48.8 cm. (8-3/8 in. × 19-3/16 in.)
SKETCHBOOK XII

Map reference: Harrisburg West Quadrangle, Pennsylvania
UTM coordinates: 18.034023.445752
Orientation: 305°

Harrisburg is situated on the east branch of the Susquehannah, 97 miles from Philadelphia. It is handsomely laid out on the plan of Philadelphia, having four streets running parallel with the river, named Front, Second, and so on. . . . The houses are mostly built of brick, and have a good appearance, and the town is rapidly encreasing. . . . The inhabitants of the township amount to 2287. . . . Harrisburg was laid out in 1785, and has made progress ever since; and from its commanding and central situation, it will, in all probability, become one of the largest inland towns in America. . . .

After breakfast we crossed the Susquehannah river in a flat boat, poled by four men. The river is here nearly a mile wide, and was, when we crossed it, from three to five feet deep, with a pretty rough gravelly bottom; the current was swift, and the water pure. (Melish, *Travels,* pp. 27–28)

The Susquehannah near Harrisburg is about three quarters of a mile in breadth: in summer it is frequently fordable. The navigation is extremely dangerous for several months, in consequence of some rapid currents, and never safe except in spring and autumn, when the water is sufficiently high to cover the rocks, which become more numerous at the point where the Juniata falls into the Susquehannah, nine miles above Harrisburg, and greatly encrease the dangers of the navigation. (Rochefoucauld Liancourt, *Travels,* pp. 98–99)

The ferry was originally known as Harris's Ferry, after John Harris (c. 1726–91), who first secured the rights to conduct the ferry in 1753. The settlement around the ferry was called Harris's Ferry until about 1786, when its name was changed to Harrisburg. Only a few years after Latrobe's journey through Harrisburg, a bridge was erected there over the Susquehanna. No doubt while waiting for the ferry on his way to Carlisle, Latrobe sketched this scene from a point just south of the town on the east bank of the river looking to the northwest. The island in the center of the drawing is most likely what is today known as City Island. The mountain outlined in the background on the western shore of the river is Blue Mountain.

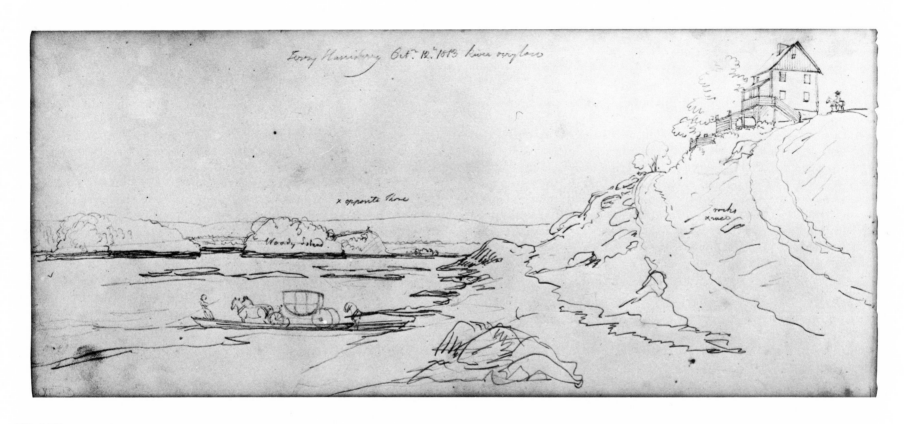

Ferry Harrisburg Oct.r 12.th 1813 River very low

x opposite Shore

Woody Island

rocks x med

NO. 127

128. Dickinson College, Carlisle, Pennsylvania

Undated [October 1813]
Pencil
21.3 cm. × 48.8 cm. (8-3/8 in. × 19-3/16 in.)
SKETCHBOOK XII

Map reference: Carlisle Quadrangle, Pennsylvania
UTM coordinates: Viewing position: 18.031332.445243; Building: 18.031327.445252
Orientation: 320°

This is a view of the south front of the building today known as West College on the campus of Dickinson College, looking to the northwest with the Conodoguinet Creek floodplain and Blue Mountain in the background. Latrobe designed this building for the trustees of the college in 1803. He donated his services because he believed "it to be the interest and duty of every good citizen to promote . . . the education, and *civilization* of the society in which he and his children are to live." Constructed of local gray limestone and trimmed with red sandstone, the college building is approximately U-shaped with projecting wings on the north side. Latrobe explained the principles of his design in a letter to college trustee Hugh Henry Brackenridge:

> I have stated these things, which are indeed known to every body, in order to explain a *law*, which is thereby imposed upon the Architecture of our Country: It is, to reserve the Southern aspects of every building in the erection of which the choice is free, for the inhabited apartments, and to occupy the Northern aspects by communications, as Stairs, Lobbies, Halls, Vestibules &c.
>
> This Law governs the designs herewith presented to you.
>
> On the North are the Vestibule and lobbies, or passages. They protect the Southern rooms from the effect of the Northern winds. On this Aspect I have also placed the dining room, a room only occasionally occupied and for a short time, and the Schoolrooms above it, which by means of Stoves, and the concourse of Students are easily kept warm. There are indeed two Chambers in the N.E. wing on each story. If these Chambers be inhabited by Preceptors, the one as a study, the other as a Bedchamber, the disadvantages of the Aspect must be overcome by such means, of Curtains and Carpets, as a Student does not so easily acquire. The South Front affords on each story 6 rooms for Students. The angle rooms will accommodate 3, and each of the other, 2 Students; in all 14 on each floor.
>
> The Hall is intended to occupy two stories. Above the Hall a room of equal size may be appropriated to a Library, or may furnish 4 or 6 Students rooms, 2 or 3 to the South and as many to the North.
>
> The usual mode of planning colleges, by arranging the rooms on each side of a long passage, has many disadvantages, the chief of which are the noise, and necessary darkness of the Passage, and the bad aspect of one half of the rooms. These inconveniences do not, I believe exist in the plan I present to you, and should at a future period, the celebrity of your institution encrease the number of your students, as it no doubt will, it will be better to erect new accommodations, than to obtain room by connecting the wings, in order to save expence; as has often been done. (BHL to Brackenridge, 18 May 1803, in BHL, *Correspondence*, 1)

Latrobe's journey to Pittsburgh provided him with his first opportunity to see the realization of his design. At the time of his visit, the exterior of the building had been completed, though the interior was yet unfinished. Today West College stands in the eastern section of the Dickinson College campus. It has suffered some alteration to its exterior, but its limestone facade generally looks much as it did when Latrobe committed it to his sketchbook in 1813.

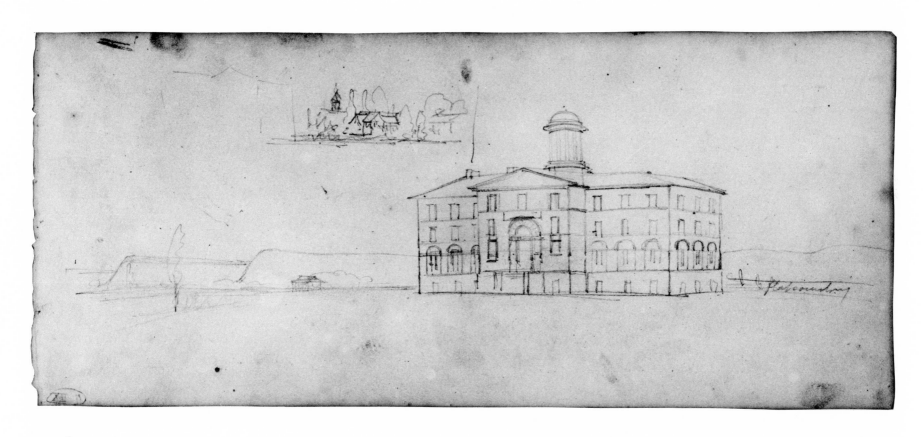

NO. 128

129. "Steubenville Ohio"

9 March 1815
Pencil, pen and ink, watercolor
20.3 cm. × 32.2 cm. (8-in. × 12-11/16 in.)
SKETCHBOOK XI

Map reference: Steubenville East Quadrangle, West Virginia–Pennsylvania–Ohio
UTM coordinates: Viewing position: 17.053190.446776; Cloth Mill:
17.053229.446777; End of Market Street (Riverside): 17.053302.446742
Orientation: 110°

"Of all the towns on the Ohio Steubenville is the most remarkable for its rapid growth, and beautiful situation." (BHL to Robert Goodloe Harper, 29 May 1816, BHL Letterbooks)

The site of this town is like that of Cincinnati, composed of two banks rising from the river. The scenery in the neighbourhood is romantic and pleasing; the opposite shore of Virginia is a bold ledge of rocks rising abruptly almost from the water edge to an elevation of 250 or 300 feet. Though very hilly and broken in both Virginia and the state of Ohio, the adjacent country affords much very fertile bottoms and high land. It is one of the most wealthy, best peopled and cultivated tracts in the United States west of the Aleghany mountains.

The town was laid out in streets and lots in 1798. . . . there was then one mercantile store, two slight frame houses, and about a dozen miserable cabins. Most of the ground was covered with a thick forest; little appearance was then exhibited of the flourishing and beautiful town that now adorns the banks of the Ohio. . . . [In 1817] Steubenville contained upwards of 450 dwelling-houses, and a population of 2000 inhabitants; a printing office, woollen and cotton factory, paper-mill, near 60 mercantile stores, a bank, a spacious market-house, an air foundry. In the vicinity are several saw and grist mills, as also a number of distilleries. (Darby, *The Emigrant's Guide*, p. 228)

Before traveling from Pittsburgh to Washington for an interview with the commissioners of public buildings concerning the rebuilding of the Capitol, Latrobe took a short trip to Steubenville in order to examine the woolen mill there and to oversee the construction of the steam engine that he had designed to power the mill's machinery. The mill, which is depicted in the following drawing, is seen in the left foreground of this view. Latrobe was standing just west of Steubenville when he sketched this view of the town looking east across the Ohio River to the mountainous shore of the panhandle of what was then Virginia and is today West Virginia. In the upper right-hand corner of the drawing, Latrobe drew a circled "x" and wrote the word "Creek" as a legend. The symbol can be seen on the Ohio shore just to the right of the town.

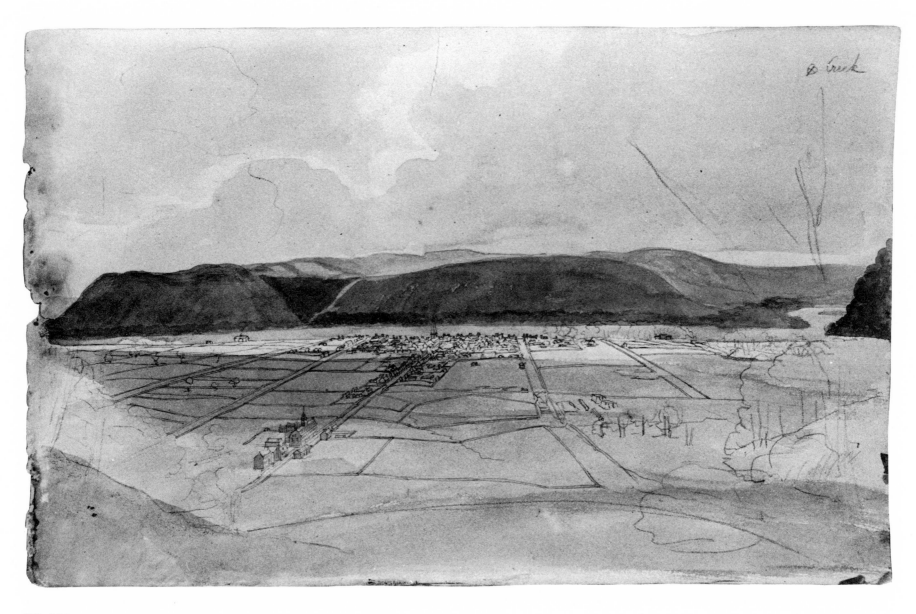

NO. 129

130. "Cloth Manufactory Steubenville"

9 March 1815
Pencil, pen and ink, watercolor
20.3 cm. × 32.2 cm. (8 in. × 12-11/16 in.)
SKETCHBOOK XI

Map reference: Steubenville East Quadrangle, West Virginia–Ohio–Pennsylvania
UTM coordinates: Viewing position: 17.053230.446766; Cloth Mill: 17.053229.446777
Orientation: 355°

The Steubenville Woolen Mill was one of the earliest steam-powered woolen mills in the United States, as well as one of the most prominent of the era. Built in 1814 by the partnership of Bezaleel Wells and Samuel Patterson of Steubenville, and James Ross and Henry Baldwin of Pittsburgh, the mill was a three-story brick structure, 110 by 28 feet, surmounted by a spire displaying a golden ball and fleece. It was situated on the north side of Market Street, west of Seventh, at the western end of Steubenville (see left foreground of preceding drawing).

Latrobe designed the steam engine for this mill and supervised its installation. He depicted this scene during one of his last trips to the mill when the installation of the engine was nearly completed. Although the engine had some initial operating problems, by 1816 it was working well, and Latrobe heard at that time from several quarters that it was "the best in the Western Country." (BHL to Jonathan Criddle, 26 May 1816, BHL Letterbooks)

In 1820 the mill contained "5 carding machines, 1 picker, 572 spindles, 8 shearing machines, working 16 pairs of hand shears by steam power; 3 shearing machines with spiral blades; 4 fulling stocks, 12 broad looms, 6 narrow looms, 1 bobbin winder, 2 warping mills, 2 machines for nap raising." (*American State Papers. Finance,* 4:198) The mill was well known in the 1820s for its production of quality cloth, especially broadcloth. *Niles' Weekly Register,* a newspaper of national circulation, referred to the mill as "the celebrated establishment of Messrs. B. Wells and company, [which sends] to the Atlantic states many thousand dollars' worth of superior superfine cloths every year and a large amount of other woolen goods." (*Niles' Weekly Register* [Baltimore], 28 [1825]: 82n) The mill operated under several different owners until 1867, when it was destroyed by fire.

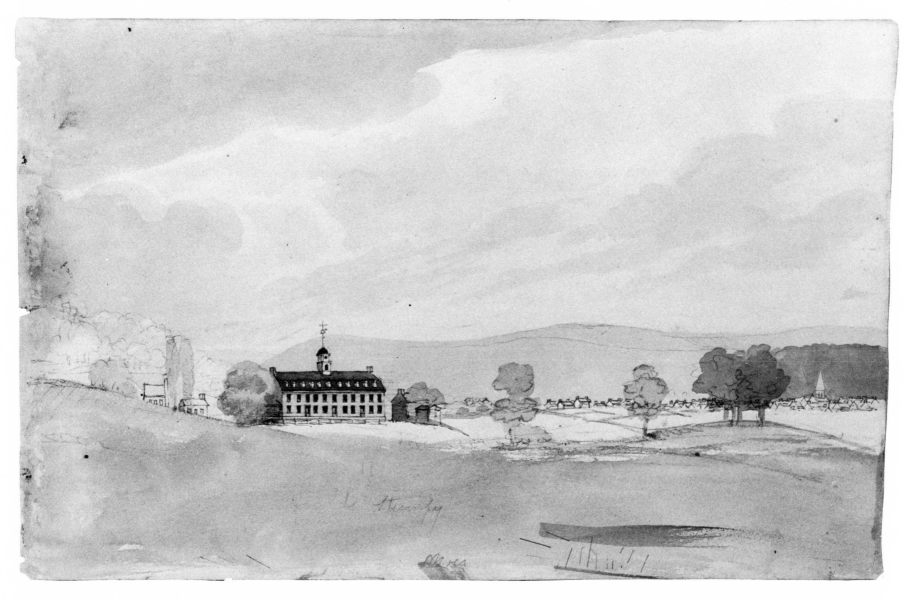

NO. 130

131. View on the Ohio River

Undated [March 1815]
Pencil, watercolor
20.3 cm. × 32.2 cm. (8 in. × 12-11/16 in.)
SKETCHBOOK XI

Map reference: Steubenville East Quadrangle, West Virginia–Pennsylvania–Ohio
UTM coordinates: Viewing position: approximately 17.053260.446642; Highland Hills:
 17.053340.446668
Orientation: 155°

No river in the world rolls, for the same distance, such a uniform, smooth, and placid current. Its banks are generally high and precipitous, rising into bluffs and cliffs, sometimes to the height of three hundred feet. . . . These bluffs exhibit a wild and picturesque grandeur, which those who have never viewed nature in her primitive and unspoiled state, can hardly imagine. Dense and interminable forests—trees of the most gigantic size, casting their broad shadows into the placid stream—the luxuriant and mammoth growth of the timber in the bottoms—the meanderings, and frequent bends of the river, and the numberless beautiful wooded islands, all of which, in rapid succession, shift and vary the scene to the eye, as you float down the endless maze before you, are calculated to fix upon the mind an indelible impression. . . .

In the infancy of the country, every species of water craft was employed in navigating this river. . . . The barge, the keel boat, the Kentucky flat, or family boat, the pirogue, ferry boats, gondolas, skiffs, dug-outs, and many others, formerly floated in great numbers, down the current of the Ohio and Mississippi, to their points of destination, at distances, sometimes of three thousand miles. (Cummings, *The Western Pilot*, pp. 6–7)

The placement of this drawing among the other Steubenville scenes in Latrobe's sketchbook, and the similarity of this unidentified view with Latrobe's depiction of the Ohio River below Steubenville (see the right middle ground of No. 130), both suggest that Latrobe recorded this scene along the Ohio River from the western shore just south of Steubenville, looking downriver. The east bank of the river, on the left side of the picture, would be part of the panhandle of what was then Virginia and is today West Virginia. The area on the east bank that Latrobe marked "very high Cliffs" would probably be the present-day Highland Hills in Brooke County, West Virginia. Much of the scenery along the Ohio just south of Steubenville has, over time, been either altered or obscured by the construction of steel mills and associated facilities and filling in the area.

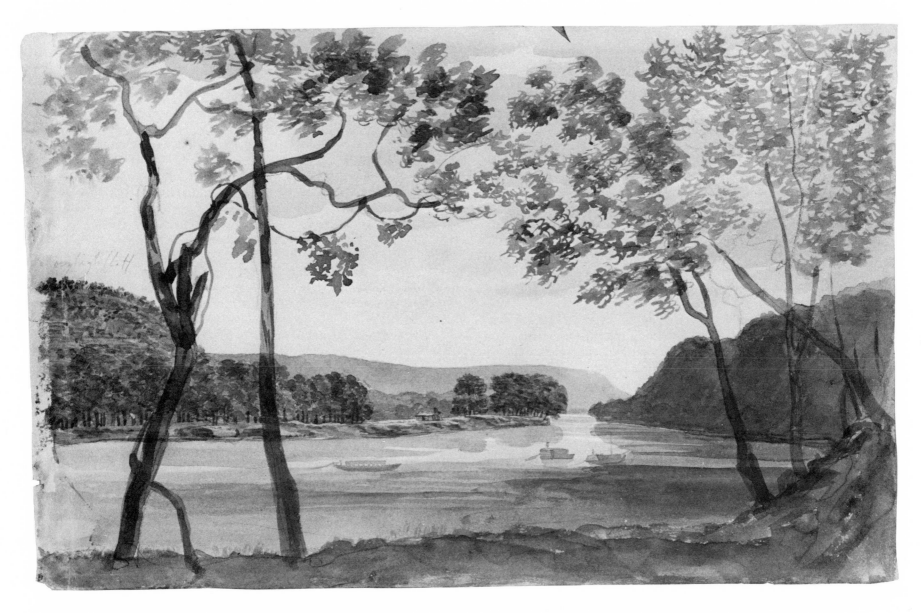

NO. 131

132. Suspension Bridge in Fayette County, Pennsylvania

Undated [April 1815]
Pencil, wash
21.3 cm. × 16.0 cm. (8-3/8 in. × 6-3/8 in.) on a page measuring 21.3
 cm. × 48.8 cm. (8-3/8 in. × 19-3/16 in.)
SKETCHBOOK XII

This is certainly one of the two suspension bridges erected near Brownsville, Fayette County, by James Finley (1756–1828). Latrobe would have passed through the area on his way to Washington in April 1815. Finley's own description of the Brownsville bridges states that one had a 120-foot span and was 18 feet wide, and the other had a 112-foot span and was 15 feet wide. Both utilized chains made of 1-1/4-inch square rods. The first bridge, constructed in 1809, connected Brownsville with Bridgeport over Dunlap's Creek. It collapsed in 1820 under the combined weight of deep snow and a team of horses with a heavily laden wagon. The second bridge was constructed near Brownsville between 1807 and 1810.

Suspension bridges such as Finley's were of limited use at the time. They were inexpensive to build because there was little superstructure and no central piers to erect in the water. However, the weight of crossing traffic had to be limited, they were subject to oscillations, and there were no effective tests for making certain of the strength of the chains. Finley described his patented chain bridge as follows:

The bridge is solely supported by two iron chains, one on each side, the ends being well secured in the ground, and the chains raised over piers of a sufficient height erected on the abutments at each side, extended so slack as to describe a curve, so that the two middle joists of the lower tier may rest on the chains. The other joists of the same tier, are attached to the chains by iron pendants of different lengths so as to form a level of the whole. In order that the chain may support as much weight as it could bear, when hung with the weight attached to the end of it, the piers must be so high as to give the chain a sinking or curve of the one full seventh of the span. The ends of the chains must descend from the tops of the piers with the same inclination that they take inwards, until each end reaches the bottom of a digging, large enough to contain stones and other materials sufficient to counterbalance the weight of the bridge and what may chance to be thereon. The chains, if only one to a side, must be made with four branches at each end, to be let down through as many stones, and to be bolted below. These stones are laid flat on the bottom of the digging: other flat stones may be placed thereon, to bind and connect the whole, that they may have the same effect as a platform of one piece; four or more joists will be necessary for the upper tier—to extend from end to end of the bridge—each will consist of more than one piece; the pieces had best pass each other side by side, so that the ends may rest on different joists on the lower tier. The splice will then extend from one joist to another of the lower tier, and must be bolted together by one bolt at each end of the splice. The plank flooring is laid on this tier. It will be probably found most convenient that the chains be made with links as long as the space between the joists: every other suspender must attach to a link of the chain edge upwards, perhaps this may best be done by a clevis to go through the upper link of the suspender, and embrace the link of the chain and receive a key above—the other suspenders will come up through the flat links of the chain and receive a key above—the lower end of the lower link of the suspender may be made so wide as to receive the end of the lower tier of joists. (Finley, "A Description of the Patent Chain Bridge")

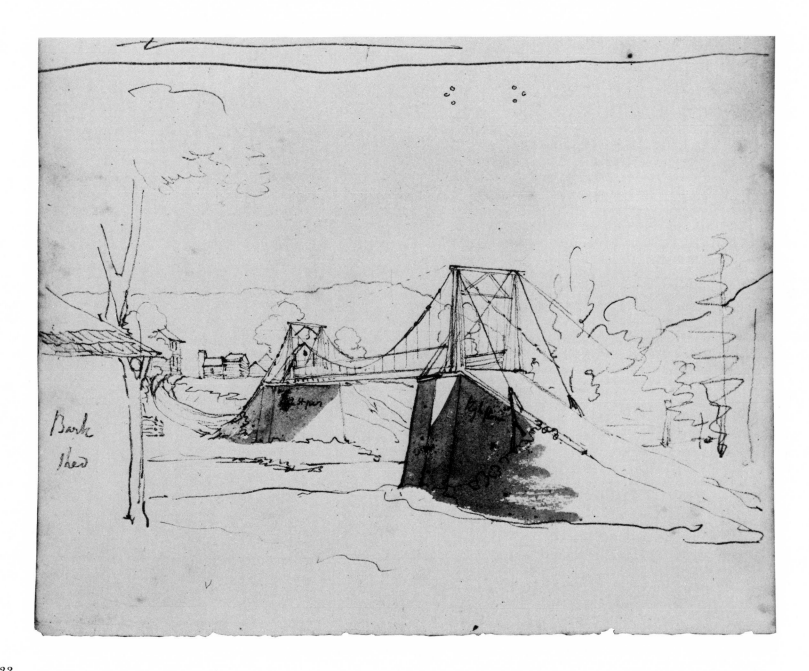

Bark
Shed

133. "View Eastward from the Gap of the Alleghenny on the Somerset road"

Undated [April 1815]
Pencil
20.3 cm. × 34.5 cm. (8 in. × 13-9/16 in.)
SKETCHBOOK V

Map references: Buffalo Mills Quadrangle, Pennsylvania; Fairhope Quadrangle, Pennsylvania; Hyndman Quadrangle, Pennsylvania; New Baltimore Quadrangle, Pennsylvania
UTM coordinates: 17.068312.442225
Orientation: 135°

On his journey to Washington, D.C., Latrobe traveled east from Pittsburgh across western Pennsylvania. At the beginning of April 1815, he passed through the gap in the Allegheny Mountains (now known as Deeters Gap) near the boundary between Somerset and Bedford counties, stopping on the mountain ridge at the White Horse Inn. A popular stagecoach stop, the White Horse, Latrobe wrote, was "a very capital Tavern built of white stone. . . . But its front is placed up against the Mountain, and its back towards one of the most astonishing prospects I have ever seen, and what is as *stupid,* as it is in other respects tasteless, great expense as well as *inconvenience* has been encountered to destroy every advantage of this magnificent position."

In this sketch, Latrobe has depicted the folly of the White Horse Inn's position in the left foreground and an unidentified frame structure along the road in the right foreground. As for the scenery further eastward beyond the gap, Latrobe made no attempt to portray it in his sketch, though he outlined a suggestion of the mountainous terrain in the background. Instead of images, he resorted to words to convey his impression of the spectacular landscape before him:

From the tavern a *World* of forests lies in view, reaching far beyond Bedford. Little squares indicate the farms lost in the immensity of Woods. There is no describing it, nor drawing it. It is altogether a different Mountain prospect from any I have seen. The sudden and bold breaks, and perpendicular naked craggs of the Mountain scenery of Europe have so totally a different character, that there is no mean of comparison between the two. We must travel this road, if it were only for the sake of this single prospect. (BHL to MEL, 10 April 1815, MGLC, PBHL)

In his letter to his wife, Latrobe drew a rough sketch of the topography of the area and of the road he was following (see below).

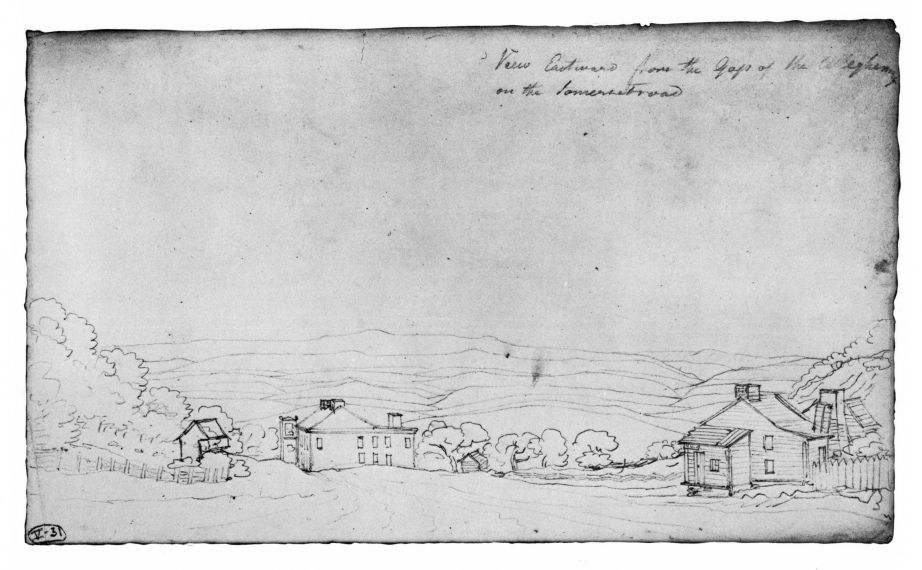

View Eastward from the Gap of the Allegheny
on the Somerset road

Ⅴ·31

NO. 133

134. "Hartley's Juniata"

10 April 1815
Pencil
20.3 cm. × 34.5 cm. (8 in. × 13-9/16 in.)
SKETCHBOOK V

Map reference: Everett West Quadrangle, Pennsylvania
UTM coordinates: Viewing position: 17.072184.443276; Hartley's Tavern:
 17.072195.443274; Warrior Mountain: 17.072215.443204
Orientation: 140°

Another of Latrobe's stops on this eastward trip was at Hartley's Tavern, situated about four and a half miles east of the borough of Bedford at Mount Dallas, just above the confluence of Snake Spring Valley Run and the Raystown Branch of the Juniata River. The sketch shows the stone tavern in the left foreground, with the Juniata River to the right, winding its way eastward toward a gap in the Tussey Mountain, of which Mount Dallas (not pictured) forms the north side, and Warrior Mountain (pictured) forms the south side.

The tavern was built by an Englishman, William Hartley (d. 1798), in the early 1790s. In 1794, George Washington stopped at Hartley's on his return from Bedford, where he had reviewed U.S. troops prior to their confrontation with the Whiskey Rebels of western Pennsylvania. Following Hartley's death, his widow and her new husband, Capt. William Graham of Bedford, ran the tavern. At the time of Latrobe's visit, William Hartley's son, William, whom Latrobe described as a "fat good tempered fellow," was managing the tavern.

Latrobe wrote Mary Elizabeth that Hartley's was a "most excellent house." (BHL to MEL, 12 April 1815, in BHL, *Correspondence*, 3) An earlier traveler described the tavern as a "neat and commodious dwelling . . . principally built with lime-stone, laid in mortar. The rooms and chambers are snug, and handsomely furnished; and the accommodations and entertainment he provides are the best to be met with between Philadelphia and Pittsburgh. A fine lawn spreads before the house, bordered on one part by a meandering brook [Snake Spring Run], and on the other by the Juniata river." (Harris, *Journal of a Tour*, pp. 18–19) Hartley's Tavern, now known as Mount Dallas Farm, still stands as a private residence on the north side of U.S. Route 30 in the Snake Spring Scenic Area.

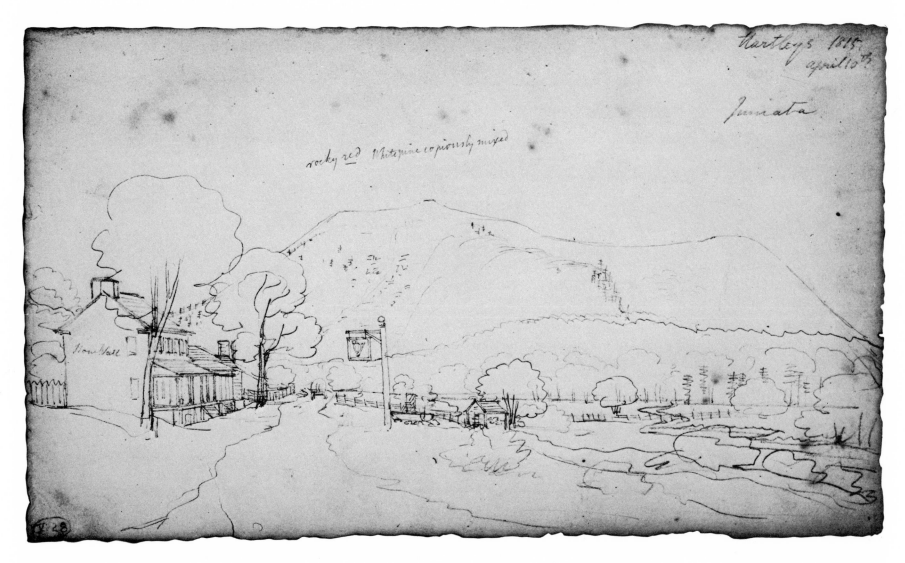

NO. 134

135. "View of Bloody run village and the Gap thro' which the Juniata flows . . ."

11 April 1815
Pencil, watercolor
17.3 cm. × 33.0 cm. (6-13/16 in. × 13 in.)
SKETCHBOOK XIII

Map references: Everett East Quadrangle, Pennsylvania; Everett West Quadrangle,
 Pennsylvania
UTM coordinates: Viewing position: approximately 17.072520.443220; Warrior
 Mountain: 17.072215.443204; Mt. Dallas: 17.072270.443218
Orientation: Approximately 270°

View of the Village of Bloody run, and of the Passage of the river Juniata through the Warrior Mountain, drawn from Nature April 11th. 1815, (immediately after the peace, when a number of Volunteers, were returning home): from the old road about one Mile east of the Village. (Inscription on No. 136)

Latrobe rode only a few miles east from Hartley's (see No. 134) along the Juniata and through the gap in Tussey Mountain before he stopped to look back and make the sketchbook drawing of "the beautiful Gap" and some of the "romantic scenery" east of it. (BHL to MEL, 12 April 1815, in BHL, *Correspondence,* 3) With pencil he laid out the scene. Right of center he drew Bloody Run, now known as Everett, Pennsylvania, a small village situated on the northern bank of the Raystown Branch of the Juniata River, eight miles east of the borough of Bedford. In the background, he sketched Warrior Mountain and Mount Dallas, both part of Tussey Mountain, rising, respectively, on the south and north sides of the gap. At some later time he blocked in gradations of modeling for his composition, which centers on a pale triangle at Warrior Mountain.

On some occasion more leisurely than his journey to Washington, Latrobe worked up the larger, finished landscape from his sketch. Despite the portion of its inscription that reads "drawn from Nature," the finished drawing differs in almost every detail from the sketch made from nature (see pp. 26–27). Fitness to the scene habitually guided Latrobe's choice of figures to animate a view. He indicated the importance of this area as a route to the west with his depiction of the Conestoga and the veteran infantrymen of the War of 1812.

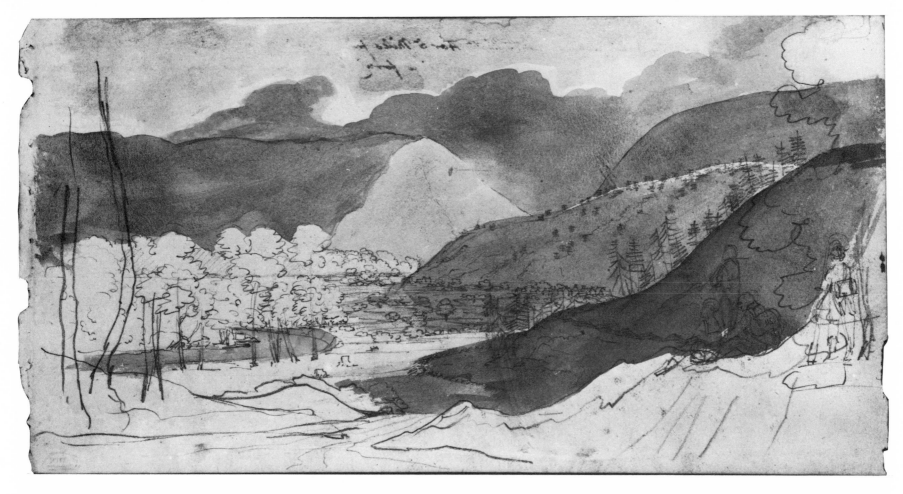

NO. 135

136. "View of the Village of Bloody run . . ."

[After] 11 April 1815
Pencil, pen and ink, watercolor
36.5 cm. × 49.5 cm. (14-3/8 in. × 19-1/2 in.)
B Henry Bonl. Latrobe.
Ferdinand C. Latrobe III

(See commentary for No. 135)

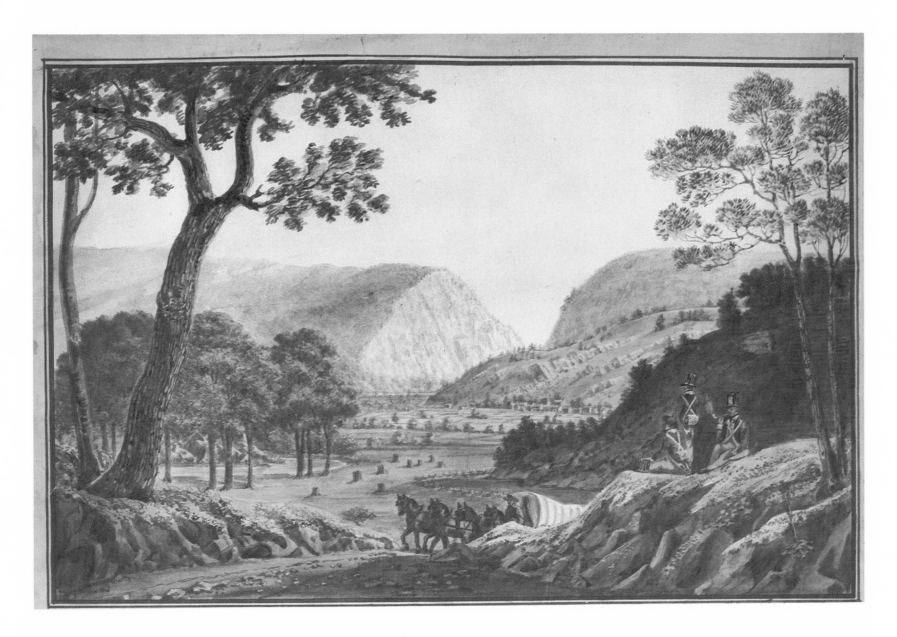

NO. 136

137. "View towards the Northwest . . . 4 or 5 Miles East of Bloody run . . ."

[After] 11 April 1815
Pencil, pen and ink, watercolor
33.0 cm. × 47.0 cm. (13 in. × 18-1/2 in.)
April 11th 1815. by B Henry Bl. Latrobe.
Mr. & Mrs. Clayton F. Ruebensaal

Map references: Breezewood Quadrangle, Pennsylvania; Clearville Quadrangle, Pennsylvania; Everett East Quadrangle, Pennsylvania; Everett West Quadrangle, Pennsylvania; Mench Quadrangle, Pennsylvania; Wells Tannery Quadrangle, Pennsylvania
UTM coordinates: Viewing position: approximately 17.073756.443152; Warrior Mountain: 17.072215.443204; Evitts Mountain: 17.071550.443260; Bend of Juniata: 17.073220.443116
Orientation: Approximately 270°

View towards the Northwest, on the old road, 4 or 5 Miles East of Bloody run. The river Juniata winds between the Warrior Mountain, and the wooded Mountain, both on the left hand, passes in front of the nearest Hill in the Gap, to the right, returns behind it to the left, and then returns to the right behind the second Mountain. In the distance are seen Evatts [Evitts] mountain, and more distant ridges towards the Alleghenny. Drawn from nature. (Watercolor inscription)

Latrobe began a drawing of this subject on 11 April 1815 in Sketchbook XIII, and he subsequently worked up the present landscape. He drew the scene from a position east of the village of Ray's Hill (now Breezewood, Bedford County), looking west across the bend of the Raystown Branch of the Juniata River to Warrior Mountain and, in the distance, Evitts Mountain. The landscape today remains much as it was when Latrobe viewed it. The only major intrusion into this pastoral setting is the Pennsylvania Turnpike.

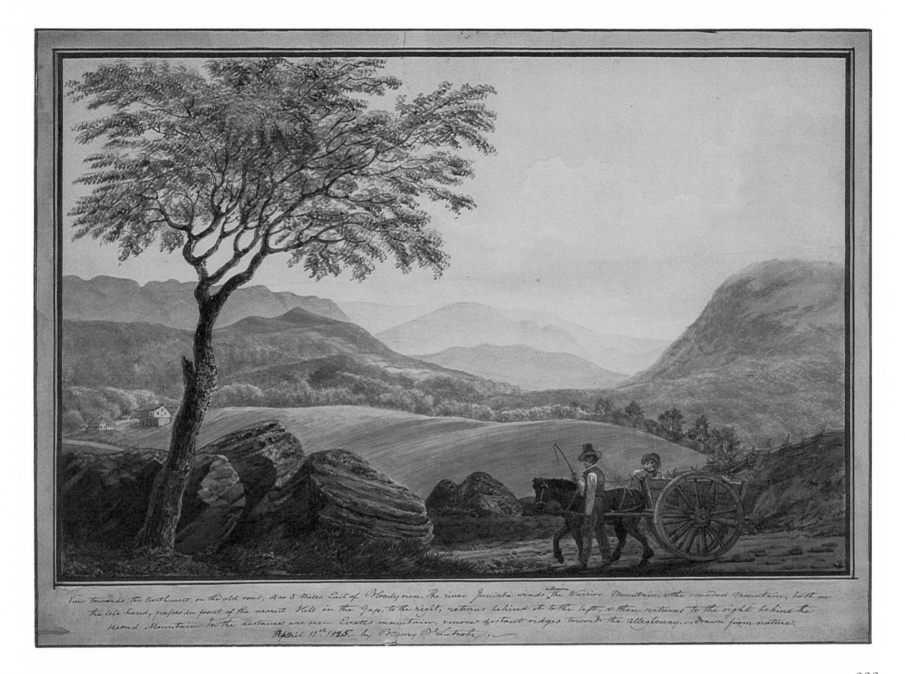

View towards the Northwest, on the old road, 4 or 5 Miles East of Bloody run. The river Juniata winds between the Warrior Mountain, & the wooded Mountain, both on the left hand, passes in front of the nearest Hill in the Gap, to the right, returns behind it to the left, & then returns to the right behind the second Mountain. In the distance are seen Evatts mountain, & more distant ridges toward the Allegheny. Drawn from nature. April 11th 1815. by Henry B Latrobe.

138. "Leesburg Courthouse"

10 May 1815
Pencil, pen and ink, wash
17.3 cm. × 33.0 cm. (6-13/16 in. × 13 in.)
SKETCHBOOK XIII

Map reference: Leesburg Quadrangle, Virginia–Maryland
UTM coordinates: Viewing position: 18.027827.433234; Courthouse:
18.027835.433236
Orientation: 90°

After he received his appointment to rebuild the Capitol in April 1815, Latrobe returned to Pittsburgh in May in order to bring his family to Washington. He traveled by way of Loudoun County, Virginia, for the purpose of inspecting the local deposits of white marble, for potential use at the Capitol, and he paused to sketch the Loudoun County courthouse in Leesburg. A courthouse was completed in 1761 on the site that he showed, looking east from the vicinity of the present-day King and Market streets. But the building that he sketched, in effect a temple with a cupola, must represent a remodeling or a replacement of the 1761 structure, because the design, in taking the temple form, imitates Jefferson's Richmond statehouse (1786ff., see Nos. 13, 28, 37, 49), the first full-fledged imitation of a classical temple in American civic architecture. It is not impossible that Latrobe's own Bank of Pennsylvania in Philadelphia (1799–1801; see Fig. 14, p. 33), an instantly famous rendition of the temple theme, had some influence upon the design of the courthouse, too. What interested Latrobe enough to draw the edifice was—from his point of view—the ignorant mutilation of an architectural theme that he had himself used. He made this hasty perspective, jotted notes—particularly about the barbaric version of the Tuscan order—on the drawing, and, in a sketch on the facing page of his sketchbook, contrasted the order with a proper version of the Tuscan (at right).

A courthouse, built in 1894, today stands on the site of the structure Latrobe sketched. Four column bases sit on the front lawn of the existing courthouse, presumably the remains of the columns of the building that captured Latrobe's attention.

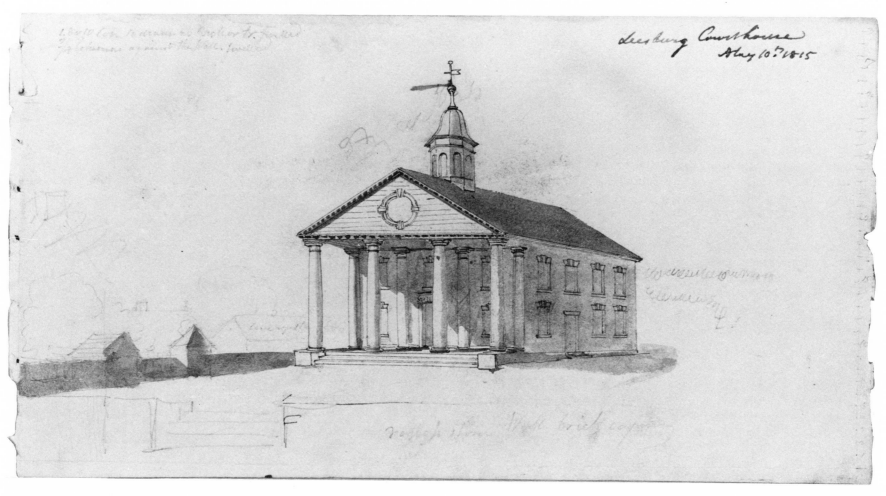

Leesburg Courthouse
May 10th 1815

NO. 138

335

139. "Breccia Marble Rock opposite Clapham Island"

14 March 1816
Pencil
17.3 cm. × 33.0 cm. (6-13/16 in. × 13 in.)
SKETCHBOOK XIII

Map reference: Poolesville Quadrangle, Maryland–Virginia
UTM coordinates: Viewing position: 18.028480.443974; Quarry site:
 18.028486.443938
Orientation: 170°

The public buildings had hitherto been constructed with the free stone found in the neighbourhood of Aquia Creek [Virginia]. The same quarries were resorted to, for their re-establishment, but it has singularly happened, that neither in the old quarries, nor in the new ones which have been opened, stone, of a texture fit for the finer works of the buildings, has as yet been discovered. Although formerly no difficulty was found in procuring stone of every quality required, for the columns of the House of Representatives, and Senate chamber particularly, no fine stone could be got. This gave an opportunity of recommending a trial of the new marble. (BHL to Joseph Gales and William Seaton, 18 January 1817, in BHL, *Correspondence*, 3)

There is on the S. East of the Cotocktin Mountain a very large extent of country, which abounds in immense Rocks of Marble, or Limestone *Breccia,* that is of a Stone consisting of fragments of ancient Rocks bound together by a calcareous cement, and thus becoming one solid and uniform (homogeneous) Mass of Marble. . . .

The largest Mass of this Kind of Rock is situated on the Maryland side of the Patowmac on land the property of Samuel Clapham Esqr. It overhangs the River, and would furnish without any land carriage *all the Columns of the Capitol of one block each* if required, and of beauty not exceeded in any modern or ancient building. It is impossible for me at this moment to say more, than that it is *practicable* to obtain all our Columns there, but at what price of material or Labor, must be determined by further investigation. . . .

The same Stone is found on both sides of the Potowmac plentifully, for 12 to 14 Miles above Mr. Clapham's, and on the virginia side for 2 or 3 miles below. (BHL to the U.S. Commissioners of the Public Buildings, 8 August 1815, in BHL, *Correspondence*, 3)

Samuel Clapham lived at Chestnut Hill along the Potomac River by the Catoctin Mountain in Loudoun County, Virginia. He owned property on both sides of the Potomac River, in Loudoun County as well as in Montgomery County, Maryland. In this drawing, Latrobe was looking south from Clapham Island, today known as Lower Mason Island, to the marble deposit on the Montgomery County shore, about one mile northwest of Martinsburg, Maryland.

Around June 1816, the federal government contracted with John Hartnet to quarry Clapham's breccia, principally for the shafts of twenty-two Corinthian columns, each 26-2/3 feet tall, for the Hall of Representatives. The so-called quarry was not a true quarry-hole but rather a ledge outcrop. The stone proved immensely difficult to work. Within a year Hartnet had exhausted his finances, the government had taken over the quarrying, and Latrobe had had to settle for the idea of piecing at least some of the column shafts from multiple blocks of stone. The difficulties posed by the breccia delayed the completion of the Hall of Representatives until 1819, some two years after Latrobe's resignation as architect of the Capitol. In December of that year, U.S. Commissioner of Public Buildings Samuel Lane informed the House of Representatives that the column shafts had cost not the $1,500 apiece estimated by Latrobe but in fact approximately $5,000 apiece. But Latrobe's vision of a magnificent Neoclassical hall formed with a towering, richly colored colonnade had been realized.

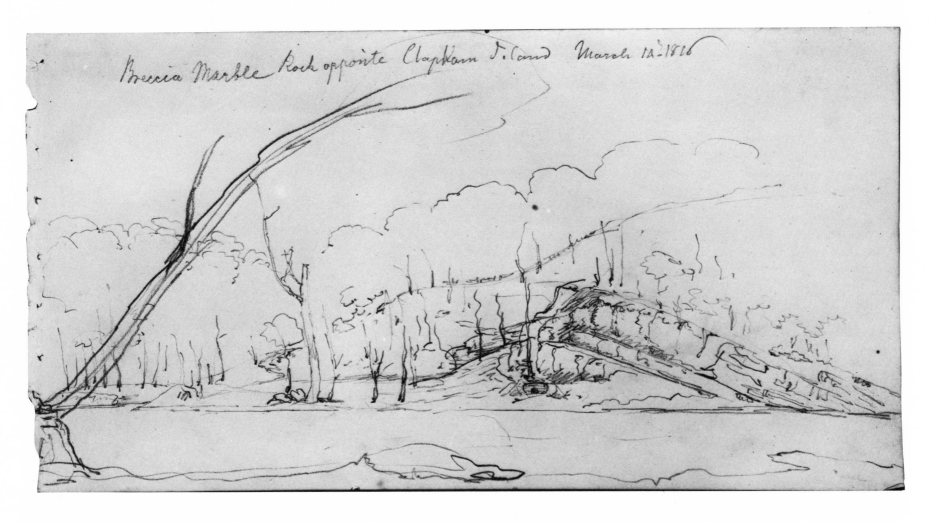

Breccia Marble Rock opposite Clapham Island March 12. 1816

NO. 139

140. "Collier and [family] on the Sugarloaf Mountain"

3 November 1816
Pencil, watercolor
17.3 cm. × 33.0 cm. (6-13/16 in. × 13 in.)
SKETCHBOOK XIII

Map reference: Buckeystown Quadrangle, Maryland–Virginia
UTM coordinates: Sugar Loaf Mountain: 18.029345.434837
Orientation: Cannot be determined from drawing

In this drawing Latrobe depicts a charcoal collier, his hut, and what appear to be his wife and child on Sugar Loaf Mountain in Frederick County, Maryland. Cone-shaped colliers' huts were formed by slanting timbers and were usually covered with leaves and soil. However in this view the hut seems to be covered with either sheets of bark or squares of sod. Huts such as this were temporary habitations located within a few yards of a collier's pit, where cordwood was burned to produce charcoal.

Covered with soil and leaves, the pit burned for ten to fourteen days and required the collier's constant attention; hence the proximity of the hut. The collier, at the center of the drawing, is holding a rake with which leaves were gathered from the forest floor. The leaves were then carried to the charcoal pit in baskets such as the one on the head of the woman at the left. The charcoaling season usually lasted from May to October or November.

The production of charcoal was responsible for the initial clearance of large tracts of both agricultural and mountain land in Maryland and Pennsylvania in the late eighteenth and early nineteenth centuries. Sugar Loaf Mountain was apparently extensively exploited during this period for the production of charcoal. In the early 1830s, when Sugar Loaf came into the possession of the Bank of the United States, many of the woodlots into which the mountain area was divided were sold to colliers, whose level, circular niches dot the mountain slopes. (For a distant view of Sugar Loaf, see No. 113.)

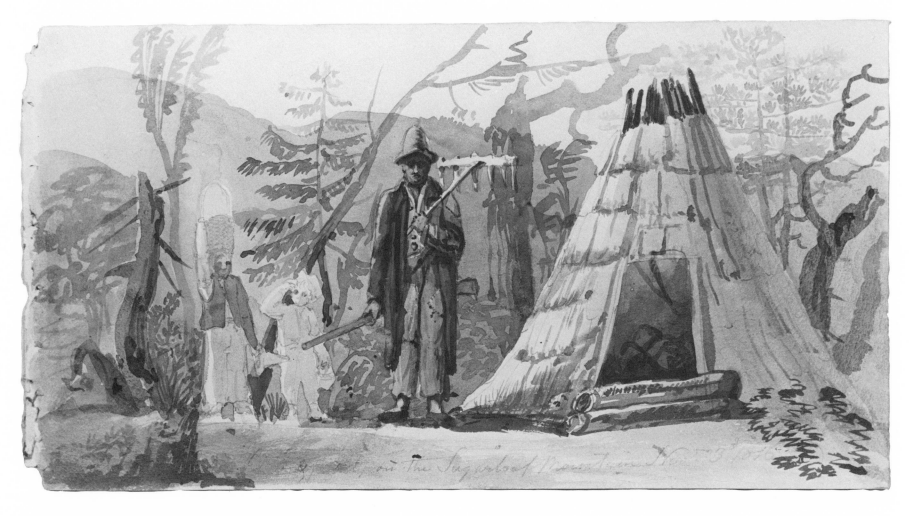

NO. 140

141. "St. John's Church, in the city of Washington . . ."

[Inscription in an unidentified hand]
1816
Pencil, pen and ink, watercolor
12.8 cm. × 22.2 cm. (5-1/16 in. × 8-3/4 in.)
B H Latrobe.
St. John's Church, Washington, D.C.

Map reference: Washington West Quadrangle, District of Columbia–Maryland–
 Virginia
UTM coordinates: Viewing position: 18.032329.430747; Church: 18.032334.430738
Orientation: 175°

Latrobe made this drawing to record the general appearance of one of his works, St. John's Church, along with both the appearance of the President's House, or White House, in the course of its reconstruction after the British fire of 1814 and the appearance of the general setting. Latrobe designed St. John's Episcopal Church over the years 1815 to 1816. At the northeast corner of Sixteenth and H streets, NW, the church became the first building to stand on President's Square (now Lafayette Square), other than the President's House itself and a small farmhouse. Given the restricted funds available for the church, Latrobe designed a modest building, to be built of brick with stucco exterior and to be covered by brick arches combined with a counterfeit dome and vaults of timber and plaster. As was his practice in commissions for religious or educational organizations, he donated his services. The church was completed by the fall of 1816 at an estimated cost of $25,000 for the land, building, and furnishings. The Rev. William Holland Wilmer conducted the first service there on 27 October 1816.

The architect enjoyed cordial relations with the vestry of the church as well as with its minister. He served as organist and choirmaster without charge and composed new verses to the air "Jesus, Savior of my Soul" for the dedicatory hymn (first performed on 27 December 1816). After he declined the vestry's offer of a rent-free pew as a testimonial, they voted to give him an inscribed silver goblet. Around the time of the church's dedication Latrobe wrote to his son Henry: "St. Johns Church . . . is a pretty thing, and has a celebrity beyond all bounds. It has made people religious who were never before at Church." (19 December 1816, in BHL, *Correspondence*, 3)

Latrobe selected a spot slightly to the north and west of Sixteenth and H streets as his vantage point for this drawing. He did not make an entirely reliable representation of his church. Thus, he omitted ornaments over the rectangular windows and small chimneys at the corners of the pyramidal roof. A plausible explanation would be that he saw no reason to fill in the smaller details of a church that he had just designed when he made his original pencil drawing, and that, when he came to make a finished picture later on, he did not think to add those details.

Right of the church, in the middle ground, stands the White House, across the present-day Lafayette Square. Latrobe showed it at a point when James Hoban, its original designer in 1792, had just begun the demolition of the damaged wall areas. Left of the church, Latrobe gave a glimpse of the Treasury building, begun as one of a pair of executive buildings in 1798 to the design of George Hadfield (Latrobe's predecessor at the Capitol and later his friend) and restored after the British damage by James Hoban.

In front of the White House, a horse-drawn carriage travels along the elliptical road designed by Latrobe in 1807 linking the Treasury building with the War Department building (not pictured). Behind the White House stretches the Potomac surrounded by scenery that was much admired in the period. This distant landscape includes a last public work, the mile-long Washington Bridge, completed in 1809. Burned at both its north and south ends by British and American forces during the war, the bridge was restored to normal business in 1816. Today the bridge site is occupied by the Fourteenth Street Bridge, also known as the Mason Memorial Bridge.

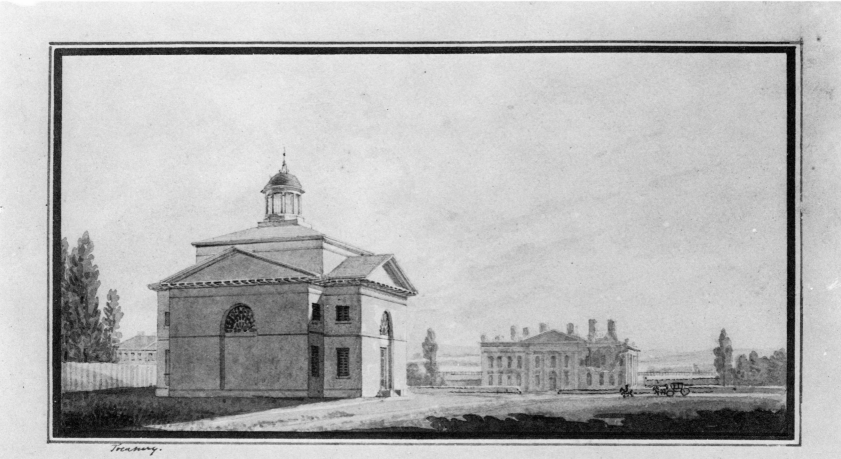

Treasury.

St John's Church, in the city of Washington, with the Presidents house
as it appeared in 1816, when the Church was built.

J.H.B.Latrobe

NO. 141

IX. Two Journeys from Baltimore to New Orleans; New Orleans Area Scenes, 1818–1820

142. "Appearance of the Sky, after Sunset . . . previously to the Gale of Decr. 23d–24th 1818"

[December] 1818
Pencil, watercolor
22.9 cm. × 29.1 cm. (9 in. × 11-7/16 in.)
B H Latrobe 1818.
SKETCHBOOK XIV

Latrobe traveled from Baltimore to New Orleans on the *Clio,* Capt. Wynne, from 17 December 1818 to 11 January 1819. He went there to superintend the construction of the New Orleans Waterworks, which he had designed, after his son Henry, who had gone to New Orleans earlier to secure the franchise and superintend the waterworks, died of yellow fever on 3 September 1817. Latrobe returned to Baltimore later in the year on the *Emma,* Capt. Bartlett Shepard, arrived in Philadelphia on 13 October, and then proceeded to Baltimore, arriving on 14 October.

The *Clio* was probably off the Carolina coast when Latrobe made the following observations in his journal:

> *Monday, 21st.* A fine NW breeze all night. At sunrise the water was still green, but large smooth patches to the SE indicated the Eddy of the Gulphstream. At 7 passed in a few minutes from Soundings into blue water. A heavy swell, which made the Brig roll intolerably and prevents my writing with convenience. At 12 fell in with the first Gulphweed, an exquisitely fine day. Lat. 35°17′. The Wind from NW to NNE very light. Two schooners in sight bound Northward.
>
> Tuesday 22. About 2 o'clock A.M. A perfect calm. The wind then shifted to SW. Remarkably smooth sea without swell. At 8 a very large Shoal of porpoises played for an hour about the ship, and left her steering their course to the S West. Little or no Gulph Weed this morning. Cloudy. At 12 o'clock Lat. 34°30 having steered chiefly SE and SE by S since morning. Wind encreasing from the SW. In the evening a Gale. (BHL, *Journals,* 3:147–48)

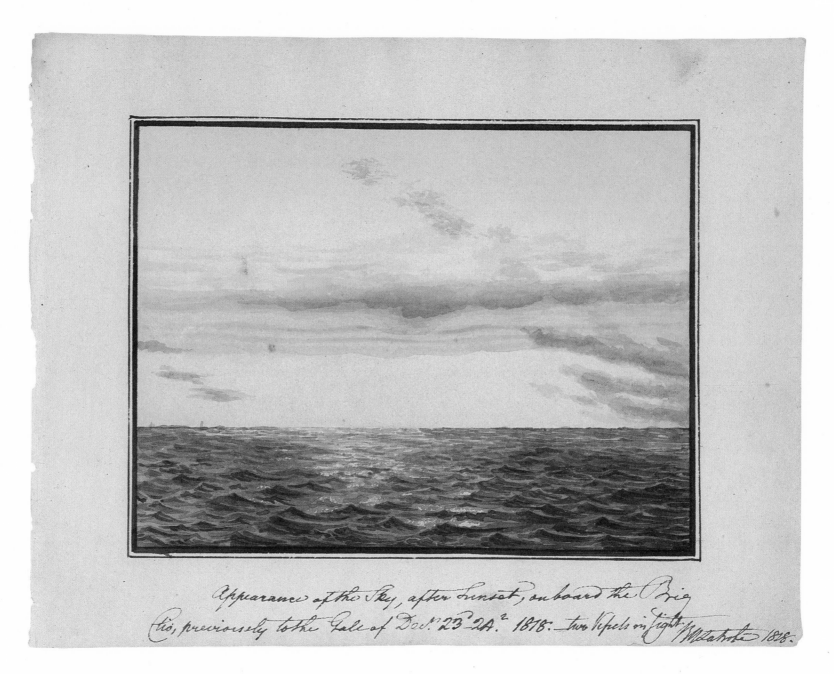

Appearance of the Sky, after Sunset, on board the Brig
Clio, previously to the Gale of Dec.r 23 - 2A.m 1818. two Vessels in Sight. B H Latrobe 1818.

143. "Character of the Sky and Sea during the Gale of the 23d and 24 Decr. 1818"

[December] 1818
Pencil, pen and ink, watercolor
22.9 cm. × 29.1 cm. (9 in. × 11-7/16 in.)
B H Latrobe 1818.
SKETCHBOOK XIV

Wednesday 23d. a heavy gale, reefed our Sails, and all our passengers more or less sick. Wednesday night, lat. 34° about, between Cape Hatteras and Bermuda, East of the Gulph stream which we had crossed the day before, a tremendous storm from the West to N. West obliged us to hand all our Sails except the Main Staysail and close reefed trysail under which we lay to all night. In the morning the wind was North, a furious Gale and such a Sea, as the Captain even called tremendous. And yet this day was one of the pleasantest I ever spent, as to the pleasure of the eye and mind, and of that sort. For the sea was in a perfect foam; and as we put the Vessel before the Wind under close reef Main topsail and close reefed foresail, and the weather was otherwise fine, I sat under the Tafrail and saw with astonishment how the Brig, more as if alive tha[n] a Mass of dead matter darted thro', and among, and over the waves, without shipping a drop of Water. There is no describing such a scene and such a sight. (BHL to MEL, 26 December 1818, in BHL, *Correspondence*, 3)

Latrobe also described the storm in his journal:

Wednesday 23d. The Gale greatly encreased, and a heavy Sea. The wind hauling more [to] the West enabled us under close reefed topsails to lay nearer our course. Seasick again. Kept my birth. Lat. 34.6. A heavy Storm at night, with thunder and lightning, and exceedingly heavy squalls occasionally; much and heavy rain. Laid the brig to, under Mainstay sail, and close reefed topsail, all night. A tremendous Sea running (for as the Captain had seldom seen a heavier, I may call it so). The brig rode it out, like a duck.

Thursday 24th. The wind during the night had got round to the North NW and N. The sea still as high as ever, and the Wind not abated: but being quite favorable, the brig was put before it, and scudded under close reefed main topsail and close reefed foresail. Got on deck, and sat on the taffrail, from whence the motion of the brig through the most awful sea I ever beheld or imagined, at the rate of 9 or 10 knots, appeared the most wonderful effect of human art, and indeed of human Courage that can be imagined. The Vessel is a most admirable seaboat, and skips over these mountainous waves, without appearing to labor in the least. Lat. 33°6'. (BHL, *Journals*, 3:148–49)

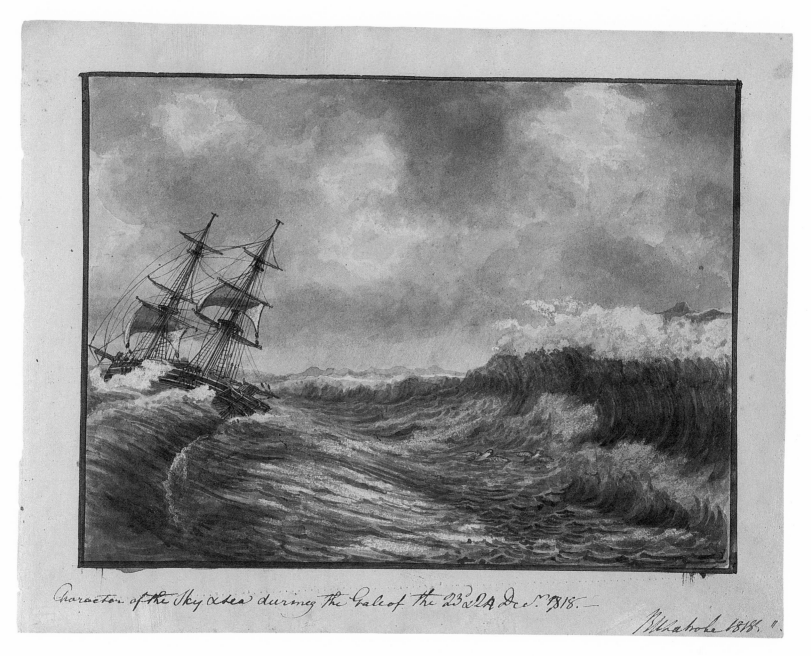

Character of the Sky & sea during the Gale of the 23 & 24 Dec.ʳ 1818. —

BHLatrobe 1818. "

144. Routes of the *Clio* and the *Emma* South of Florida

Undated [30 December 1818–1 January 1819, 27–29 September 1819]
Pencil, pen and ink, watercolor
22.9 cm. × 29.1 cm. (9 in. × 11-7/16 in.)
SKETCHBOOK XIV

Map reference: Not applicable
Geographical coordinates: From 22° 50′ 00″ N to 26° 00′ 00″ N; from 79° 00′ 00″ W to 83° 15′ 00″ W

This map is probably a generalized copy of a larger, more detailed chart, perhaps drawn on a mercator projection. Latrobe constructed the map by first drawing a grid of lines of longitude and latitude (without the angular deformation necessary to accommodate the spherical nature of the earth). Then, using the grid as an outline, he drew in the land mass and island configurations. While basically correct as to relative positions, the map incorporates a series of errors: the shape of the tip of Florida is inaccurate, particularly the southeastern portion; Florida actually extends only as far south as 25°25′00″ N rather than 24°50′00″ as drawn by Latrobe; the Florida Keys actually extend west to only 82°00′00″ W rather than 82°30′00″ W as drawn by Latrobe; and the northern coast of Cuba is angularly deformed, especially between 80° and 81° W longitude. Most minor island groups are depicted in approximately their correct locations. Poor configuration in the case of both Cuba and Florida may be attributed to limited coastal survey of these areas due to Spanish hostility to such activities, and to restricted dissemination of navigation charts by the Spanish for areas adjacent to their colonial possessions.

While the *Clio* sailed past the Florida Keys, Latrobe entered the following passage into his journal:

> Thursday Decr. 31st. At sunrise it rained a little and as usual over the Gulph was squally. The current had set us in the night 58 miles to the ENE, as will be seen by my course upon the Chart, and as soon as it was light, we saw Cayo Largo, on the Coast of Florida 12 miles distant bearing North, and the horizon bounded by the long string of wooded Islands and keys, which skirt the Main land of Florida. Our course was parallel to these Islands under very favorable wind. Lat. 24°35′ at noon.
>
> The long string of Islands, and Sandbanks, and rocks that extend from the South point of Florida Westward in a pretty straight line, have bold blue Water along their Southern edge, and seem with Cuba to form the Mouth of the funnel by which the Water accumulated in the Gulph of Mexico is guided into the straight, between Florida and the Bahama shoals. This stream of warm water is certainly of immense importance to the climate of the Western part of Europe, and gives to it the temperature which renders the same degree of latitude in Europe productive of oranges, lemons, and grapes, while the opposite Coast of America is scarcely habitable on account of its long and cold winters, and fierce and tardy Summers. But the navigation of the Gulph stream is extremely unpleasant. The difference of the temperature of the Water and of the Air, at least at this season, is probably the cause of the perpetual Gusts and Squalls, that torment the voyage, and the frequent opposition of wind and stream, creates a short and chopping Sea, that tosses a Vessel, especially a small one, like a Chip. (BHL, *Journals*, 3:156–57)

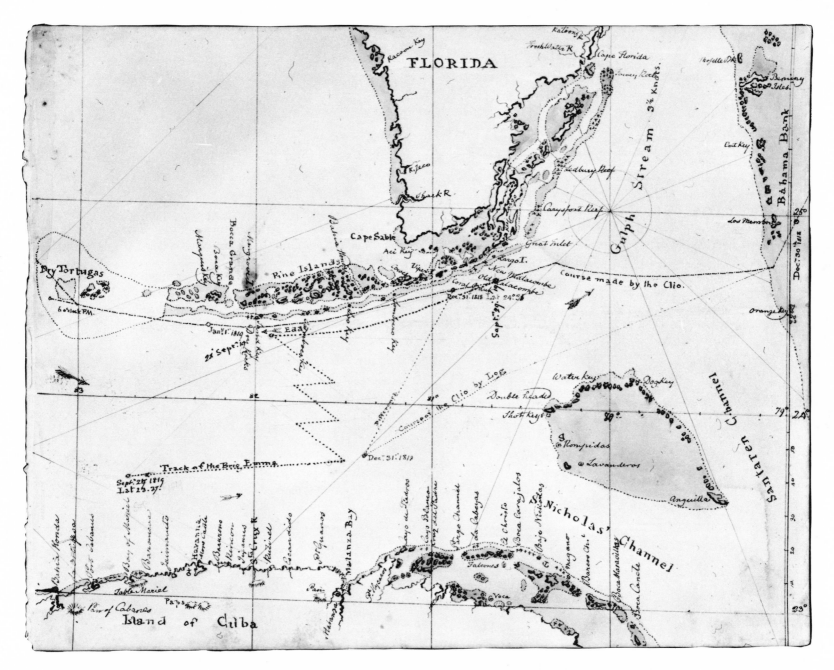

145. "The hole in the Wall . . . Island of Abaco . . ."

28 December 1818
Pencil, watercolor
22.9 cm. × 29.1 cm. (9 in. × 11-7/16 in.)
B H Bonl. Latrobe
SKETCHBOOK XIV

Map reference: Northwest and Northeast Providence Channels, West Indies, Bahamas,
U.S. Defense Mapping Agency, Hydrographic Center, Scale 1:300,000
Geographical coordinates: Viewing position: approximately 25° 46′ 45″ N, 77° 12′ 30″
W; "Hole in the Wall": 25° 51′ 15″ N, 77° 11′ 15″ W
Orientation: Approximately 22.5°

The Island of Abaco has not any thing like mountains but appears to consist of Rolling hills, similar in Character to the English downs, bounded by a perpendicular Shore of Rocks, those nearest to the Water whiter, and those above black and craggy. Few trees appeared on the hills, but towards evening a lower wooded point stretched along to the West. Abaco wants water, as do all these Islands, and is not permanently inhabited. Towards sunset we had entered the straight between Abaco and Eleuthera, called Ethera, and Thera, and I took a sketch of the singular opening through the Rocky point of the Island, called the *Hole in the Wall*. Detached from this point is a bold Rock, opposite exactly to it, from which is a most extraordinary projection of the Same stratum which forms the roof of the Arch of the *Hole,* pointed to a similar projection from the point, which leads to a belief that they are the remains of another Arch formerly connecting the point with the detached rock. It seems as if the stratum forming the roof or Arch of the hole is of a harder material than the stratum beneath, which giving way to the violence of the Sea, leaves the upper Rock suspended. Although there was almost a perfect Calm, the Sea broke with great violence against this Island, rising in foam to the highth, as it appeared from the deck of 50 or 60 feet. There is the appearance of a Castle on the ridge, said to be an old fort. (BHL, *Journals,* 3:153)

The "Hole in the Wall" is an arch created by erosion at the extreme southeast end of Great Abaco Island adjacent to Southwest Point. On the upper land surface immediately beyond the left edge of the view is the modern Abaco Lighthouse. The high level of detail suggests that Latrobe made his observations with a telescope. Map inspection suggests that the rock to the right of the drawing still exists.

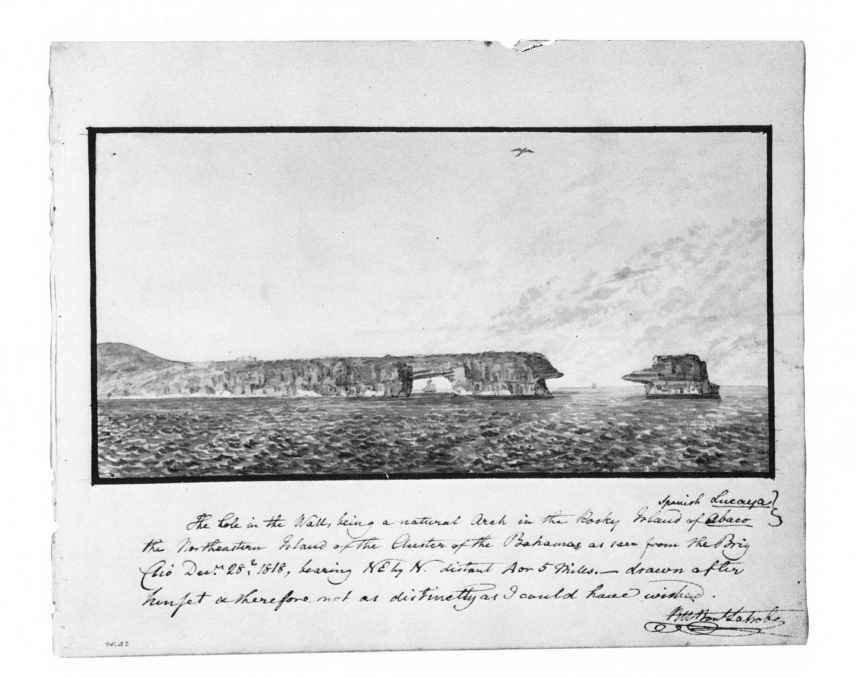

The Hole in the Wall, being a natural Arch in the Rocky Island of Abaco Spanish Lucaya the Northeastern Island of the Cluster of the Bahamas, as seen from the Brig Clio Decr. 28th. 1818, bearing NE by N distant 4 or 5 Miles. — drawn after Sunset & therefore not as distinctly as I could have wished.

BHBLatrobe

146. "Entrance of the Mississippi . . ."

7 January 1819
Pencil, pen and ink, watercolor
22.9 cm. × 29.1 cm. (9 in. × 11-7/16 in.)

SKETCHBOOK XIV

Map reference: Garden Island Pass Quadrangle, Louisiana (Orthophoto)
UTM coordinates: Approximately 16.029950.321850
Orientation: Cannot be determined from drawing

The last 2 or 3 days have been so monoto[no]us and unvaried by any
occurence whatever that a week more such would make us all mel-
ancholy. Towards evening, the appearance of many Vessels on the
horizon and of a change of colour in the Water induced the Captain
to believe himself carried to the West, as well as to the North by a
current, and he changed his course to due West. At dusk we cast
anchor in 9 fathoms of Water. The wind increased and the current
keeping the Ship in the trough of Sea, the Brig rolled much worse
than in the Gale of the 24th of Decr. No pilot obeyed our signal till
12 o'clock when we got under weigh, and after taking a long trip to
the SSE we crossed the bar under press of Sail in a few minutes.
That which is properly the bar, is said to be not more than 100 feet
in width and between the breakers not more than 1/4 of a mile wide.
All round are the embryos of islands, consisting first of single logs
sticking in the mud, then of several which have adhered, being
lodged against each other by the current, and covered more or less
with black mud. Those that are further advanced present banks of
mud to view, and at last reeds begin to show themselves growing
here and there upon the mud banks. After passing the bar, the
water assumes the character of a river, bounded on each side by a
margin of reeds apparently growing in the water, among which low
shrubs, and willows 15 to 20 feet high form higher tufts, a mile from
this mouth of the river lies the Balise. (BHL, *Journals,* 3:159–60)

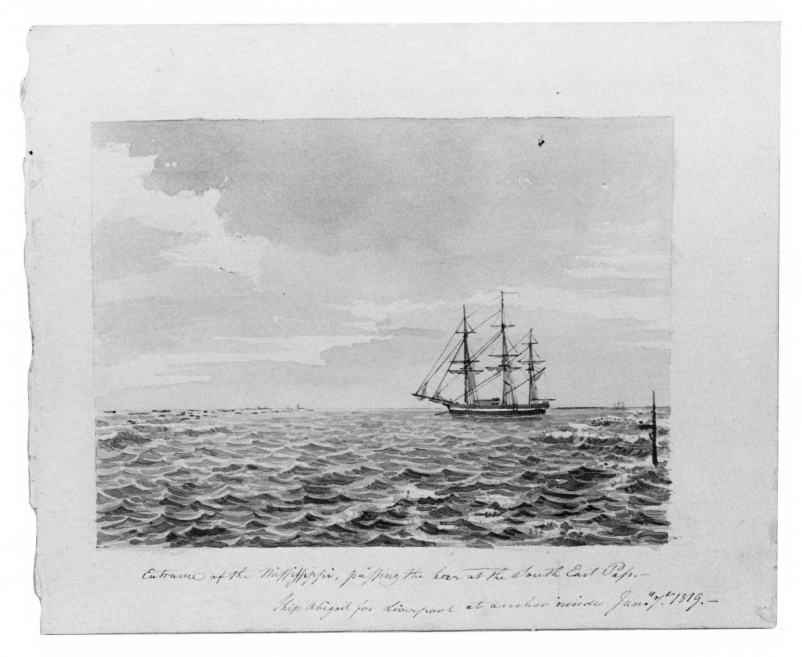

Entrance of the Mississippi, passing the bar at the South East Pass. —

Ship Abigail for Liverpool at anchor inside Jan.ᵈ 7ᵗʰ 1819. —

147. "View of the Balize, at the mouth of the Mississippi"

7 January 1819
Pencil, watercolor
22.9 cm. × 29.1 cm. (9 in. × 11-7/16 in.)
SKETCHBOOK XIV

Map reference: Garden Island Pass Quadrangle, Louisiana (Orthophoto)
UTM coordinates: Approximately 16.029862.322267
Orientation: Cannot be determined from drawing

From 6 to 8 January 1819 the *Clio* lay at the Balize (Spanish for *buoy* or *beacon*), which was a small settlement at the junction of the Southeast and Northeast passes near the mouth of the Mississippi. Latrobe described it as "an assemblage of mean wooden buildings among which rise two framed towers, serving the pilots as look outs or observatories, from which to descry Vessels at Sea."

Three months later, after another visit, Latrobe wrote:

A more wretched village—for it is a sort of a village—cannot be conceived. It consists of a Tavern, a wretched habitation for the revenue officer U.S. and three or four other wooden buildings, belonging to the Pilots besides the Blockhouse. The whole population consists of 90 Men and 11 Women, and an internal feud breaks up this little society into parties who are at war with each other. Lately all the Pilots, whose competition was greatly advantageous to the public, have united, and the consequence is, that working only for their own convenience, and having the monopoly among them of the business, the ships are exceedingly neglected, and both in coming in and going out are most unjustifiably delayed: the Association keeping as few boats as possible and employing *journeyman* pilots, generally English sailors who have deserted their Vessels. These men are of course neither very skilful nor very sober. One of the Pilots keeps a tavern and a billiard room, which, it is supposed, absorbs the principal part of the wages of their underlings. There is, however, some usefull industry here also. Two coasting Vessel were here for repair and several boats were building.

Two days later Latrobe continued his description:

The Village consists as mentioned above of two two story wooden houses habitations of pilots, a miserable one story hovel the floors of which are several inches under Water when the wind blows high, a roomy one story tavern with a billiard room attached to it, and the Spanish timber block house, on which is a timber tower [A in the drawing], in which the present light is kept. A wooden tower [B in the drawing] or lookout was built a Year or two ago by the pilot who keeps the tavern as a speculation on the Government, under the expectation that he would be appointed keeper of the light. But he was disappointed, for the Collector [Beverley Chew] had the present tower repaired as part of a very strong and permanent building, considering its foundation.

The miserable one story hovel mentioned above, is the property of the United States and is the residence of Captain Gardner, the boarding Officer of the Customs. His salary is 3 dollars a day, or 1095 dollars per Annum to which the salary of the lightkeeper is added so as to make it altogether about 14 or 1500 dollars a Year. He cannot indeed spend much in this exile, and has plenty of fish and oysters for taking them; but it is a severe punishment to his family thus to be confined on a marsh in the midst of ruffians, muskitoes and Aligators. The situation otherwise is admirably adapted to the purpose of boarding Ships going in or out. (BHL, *Journals,* 3:160, 287–88)

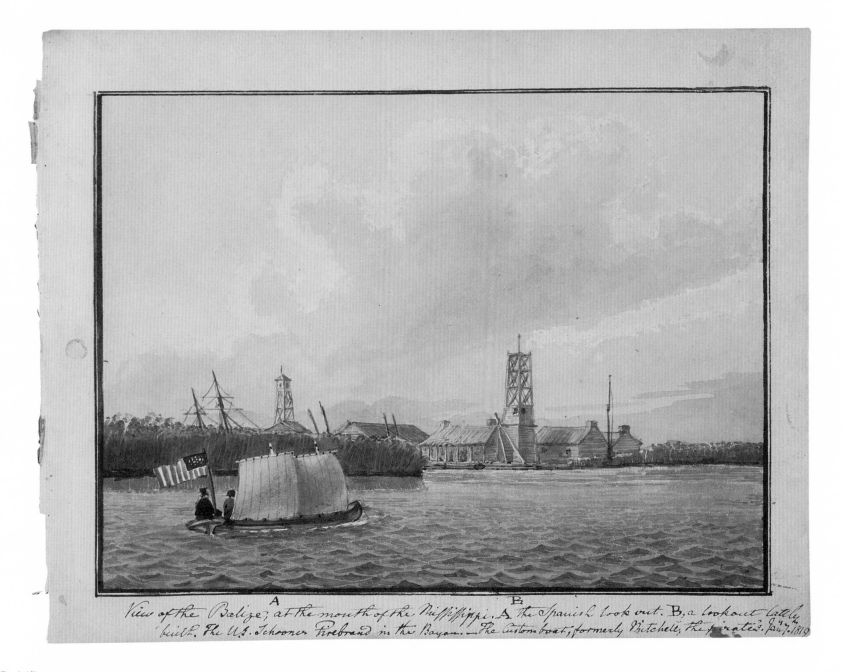

A B₂

View of the Balize, at the mouth of the Mississippi. A the Spanish look out. B, a lookout lately built. The U.S. Schooner Firebrand in the Bayou.— The Custom boat, formerly Mitchell, the pirate's Jan.y 7.th 1819

148. "Market folks"

Undated [1819]
Pencil, watercolor
22.9 cm. × 29.1 cm. (9 in. × 11-7/16 in.)
SKETCHBOOK XIV

Arriving in New Orleans in January 1819, Latrobe recorded his first impressions of the city:

The strange and loud noise heard through the fog, on board the *Clio,* proceeding from the voices of the Market people and their customers was not more extraordinary than the appearance of these noisy folks when the fog cleared away, and we landed. . . .

Along the Levee, as far as the eye could reach to the West, and to the Market house to the East were ranged two rows of Market people, some having stalls or tables with a Tilt or awning of Canvass, but the Majority having their wares lying on the ground, perhaps on a piece of canvass, or a parcel of Palmetto leaves. The articles to be sold were not more various than the sellers. White Men and women, and of all hues of brown, and of all Classes of faces, from round Yankees, to grisly and lean Spaniards, black Negroes and negresses filthy Indians half naked, Mulattoes, curly and straight haired, Quateroons of all shades long haired and frizzled, the women dressed in the most flaring yellow, and scarlet gowns, the men capped and hatted. Their wares consisted of as many kinds as their faces. Innumerable wild ducks, oysters, poultry of all kinds, fish, bananas, piles of Oranges, Sugar Cane, sweet and Irish potatoes, corn in the Ear and husked, apples, carrots and all sorts of other roots, eggs, trinkets, tin ware, dry goods, in fact of more and odder things to be sold in that manner and place, than I can enumerate. The market was full of wretched beef and other butchers meat, and some excellent and large fish. I cannot suppose that my eye took in less than 500 sellers and buyers, all of whom appeared to strain their voices, to exceed each other in loudness. (BHL, *Journals,* 3:171–72)

A year later, Mary Elizabeth Latrobe came upon the same scene, expressing a similar astonishment at her first view of New Orleans:

I have no language to describe my wonder on arriving at N. Orleans! *So* different from what I expected. Natchez is a vile hole and I expected New Orleans to be like it. How then was I *astonished* at the appearance of everything? There is a space from the Levee which bounds the river to the fronts of the houses four times as wide as Baltimore street. . . . In on the Levee near the water sat a woman selling oranges as big as John's head almost, four for a *fippeny* bit. Peas, buns, apples etc. A jargon assailed me equal to Babel its-self. (MEL to Catherine Smith, 18 April 1820, typescript, PBHL)

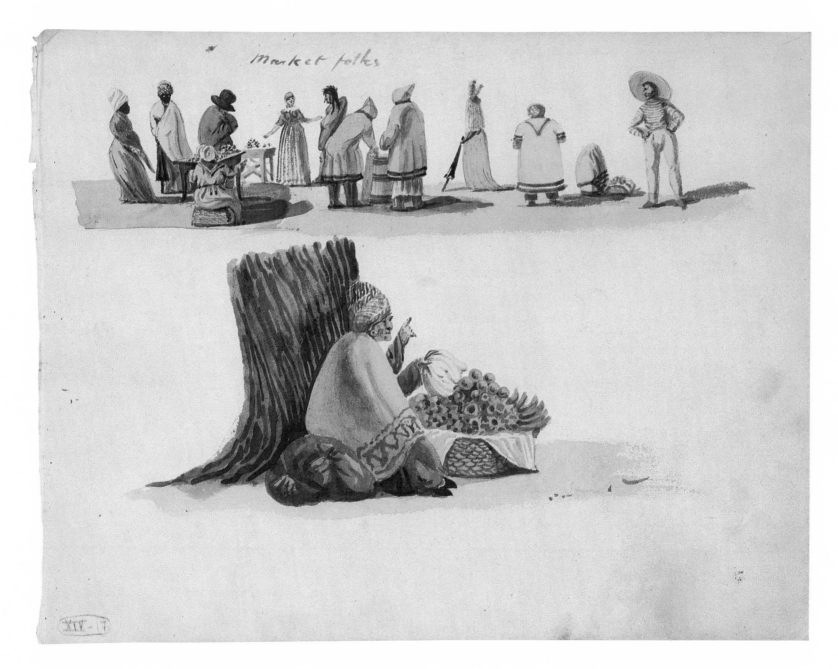

Market folks

149. "View from the window of my Chamber at Tremoulet's hotel New Orleans"

Undated [January 1819]
Pencil, pen and ink, watercolor
22.9 cm. × 29.1 cm. (9 in. × 11-7/16 in.)
SKETCHBOOK XIV

Map reference: New Orleans East Quadrangle, Louisiana
UTM coordinates: 15.078332.331757
Orientation: 220°

On the day after the *Clio* docked at New Orleans, Latrobe wrote of the city: "Every thing had an *odd* look. For 25 years I have been a traveller only between New York and Richmond, and I confess that I felt myself in some degree, again a Cockney, for it was impossible not to stare, at a sight wholly new even to one who has travelled much in Europe and America." (BHL, *Journals,* 3:171)

In New Orleans, Latrobe took up temporary quarters at Tremoulet's Hotel, a French boardinghouse at the southwest corner of what is today Jackson Square. Though Tremoulet's was an "unfashionable" establishment due to "the growing Americanism of this city," Latrobe hoped that his residence there would assist him in reacquiring "a facility in speaking French." (Ibid., p. 174) As this drawing records, the window in his chamber at Tremoulet's revealed a novel and striking scene to the newcomer, Latrobe—the solitude and relative serenity of rooftop retreats set off by the thronging crowds and bustling activity of trade on the levee below.

On the margin of the watercolor Latrobe described the view: "The distant houses are in the suburb St. Mary. The house of which the roof occupies the center of the view is the Government house. The opening beyond the flat roof in the foreground is Jefferson street." Latrobe was looking southwest from the hotel (at the corner of St. Peter and present-day Decatur streets) along the levee of the Mississippi River when he made this drawing. What he called the "Government house" was the old French Government House, at the corner of Toulouse and Decatur, which was destroyed by fire in 1828. The Faubourg Ste. Marie, or St. Mary suburb, was the American section of the city, upriver from Canal Street.

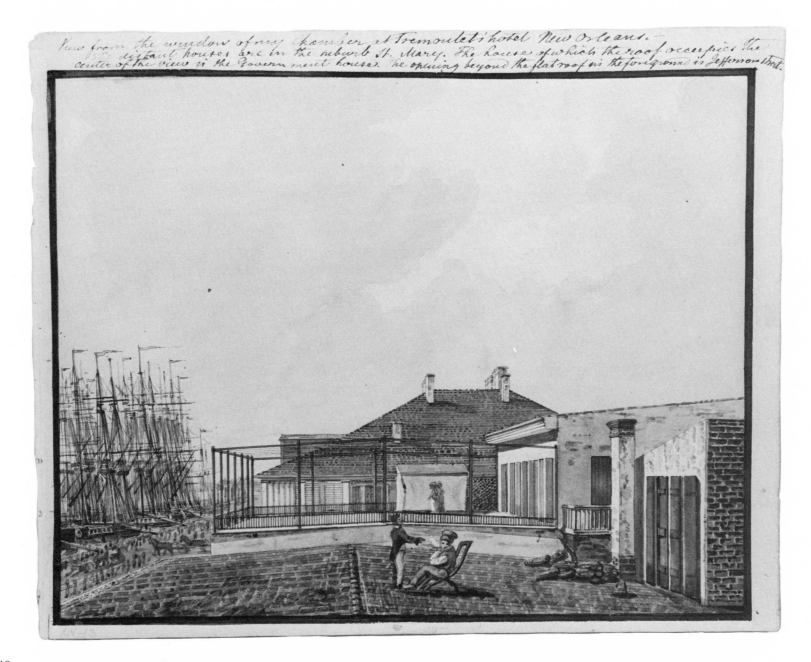

View from the window of my chamber at Tremoulet's hotel New Orleans.— The distant houses are in the suburb St. Mary. The house of which the roof occupies the center of the view is the Government house. The opening beyond the flat roof in the foreground is Jefferson Street.

The New Orleans Battleground

Last Sunday [14 February 1819] my friend Mr. [Vincent] Nolte, took me down to the famous Battle Ground, about 6 Miles below the city. . . . He was . . . in all the actions from the 23d Decr. to the 8th of Jany. 1815. I could not therefore have a better Cicerone, and he kindly took the trouble to explain every thing, that remained to be explained after the numerous descriptions and drawings that the importance of the events has given to the public.

The battle of the 8th terminated the campaign but the attack of the British immediately on Landing decided its ultimate event. This is generally known and believed. The retreat of General [Jackson] to the Lines at which the battle of the 8th was fought was a most judicious measure and worthy of Hannibal. These lines or rather this *Line,* is now visible only as the somewhat elevated bank of a narrow Canal from the Mississippi to the swamp. On the Mississippi itself was constructed, very injudiciously, a redoubt, the same which was actually entered by the British, and in which Major Rennie fell. The redoubt was placed injudiciously because its advanced position covered the British from the fire of the line. Close to the river, and separated only by the Levee and road, is the old fashioned, but otherwise handsome Garden and house of Mr. [William W.] Montgomery. The Garden which I think covers not less than 4 Acres, is laid out in square walks, and flower beds in the old french style. It is entirely enclosed by a thick hedge of Orange trees, which have been suffered to run up to 15 or 16 feet high on the flanks and rear, but which are shorn down to the highth of 4 or 5 feet along the road. The walks are bordered by very large Myrtles cut into the shape of large hay Cocks, about 8 feet high and as

much in diameter. There are so many of them and they are so exactly equal in size and form, that the effect is curious if not elegant. The house itself is one of the usual French plantation houses of the first class and, I think by far the best kind of house for the climate, namely a mansion surrounded entirely by a Portico or Gallery of two stories. The roof is enormous however. In this house General Jackson had his head quarters. In order to build the redoubt the corner of the Garden was cut off, and part of the orange hedge still grows, in a very decayed state, within the lines of the redoubt. The road has been turned round it. Mr. Montgomery intends restoring his Garden to its former state, when the ruins of this work will entirely disappear. A Canal, serving at the time of high water to lead the Water of the Mississippi to the Swamp in the rear, and to drive a Mill, prepared the ditch of the lines, and to make them defencible it was only necessary to raise the bank on the West side, which was done. But it hardly ever deserved the name of a military work. The battery *D*, as well as the others, was strengthened, and indeed built, by laying down a Mass of Bales of Cotton, covering them with Earth, piling others upon them, and thus producing perhaps a much better work than harder materials could have supplied. When the campaign was at an end, the Bales were taken up, and in the place of the Battery is now a pond and a Gap in the line. This ditch and something of a bank extending from the river road to the Swamp will probably remain for many Years, because the ditch serves as a plantation drain. But the soluble quality of the Earth and the exceedingly heavy rains of the Climate would otherwise in a few Years destroy every vestige of a work, which saved the city and the whole country of the Delta from conquest.

The field of Battle is itself a level uninterrupted plain without cover or defence of any kind, immediately in front of the Line; on

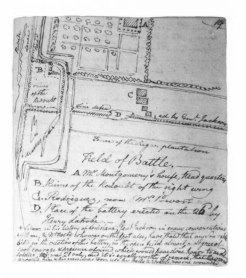

which it was necessary to sacrifice a great number of Men before the Line could be approached. The event is known, and will live as long as the American history shall be read. (BHL, *Journals,* 3:195–97)

Latrobe made the plan of the battlefield, at left, in his journal. It is from the southeast to the northwest, showing the northeast shore of the Mississippi. Portions of the battlefield are now submerged; the remainder has been incorporated into Chalmette National Historical Park, administered by the National Park Service. Reference to the plan facilitates an understanding of the succeeding two drawings.

150. View of the New Orleans Battleground

Undated [February 1819]
Pencil, wash
22.9 cm. × 29.1 cm. (9 in. × 11-7/16 in.)
SKETCHBOOK XIV

Map reference: Chalmette Quadrangle, Louisiana
UTM coordinates: Viewing position: approximately 16.021100.331551; Montgomery
 House: approximately 16.021086.331549; Rodriguez/Prevost House:
 approximately 16.021095.331535
Orientation: Approximately 310°

This view is to the northwest up the bank of the Mississippi River from just below the "Fence of the Sugar plantation" shown in Latrobe's plan of the battlefield. In this drawing Latrobe shows more buildings than appear on the plan. The Montgomery house is in the left center and the house once owned by Jean Rodriguez and later by Jean Baptiste Prevost is to the right. At the far left are the Mississippi River and remains of the redoubt. The gap in the levee at the right center is marked *D* in the plan; it was the location of the battery erected by Henry Latrobe. Of Henry's conduct during the battle, Latrobe wrote:

Latour in his history of Louisiana, Genl. Jackson in many conversations with me, and Mr. Nolte who was on the spot also, have stated that my Son exhibited in the erection of this battery, in the open field almost, a degree of cool courage and presence of mind which would have done honor to an old Soldier. He was 21 only, and it is equally worthy of remark, that the ground around him and his men, was torn up by balls and rockets, and no one wounded. (BHL, *Journals,* 3:197–99)

Major A. Lacarrière Latour had written:

That very morning [28 December 1814] the engineer, H. S. Bonneval Latrobe, had established, under the fire of the enemy's artillery and a cloud of rockets, a twenty-four pounder on the left of the battery No. 1, on the line. This gun dismounted one of the field pieces which the enemy had placed in battery on the road. (Latour, *Historical Memoir,* p. 120)

a fence along the line

+ shingles
o Venetian blinds
◇ brick

151. "Battle Ground from the Bank of the Mississippi"

Undated [February 1819]
Pencil
22.9 cm. × 29.1 cm. (9 in. × 11-7/16 in.)
SKETCHBOOK XIV

Map reference: Chalmette Quadrangle, Louisiana
UTM coordinates: Viewing position: approximately 16.021104.331536; Montgomery
 House: approximately 16.021086.331549; Rodriguez/Prevost House:
 approximately 16.021095.331535
Orientation: General focus: approximately 350°; Right edge: approximately 85°; Left
 edge: approximately 320°

This was intended to be a panorama, the upper portion to be visualized to the right of the lower portion, with the asterisks aligned. Latrobe was standing near the bank of the river and looking northwest. He would have been just to the left of the letter *D* in the legend of the plan of the battlefield. The tree-covered area in the distance was a swamp at the time of the battle and at the time Latrobe made this drawing. The British forces under Pakenham advanced from the right of the view across the open plain of the sugar plantation to attack the American forces behind the levee, which runs across the lower portion of the drawing.

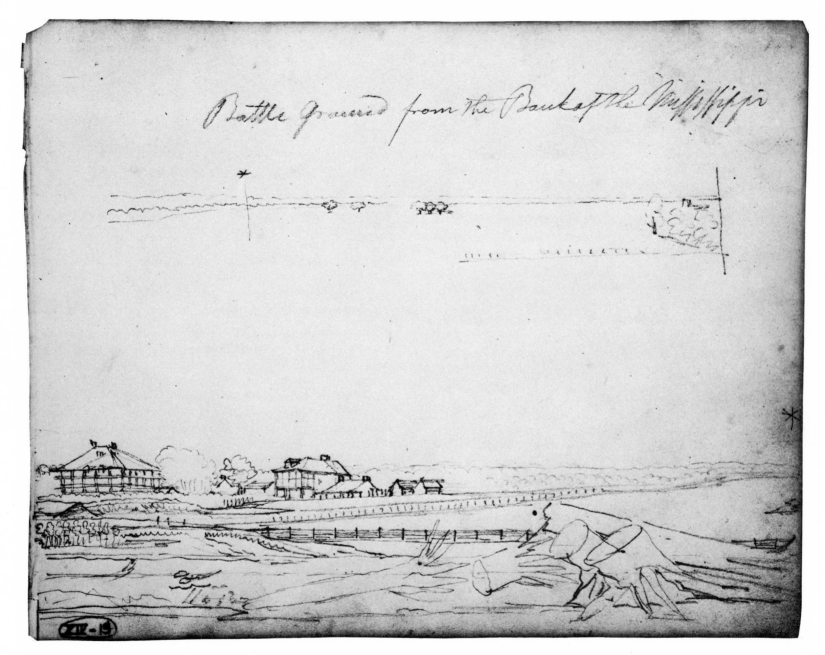

Battle Ground from the Bank of the Mississippi

152. "Lighthouse foundations"

Undated [11 April 1819]
Pencil
22.9 cm. × 29.1 cm. (9 in. × 11-7/16 in.)
SKETCHBOOK XIV

Map reference: Pass a Loutre East Quadrangle, Louisiana
UTM coordinates: 16.030021.322517
Orientation: Cannot be determined from drawing

Latrobe left New Orleans on the morning of Saturday, 10 April 1819, on board the steamboat *Alabama,* for the Balize and Frank's Island, about one hundred miles downriver at the mouth of the Mississippi. He arrived at the Balize that evening, and on Sunday morning he and Beverley Chew, collector of the customs at New Orleans, went to Frank's Island, several miles to the east, on the revenue boat. Latrobe's object

was to inspect by desire of the Government U. States the state of the work at the Lighthouse. This building was designed by me some Years ago while Surveyor of the public buildings U. States [1805], and contracts invited for its erection. But as none were offered, the Mississippi remained without even a light untill after the late War [of 1812], when by the exertions of Mr. Chew the present Collector of N. Orleans (than whom a more meritorious Officer of Government does not exist), a light was put into the old Lookout of the Spaniards at the Balize. Commissioners were also appointed to fix upon the site of the Lighthouse, and they chose the situation of Frank's island.

Latrobe's son Henry was one of the three commissioners, and he designed the new lighthouse. Henry died in New Orleans of yellow fever on 3 September 1817, several months before a contract was let for the erection of the lighthouse.

At the time Latrobe made his inspection, Frank's Island had about an acre and a half of solid, elevated land.

Frank's Island is a hummock never overflowed, highest in the center, and 5 or 6 feet perpendicular above the Water at its edge where it is washed and wafted by the surf.

The whole Island being covered with temporary buildings and Shops, Brick Yards and kilns, lumber and Materials for the lighthouse the foundation of which was already laid, I can say nothing of its natural vegetable productions for they were all destroyed. (BHL, *Journals,* 3:284–85, 286)

As the action of waves was slowly washing away the island, Latrobe had a wharf constructed to protect the site of the lighthouse. The drawing shows the foundation of the lighthouse, the line of wharfing then being built, and some of the temporary buildings. The lighthouse collapsed when almost completed, and it was rebuilt in 1823. It was abandoned about 1855, when a new lighthouse at Pass à L'Outre began operation. Frank's Island has since been submerged, but the lighthouse tower still rises from the water.

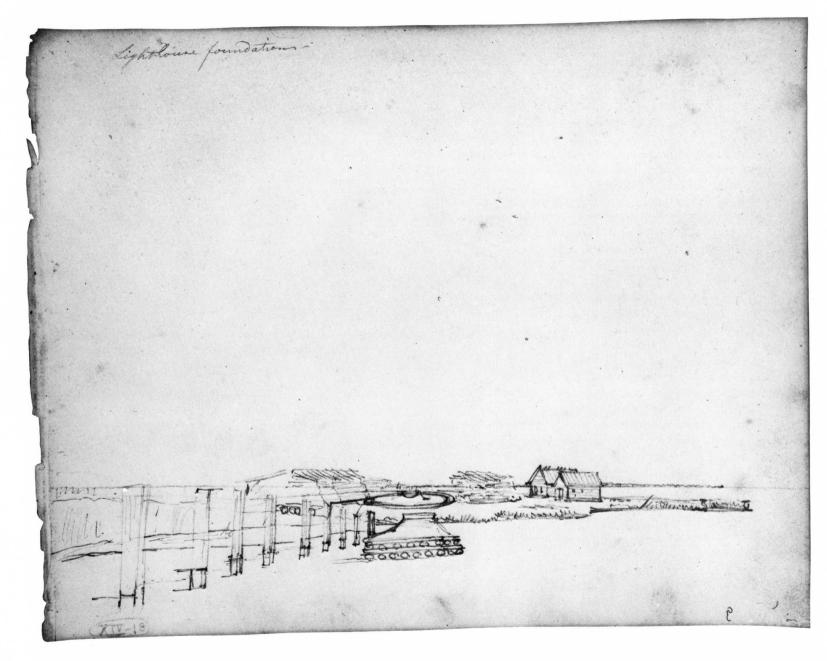

Lighthouse foundations

153. The Jack

1 October 1819
Pencil, pen and ink, watercolor
22.9 cm. × 29.1 cm. (9 in. × 11-7/16 in.)
SKETCHBOOK XIV

Latrobe's description of this fish as a "Rudderfish, full size" is incorrect on both counts. The fish is neither a rudderfish nor an adult specimen. The five-inch specimen illustrated here is an immature jack, possibly a blue runner (*Caranx fusus*), which can reach a length of two and one-half feet. Like the rudderfish, the blue runner is found along the east coast of Florida, where the *Emma* was on 1 October 1819 on her voyage from New Orleans to Philadelphia. The range extends from Nova Scotia to southeastern Brazil. Unlike the dull appearance of the rudderfish, "the gold and silvery brightness of the beautiful skin," which Latrobe found so difficult to replicate on paper, is typical of jacks.

Latrobe accurately drew the dark opercular patch behind the eye and the narrow peduncle of the tail, both characteristic of the jack. The mouth, however, is not so well drawn, and the pectoral fin should be asymmetrical rather than rounded. Latrobe also failed to note the third short spine at the anal fin, but in immature specimens this is difficult to see.

Young jacks are common in shallow water, even in brackish areas around river mouths. They are usually found where Latrobe took his specimen—in schools ranging along and over reefs. The solitary adults are common along the eastern seaboard, where they feed upon small fish, shrimp, and other crustaceans. Although a fine game fish, the large jack makes poor eating if the tail is not cut and the fish allowed to bleed immediately upon capture.

Rudderfish, full size
Brig Emma, Oct.r 1.t 1819

drawn, the Brig, pitching very much
off the Manzilla reef in the Gulph stream.

The Rudder fish follow ships under moderate way, in shoals, swarming about the rudder & along the keel. When seen over the Taffel rail they appear to be almost black, or, a very dark purple, with white bellies. But when taken out, their colors vary with the light, so that even the back, may be seen of a bright gold color. This, independently of the impossibility of expressing by any coloring, the gold & silvery brightness of the beautiful skin of the fish, renders it difficult to give a true idea of their any thing but their form. They appear to belong to the tribe of Perch. Inside the sharp spines of the back fin, there are just behind the anus two small fins + furnished with strong spines. They being constantly in shoals under the bottom of ships is a singular circumstance, whether they seek that situation to escape from the Dolphins, or for the benefit of a cool shade, cannot be known, & on the latter account, there would be more sense than is generally supposed in the ludicrous lines, The sun's perpendicular heat, Illumines the depth of the sea. The fishes beginning to sweat, Cry, damn it, how hot we shall be. —

NO. 153

154. Elevations of the Cabildo, or Principal, and St. Louis Cathedral, New Orleans

Undated [1819–20]
Pencil, pen and ink
18.9 cm. × 64.4 cm. (7-7/16 in. × 25-3/8 in.)
Maryland Historical Society, Baltimore

Almost immediately upon his arrival in the city, Latrobe made the following observations on the public square, which was known as Place d'Armes under the French and was renamed Jackson Square in 1856:

> The public square which is open to the river has an admirable general effect, and is infinitely superior to any thing in our atlantic cities as a Water view of the city. . . . The whole of the side parallel to the river is occupied by the Cathedral in the Center and by two symmetrical buildings on each side. That to the West is called the Principal, and contains the public Offices and Council chamber of the city. That on the East is called the Presbytery, being the property of the Church. It is divided into 7 stores and dwellings above, which are rented and produce a large revenue. . . . The square itself is neglected, the fences ragged, and in many places open. Part of it is let for a depot of firewood, paving stones are heaped up in it, and along the whole of the side next the river is a row of mean booths in which dry goods are sold, by yellow, black, and white women, who dispose, I am told, of incredible quantities of slops and other articles fit for sailors and boatmen, to those sort of Customers.
>
> Thus a square, which might be made the handsomest in America, is really rather a nuisance than otherwise. (BHL, *Journals*, 3:172–73)

The three most prominent buildings in the city, are the Cathedral, the Principal, and the Presbytère. They form the N West side of the Place d'armes. The Cathedral occupies the Center, the two others are perfectly symmetrical in their exterior, the Principal to the South, the Presbytère to the North of the Church. Altho' in detail these buildings are as bad as they well can be, their symmetry, and the good proportions and strong relief of the façades of the two latter, and the solid Mass of the former produce an admirable effect when seen from the river or the Levee.

The construction of these buildings is curious. The foundations are laid about six inches below the natural Surface, that is, the turf is shaved off, and logs being then laid level along this shallow trench, very solid piers and thick walls of brick are immediately built upon the logs. The Cathedral is bound together by numerous Iron cramps, which appear externally, in and other forms; but I do not think that they were very necessary, the settlement of buildings here being very equal *in general*, and few if any cramps appear on the outside of the two other buildings. The SE corner of the Principal however has not settled as much as the rest of the front: for tho' no crack appears, the horizontal mouldings are swayed down, at least 4 inches towards the NE. The corner that has not settled, as I was informed by the Mayor, was built upon the foundation of an old Wall, from which circumstance it would appear, that the Earth once pressed down by considerable weight does not afterwards admit of further condensation. In digging the foundation of my boring Mill [for hollowing logs to be used as pipes for the waterworks] I found the ground hardest at the very surface, and almost a quicksand on the NW side, where the foundation of the old building obliged me to dig deeper.

These three buildings are in fact the best looking in New Orleans at present. (BHL, *Journals*, 3:192–93)

St. Louis Cathedral, designed by Gilberto Guillemard, was built between 1789 and 1794 on the site of a church destroyed by fire in 1788. Latrobe added a central tower to the cathedral in 1820. The Cabildo, or Principal, also designed by Guillemard, was erected between 1795 and 1799. The Presbytère, originally intended to be the rectory of the cathedral, was begun in 1789 from Guillemard's plan. The church rented it, and finally sold it to the city for use as a courthouse. The Cabildo and the Presbytère are now part of the Louisiana State Museum.

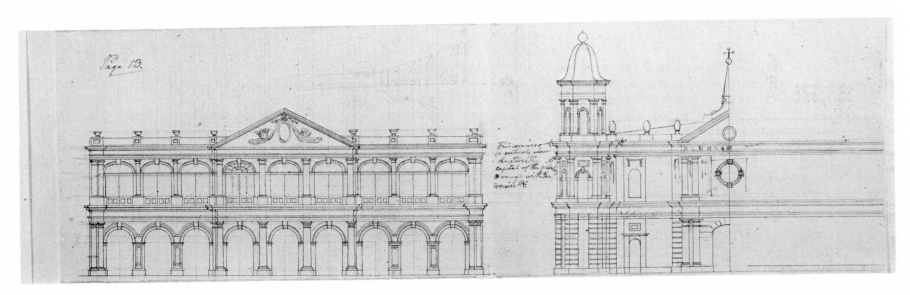

NO. 154

371

155. "View on the new turnpike road from Chambersburg to Bedford"

22 January 1820
Pencil, watercolor
20.3 cm. × 31.8 cm. (8 in. × 12-1/2 in.)
SKETCHBOOK X

Map references: Everett East Quadrangle, Pennsylvania; Everett West Quadrangle,
 Pennsylvania
UTM coordinates: In vicinity of 17.072642.443305
Orientation: Approximately 275°

The road, which formerly was carried along the slope of the rocky mountain on the right, is now made, by blowing down the road, to run close to the Bank of the Juniata for a very considerable distance. The rocky [mountain] is a red argillaceous schist regularly chrystalized in rhomboidal parallelopipedons. The distant mountain called the Warrior's mountain. The Juniata passes through it beyond the village of Bloody run.

The view was taken when the country was covered with snow. Jany. 22d, 1820. On the rocks the Sun had however melted it and left them almost bare. (BHL, SKETCHBOOK X)

Having decided to bring his family to New Orleans, Latrobe returned to Baltimore in the fall of 1819 to settle his affairs in the East and escort his family on the trip west. The Latrobe family traveled overland from Baltimore through Pennsylvania to Wheeling, Virginia, where they could board a steamboat to New Orleans. Leaving Baltimore on 15 January 1820, they proceeded through Reisterstown, Maryland, and Gettysburg, Pennsylvania, arriving at Chambersburg, Pennsylvania, four days later. The family remained in Chambersburg until 21 January, when they departed for McConnellsburg and Bedford along the turnpike depicted in this scene. The Chambersburg and Bedford Turnpike, which was completed shortly before their trip, was one of the final links in the system of turnpike roads connecting Philadelphia and Pittsburgh. Latrobe commented on the new road in a letter written on the same day he executed the watercolor:

The new road, (turnpike) is a work of immense labor. The snow covers it, on the mountains, about a foot deep; so that I could judge only of its line and gradation, both which appear to be well effected, and with the least possible waste of labor in cutting, and filling. I had the satisfaction of learning from our very sensible Landlord, a Mr. [John] Tait, at Bloody run, (he being a Large Stockholder and Director of the Company from Bedford to Chambersburg) that my dissertation and report on roads, published in the emporium [*Emporium of Arts and Sciences* 3 (1814)], has been the guide in their construction of this great Turnpike. They have namely made the road without any rise in the middle, beyond 1/4 of an inch, the law requiring it *to be rounded,* and have taken care to drain it well; and that all the stones from the bottom to the top should be broken to any equal size. (BHL to Robert Goodloe Harper, 22 January 1820, in BHL, *Correspondence,* 3)

Latrobe was most likely on the north side of the Raystown Branch of the Juniata River looking west from a position approximately one to two miles east of Everett (Bloody Run) when he composed this scene. Eventually, he executed two virtually identical watercolors of this view on the turnpike. The other one, now in a private collection, is larger (30.2 cm. × 45.2 cm.) and shows a sleigh on the road. It is reproduced in BHL, *Journals,* 3: plate 14.

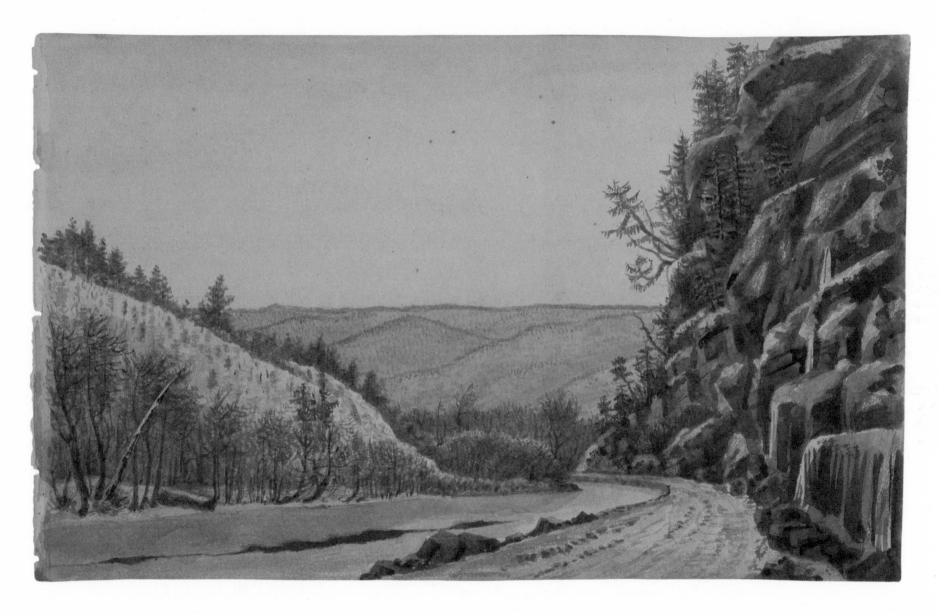

NO. 155

156. "Washington Pensa."

16 February 1820
Pencil
17.3 cm. × 33.0 cm. (6-13/16 in. × 13 in.)
SKETCHBOOK XIII

Map references: Washington West Quadrangle, Pennsylvania; Washington East
 Quadrangle, Pennsylvania
UTM coordinates: Viewing position: 17.056365.444651; Courthouse:
 17.056423.444672
Orientation: 70°

Continuing their trip west, the Latrobe family arrived in Washington, Pennsylvania, on 27 January 1820. Since they were just thirty-two miles east of Wheeling, their destination, and having family and friends in the town, they decided to remain there "untill there is a near prospect of our being able to proceed down the river." (BHL to Robert Goodloe Harper, 30 January 1820, MGLC, PBHL) His extended stay in Washington gave Latrobe ample time to record his knowledge and impressions of the town in both his journal and sketchbook.

Washington was about the year 1775 an indian town, the residence of an Indian chief called old Catfish, of whose existence there is still evidence in the name of a small rivulet, which is a branch of Chartrees creek (called vulgarly Shirtee) and runs along the south and West foot of the hill on which Washington is built. It is still called Catfish run, tho' I believe no Catfish ever were caught in it.

The town is built upon a ridge of which the sections are below.

This hill is surrounded by hills much higher, so that on approaching the town from the east especially it appears to lie in a hollow.

It has about 2500 inhabitants. The principal street occupies the bank of the ridge, on the highest point of which is the court house. The court house was built about 27 Years ago, and is now a mean building, though at that time might have been beyond the general

advance of art so far to the Westward. There is a college also, poor, and having more reputation, as a place of education, than beauty or convenience. A presbyterian and methodist Church are such plain buildings as you find every where. (BHL, *Journals,* 3:322–23)

Latrobe sketched this view from a hillside south of the town. Catfish Run is in the left foreground. The courthouse, with its "remarkable" cupola, is depicted in the center at the top of the hill. Destroyed in 1839, the courthouse stood on Main Street between Beau and Cherry, which remains the site of the Washington County Courthouse. The "poor" college which Latrobe saw (though not depicted in this view) was the Washington Academy, predecessor of Washington and Jefferson College.

During his stay in Washington, Latrobe drew a plan and an elevation of the courthouse cupola in his sketchbook (see below), making another entry into his casual collection of drawings of inelegant American architectural curiosities. On the drawing, he noted that the cupola was "remarkable for its position with a Column in front." In a tradition of architectural symmetry that descended from the classical temple, with its central entry on the main facade (see Fig. 14, p. 33), the normal cupola of the period had a bona fide front face, with a central aperture. The Washington courthouse "turret" (a kind of miniature octagonal temple) unclassically enough turns an angle with a column to the front of the building, as if the designer had rotated the cupola out of its correct position. In the later nineteenth century, such positioning came into fashion during a phase of Picturesque taste quite different from Latrobe's.

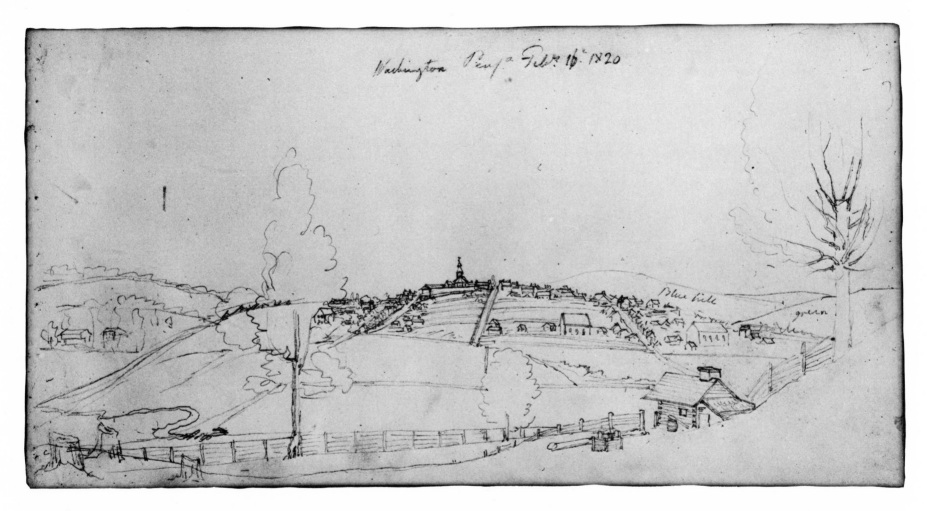

Washington Penpa Febr. 16th 1820

Blue hill

green

NO. 156

157. "Wheeling [Virginia]"

18 February 1820
Pencil
17.3 cm. × 33.0 cm. (6-13/16 in. × 13 in.)

SKETCHBOOK XIII

Map reference: Wheeling Quadrangle, West Virginia–Ohio
UTM coordinates: Viewing position: 17.052340.443512; Upstream end of Wheeling
 Island: 17.052300.443706
Orientation: 350°

We came yesterday to this place, and expect hourly a Steam boat from Pittsburg in which we have engaged our Passage to New Orleans. . . .

Wheeling is a delightfully situated town on the Virginia side of the Ohio. It must soon become a place of great importance, having two advantages, which alone will secure to it great commercial wealth. The roads to the Westward, from the Potowmac at Cumberland, and from Washington city, from Baltimore thro' Cumberland, and thro' Bedford and Somerset, and from Philadelphia thro' Somerset or Pittsburg, unite at this point. It must therefore become the great Emporium of goods going further by Water. The other advantage for Wheeling arises from the Shoals and bars of the Ohio between this place and Pittsburg, so that the navigation ceases at Pittsburg, long before the Water falls too low to descend from hence. The great Western road is finished from Washington Pa. to this place. For 16 Miles it follows the narrow Valley, or rather Glen, of Wheeling creek, crossing the Creek, 20 times at least by means of solid Stone bridges, all of which are constructed with more expense than skill and good judgement. They add on that very account greatly to the beauty of this incomparably beautiful Country; and the road itself has all the grandeur and character of a national work. But, (as you will have ample opportunity of experiencing if you ever become a slave of the public) Local interests have prevented for the present at least, the most rational and easy construction of the road. There was preponderating interest enough to carry the road through the upper town instead of following the dotted line to the lower town. And there was not knowledge or skill enough to carry it about 100 Yards in length, by means of a drift or Gallery ⊙ thro' the Coal stratum which is just 18 feet thick and has solid rock above and

below it. The Coal gained would have paid the expence of the cutting thro', and of the necessary piers and walls; and 100 feet of ascent and descent, and an immense expense of blowing out and walling the road along the precipice of the creek, would have been saved. (BHL to John H. B. Latrobe, 18 February 1820, including sketch below, in BHL, *Correspondence*, 3)

Wheeling is delightfully situated. 25 Years ago it consisted of only 5 Cabins. It is now a large town of, *one half*, brick houses and is growing in the Mushroom style of America. (BHL to Robert Goodloe Harper, 20 February 1820, MGLC, PBHL)

This rough sketch of Wheeling (now part of West Virginia), looking north on the Ohio River, depicts what Latrobe labeled "the lower town," including a mill and several houses, in the foreground, and "the upper town," with a few vaguely outlined houses, on a hill in the background. On the left is a small portion of Wheeling Island. The hills in the background are part of Ohio. None of the buildings depicted in this view are extant.

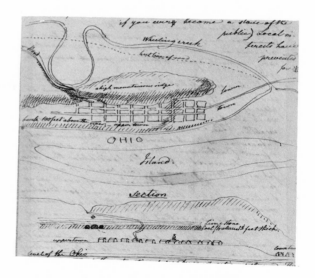

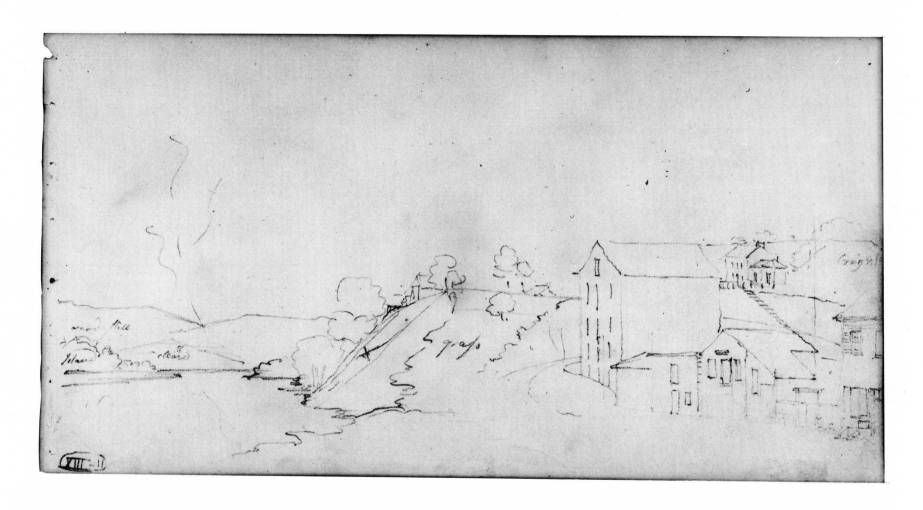

NO. 157

158. "Marietta [Ohio]"

Undated [22 February 1820]
Pencil
17.3 cm. × 33.0 cm. (6-13/16 in. × 13 in.)
SKETCHBOOK XIII

Map reference: Marietta Quadrangle, Ohio–West Virginia
UTM coordinates: Viewing position: 17.046056.436234; Court House:
 17.046089.436282; First Congregational Church: 17.046066.436278
Orientation: 20°

Marietta, Ohio, was the first stop on the Latrobes' steamboat voyage down the Ohio River from Wheeling. What was meant to be an overnight layover in Marietta extended into three days when the shaft of the steamboat wheel broke, thus providing Latrobe with the opportunity to explore one of the oldest towns in what had been the Northwest Territory.

When Latrobe executed this sketch, he was standing near the site of Fort Harmar in the village of Harmar on the west bank of the Muskingum River looking east and upriver. Unable to encompass the entire panorama on one level of his sketchbook page, Latrobe continued the scene at the top of the page, signifying the connecting points with a small cross. The most outstanding edifice in the landscape is the two-towered First Congregational Church, also known as "Old Two Horn," in the center of the scene. It was built in 1809 on Front Street north of Putnam Street, destroyed by fire in 1905, and in 1906 replaced by a brick replica which is still standing. Just north of the church, Latrobe sketched and identified the home of Gov. Return Jonathan Meigs, Jr. (1764–1824), built about 1810 and still standing in a slightly altered form. To the south of the church was the home of Capt. Daniel and Mary Greene, originally built by Col. Ebenezer and Catharine Sproat in 1795.

Further south, on the southeast corner of Putnam and Front streets, was the post office, which was built about 1810 and is still standing, though altered. One block east, on the southeast corner of Putnam and Second streets, was the Old Court House, built in 1798 and replaced in the 1820s. Other buildings labeled by Latrobe in this scene were the "markethouse," east of the Old Court House, and further south "Mr. Willard," probably the home of the Rev. Joseph Willard (d. 1823), an Episcopal clergyman.

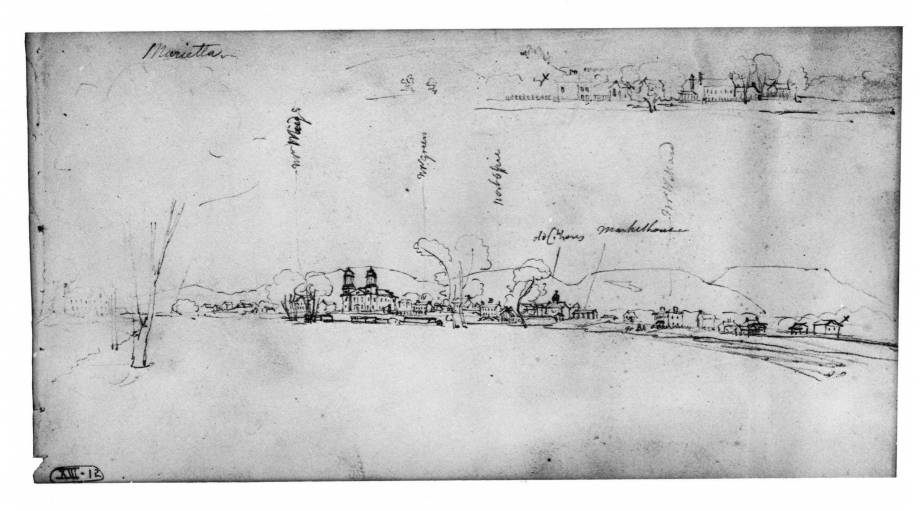

NO. 158

159. "Maysville Limestone Kentucky"

28 February 1820
Pencil
Two pages, each 17.3 cm. × 33.0 cm. (6-13/16 in. × 13 in.)
SKETCHBOOK XIII

Map references: Maysville East Quadrangle, Ohio–Kentucky; Maysville West
 Quadrangle, Kentucky–Ohio
UTM coordinates: Viewing position: 17.025793.428256; Mouth of Limestone Creek:
 17.025972.428100
Orientation: 130°

Soon after the Latrobes left Marietta, their steamboat voyage down the
Ohio River was again interrupted by mechanical difficulties. They ar-
rived in Maysville, Kentucky, on 26 February, where they remained
until 1 March while repairs were being made. Mary Elizabeth Latrobe
expressed her annoyance with their slow progress in a letter to a friend:
"Our *next* accident was near Marysville, and as it was the breaking of a
shaft, we were delayed five days—we were immediately called upon by
Mrs. Burt and her daughters, you know they moved from Baltimore
some time last summer. They are miserable and discontented at their
situation! and say they would rather live upon bread and water in Bal-
timore than upon Luxuries at Marysville." (MEL to Catherine Smith, 18
April 1820, typescript, MGLC, PBHL)

Maysville was known for many years as Limestone, after the creek
of that name which empties into the Ohio at this point. Situated sixty
miles east of Cincinnati, Maysville was established as a town in 1788. It
was an important port for northeastern Kentucky, serving as a principal
point of entry for immigrants to this frontier state and for merchandise
and supplies for the interior. Latrobe sketched this panoramic view
from a position just west of the town, looking upriver, with the Ohio
shoreline at the extreme left.

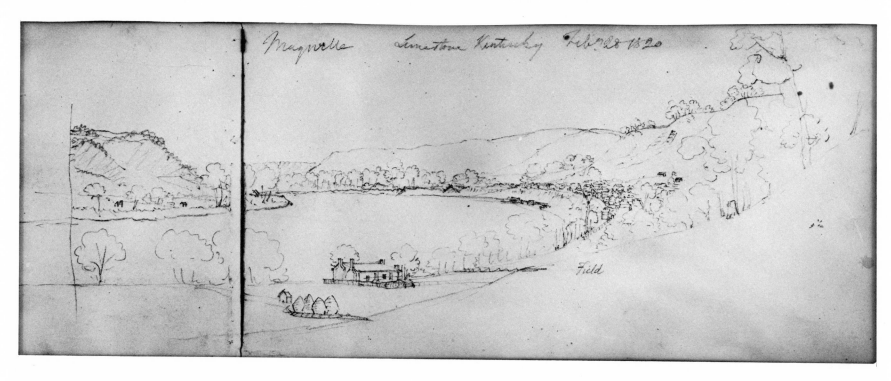

Maysville Limestone Kentucky Feb.r 28 1820

Field

NO. 159

160. "Louisville and Shippingport from Clarkesville [Indiana]"

22 March 1820
Pencil
Two pages, each 17.3 cm. × 33.0 cm. (6-13/16 in. × 13 in.)
SKETCHBOOK XIII

Map references: New Albany Quadrangle, Indiana–Kentucky; Jeffersonville
Quadrangle, Indiana–Kentucky
UTM coordinates: Viewing position: 16.060640.423842; Shippingport:
16.060640.423780; Goose Island: 16.060748.423722; Corn Island:
16.060824.423545; Central Louisville: 16.060910.423480
Orientation: Approximately 140°

The anxiety that devour'd us, both myself and Husband respecting his business at New Orleans, prevented our enjoying ourselves with the hospitable friends we met, and we could only feel vexation at the delay occasioned by the bad Management on Board our Boat, subjecting us to repeated accidents, for instance, on a voyage of 8 days (the usual time) from Wheeling to New Orleans we were on board 5 weeks. At Louisville we went ashore and remained six days while repairs were making. Having many letters of Introduction, some from [Henry] Clay the Speaker and others from Luke Tiernan, we were entertained with a sort of ostentatious grandeur that made us think less favorably of the place than any we had been at. (MEL to Catherine Smith, 18 April 1820, typescript, MGLC, PBHL)

Following their stay in Louisville, the Latrobes journeyed two miles overland around the falls of the Ohio, rejoining their steamboat at Shippingport, Kentucky. There, they once again found their voyage delayed. During this three-day hiatus, Latrobe traveled directly across the river to Clarksville, Indiana, and sketched this view of the region, looking upriver toward the falls of the Ohio and toward Louisville. The drawing depicts the town of Shippingport at the right, the town of Clarksville on the near shore at the left, and the faintest representation of Louisville in the center. Goose Island, in the middle of the Ohio just downriver from Louisville, and Corn Island (no longer in existence), situated alongside of Louisville, are represented in the center and right center of the sketch.

Shippingport, today an island created as a result of the construction of the Louisville and Portland Canal, was in Latrobe's time an important transshipment center, situated at the head of the navigation of the lower Ohio River. An 1819 report described the town: "The population of Shippingport, may be estimated at 600 souls, including strangers. Some taste is already perceptible in the construction of their houses, many of which are neatly built and ornamented with galleries, in which, of a Sunday, are displayed all the beauty of the place. It is, in fact, the 'Bois de Bouloigne' of Louisville, it being the resort of all classes, on high days and holidays." (McMurtrie, *Sketches of Louisville,* p. 161) Latrobe's sketch of Shippingport features what appears to be a large mill, most likely the Merchant Manufacturing Mill, a six-story structure built in 1817.

Clarksville, Indiana, was at this time a tiny village, consisting of "a few log houses of one story, . . . and from their number and appearance I should suppose that they do not contain altogether one hundred inhabitants. . . . It is said to be very unhealthy, which is more than probable from the number of marshes that are in the vicinity." (McMurtrie, pp. 168–69) The present-day town of Clarksville is no longer situated on the shores of the Ohio, but just to the northeast of the area it occupied when Latrobe saw it.

Only twelve years after Latrobe visited this area, his nephew traveled to the falls of the Ohio. "Our next halting-place was Louisville, another large and thriving city, situated on the Kentucky shore, just above the Falls of the Ohio. Its position on one of the great bends of the river, with the islands and rapids below, forms one of the most striking among all the beautiful scenes with which Ohio abounds." (Charles Joseph Latrobe, *The Rambler in North America, 1832–1833,* 2 vols. [New York, 1835] 1:84)